Bilborough College
Library and Information Centre

Highlights of Art

JSEUM, MADRID

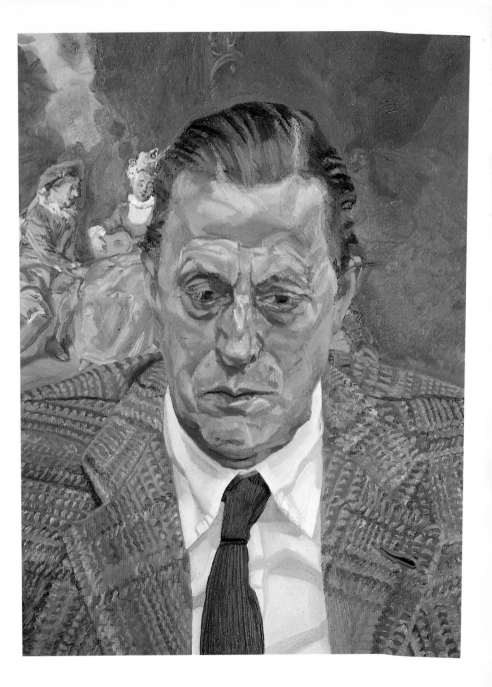

Highlights of Art

THYSSEN-BORNEMISZA MUSEUM, MADRID

Text by Teresa Pérez-Jofre

TASCHEN

KÖLN LONDON MADRID NEW YORK PARIS TOKYO

FRONT COVER:

Salvador Dalí: *Dream caused by the Flight of a Bee around a Pomegranate one Second before Awakening* (detail), 1944
Oil on canvas, 51 x 41 cm

SPINE:

Richard Lindner: *Moon over Alabama* (detail), 1963
Oil on canvas, 200 x 120 cm

BACK COVER:

El Greco: *The Annunciation – Italian period* (detail), c. 1567–1577
Oil on canvas, 117 x 98 cm

PAGE 2:

Lucian Freud, *Portrait of Baron H. H. Thyssen-Bornemisza*, 1981/82
Oil on canvasa, 51 x 40 cm

© 2001 TASCHEN GmbH
Hohenzollernring 53, D–50672 Köln
www.taschen.com
© 2001 for the photos: Museo Thyssen-Bornemisza, Madrid

Project management: Petra Lamers-Schütze, Cologne
Editorial coordination and layout: Juliane Steinbrecher, Cologne
Design: Claudia Frey, Cologne
Translation: Laura A. E. Suffield, Madrid
Cover design: Angelika Taschen and Catinka Keul, Cologne
Production: Ute Wachendorf, Cologne

Printed in Italy
ISBN 3–8228–6307–6

Contents

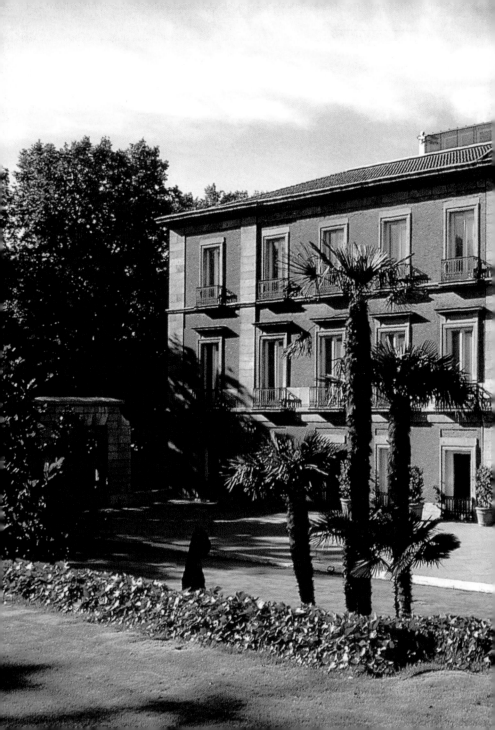

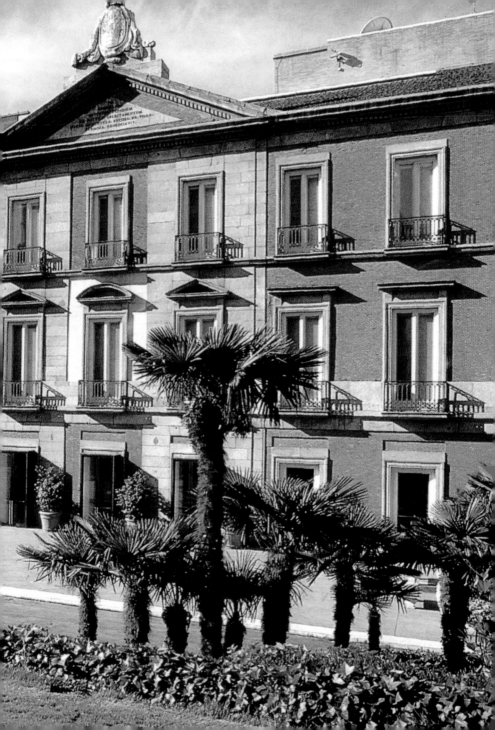

Introduction

The Thyssen-Bornemisza Collection is one of the world's most important collections of western art. It comprises around 800 works of art of the highest quality, which together present a cohesive overview of international painting from the 13th century to the present day. The Thyssen-Bornemisza Museum in Madrid houses the most significant part of the collection, while a carefully selected group of around 70 works of art is on display at the Monastery of Pedralbes in Barcelona.

Both in the quality of its paintings and the specific artists represented within it, the collection brings to the Spanish museum world painters and movements not to be seen elsewhere in Spain, such as 17th-century Dutch painting, Impressionism, German Expressionism, and American painting, as well as a different type of permanent collection, organized not by national schools but stylistically. This was a fundamental notion in the theory of art history and one to which we find numerous references in the writings of Burckhardt, Riegl, Wölfflin and Berenson, among others. It is also the principle which informs the installation of both the Madrid and the Barcelona displays.

The Thyssen-Bornemisza Museum was inaugurated in October 1992 and is one of the most ambitious new additions to the Spanish cultural scene in recent years. The Museum was born with a great asset as well as a great responsibility: the permanent display and preservation of one of the world's most important collections, already well-known internationally through exhibitions in Europe and America over the years. Its opening was greeted with widespread acclaim, both by the art world and by visitors. Its initial success has been confirmed over the past seven years, during which time the Museum has established itself as a dynamic and modern institution and as a cultural focus both within Spain and internationally.

The high reputation which the Museum has already earned is a reflection of several factors. First, the extraordinary quality of the works in the collection, through which the history of painting from the 13th century to the present day can be charted through the works of its great-

PAGES 6/7 AND ON
THE LEFT:
The Thyssen-
Bornemisza
Museum, Madrid
The main façade

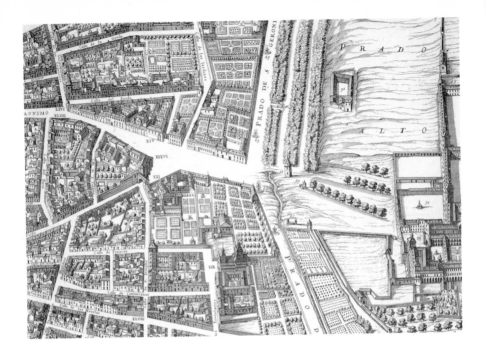

The site of the Villahermosa Palace, next to the "Meadow of Saint Jerome" Plan of Madrid by Teixeira (1665)

est masters. Second, the attractiveness of the two sites which house the collection in Madrid and Barcelona, and in particular the fine Palacio de Villahermosa in Madrid, a neo-classical palace of which only the original façades survive, and whose interior has been restored with great beauty and harmony by the Spanish architect Rafael Moneo. His new interiors combine the most up-to-date systems of environmental control, as designed specifically for works of art, with a great sensitivity with regard to the organization of the spaces in which visitors can contemplate the works of art.

Finally, special emphasis has been placed on the concept of the Museum as a cultural centre offering an attractive, varied and original programme, in which quality and intellectual rigour are not at odds with success; in particular, service to the public has always been a high priority. Especially noteworthy among the wide range of activities organized by the Museum are its temporary exhibitions, which are always related to a specific aspect or artist in the Permanent Collection. These exhibitions have enjoyed great public and critical acclaim, particularly "17th-

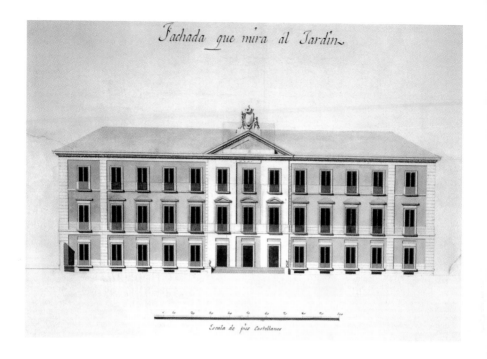

century Dutch painting", "André Derain", "Paul Klee", and recently the major retrospective devoted to El Greco.

A short history of the collection: from private collection to museum
The Thyssen-Bornemisza Collection in Madrid, run and managed by the Fundacíon Colección Thyssen-Bornemisza, is the result of successful negotiations between Baron Hans Heinrich Thyssen-Bornemisza and the Spanish State. Since August 1993, the latter has been the new proprietor of a collection built up and cared for by the Thyssen-Bornemisza family over two generations.

August Thyssen (1842–1926), grandfather of the present Baron, was the founder of a powerful steel-making concern in Germany. An art lover, although not a collector, he was a friend of Auguste Rodin, whom he commissioned to execute six sculptures, which can in some ways be considered the seeds of the collection. His third son Heinrich (1875–1947) inherited his father's love of art as well as his business acumen. In 1905 he married Baroness Margit Bornemisza, daughter of a Hungar-

ian aristocrat, and incorporated her family name into his own, creating the title as it is used today. Baron Heinrich moved to Holland in the second decade of the century, developing a financial business empire in both Holland and Germany. This allowed him to devote himself seriously to what had become his great passion: collecting works of art.

In the space of just 20 years Baron Heinrich Thyssen-Bornemisza built up a major art collection on the advice of leading experts such as Friedländer and Berenson. From the outset his acquisitions were guided by selective criteria, with the aim of building up groups of works representative of historical styles. Most of the paintings from the 14th to the 18th century currently on show in Madrid, a body of works traditionally referred to as the "Old Masters", were bought by Baron Heinrich. He started by acquiring German paintings of the 14th, 15th and 16th centuries, later directing his attention to Flemish and Dutch artists, and finally completing his panorama of the history of art with Italian, French and Spanish works.

The Thyssen-Bornemisza family has always aimed to share its enjoyment of these works of art with the public at large. Thus in 1937, when Baron Heinrich acquired the Villa Favorita, a mansion on the banks of Lake Lugano, he had a picture gallery built next to the house in order to be able to exhibit the collection to the public. At that time the collection already numbered an outstanding group of around 500 works, which offered a dazzling overview of the history of European art through the work of its greatest exponents, such as Dürer, Cranach, Holbein, Jan van Eyck, Caravaggio, Titian, Veronese, Canaletto, Watteau, Corot and Courbet, among many other equally famous names.

On the death of Baron Heinrich in 1947, his younger son, the present Baron Hans Heinrich Thyssen-Bornemisza, inherited the title and most of the collection. Born in Holland in 1921, the Baron shared his father's passion for art and continued to collect actively and with the same aims. He began by completing the Old Master collection which he had inherited, on some occasions buying back works of art which his brothers and sisters had inherited. However, from the 1960s the Baron changed the emphasis of his collecting activities and started to focus mainly on modern art. The collection was thus enriched by a significant number of works by artists considered to be key names in the history of modern and contemporary art. Impressionism, Expressionism, Cubism and the Russian avant-garde are some of the movements best repre-

Baron Hans Heinrich
Thyssen-Bornemisza
at the Villa Favorita,
Lugano

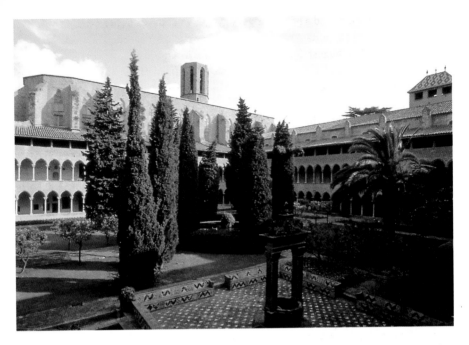

The Monastery of
Pedralbes, Barcelona
View of the cloisters

sented, in addition to which the Baron was also particularly interested
in American 19th-century painting, a "rare bird" in European collections.
With regard to particular artists, the collection features works by Monet,
van Gogh, Kandinsky, Picasso, Miró, Mondrian, Braque and Rothko
among numerous other modern masters, adding up to a remarkable
concentration of artistic genius.

However, the desire to keep the collection permanently open to
the public, together with the size which it had reached, made the Villa
Favorita no longer viable as a gallery, as it only had room for the display
and storage of 350 works. In the 1980s the Baron therefore decided to
find a new location where the collection could be shown in its entirety
and with the optimum conditions for display and preservation. He
received proposals from a number of countries: England, America,
Switzerland, Germany, Japan and Spain. Throughout the negotiations
the Baron's Spanish wife, Baroness Carmen Thyssen-Bornemisza, was
active in promoting the Spanish option.

Finally, in December 1988 an initial loan agreement was signed
with the Kingdom of Spain under which the collection would be dis-

played in Spain for nine and a half years. However, it was Spain's desire that such a large and important collection should remain permanently in the country, and in August 1993, one year after the inauguration of the Museum in Madrid and one month before the opening of the Barcelona rooms, an agreement was signed to acquire the collection permanently.

Baron and Baroness Thyssen-Bornemisza are life members of the Board of Trustees of the Fundacíon Coleccíon Thyssen-Bornemisza, which is responsible for the running and management of the Museum in Madrid and the Barcelona display. They maintain close contacts with their former collection and participate actively in the life of the Museum. The Baron recently described his feelings for the Museum on its fifth anniversary in these words: "Now that five years have passed since the opening of the Thyssen-Bornemisza Museum in Madrid, I remember the emotion I felt when the collection built up by my father, and which I reassembled and expanded over many years, was permanently installed in such an exceptional place as the Palacio de Villahermosa, thus fulfilling my long-held wish to exhibit these paintings – each one of which represents a little piece of my personal memories – to the rest of the world. I experience this feeling each time I visit the rooms of the Museum, filled with visitors".

The historical concept behind the Thysssen-Bornemisza Museum
The installation of the collection in the Museum in Madrid has been conceived in response to two fundamental characteristics of the works of art on display: firstly, the individual quality of each one, which makes them worthy of forming part of a collection without the need to relate them to a specific period or style, as they naturally constitute highlights in the history of art; and secondly, the high degree of internal coherence which characterizes the collection, thanks to the desire by its original owners to compile an international compendium of western painting, taking us on an unbroken journey through the history of art from the 13th century to the present day. In this way the collection allows visitors to learn about artistic styles through the individual study of masterpieces of art.

Early Italian and Netherlandish painting begin this historical discourse on the second floor of the Madrid Museum. In these first rooms, we assist at the birth of a new way of looking at the world, with a greater emphasis on man as the protagonist, and a growing awareness of the

temporal as opposed to the heavenly sphere which had prevailed in the Middle Ages. In art this becomes evident in the increasing emphasis on realism as opposed to the medieval use of symbolism, which would culminate in the artistic and cultural revolution of the Renaissance. The earliest work in the Museum is by the Master of the Magdalene; dating from the 13th century, it demonstrates the continuing use of symbolism and the anti-naturalistic style of representation as typical of medieval art. Next to it is a work by Duccio de Buoninsegna, *Christ and the Woman of Samaria*, dating from the early 14th century and centred on the search for a more realistic and lifelike form of representation. In addition to artists working in the most important artistic centres in Italy, such as Taddeo Gaddi from the circle of Giotto in Florence, and Vitale da Bologna in Siena, the Museum also has unique examples of the work of Early Netherlandish and German artists.

Renaissance painting from regions south of the Alps is amply re-presented in the collection, together with northern painting from the same era, allowing the visitor to compare the two different approaches and to gain an overall idea of the artistic advances being made in Eur-ope, marking the rise of new modes of thought and social constructs indicative of the dawn of the modern age. The imitation of nature and an emphasis on the individual reached a peak of artistic expression at this period, directed in some cases towards an ideal of beauty and an imitation of antiquity, and in others towards a search for a realism through which to represent contemporary life. The collection is particu-larly rich in works from the 15th and 16th centuries by artists as import-ant as Ghirlandaio, Bellini, Carpaccio, Raphael, Titian and Tintoretto, together with Holbein (*Portrait of Henry VIII of England*), Cranach, Pa-tinir and Anthonis Mor, through whose work we can see the differences and common ground between the artists of the north and the south. A major stylistic revolution took place over the course of these two centuries, as we can easily see if we compare the Early Renaissance portraits (to which the Museum dedicates an entire room) with those painted around 1600 by artists such as El Greco and Titian, which point the way towards Mannerism and the Baroque respectively.

The Baroque represents the eruption of a new spirit in art and can be seen as a quest for a more natural and direct mode of painting man and his environment, with an emphasis on psychological and emotional aspects. This art was essentially an attempt to render man as he truly is,

The Thyssen-
Bornemisza
Museum, Madrid
The main hall

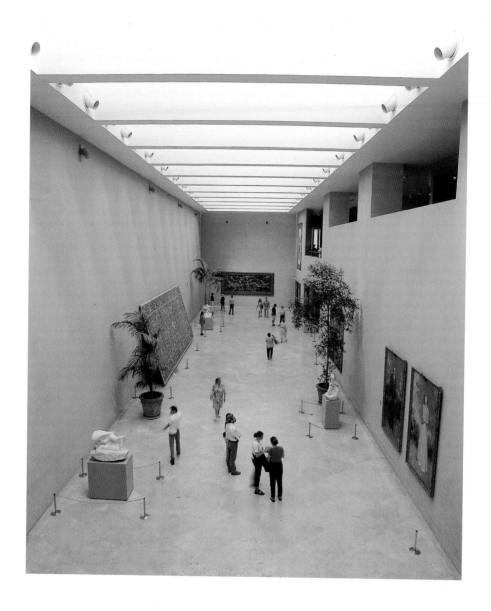

with all his weaknesses, his passions and his intrinsic imperfection. The style was developed in Italy, France and Spain, and the Thyssen-Bornemisza Collection has examples by Caravaggio, Bernini, Ribera and Valentin de Boulogne which offer an overview of the different trends within Baroque art. The classical trend embodied by Flemish Baroque art is also represented here, most notably by Rubens and van Dyck. Over the course of the 17th century, Baroque art gradually abandoned its initial interest in realism to place more emphasis on the theatrical and courtly, evolving towards the so called "triumphal Baroque" with its markedly classicizing tendencies. In Italy, in the hands of artists such as the Tiepolo family, this style continued well into the 18th century and was the glorious swansong of a dying era. At this time Venice became the most important artistic centre in Europe, as the continuing home of an aristocratic society already in decline. Venice and the Venetians were portrayed by important artists who created a new genre in painting: the *vedutà*, or view of Venice. The collection has an entire room dedicated to works by Canaletto, Guardi and Marieschi, which stylistically mark a midway point between the grandeur of the Baroque and the picturesque of the Rococo.

Dutch realism of the 17th century, with which the galleries of the first floor begin, marks a radical change in painting, both conceptually and with regard to subject matter. While the south of Europe saw the development of a classical Baroque mode, in the north, and particularly in Holland, a different way of understanding art was evolving, fuelled by a profound shift in the social structure which saw the rise of the new Dutch middle classes. As the force behind the flourishing economy and the political autonomy of the Dutch cities, this cultured, urban bourgeoisie formed a new class of art patrons, and artists responded by developing a style whose artistic aim became the expression of everyday reality, giving rise to new genres such as paintings of everyday life and landscape, until then considered "minor" subjects. The ample selection of such works in the collection includes paintings by Frans Hals, Rembrandt, de Hooch and Maes, as well as magnificent landscapes by Ruisdael, Hobbema and Koninck. These paintings, characterized by a technical mastery and virtuosity as well as by considerable expressiveness, are not just an outstanding testament to Dutch society of the time, but also a reflection of the birth of a new taste in art. This taste had little to do with the ideals of classical beauty, but was closely linked to everyday things and to the discovery of the beauty to be found near at hand.

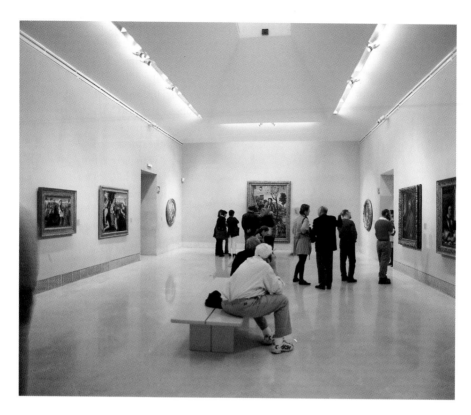

The Rococo is the next style to be represented on the first floor of the museum. It marks the expansion, in the 18th century, of the more light-hearted art which initially emerged in 17th-century Holland in opposition to classicism. Works by artists such as Watteau, Fragonard and Longhi are outstanding examples of Rococo painting; in mixing their new artistic aspirations with lingering elements from the past, they place under the spotlight an already outmoded aristocratic society which is vainly attempting to adapt itself to a new and more bourgeois social reality, but without losing its status. Stylistically, these paintings can be associated with a new taste for the small scale and the anecdotal which gave rise to genre of *galante* painting; the inclusion of concepts such as grace, delicacy and the picturesque characterized 18th-century art and opened the way to a new era. English 18th-century painting, represented in the collection by artists such as Gainsborough and

View of Room 7, with the painting *Young Knight in a Landscape* by Carpaccio in the background

View of Room 48, with the painting *Express* by Rauschenberg in the background

Reynolds, implied a meeting point between purely Rococo modes and 19th-century Romanticism.

Romanticism, represented by three great artistic geniuses, Goya, Friedrich and Delacroix, leads on to one of the most unusual and distinctive facets of the Museum, and one which is unique in European collections: North American painting of the 19th century, represented by a large number of artists and works. With their nationalistic and Romantic leanings, these pictures have the common aim of celebrating America, which had recently gained its independence from Britain. In the work of artists such as Cole, Heade, Church, Homer and Peto, the visitor can see North American art spanning the whole of the century from Romanticism to Realism, and, further on, follow its encounter with European trends. This subsequently becomes the thread running through North American painting right up to Pop Art.

19th-century Realism is represented in the collection by the work of major artists such as Constable, Courbet and Corot. Their art marks the emergence in Europe of a new interest in capturing nature in its purest state, thus leading on to Impressionism, the style which opened the way to modern art.

Impressionism, which hallmarked the closing years of the 19th century and the transition to the 20th, is traditionally considered to be the first modern movement in its search for a new pictorial means of reflecting, in the most immediate way, our perception of our surroundings. Paintings by Impressionist artists such as Monet, Pissarro and Renoir denoted the start of a series of technical innovations which definitively liberated artists from the rules and regulations set down by the Academies. Almost contemporary, although a little younger, were the artists generically grouped under the heading of Post-Impressionism, each of whom developed his own pictorial idiom, and who are considered the fathers of the modern movement: van Gogh, Cézanne and Gauguin, all present in the collection. Continuing on the first floor, the Museum has an outstanding ensemble of works of German Expressionism, from its earliest years to the 1930s, showing the variety to be found within this group. Kirchner, Schiele, Macke, Grosz, Dix and Schad are among the artists who made up this broad panorama of German art at the beginning of the 20th century, one fundamental to the history of modernism related within the collection and one of its most distinguished facets.

The experimental avant-garde movements are exhibited in the first rooms on the ground floor and show the variety of trends which developed simultaneously in the first decades of the 20th century, each innovative in its own way and representing a break with the aesthetic and formal languages of the past. There are works by the two most important exponents of Cubism, Picasso and Braque, together with other Cubist artists. In addition, the Museum has a sizeable group of works by Constructivists such as El Lissitsky and Moholy-Nagy, introducing us to the field of geometric abstraction, also exemplified by Mondrian. The work of other avant-garde movements is also on display, including Balla's Futurism and Schwitters' Dadaism.

Abstraction and figuration in the second half of the 20th century are also covered. After the experimental phase of the early avant-garde movements, cut short by World War I, European art saw a return to an

order which had its roots in the classical tradition, with artists assuming individual positions rather than being associated with groups. This was the period in which the great masters evolved their own pictorial languages, as can be seen in the collection in outstanding works by Picasso, Kandinsky, Klee, Miró, Chagall and Giacometti, covering a period which has been generically termed the "synthesis of modernity". Finally, the last rooms familiarize us with the various trends which developed from the years around the start of World War II, and which implied a variety marked by the polarization around two key concepts: abstraction and figuration. The first had its leading exponents in American Abstract Expressionism, represented in the collection by artists such as Pollock, Rothko and Still, and by their European counterparts, including Fontana and de Staël. The second current responded to a wide variety of aesthetic concepts which were at times in opposition. Thus, alongside Surrealism (Magritte, Tanguy and Salvador Dalí, among others), we find the serene equilibrium of Edward Hopper, the introspection of Balthus, and the – in itself, highly diverse – School of London, represented on the one hand by Lucien Freud, and on the other by the searing art of Francis Bacon. Our chronological journey ends with a series of artists associated with Pop Art, some as typical of the movement as Lichtenstein, others who placed more emphasis on materials and their combinations, such as Rauschenberg, or whose style was closer to Hyper Realism, such as Estes, and finally others whose work contained a strong element of social criticism such as Lindner.

The Barcelona Collection

The rooms of the Fundación Colección Thyssen-Bornemisza in the Monastery of Pedralbes house 72 paintings and eight sculptures dating from the 13th to the 18th century. The works on display in Barcelona were selected both to convey a representative idea of the significance of the collection as a whole, and also for their particular relevance to the history of Catalan art.

The eight sculptures are therefore examples of European Gothic, whose echoes are to be found in the architecture of the monastery itself. In the same way, the collection of 14th-century Italian paintings by followers of Giotto can be compared with the Giottesque frescoes by the Bassa brothers in the chapel which leads onto the cloister. Among the works which illustrate 15th- and 16th-century Renaissance art is

the jewel of the Pedralbes Collection, the *Virgin of Humility* by Fra Angelico. Works by Lotto, Titian, Tintoretto and Veronese complete the panorama of High Renaissance art. In addition, there are examples of work by northern Renaissance artists, including a group of German paintings with portraits by Polack and Muelich and religious works by Apt and Lucas Cranach.

The 17th century is also represented by a small but select group of masterpieces. Paintings by Rubens, Carracci, Velázquez, Zurbarán and Ruisdael show the diversity of artistic trends within European art at this period. The itinerary concludes in the room dedicated to 18th-century Venetian painting, in which the visitor will find outstanding works by artists such as Piazzetta, Ceruti and the painters of the Venetian *vedutà*, Canaletto and Guardi.

The Monastery of Pedralbes, Barcelona View of the temporary exhibition room (the former refectory)

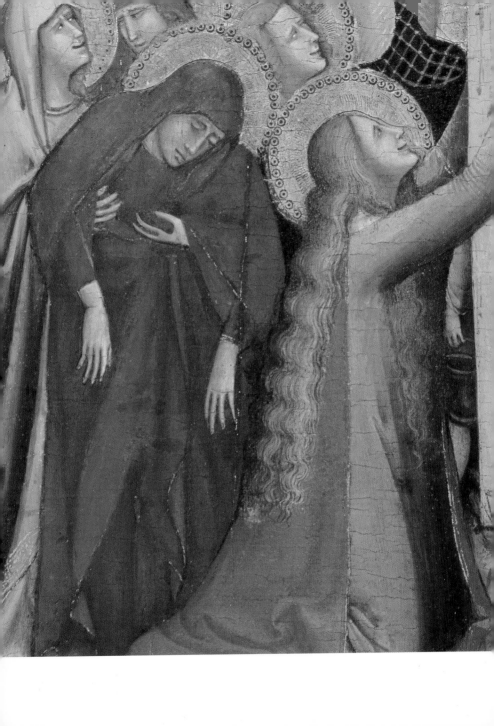

The 14th Century

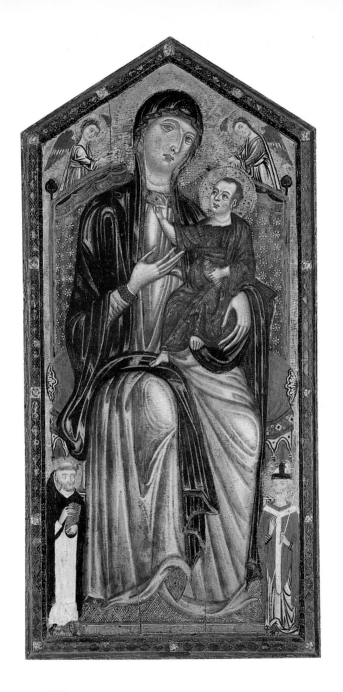

The Master of the Magdalene

ACTIVE IN FLORENCE IN THE SECOND HALF OF THE 13TH CENTURY

This work by the Master of the Magdalene, an anonymous artist work-ing in Tuscany in the Byzantine manner, is the earliest painting in the chronological and stylistic progression charted by the Thyssen-Borne-misza Collection.

While artistic production in the rest of Europe in the 13th and 14th centuries centred chiefly around stained glass and manuscript illumina-tion, Italy's close links with Byzantine culture meant that, here, the tradi-tion of painting on panel was maintained (as was the art of mosaic and fresco painting). Italian art also had its own monumental and synthetic artistic style which was unrelated to the narrative tendencies of Gothic art elsewhere in Europe.

The Virgin is represented here as the Queen of Heaven, seated on a throne held up by angels who look out at the viewer in the Byzan-tine manner. Below, the two saints are identified by their names. The frontal, symmetrical and spatially shallow composition and the use of gold (symbolizing the heavenly kingdom), together with the hieratic and solemn character of the figures, are all intended to convey the image of divinity. The influence of Byzantine art can be seen, too, in the use of size to indicate importance and in the stylized treatment of the draperies, as well as in the figures' gestures and poses.

The Virgin and Child
enthroned with St
Dominic, St Martin
and two Angels,
c. 1290
Tempera on panel,
117 x 86.5 cm

PAGES 24/25:
Detail of illustration
page 41

PAGES 26/27:
Detail of illustration
page 30

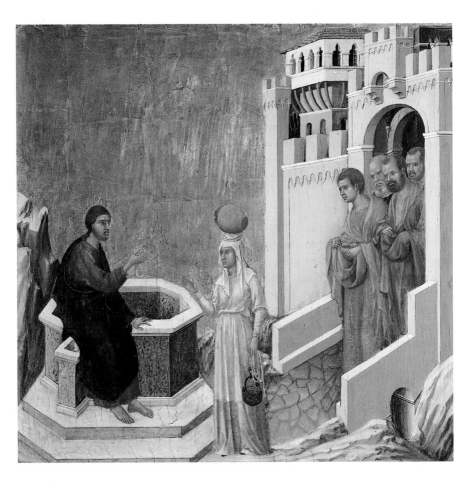

*Christ and the Woman
of Samaria*, 1310/11
Tempera on panel,
43.5 x 46 cm

Duccio di Buoninsegna

SIENA, C. 1260–1319

The beginnings of a new approach to painting first became evident in the 14th century in the Italian region of Tuscany, and specifically in two cities: Florence and Siena. Giotto was the outstanding figure in Florence, creating a school which would represent one of the first manifestations of Early Renaissance painting. Contemporary with Giotto was Duccio di Buoninsegna, traditionally considered the founder of the Sienese school. His masterpiece was his *Maestà* altarpiece for Siena cathedral, which comprised a central panel depicting the Virgin enthroned, predella panels and, on the back of the altarpiece, depictions of scenes from the lives of the Virgin and Christ.

The predella panels (of which this is one) narrate scenes from the life of Christ, and are the part of the altarpiece in which Duccio shows himself most innovative. This is confirmed by a number of features – even if they continue to coexist with elements still in the Gothic tradition. Duccio nevertheless appreciated the monumentality of Byzantine art. For the first time we find an architecture which configures space, which lends depth and contains volumes – so much so that the disciples are gathered beneath the arch of the gateway to the city, and Christ, significantly, seated on top of the well.

Furthermore, the figures are made truly human and – more importantly in terms of their representation – have a three-dimensional feel and seem to occupy a space within the picture. They are also related within that space to each other, and their faces and gestures are individualized. Some elements from the older style remain, such as the gold background, whose decorative quality and symbolic reference to the zone of heaven meant that artists continued to use it in order to give their narrative the importance it deserved. Duccio's sensitive use of colour is also noteworthy here.

"Duccio applied himself to the imitation of the old style, and with very sound judgement formed his figures properly and fashioned them excellently ..."
GIORGIO VASARI, 1550

Taddeo Gaddi

FLORENCE, C. 1300–1366

Taddeo Gaddi was a pupil of Giotto and one of his closest collaborators. His style is typically giottesque, as we can see in this small panel which reflects his master's artistic innovations. The simple but at the same time carefully studied composition, with its coherent conception, its austere reduction to essentials, and its monumental feel (following in the tradition derived from the Byzantine style of Cimabue), all give Gaddi's works a new realism and intimacy. The figures and the principal scene are placed in the foreground on the level of the viewer. Through his careful study of composition, Gaddi has succeeded in recreating the forms, weight and three-dimensionality of the figures (something which would be taken up later by Masaccio), as well as the expressiveness of their faces.

This small panel may have formed part of a larger composition, as can be inferred from the arrangement of the figures on the left. The angel on the left seems to be moving towards a figure who is outside the panel, while below we can see a sheep and a stick which may be a shepherd's crook, suggesting that the scene continues to the left with the episode of the Annunciation to the Shepherds. Characteristic of the school of Giotto is the use of groups of standing figures, for example the two women on the right, who form a conical shape which, together with the tower behind, closes the composition and provides a vertical counterbalance to the pronounced horizontality of the rest of the scene (the terraced ground, the Virgin and Child group and the roof of the stable).

The composition is organized along receding orthogonals and is balanced and ordered, occupied only by a small number of figures whom the artist has individualized through their poses and gestures (in contrast to the more colourful, dynamic and crowded compositions of the Sienese school). Here the mood is solemn but also human and the figures seem to be real people.

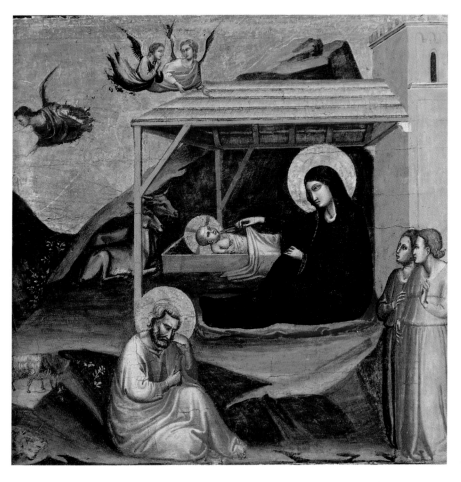

The Nativity, c. 1325
Tempera on panel,
35.5 x 37 cm
(Pedralbes)

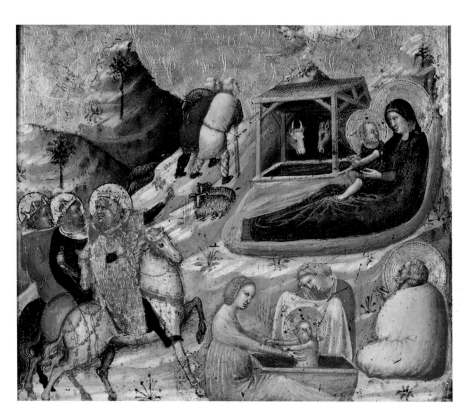

*The Nativity and
other Episodes from
the Childhood of
Christ*, c. 1330
Tempera on panel,
17.2 x 19.7 cm
(Pedralbes)

Pietro da Rimini

ACTIVE BETWEEN 1315 AND 1335

This artist's work shows characteristics of the new Italian style and its striving towards imitation of nature, expressive narrative, spatial depth and composition. Although primarily influenced by Giotto, Pietro da Rimini's work nevertheless reveals a blend of the two main currents in Italian art – the Florentine (embodied by Giotto) and the Sienese (led by Duccio), the two leading schools of Trecento painting. Florentine painters and other followers of Giotto emphasized the volume of the figures and thereby lent them a sense of depth. While Sienese art emphasized line, the Florentine focus was on large areas of colour and on the modulation of light and dark to create volumes and thus give three-dimensionality to the figures.

This scene, which probably formed part of a group of panels devoted to the life of Christ, brings together in one spatial setting various episodes from Christ's childhood, giving the painting great narrative interest. Along with the Nativity (treated in the traditional manner of the period, with the Virgin lying down and Joseph on a lower level), the artist has also included the shepherds in the background, two women washing the new-born Christ, and the Adoration of the Magi.

The new interest in narrative detail and in bringing the biblical stories to life, as well as humanizing the characters within them, prompted many artists to draw on the Apocryphal Gospels, whose accounts of the life of Christ are full of anecdotal, picturesque detail. Although the present work still adheres to certain Byzantine conventions, the artist has aimed to the give the scene and its figures a naturalistic feel. He has conveyed movement and the relationships between the figures and has emphasized expressions and gestures.

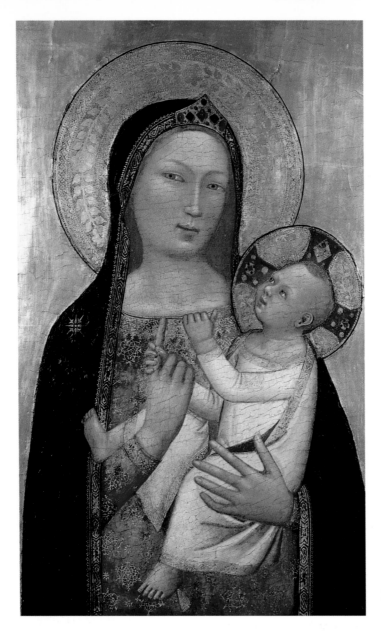

The Virgin and Child,
c. 1340–1345
Tempera on panel,
84 x 54.8 cm

Bernardo Daddi

FLORENCE, C. 1295–1348

Another pupil of Giotto and perhaps one of the most important, Daddi combined Sienese and Florentine influences in his painting. It might be said that in these two works he shows himself more Sienese and influenced (through the work of Ambrogio Lorenzetti) by the International Gothic, as evidenced by the stylization of the figures, the primarily decorative treatment of the draperies and the profusion of gold.

The Virgin and Child, like many other panels from this date and, indeed, from this Museum, may once have formed part of a larger ensemble, the other parts of which are now lost. Notable is the sweetness of the Virgin's face and the melodiousness of the figures, which may refer to the work of artists such as Simone Martini, the other great Sienese painter along with Duccio. Both the Virgin and the Child lack the solemnity found in earlier representations, and the artist here offers us a more human interpretation in which the most important relationship is that of mother and child (the Infant's pose, looking at His mother and clutching one of her fingers, is particularly eloquent).

While the portrayal of gentler biblical scenes became more widespread during this period, the Crucifixion remained an important subject, losing the emphasis on pain and brutality but retaining its dramatic intensity. The figures here are grouped closely together on each side of the cross very much in the Sienese style (like the disciples in Duccio's *Christ and the Woman of Samaria*), in contrast to the sparsely populated compositions of the school of Giotto, although the artist has borrowed from the latter its modulation of light and shade to achieve greater volume. In the present scene, the Virgin Mary has fainted and is supported by St John. The dramatic pose of Mary Magdalene kneeling at the foot of the cross is particularly noteworthy.

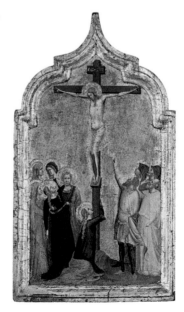

The Crucifixion,
c. 1330–1335
Tempera on panel,
37.4 x 22.2 cm

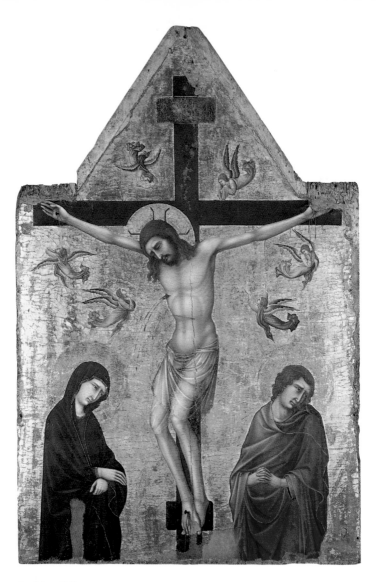

*Crucifixion with the
Virgin, St John and
Angels*, c. 1330–1335
Tempera on panel,
135 x 90 cm

Ugolino di Nerio

ACTIVE IN FLORENCE AND SIENA FROM 1317 TO 1339/40

The present work has lost its lower part in the past and originally the Virgin and St John would have been represented full-length. The artist, known as Ugolino di Siena, was one of Duccio's closest followers, although he may also have been associated with Cimabue.

The figures, which are crisply outlined against the gold ground, are drawn with fine strokes, with line the principal tool for creating form. The modelling of the volumes is nevertheless skilfully handled in a play of subtly gradated light and shade, noticeable as much in the flesh of the figures – particularly in Christ's body – as in the robes of the Virgin and St John, where the folds of the drapery are rendered with great mastery. While the brushstroke is a busy and detailed one, the composition nevertheless achieves a marked austerity and an absence of superfluous detail, even if it retains a certain decorative impulse in the rhythm established by the figures' poses (with both heads leaning in the same direction) and in the depiction of the little angels, full of colour and movement. The angels, and in particular the shape of the pleats at the bottom of their robes, contain stylistic echoes of painting north of the Alps. Ugolino was influenced not just by Duccio, but by other Sienese artists following in Duccio's footsteps, such as Simone Martini and Pietro Lorenzetti. Both of these were closely linked to the papal court at Avignon, where the Italian style mixed with the French Gothic (which was still restricted primarily to sculpture), characterized by stylization and certain decorative qualities.

At the same time, however, the artist has also conveyed intense emotion in the faces of the Virgin and St John, a restrained pathos which is emphasized by their withdrawn and introspective poses and their folded hands. These characteristics, set against the gold background, give the figures a sculptural quality.

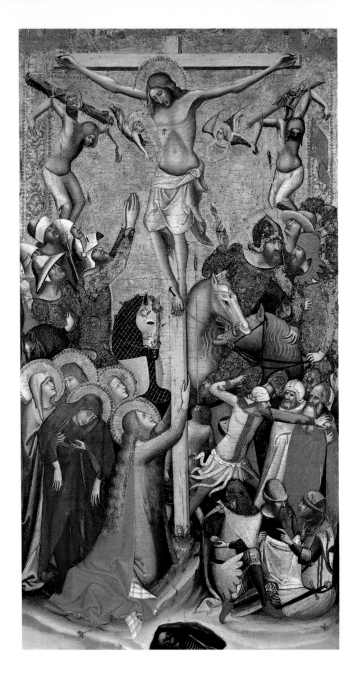

The Crucifixion,
c. 1335
Tempera on panel,
93 x 51.2 cm

Vitale da Bologna

BOLOGNA, C. 1300–1359/61

Vitale da Bologna was trained in Bologna, where the presence of the University, with its close links to French and German artistic and cultural trends, fuelled the art of the illuminated miniature to splendid heights. At the same time, Vitale's style indicates the spread of Sienese influence throughout Italy during the course of the 14th century. The result was a type of painting with a strong narrative impulse, an interest in detail and an emphasis on line in the execution of form.

This busy and crowded composition is filled with anecdotal detail. In the soldiers' uniforms and the caparison worn by the horse to the left of the cross, we see the artist taking pleasure in the decorative elements of the clothing. The composition also seeks to bring together all the components making up the Crucifixion episode: the Virgin and the three Marys; the Magdalene kneeling at the foot of the cross; the soldiers playing dice in the foreground; the Good Centurion giving Christ the sponge with the vinegar; the Good Thief (on the left, his soul being carried off by an angel); and the Bad Thief (on the right, his soul being carried off by a devil); and finally, the skeleton of Adam.

A large number of figures crowd into the heterogeneous lower part of the composition with no space between them. In the upper part, however, the composition has been emptied in order to emphasize the figure of Christ, creating spatial depth through the positioning of the two thieves in foreshortening and on a lower level.

The synthesis of the Sienese school and the art of miniature painting reflected in this work was to be a decisive factor in the rise of the International Gothic, the style which developed at the courts of central Europe at the end of the 14th and the beginning of the 15th century.

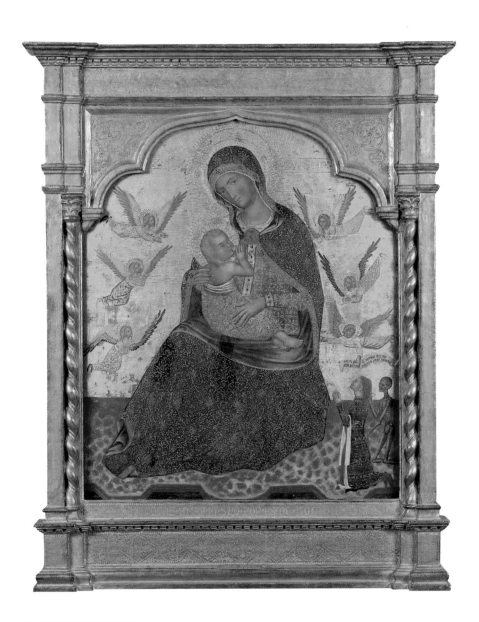

Venetian Master

The Virgin, depicted breast-feeding the Infant Christ, bears an inscription to the right of her halo with the word Humility – she is the Madonna of Humility who protects the humble under her cloak. This anonymous master of the Venetian school, probably working in the circle of Paolo Veneziano, paints in a transitional style, whereby the lingering influence of Byzantine art can be seen in the decorative treatment of the draperies and the compositional structure of the scene, in which the gold ground prohibits any sense of spatial depth. The faces and the visible areas of flesh are nevertheless painted with a certain solidity and realism which distinguishes this panel from works such as the previous one and gives the figures a more human feel.

The Black Death of 1348 precipitated a significant new development in devotional painting, as illustrated in the present panel – dating from around 1360 – in the figure of the donor, precursor of the genre of portraiture. For the first time, ordinary mortals appear in the space previously reserved for celestial beings. The figure here is probably the person who commissioned the panel as an invocation to the Virgin to protect him against death (hence the skeleton behind him). The subject of death naturally became a particularly relevant one following the great plague. The inscription which one of the angels bears is difficult to decipher: it seems to say that death is inevitable and that one should always be prepared for it. With his kneeling, supplicating pose the donor places himself under the protection of the Virgin to achieve this end.

*The Virgin of Humility
with Angels and
Donor,* c. 1360
Tempera on panel,
68.8 x 56.7 cm

VENETIAN MASTER · **43**

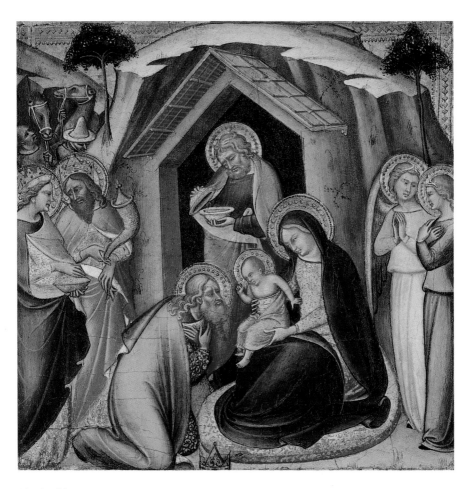

*Adoration of the
Magi*, c. 1360–1365
Tempera on panel,
41 × 42 cm

Luca di Tommé

SIENA, C. 1330—AFTER 1390

Following the great plague of 1348, which devastated artistic production everywhere, the Sienese artist Luca di Tommé endeavoured, with others, to maintain the Sienese tradition throughout the second half of the century. Although his *Adoration of the Magi* employs a conventional composition, however, it is also a good example of the evolution taking place in painting, especially in Italy, towards a closer imitation of nature, in a desire to represent reality. Thus, while the landscape is indicated in no more than conventional shorthand and is compositionally subordinate to the main scene, located in the immediate foreground, the artist has succeeded in creating a sense of real space between the figures, who are also depicted in more or less naturalistic proportion. This sense of three-dimensional space is achieved in the foreground through the arrangement of the Virgin's robe, the two angels on the right (who are modelled with great skill and harmony both in their colouring and volumes, recalling the art of Simone Martini), and the empty spaces. We see a real ground and can appreciate how Joseph, situated in a second plane further back, contributes to the impression of depth.

The painting illustrates how, in their striving towards the imitation of nature along the path to the Renaissance, artists first conquered the representation of the human body. Since the primary aim of painting was still to relate stories, mainly religious ones, landscape and other elements of secondary importance served simply as the backdrop to the principal events. Gradually, however, this imitation of nature would be extended to those elements which surrounded the central characters, out of the necessity to make the entire image more lifelike.

The compositional structure is symmetrical, with a vertical axis in the centre which descends through Joseph and passes through the King and the Child. The vibrant palette consists almost solely of primary colours, and the robes of the foreground figures stand out against the earthy tones of the middle ground. The artist continues to use a traditional gold background to symbolize the holy subject and for its highly decorative character.

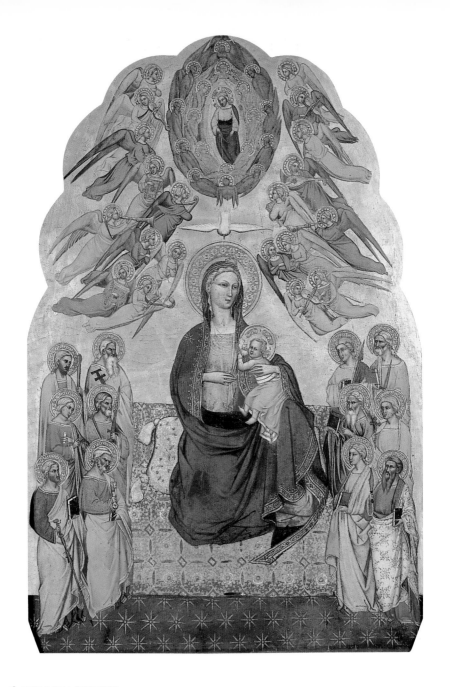

Cenni di Francesco di Ser Cenni

ACTIVE IN FLORENCE AFTER 1369 UNTIL C. 1415

This painting is strangely conceived, appearing to combine skill in the portrayal of figures with a complete disregard for spatial perspective and a patently medieval subject. Iconographically it is no less strange in its combination of a pantocrator (the mystical mandorla with Christ at the centre, surrounded by angels) with the Holy Spirit, with the Virgin and Child surrounded by the twelve Apostles and a heavenly choir of angels. All this makes reference to the descent of the Holy Spirit at Pentecost, and at the same time to the second coming of Christ at the Last Judgement. Christ is not presented here as God incarnate, however, but as the Infant Jesus with His mother the redeemer (the Virgin of Humility is the protector of the weak and helpless).

The image is thus charged with symbolic meaning very much in the medieval manner, but rather outdated for the end of the Trecento. At the same time, however, the figures are executed in a naturalistic fashion, in proportion and with a sense of three-dimensionality; the artist has clearly mastered the handling of line. The space, on the other hand, is resolved in a conventional manner. For this reason we might describe this artist as one who has assimilated the formal techniques of naturalistic representation, but whose art still remains tied to the medieval past in its thematic material and composition.

While the painting shows the influence of the International Gothic style, it also retains traces of the orientalizing style, Byzantine in origin, which survived in Italy and particularly in medieval Venetian art. It presents an anachronistic combination of perfection in the execution of each figure, but conventionalism and a lack of naturalism in the overall composition of the scene, which is devoid of all atmospheric setting as it takes place against an indeterminate ground of gold leaf, symbol of the heavenly kingdom. It thus uses the medieval device of portraying the divine beings in their own realm, separate from the mortal sphere, and arranges the figures in line with pre-established conventions and the dictates of religious symbolism.

The Virgin of Humility, c. 1375–1380 Tempera on panel, 76.6 x 51.2 cm (Pedralbes)

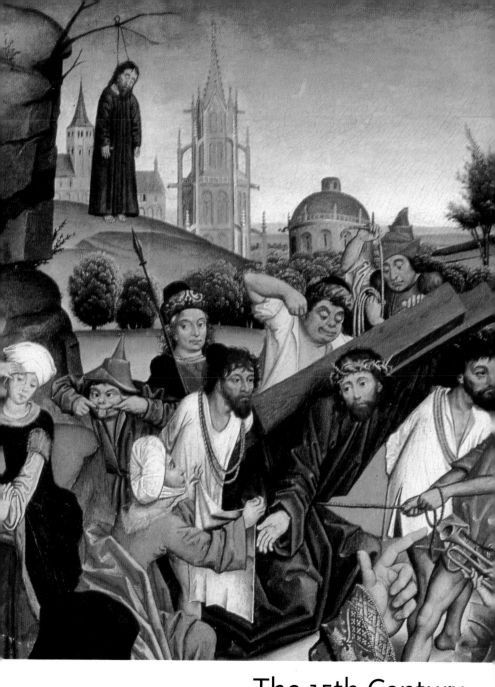

The 15th Century

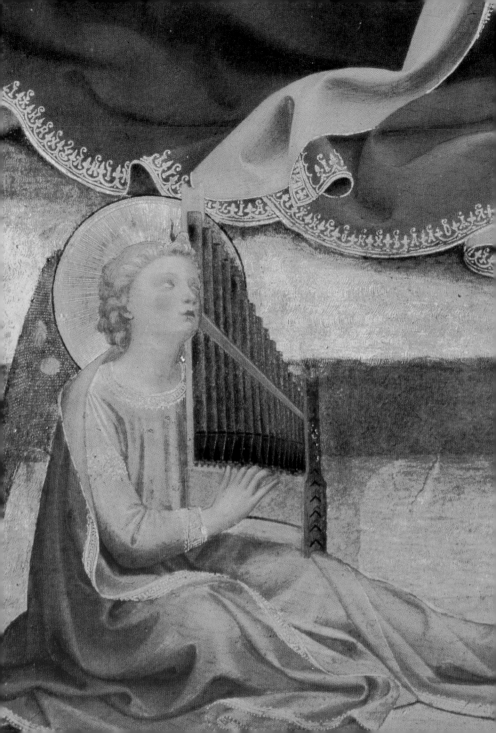

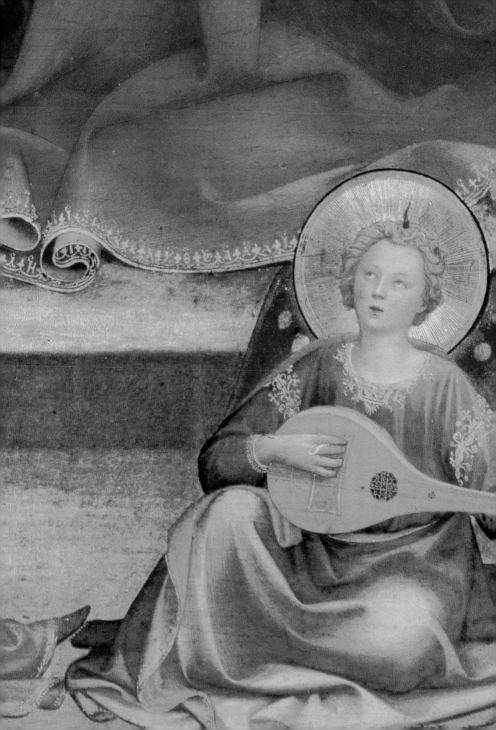

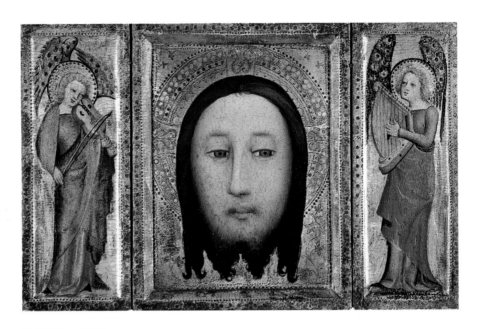

*The Holy Visage of Christ
Triptych,* c. 1395–1410
Oil on panel,
central panel,
30.8 x 24.2 cm,
wings, 30.8 x 12 cm

Master Bertram

MINDEN, C. 1330/40 – HAMBURG, 1414/15

Master Bertram is one of the first artists in the history of German art who is known to us by name. His style exercised a major influence on the Hamburg school of painters. His work exemplifies the artistic position of German painting around the beginning of the 15th century, in which medieval traditions continued to live on in the prevalence of gold backgrounds, a lack of spatial setting, an emphasis on line and the use of simple compositions.

While these features are evident in this small portable triptych depicting the *Holy Visage of Christ*, there are others which indicate progress in German art. In particular, the attempt to represent the human figure with a certain degree of realism, as well as the early use of oils – another novelty in the 15th century, and a technique whose introduction has traditionally been ascribed to the early 15th-century Flemish painters.

In the central panel, the majestic Holy Visage makes a strong impression, which the painter achieves by giving it a certain realism, modelling the volumes through subtle tonal gradation; the down-cast eyes, in particular, add expressiveness to Christ's face. The side panels depict two musical angels, who convey a sense of movement and have well articulated bodies, even though they retain the decorative character which links them to Gothic art. Without great technical display, the artist creates the impression that the figures are firmly placed on the ground and are three-dimensional forms. This is achieved through the movement of the draperies and a slight but successful gradation of light and shade, made possible through the use of oils, which were more flexible than tempera.

The side wings fold into the centre to close the triptych, and hence are also decorated on the back, in this case with an *Annunciation*. On one side is the archangel Gabriel and on the other the Virgin Mary. These figures are executed in a calligraphic style against a vermilion background.

PAGES 48/49:
Detail of illustration
page 95

PAGES 50/51:
Detail of illustration
page 73

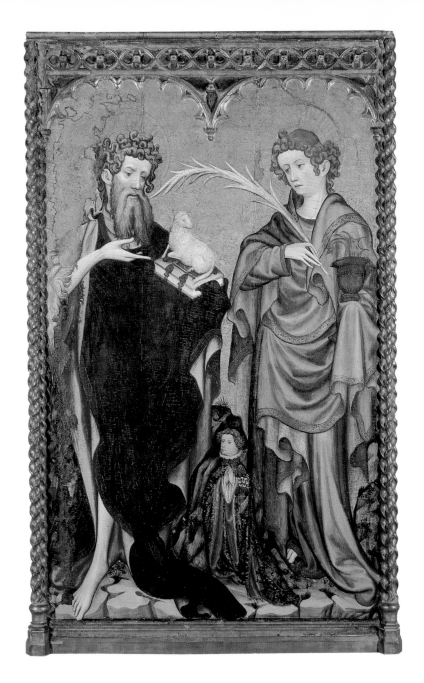

Joan Mates

CATALUNYA, ACTIVE BETWEEN 1392 AND 1431

This artist worked in the International Gothic style in Catalunya. This painting of around 1410 shows how the Italian Sienese style, which was closely connected with the International Gothic, spread throughout Europe. We can appreciate the stylization of the figures and the highly decorative manner in which they are executed, evident in the snaking ringlets of hair, the folds of the draperies and the rock formations on which they stand.

The imitation of nature is overshadowed by an excessive stylization of the forms in a desire to achieve ever more decorative effects. Although the artists of this era had undoubtedly mastered the technique of modulating volumes through the manipulation of light and shade – even if the draughtsmanship with which they combined it still remained the basis of their painting – the artist's main preoccupation here is the aesthetic effect. Thus the message of the painting is subordinated to the elegance of the representation.

Nonetheless, we find here an element which we have already noted in an earlier work in the collection: the presence of a donor (the client who would have paid the artist to paint the work, most likely in order to offer it to a church for prayers to be said on his or her behalf). The subjects of painting and sculpture in the Middle Ages had been drawn exclusively from the religious sphere, and thus the appearance of the donor in sacred works has been considered the first sign that subject-matter in art was changing – a shift which in the 15th century would find expression in the appearance of the portrait. There was a growing interest in portraying the present, and the donor represented a sort of proto-portrait, even though in many cases such figures were recognizable not so much by their appearance as by the attributes which accompanied them (in the same way as with saints): thus a diadem, a crown or an ermine cloak would be attributes of royalty. In the case of the present painting, the donor's identity is unknown to us, even though his clothing suggests that he could be a member of the aristocracy with links to the crown.

St John the Evangelist and St John the Baptist with a Donor, c. 1410
Tempera on panel, 191 x 121 cm

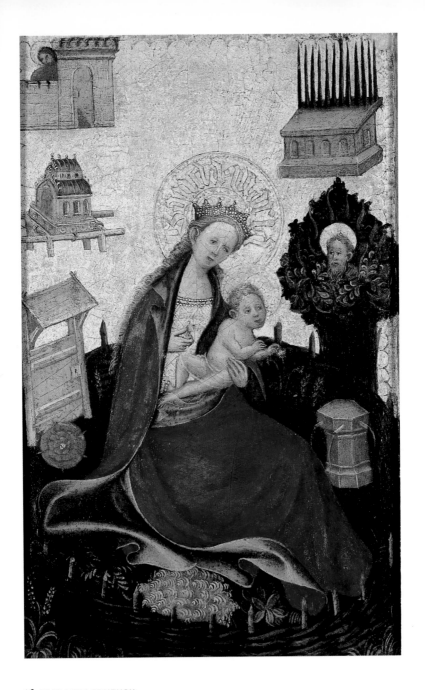

German Master

ACTIVE IN WESTPHALIA AT THE BEGINNING OF THE 15TH CENTURY

The composition and iconography of painting at the beginning of the
15th century was evolving. Paintings began to take on a narrative charac-
ter, incorporating anecdotal or symbolic elements. This panel is a good
example of that trend. The desire to illustrate narratives in late Gothic
art, which became evident in Germany at the beginning of the 15th cen-
tury, led artists to look to sources outside the Gospels. These included
the Apocrypha, lives of the saints and other texts. In the present work,
the concept of the *hortus conclusus* (meaning "enclosed garden" in Latin)
is used. The phrase comes from the Song of Songs and is illustrated by
the Virgin and Child in a garden enclosed by a fence, normally with a
fountain. The image is surrounded by symbols of Christianity: the Ark
of the Covenant, Ezekiel's Closed Gate, the Burning Bush with God the
Father, and the rose, symbol of the Virgin.

Stylistically there is a contrast between the incipient realism of
the treatment of the Virgin and Child (although they retain a degree of
naivety) and a certain crudeness in the composition, particularly in the
individual elements painted against the gold background, recalling me-
dieval art in which the spatial structure is unimportant in comparison
to the picture's symbolic significance. On the other hand, some of the
details, such as the plants, are painted with a degree of realism, even if
rather schematically.

The panel forms a diptych with another panel, also in the Thyssen-
Bornemisza Collection, which depicts Christ as Salvator Mundi and also
contains a wealth of symbolic motifs. In both panels these motifs are
related to a complex iconography which, in the case of the Virgin and
Child panel, refers to Mary's virginity (she is the "enclosed garden")
and the fact that she redeems Original Sin through the sacrifice of her
own son. The Virgin is thus presented as the New Eve.

*The Virgin and Child
in the Hortus
Conclusus*, c. 1410
Oil on panel,
28.6 x 18.5 cm

Andrea di Bartolo

SIENA, C. 1360/70 – 1428

The influence of the great Sienese masters of the 14th century, such as Duccio and Simone Martini, is evident in the work of the Siena-born artist Andrea di Bartolo. He also worked with Luca di Tommé, an artist represented in the Thyssen-Bornemisza Collection.

The present painting shows Christ on the road to Calvary bearing the cross on his back. Behind him, a figure who is probably Simon of Cyrene helps him to bear up the cross, while in front another figure pulls at a cord around his neck. Christ turns his head back towards his mother, the Virgin Mary, who helplessly holds out her arms towards her son. Behind her are the holy women, recognizable by their haloes.

The composition adheres very closely to a painting of the same subject by Simone Martini (now in the Louvre), which was at that period considered the model for portrayals of this episode. A comparison of the two works shows numerous similarities in the figures and poses as well as in the overall composition. The city, for example, is portrayed receding towards the background, from which emerges a crowd of people who accompany Christ (as in the painting by Duccio of *Christ and the Woman of Samaria* also in the Thyssen-Bornemisza Collection). We should remember that religious painting obeyed a fixed iconography, based on the Gospel accounts (including those of the Apocrypha), which artists followed in order to represent the story faithfully. Thus the content of the present painting was dictated by the events as recounted in the original text: the Virgin, Christ looking at her, the Cyrene helping him with the cross, the presence of the soldiers, and the two children, all of which are elements in the account of Christ on the way to his crucifixion.

Andrea di Bartolo remains faithful to the Trecento style of Sienese painting in the way he packs the figures closely together, and also in his gold background, architecture and landscape. Nonetheless, he manages to create a sense of spatial depth through the buildings and the landscape which opens out to the right. This depth is accentuated in the foreground by the placement of the legs of the figures on the realistically painted ground, which acts as a stage for the action.

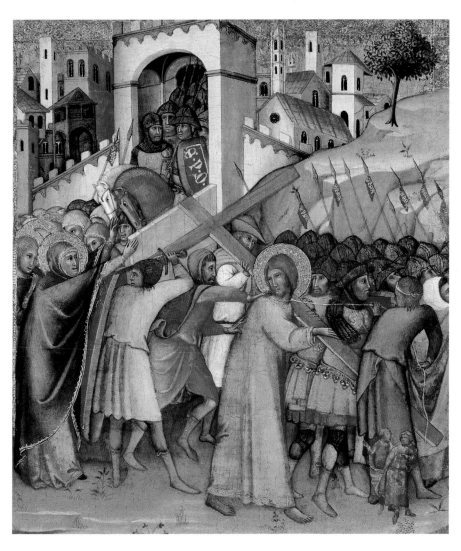

*Christis on the Road to
Calvary*, c. 1415–1420
Tempera on panel,
54.5 x 49 cm
(Pedralbes)

ANDREA DI BARTOLO · **59**

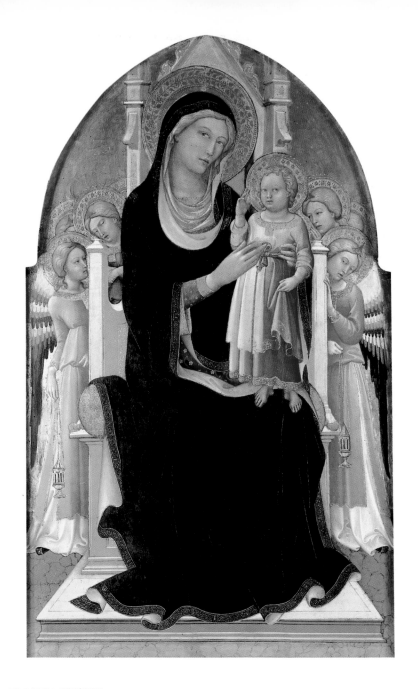

Lorenzo Monaco

SIENA, C. 1370 — FLORENCE, C. 1425

Lorenzo Monaco was an artist whose work bridged the 14th and 15th centuries, between the Trecento art of Duccio and Giotto and the Quattrocento painting of Masaccio and Fra Angelico – upon whom Monaco was an important influence. His art was a synthesis of the Sienese and Florentine Trecento styles and was also one of the most important examples of International Gothic in Italy. Monaco was born in Siena but worked in Florence, where he executed miniatures for the illuminated manuscripts, produced in the International Gothic style, by the monks of the monastery of Santa Maria degli Angeli. As a painter, his work is of the highest quality and refinement. While Monaco's career started in the 14th century, it continued into the lifetime of Masaccio, and although he remained faithful to an older style of painting, his works show an enormous technical advance, both in their use of colour and in the approach to perspective and the volume of the figures.

The present painting follows the traditional compositional type of the *Maestà* (the Virgin and Child enthroned), and stylistically recalls the painting of that title by Giotto, although it lacks the severe monumentality of Giotto's work and is closer to the gentler style of Sienese art. The advances in the representation of space are evident in the depiction of the Virgin's throne, which is constructed from orthogonals which recede to a vanishing-point in the centre of the painting. The angels contribute to this illusion of a coherent spatial setting, although not with the perfection which would be achieved by artists of the next generation. All the figures are painted with a high degree of naturalism, although still retaining the stylized idealization found in Sienese and International Gothic painting. In addition to the perfection of the modelling of the figures and the naturalism of the poses, one should also note the great skill in the painting of the faces and the artist's efforts to depict beauty, particularly in the face of the Virgin. Through its balanced composition, masterly use of colour and the organization of the forms, the painting transmits a calm and natural serenity as well as the spirituality of its own era.

The Virgin and Child enthroned with six Angels, c. 1415–1420
Tempera on panel,
147 x 82 cm
(Pedralbes)

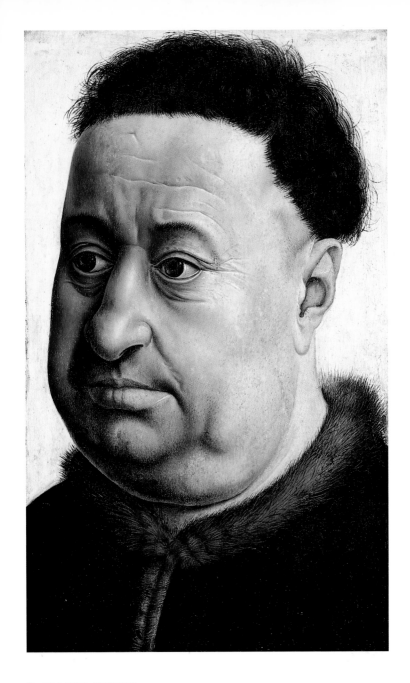

Robert Campin

TOURNAI, C. 1380–1444

Robert Campin was a contemporary of Jan van Eyck and one of the great innovators of the new realist trend in art in the Netherlands. As with van Eyck, his representation of reality was based on empirical observation. In comparison with the idealism of the Italian Renaissance, Campin, as can be seen in this portrait, had as his goal the principle of realistic, unidealized and objective representation. Modern scholarship has securely identified Campin as the Master of Flémalle, but for many years this connection was considered dubious. On the one hand, there existed a group of key works of very similar style and technique, which were attributed to an anonymous master who was named after the monastery of Flémalle, from where he was thought to originate. The life of the artist Campin, on the other hand, was well known and documented: the teacher of important artists such as Rogier van der Weyden and Jacques Daret, but an artist whose works seemed to have been almost entirely lost. A work by Daret in the Thyssen-Bornemisza Collection proved to be a decisive element in identifying the two figures.

While Jan van Eyck concentrated on the depiction of religious subjects, Campin, applied a realistic approach to another important branch of Flemish painting: the portrait. The sitter is seen slightly from the side, portrayed without flattery and in a way which makes clear the artist's desire to represent reality with complete truthfulness. This gives the portrait enormous individuality and expressiveness. Light and line are the most important elements used to create three-dimensional form, while the use of oils makes it possible to depict the hair and the fur of the coat in fine detail, as well as the smooth gradations of tones which model the face. The sitter would seem to be Robert de Masmines, a distinguished Burgundian soldier, identifiable on the basis of a drawing now in Arras. The serious and austere expression, the force and determination of the gaze and the plainness of the clothes would seem to reinforce the idea of a military man, who in this case was awarded the Order of the Golden Fleece on 10 January 1430 and died in the siege of Bouvines that same year.

Portrait of a thick-set Man (Robert de Masmines?), c. 1425 Oil on panel, 35.4 x 23.7 cm

Rogier van der Weyden

TOURNAI, 1399 – BRUSSELS, 1464

(attributed)
*Portrait of a Man
(Pierre Beffrement,
Count of Charny),*
c. 1464
Oil on panel,
32 x 22.8 cm

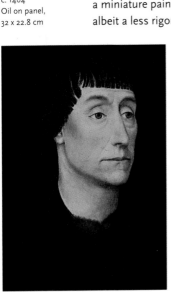

Another pupil of Robert Campin and one of the leading artists of his day, Rogier van der Weyden's art initiated an expressive trend which contrasted with the elegantly hieratic style of van Eyck. He painted religious works and portraits and had an ability to convey the feelings of the figures depicted, taking the realism of earlier Netherlandish painting and adding to it a certain expressive quality. Van der Weyden was enormously influential throughout Europe during the 15th century (with the exception of Italy), and was widely admired for his technical mastery as well as for his ability to capture human sentiment and convey it in paint.

The Virgin and Child is an early work of surprisingly small dimensions, and is a fine demonstration of the technical virtuosity which these artists were capable of expressing. The Gothic niche in which Mary is seated – and particularly the sculptures which decorate it (depicting scenes from the Nativity cycle) – could almost be the work of a miniature painter. The architectural setting is rendered in perspective, albeit a less rigorous one than would have been used by van der Weyden's Italian contemporaries, and creates a three-dimensional space in which the two figures are placed. The precise delineation of these architectural forms is counterbalanced by a gently modulated light which casts soft shadows to create volume. Against the golden tones of the architecture, the brilliant blues and reds of the mother and child assume a heightened vibrancy. The cool surfaces of van Eyck's *Annunciation* have here become warm and painterly, and envelop the Virgin in an mood of contemplation and abstraction.

Also attributed to van der Weyden is the portrait thought to show the Count of Charny. The psychological depth of the portrait, together with the masterly handling of – abeit rather hard – line, certainly suggest a close relationship with the work of van der

The Virgin and Child,
c. 1433
Oil on panel,
14.2 x 10.2 cm

Weyden, who left very few signed works and all of whose works are attri-
buted on the basis of two or three key paintings, including the *Descent
from the Cross* in the Prado. The present portrait is very close stylistically
to others by the artist, including the portrait of Francesco d'Este.

Jacques Daret

TOURNAI, C. 1403 – AFTER 1468

This painting was the key to the identification of Robert Campin as the Master of the Flémalle. Jacques Daret, born in Tournai around 1403, was a pupil of Robert Campin and is documented as his apprentice from 1427 to 1432, in which year he became a master, as did his fellow apprentice Rogier van der Weyden.

In around 1435 he was working in the Abbey of San Vaast, near Arras, on an altarpiece of the Nativity cycle, of which this present panel was a part. The similarity between this painting and a *Nativity* by the Master of Flémalle makes it seem likely that Daret based his work on the earlier painting, and gave rise to the suggestion that the Master of Flémalle was Robert Campin.

The two paintings use very similar compositions, of a type which would later become widespread in Flemish painting. The main scene with the manger and the figures takes place in the foreground, while on the right is an open space with a landscape which extends into the background. While Daret's painting simplifies the composition by using fewer figures, making the narrative easier to comprehend, it includes the two midwives (Zelomi and Salome), the figure of Joseph holding a cloth, and the small angels flying over the stable – all of which appear in both versions.

The present panel is characteristic of 15th-century Netherlandish painting, in the female type used, the richness of the clothes and draperies, which are based on contemporary dress, the stylization of the figures and a certain sculptural quality which gives them weight and volume. In addition, one very characteristic, almost emblematic detail used by these artists is the way of depicting the folds of the draperies, which fall onto the ground in angular shapes. The painting is executed in oil (a technique which quickly spread throughout the Netherlands) and achieves great brilliance and variety in its palette and tonal values.

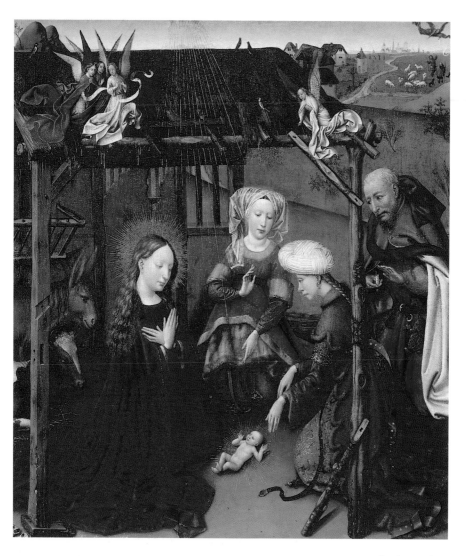

*The Adoration of the
Child*, c. 1434/35
Oil on panel,
60 x 53 cm

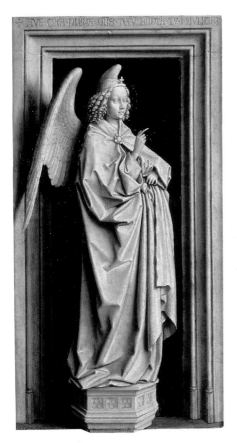
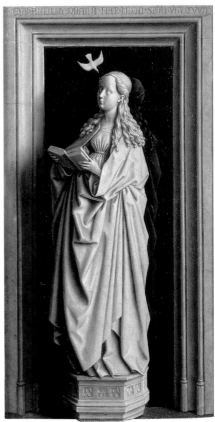

The Annunciation
Diptych, c. 1435–1441
Oil on panel,
39 x 24 cm

Jan van Eyck

MAAESYCK, NEAR MAASTRICHT, C. 1390–BRUGES, 1441

Together with Robert Campin, Jan van Eyck created the new artistic style which represented one of the high points of Netherlandish art. Like their Italian counterparts, the Flemish artists of the early 15th century set out in pursuit of a realistic manner of representation, influenced by the art of the sculptor Claus Sluter who worked for the Burgundian court. In contrast to the scientific and technical nature of the Italian enquiry, however, the approach of artists such as van Eyck, Campin and van der Weyden was subject to an empiricism based on the detailed observation of each individual element. Their art, which developed from the preoccupations of the late Gothic taken to their logical conclusions, led them towards the depiction of reality just as they saw it.

Realism and the tradition of sculpture are evident in this painting, which depicts the archangel Gabriel and the Virgin of the Annunciation as sculptures in niches. The artist plays with the textures of the materials, and unites the real and fictitious pictorial space by means of the frame, which continues into the panel and above which are suspended the pedestals of the two figures. However, its true genius lies in the ability to model the volumes through the effects of pronounced contrasts of light and dark, so that the figures seem to acquire a real presence. Every element plays a part in achieving the illusion of three-dimensionality, such as the shadows which project onto the pilasters of the niches, the angel's wing, which seems to be outside the pictorial space, and the reflection of the figures against the background which imitates alabaster.

This interest in realism is made possible through the use of a new techniqe, that of oil painting, which van Eyck was the first to use on panel. It allowed for a greater fluidity, a much refined tonal gradation and a wide variety of painterly effects, from fine glazes to much thicker paint layers, and resulted in a uniform finish in which the brushstroke was not visible. It also allowed for the most minute detail to be rendered in paint. Although the figures are painted in grisaille, the fact that the backs of these panels are painted to imitate marble suggests that the present work is a diptych on the subject of the Annunciation.

"Hail, thou that art highly favoured, the Lord is with thee."
LUKE 1:28

"Behold the handmaid of the Lord; be it unto me according to thy word."
LUKE 1:38

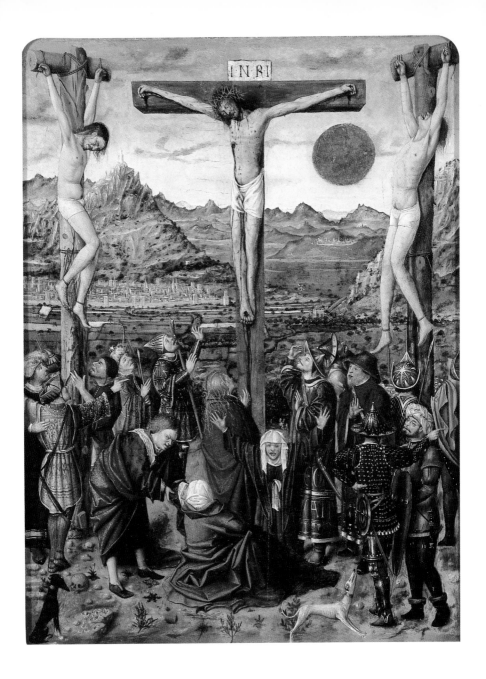

Franco-Flemish Master

ACTIVE IN NAPLES BETWEEN 1435 AND 1445

Attention to detail and drama are the two elements which stand out
most in this panel by an anonymous artist working in Naples in the
mid-15th century. In addition to the moving depiction of the scene itself,
this painting is interesting as an example of the way in which artistic
trends spread throughout Europe in the 15th century, passing between
north and south (the influence of the Italian Renaissance on northern
European art, and vice versa). In the case of the present painting, the
artist was probably a Spaniard associated with the circle of van Eyck in
Naples. Relations between the kingdom of Spain and Naples through-
out the Renaissance resulted in the widespread movement of artists
between southern Italy and Spain.

In the present panel, the subject of the Crucifixion is treated with
great drama and a naturalism which goes beyond a mere depiction of
the real. The artist's exaggeration of the poses is evident in the figures
at the foot of the cross, such as Mary Magdalene and the Virgin, as well
as in the two thieves who flank Christ, whose suffering and physical
torture is also stressed. In addition, the colourless and rocky landscape
contributes to the mood of tension and isolation in the painting, which
concentrates on conveying the pain and suffering of the Crucifixion,
rather than upon its transcendental significance as the Son of God
sacrificing himself for mankind (an aspect which would be emphasized
in the humanistic approach of the Renaissance).

The taste for detail and the bleached and hard style of the painting
are characteristics which would become pronounced in Spanish paint-
ing and were derived from Flemish art. The approach to the imitation of
nature is an empirical and to some extent unstructured one. Although
each element (the flowers and bushes, the armour and clothing, the hair
and faces) is delineated with great exactitude, there is no overall sense
of coherence: in a way each element is separate and fulfils its own
function without really blending into the whole.

The Crucifixion,
c. 1435–1445
Tempera on panel,
44.8 x 34 cm

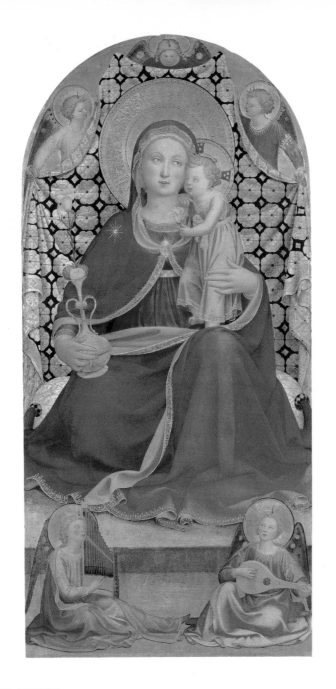

Fra Angelico

VICCHIO DI MUGELLO, NEAR FLORENCE, C. 1400 – ROME, 1455

Fra Angelico was one of the most important painters in 15th-century Florence. He was a Dominican monk and, as a member of the Order of Preachers, used his art to teach and instruct. Hence its complete clarity and simplicity and use of clearly set-out and in some ways old-fashioned compositions. Florentine artists of the mid-15th century were influenced by one or other of the two leading masters: on one side the dramatic realism of Donatello, and on the other the more classical style of Masaccio. Fra Angelico falls more in line with the monumental, hieratic and three-dimensional solidity of Masaccio (who took up the tradition of Giotto and his followers), although in many ways he shows affinities to the International Gothic.

"Fra Angelico's religiousness must be considered from a historical perspective, that is, as thought and action aimed at saving the religious essence of art threatened by the new culture of humanism."
GIORGIO VASARI

In his *Virgin of Humility*, the image of Mary recalls the ideal of beauty promoted in International Gothic art, although her pose and shape give her a three-dimensionality and solidity closer to the art of Masaccio. Even though there is very little indication of her surroundings, the Virgin is firmly situated within a coherent spatial setting, achieved through the creation of volumetric forms via the modelling of light and shade, and by the condensed reference to an architectural setting in the form of the step on which the Virgin is placed. The angels seated in the foreground and those in the background who hold up the cloth in the form of a canopy contribute to the construction of a realistic spatial setting on three different planes: that of the angels, that of the Virgin, and that of the canopy in the background.

The painting is notable for its brilliant and luminous palette, in which reds, blues and golds are harmoniously combined. Also outstanding is the sweetness and spirituality of the faces of the figures, whose poses and gestures are depicted with great naturalism. The Virgin is placed, following the traditional iconography of the Virgin of Humility, on a cushion (rather than a throne), as she also appears in other earlier paintings in the Thyssen-Bornemisza Collection (such as that by Cenni di Franceso, or in the painting by the anonymous Venetian master of 1360).

The Virgin of Humility, c. 1435–1445 Tempera on panel, 98.6 x 49.2 cm (Pedralbes)

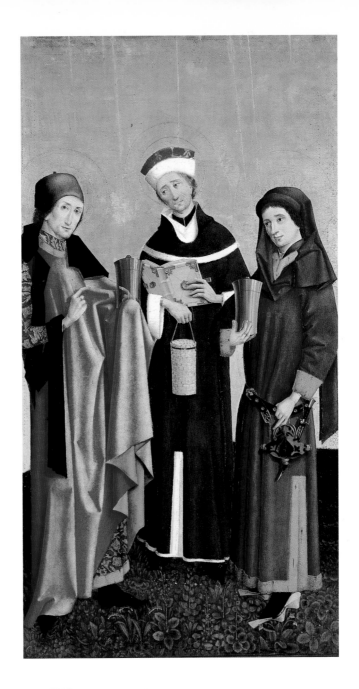

The Master of the Vision of St John

ACTIVE IN COLOGNE, C. 1450–1480

In the mid-15th century German painting, marked by the realist trend which had developed from the turn of the century onwards in the work of such artists as Konrad Witz and Stefan Lochner, saw a major evolution which was partly influenced by Flemish painting. This is evident in the present work, which reveals a notable technical advance in comparison with earlier painting. Also influential were the sociological changes which took place in the 15th century.

Against a traditional and by now old-fashioned gold background are outlined the figures of the three doctor saints, painted with great precision and in great detail. The artist has thereby clearly endeavoured to individualize each figure's face. The panel also incorporates a wide variety of different objects, connected with the saints' profession, as well as clothes and ornaments, all beautifully painted. The same detail is to be found in the grass beneath their feet, in which each plant, drawn leaf by leaf, is differentiated from the next – even if the artist has not quite succeeded in recreating the genuine sensation of standing on the grass, which appears more like a carpet under the saints' feet. This is a typical characteristic of paintings of this type, which reproduce individual elements with great fidelity to nature, but which fail to subordinate them as appropriate within the overall composition.

Nonetheless, the painting is a good example of the progress of German art towards realism and the representation of three-dimensional form. By using the now standard oil technique, the artist has been able to create volumes and represent the different textures of the objects. In addition, he uses a varied palette, a subtle tonal gradation and a soft contrast of highlights, lights and shadows, producing a bright and luminous effect in which the light is uniformly distributed.

SS Cosmas, Damian and Pantaleon,
c. 1455
Oil on panel,
130.5 x 72.2 cm

Johann Koerbecke

OELSFELD, C. 1420 – MÜNSTER, 1490

Also from the mid-15th century, the work of Johann Koerbecke shares many of the characteristics already noted in the Master of the Vision of St John, although the composition of the present panel is more complex and is executed with great mastery.

A notable feature of the painting is its division, both physical and stylistic, into two distinct parts: the lower sphere representing the earth and the upper sphere of the heavenly kingdom. In the lower part, the artist has represented the Apostles grouped around the Virgin's empty tomb. The impulse towards realism is evident in the way in which the artist has attempted to individualize the expressions and poses of each figure, as they show their surprise and awe at the miracle. He also organizes the group around the tomb into a more or less coherent spatial arrangement. The tomb, with its plain classical decoration, and in particular the lid which has fallen into the foreground space, give the scene a sensation of depth and realism, which contains otherwise little to indicate its setting: only a patch of green in the background represents what might be the side of a mountain.

Above, the heavenly Glory with Jesus receiving the Virgin is treated in a much more ordered and, one might say, atemporal manner. The Virgin is painted with great delicacy, her body forming a gentle curve. The groups of musical angels, clearly influenced by Gothic art, are nonetheless painted with considerable detail and with an attempt to achieve volume and three-dimensionality.

One of the most notable features of this work is the vitality of its palette, enhanced by the old-fashioned device of the gold background. Reds, yellows, greens and blues, with a few touches of white, combine and complement each other, revealing this artist's refined sense of colour.

The Assumption of the Virgin, before 1457
Oil on panel, 93.1 x 64.2 cm

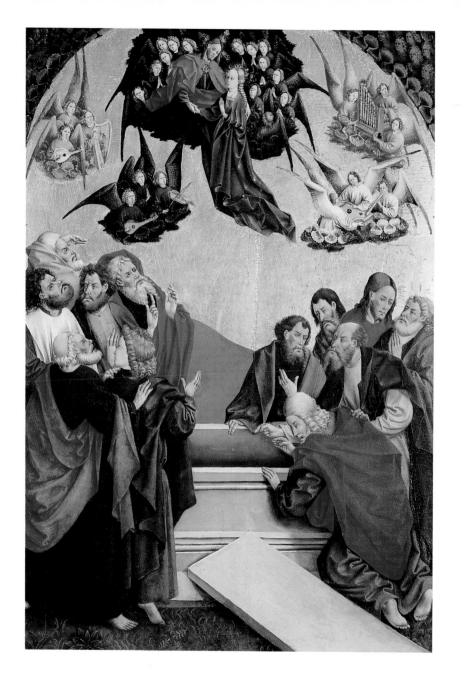

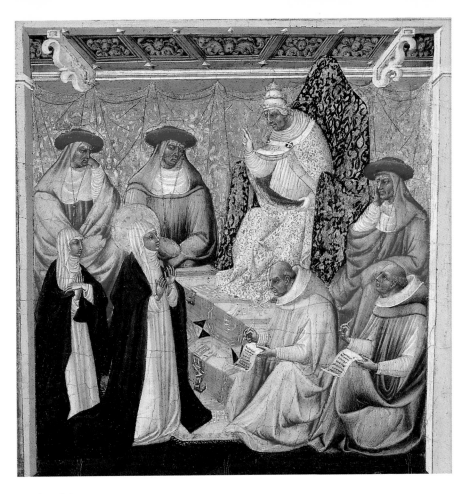

*St Catherine before
the Pope at Avignon,*
c. 1460
Tempera on panel,
29 x 29 cm

Giovanni di Paolo

SIENA, C. 1400 – 1482/83

If, during the 14th century, it had been Siena which had exerted its artis-
tic influence upon Florence, and indeed even across the Alps, contribut-
ing to the formation of the International Gothic style, in the following
century it was Florence which influenced Siena. This is evident in the
work of artists such as Giovanni di Paolo who, while continuing to work,
well into the 15th century, in a style close to that of his 14th-century
Sienese forebears, preserving their subtle use of colour and elegant and
stylized forms, was also assimilating the characteristics of Florentine
painting, such as the use of perspective, albeit adapted in a personal
way.

Although the present work was executed at a considerably later
date, its style is closer to that of the artists of the early 15th century who
bridged the old and new styles. Thus it locates its figures within an
architecture whose perspective is essentially determined by the beams
and coffering of the ceiling, which lead to a vanishing-point in the centre
of the painting, as is normal in Early Renaissance painting. However,
the pedestal under the Pope's throne has a different vanishing-point
(the use of various vanishing-points in a rather haphazard application
of the rules of perspective is also evident in the work of artists such as
Paolo Uccello and Andrea del Castagno). In addition, the Sienese Tre-
cento tradition is clearly evident in the light, sweet and at the same time
brilliant palette and in the elegant rhythm of the forms, principally the
poses of the figures.

The painting, which depicts St Catherine being blessed by the
Pope, who is accompanied by three cardinals (with their red berettas)
and two scribes, was one of a series of ten on the life of St Catherine,
who lived from 1347 to 1380 (coinciding with the period of the Popes'
exile in Avignon). The series may have been commissioned in conjunc-
tion with Catherine's canonization in 1461.

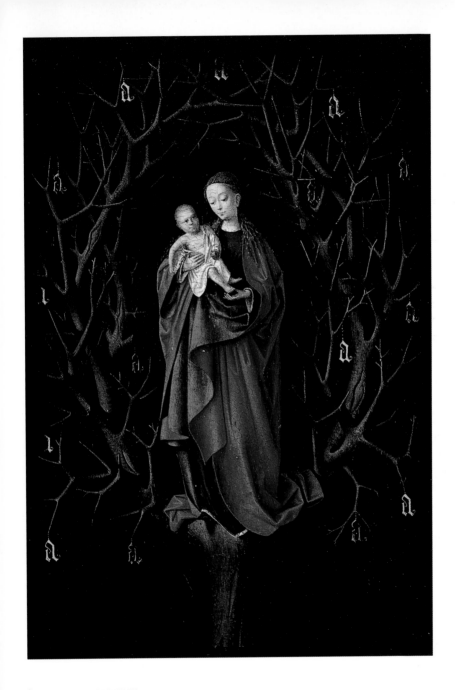

Petrus Christus

BAERLE, BRABANT, C. 1410 – BRUGES, 1472/73

Petrus Christus was the most important artist in Bruges after Jan van Eyck, whose pupil he may have been. His style has a refinement which differs slightly from that of his master, and also shows the influence of the work of Robert Campin and Rogier van der Weyden.

This small, brilliantly executed panel is a puzzling composition which conceals a complex symbolism. The painting is a late work by Christus, who from 1462 was a member of the Brotherhood of Our Lady of the Dry Tree. The dry and thorny branches could be a prefiguration of the Crown of Thorns, but the painting has also been interpreted as an early representation of the Immaculate Conception, according to which the Virgin was herself conceived without sin by her mother, St Anne – a dogma not officially accepted until the 19th century but popularly embraced long before. The symbolism could thus refer to the Virgin who was conceived after her mother had become infertile, in reference to the Book of Ezekiel. It could also signify the painful path which Mother and Child must follow to bring about the salvation of mankind. The hanging letter A's symbolize fifteen Ave Marias.

Aside from its meaning, the quality of the execution of this simple but impressive painting is remarkable. The figural type of the Virgin is highly stylized, dressed in a long red robe with a green lining, whose broad folds give a sense of movement. The other figures are outlined against a dark background, illuminated by a pale light which seems to come from a source on the left in front of the figures. The tree is painted with great skill, with the forms of the branches modelled from light and shade.

"And every tree of the field will learn that I, Yahweh, am the one who stunts tall trees and makes the low ones grow, who withers green trees and makes the withered green."
BOOK OF EZEKIEL (17:24)

The Virgin of the Dry Tree, c. 1460
Oil on panel,
17.4 x 12.3 cm

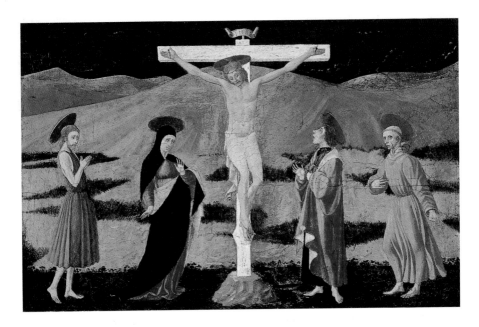

*The Crucifixion with
the Virgin and SS John
the Baptist, John the
Evangelist and Francis,*
c. 1460–1465
Tempera on panel,
45 x 67 cm

Paolo Uccello

FLORENCE, 1397–1475

While Fra Angelico followed Masaccio's style of serene monumentality, Paolo Uccello (who, although older, belonged to the same generation of artists) fell within the orbit of Donatello's dramatic realism. His style also undoubtedly shows the influence of some aspects of Gothic sculpture, as regards the stylization of the forms and a feeling of nervous movement in the figures.

PAVLI VGIELLI

Uccello was a pupil of Ghiberti, with whom he worked on the first set of Baptistry Doors in Florence from 1407. His early years were thus moulded by the International Gothic, but from the 1430s his work shows him assimiliating the new theories of perspective and fore-shortening, even if he employs them with a certain arbitrariness.

"What a lovely thing this perspective is!"
PAOLO UCCELLO, after VASARI, 1550

Uccello was a highly individual artist whose works have a high decorative value. His famous battle scenes faithfully follow Alberti's recommendations in *Della Pittura*, with regard to the inclusion of co-pious detail and in the use of monochrome, which brings painting closer to sculpture and means that forms have to be modelled from light and shade. Uccello's works use a dark palette with a colour range reduced to ochres, browns and blacks.

The unusual, elongated composition of the present panel suggests that it may have formed part of a predella, the base of an altarpiece. Against the dark and schematic background of a night-time landscape are outlined the figures of Christ, the Virgin and St John the Baptist flanking the cross, and St John the Evangelist and St Francis of Assisi at the two sides. The figures are vigorously and incisively drawn, in a very sculptural manner, showing a high level of knowledge of anatomy (particularly in the figure of Christ) and of the proportions of the human body. The cross and the haloes are depicted in perspective, as is characteristic of the artists of the Quattrocento. The plainness and simplification of the forms, together with the sombre palette characteristic of Uccello, gives the scene an unreal and spiritual air.

Gentile Bellini

VENICE, 1429–1507

GENTILIS BELLINI.

Gentile Bellini belonged to the second generation of Quattrocento artists, and lived in an era when Florentine influence was spreading throughout Italy. Son of the painter Jacopo Bellini, he worked in his father's studio together with his younger brother Giovanni. He enjoyed great fame as a portraitist and was the official painter to the Republic of Venice. Bellini dedicated most of his life to painting scenes of the history of the city, its festivals and processions. These types of works may be seen as the antecedent of a genre of painting made famous two centuries later by Canaletto and Guardi, namely the Venetian school of *vedutisti* (view painters).

The present painting depicts the moment when the Angel Gabriel appears to Mary. It is one of Bellini's few religious paintings and the main focus of interest is the architectural setting. The work shows the influence of Andrea Mantegna, Bellini's brother-in-law, particularly in the monumental and sculptural quality of the figures and in the construction of the architectural perspectives, typical of the Renaissance. The vertical axis, marked by the line of black and white inlaid tiles, is found on the left and passes through the angel's hand, while the horizontal axis is situated half-way up the painting. The perspectival structure is based on precise mathematical calculations, one of the scientific advances of the Italian Renaissance (and very different to the empirical approach of artists north of the Alps). The artists of the Quattrocento sought to imitate nature by consistently following the rational laws which ordered it, and in this sense were the heirs of classical antiquity.

This panel is a clear example of the idealization to be found in Quattrocento art, which aims to arrive at the essence of natural forms. Thus, the city could be any Italian city, but it is in fact the abstract representation of an ideal city which provided the opportunity for a detailed study of Renaissance architectural elements. However, the excessive (or perhaps too obvious) technical rigour and the coldness of the depiction considerably reduce the naturalism of the scene and the architectural background seems more like a stage set than a real space.

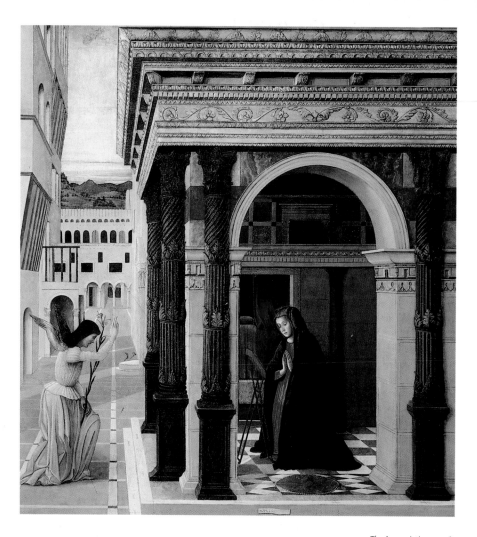

The Annunciation, c. 1465
Tempera and oil on
panel, 133 x 124 cm

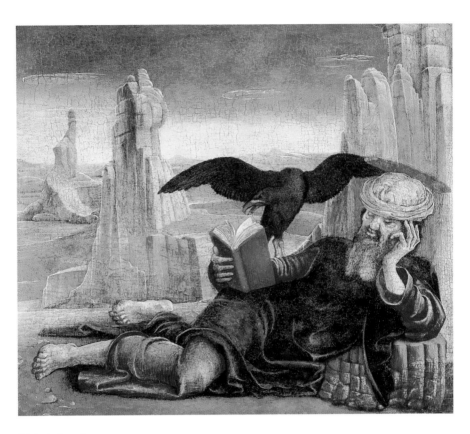

*St John the Evangelist
on Patmos*, c. 1470
Tempera on panel,
27 x 32 cm

Cosmè Tura

FERRARA, C. 1431 – 1495

The city of Ferrara enjoyed a brief period as an important artistic centre in the second half of the 15th century, under the rule of the house of d'Este. Cosmè Tura was the leading artist of the Ferrarese school, which also included Francesco del Cossa and Lorenzo Costa, also represented in the Thyssen-Bornemisza Collection.

Tura was painter at the d'Este court from 1458 and his work shows above all the influence of Mantegna, but also of Donatello and Piero della Francesca, from whom he derived his brilliant, albeit limited palette.

The present panel depicts St John the Evangelist on the island of Patmos, where he wrote the Apocalypse. The saint is identifed by his eagle, which rests on his arm with its wings outstretched, and by the book he is holding. He is thinking or resting rather than reading, leaning against a bare rock. The scene takes place in a desolate landscape of sharp crags which rise up from a deserted plain.

To create the spatial setting Tura has used a technique close to aerial perspective, softening the outlines in the background and lightening the colours. The style is characteristic of Ferrarese painting, which was influenced by Mantegna and Piero della Francesca (who was called to the d'Este court to paint some now-lost frescoes). Mantegna's influence encouraged Tura's austerity, giving rise to a severe and angular style with hard metallic contours and a brilliant surface, typical features of the Ferrarese school.

Francesco del Cossa

FERRARA, 1435 – BOLOGNA, 1478

Francesco del Cossa was a follower of Tura in Ferrara, through whose work he also absorbed the influence of Piero della Francesca and Mantegna, adopting a similar style to Tura with his bright palette and hard, angular draughtsmanship.

The present work was painted towards the end of Cossa's life when he lived in Bologna, where he moved around 1470. The sitter is placed behind a ledge which, rather than separating him from the viewer, draws him closer, as it functions to connect the real with the painted world through the idea of a window or balcony of a common Renaissance type. The artist focuses his attention on the sitter's face and on the hand holding up the ring. The foreshortening used to depict the hand, the play of light and shade (derived from a single light source), and the realism this gives to the foreground of the picture are all impressive features. The wiry and energetic lines of the face lend it great force. In contrast, the sitter's body seems to be merely a support of secondary importance, although the artist has ably given the impression of volumetric form through the handling of light. In the background is a landscape whose rocky forms and pale colours recall the work of Cosmè Tura. While its atmospheric quality, as in Tura's works, creates a certain realism, it exists outside any relationship with the sitter, serving merely as a backdrop. The austerity with which the sitter is depicted, both in his clothing and in the range of colours, again points to the influence of artists such as Mantegna and Piero.

While the identity of the sitter is unknown, the panel clearly depicts a real person who wished to have his portrait painted, perhaps as a record of his engagement, which would explain the ring which he intends to give to his betrothed.

Portrait of a Man with a Ring,
c. 1472–1477
Oil on panel,
38.5 x 27.5 cm

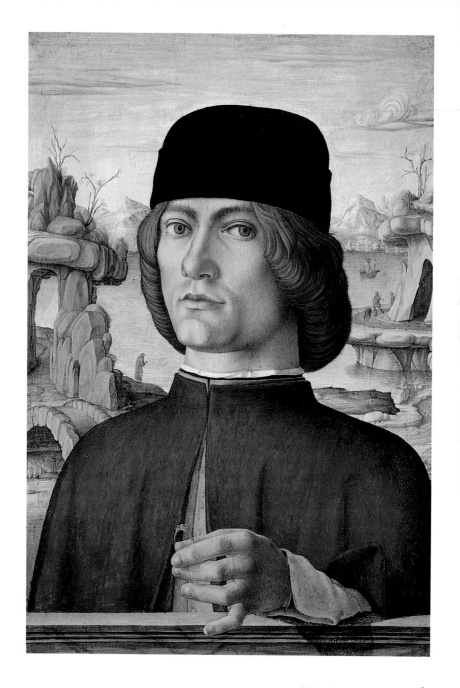

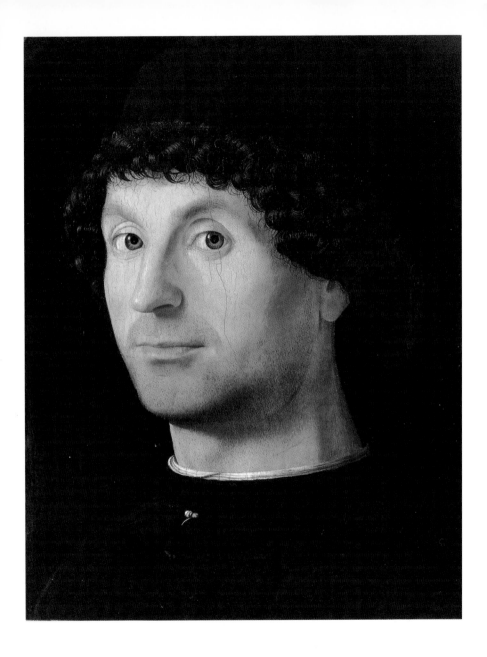

Antonello da Messina

MESSINA, SICILY, C. 1430–1479

The genre of portraiture was one of the most important and most enduring new developments of the Quattrocento and is richly represented in the Thyssen-Bornemisza Collection. The present portrait is notable not only as one of the Museum's earliest examples of the genre, but also for its use of oils; Antonello da Messina was one of the few 15th-century Italian artists who fully mastered this technique (in contrast to Flemish artists, who used oils on a regular basis). Since oil paint dries much more slowly than tempera, it allows the artist more time to execute the work, and also enables the colours to be applied with much greater fluidity and flexibility.

Antonello da Messina was born in Sicily, but little is known of his life and work, other than that he travelled around the whole of Italy before finally arriving in Venice, where his work had a certain influence. His knowledge of the oil technique and his style are influenced by the Flemish painters of the school of Jan van Eyck, examples of whose work he could have seen in Naples.

Despite its austerity, derived from Flemish art, the Thyssen-Bornemisza portrait is startling in its intense realism and the detail with which it is painted. The sitter is depicted bust length against a dark ground which emphasizes the intensity of his gaze. The painting is executed with great skill, making it one of the finest Early Renaissance portraits in the Collection, comparable with those by Domenico Ghirlandaio, Hans Memling and Robert Campin, all of which hang in the Museum's Quattrocento Portrait gallery.

"Due to the imperfection of the times, Colantonio did not achieve the perfection in his drawings of antiquities attained by his pupil Antonello de Messina ..."
Letter by PIETRO SUMMONTE, 1524

Portrait of a Man,
c. 1475/76
Oil on panel,
27.5 x 21 cm

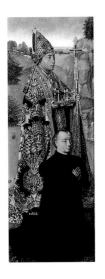
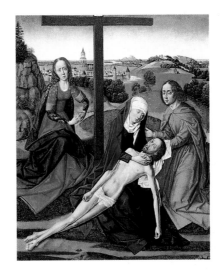
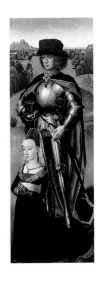

Lamentation Triptych, c. 1475
Oil on panel,
central panel, 75 x 61 cm,
wings, 75 x 27 cm

Master of the St Lucy Legend

ACTIVE IN BRUGES BETWEEN 1475 AND 1501

This artist, active in Bruges in the late 15th century, follows the tradition of the Flemish school established in the first half of the century by such artists as van Eyck, van der Weyden and van der Goes. His style, which bears some similarities to that of Memling, is characteristic of the latter years of the Early Renaissance in Netherlandish painting: the realism of the faces, a certain exaggeration in the expressions, the great attention to detail and the tendency towards angular and slightly hard forms. The stylization of the figures is also common in this era, and is a feature of a style which spread to France, Germany and Spain.

The artist has employed a compositional structure which would also prove extremely popular, particularly in paintings of the same *Lamentation* subject. The scene takes place in the foreground with a broad landscape behind, which includes a city that may be Jerusalem. The landscape becomes increasingly blue towards the background in order to increase the sense of spatial recession into depth, using criteria that are approximate to those of aerial perspective.

In the wings on either side, we see the donors and their patron saints in prayer, whereby the three separate panels are linked by the device of the continuous landscape. Each donor appears with his or her own patron saint: Donatus de Moor with St Donatus the bishop; his wife Adriana de Vos with St Adrian. Adriana de Vos' clothing reflects the fashion of the day, with a transparent veil covering her face, and in line with the ideals of beauty of that time, she also has almond-shaped eyes and a very high forehead (it seems that women shaved their hair at the front to achieve this effect). With its intense and brilliant colours deployed in strong contrasts, the palette is reminiscent of van der Weyden and other artists of his circle.

Derick Baegert

WESEL?, C. 1440 – C. 1515

Although German art in the last quarter of the 15th century had assimilated the stylistic trends of northern Europe, as issuing above all from the Netherlands, it still retained certain characteristics of its own, such as a greater emphasis on the expressiveness and individualization of the faces. The present composition – composed of two panels – was originally part of a large *Crucifixion*, which at some point in the past was broken up into smaller panels. Although five of these have been reunited in the Thyssen-Bornemisza Collection, most of the composition is still missing. These five panels were brought together through the determination of Baron Heinrich Thyssen-Bornemisza, who tried to reassemble the entire altarpiece. Sadly, however, there have been no references to further panels since 1952. Overall, the painting reveals a great interest in narrative and is built up through the accumulation of numerous different elements and incidents, whereby various episodes from the Passion take place at the same time: in the middle ground, Christ bearing the Cross takes the cloth which St Veronica offers Him. Behind this scene we see a hanged man, probably the traitor Judas. The various figures in the procession behind Christ are depicted in great detail, and the anectodal nature of the painting is obvious in the figure who makes a mocking face at the Virgin and her followers.

The sudarium – the cloth with which Christ dried His face is shown in the foreground among a group of figures that demonstrate brilliantly the artist's skill at portraiture, each being depicted with a different, individualized expression and pose. The sudarium is held up by a pale-skinned woman in a white dress, which serves to highlight the sudarium among the bright colours of the rest of the crowd. On the right the figures look towards the space where we can assume the Crucifixion would take place. Sadly this element, the most important of the composition, is now lost. The artist was influenced by the work of Flemish painters such as van der Weyden. The hardness of the folds, the precision of the outlines, the brilliance of the palette and the richness and variety of the clothes give this work an exuberance and intensity unusual for the period.

Christ bearing the Cross with St Veronica holding the Sudarium and a Group of Nobles,
c. 1477/78
Oil on panel,
upper panel,
87 x 98 cm,
lower panel,
113 x 97.5 cm

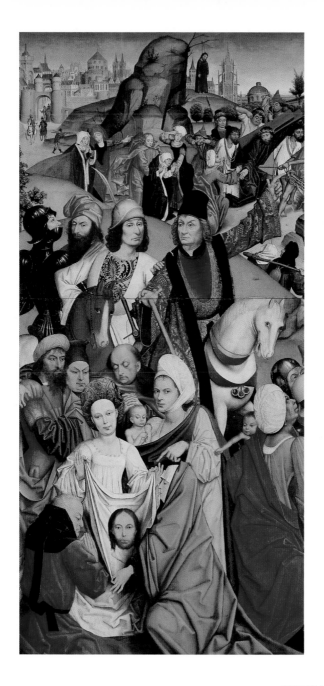

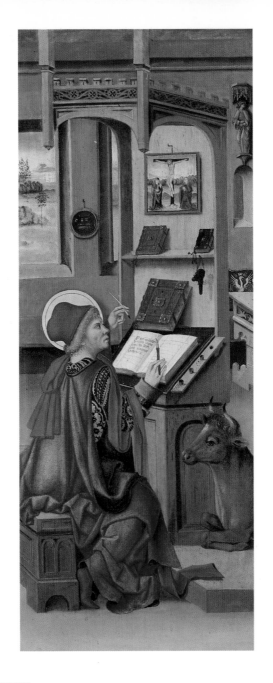

Gabriel Mälesskircher

1430/40 – MUNICH, 1495

This panel forms part of a group of eight which once belonged to an altarpiece in the monastery at Tegernsee. All eight are now in the Thyssen-Bornemisza Collection and depict the four Evangelists, Matthew, Mark, Luke and John. Each is depicted on two panels, one, as here, showing the Evangelist in his study, and the other depicting a notable episode from his life: in the case of St Luke, the artist has represented him painting the Virgin. Here St Luke is writing at his desk with his symbol, the bull, at his side, depicted in a realistic way as if it were a domestic pet.

Dating from the same period as Derick Baegert's *Crucifixion*, this work also shows the influence of Netherlandish painting in its enthusiasm for detail, its precise draughtsmanship and the general arrangement of the interior space, with the windows at the back of the room through which a landscape is visible. The study is spacious and includes numerous pieces of furniture which the artist has attempted to depict as three-dimensional forms, although they lack a rigorously applied perspective. Nonetheless, they contribute to creating a relatively coherent spatial setting, at least superficially.

Mälesskircher's delight in detail, derived from his desire to depict reality faithfully, expresses itself in such elements as the round mirror between the windows in which part of the room is reflected, the books, the sculpture on the rear wall, the inkwells, the books and the open book in which the saint is writing. The other panels also include this profusion of detail, and thereby provide a valuable historical record of the objects and furnishings of the day. Finally worth noting are the strong and powerful features of the Evangelist, which are highly individualized and depicted with great realism.

St Luke the Evangelist, 1478
Oil on panel,
77 x 32.2 cm

Jan Polack

NEAR CRACOW, C. 1450 – MUNICH, 1519

Of Polish origin, Polack worked at the end of the 15th century, a period during which German art was achieving greater expressiveness through an almost violent exaggeration of facial gestures and poses. This trend, which had developed over the course of the century, was now more pronounced and is also found in Polack's religious paintings.

Although Polack restrains this tendency in his *Portrait of a Benedictine Monk*, he still shows the expressive force of the sitter's face: a broad head with a serious and austere expression emphasized by the eyes and the set of the mouth. The monk's habit is well painted, created from gradations of black which form sharp outlines and hard and angular folds. The firm draughtsmanship is reinforced by the skilful rendering of light and shade, giving the character a lifelike and three-dimensional feel. The light, which falls from the left, throws a clear shadow against the golden background, against which the dark area of the monk's habit and cap is strongly outlined. At the top of the picture is an inscription with the date of its execution.

While one might have thought that the painting was a portrait of St Bernard himself, the strongly individualized features make it more likely that this is an anonymous sitter portrayed with the attributes of his patron saint. The book refers to the Benedictine Order, while the chalice refers to the attempt to poison the saint, who was miraculously saved when the poison which he was just about to drink changed into a serpent and the cup broke. Worth noting is the unusual placement of the chalice, which seems to be lacking any visible means of support.

Portrait of a Benedictine Monk, 1484
Oil on panel,
57.3 x 41 cm

Michael Wohlgemut

NUREMBERG, 1434/37 – 1519

A painter of altarpieces, Wohlgemut continued the Flemish tradition in his work. He is better known, however, for his book illustrations, and it was in his workshop that the young Albrecht Dürer first studied print-making.

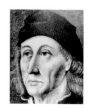

Wohlgemut has here portrayed an important citizen of Nuremberg, Levinus Memminger, a judge and member of the City Council. His physical features are precisely drawn, through lines which are visible not only in the face but also in the hands and in the background. Behind Memminger, who leans on what could be a table, is a tapestry with a coat-of-arms, probably his own, and on the right a window, a typical featue of portraits of this date. Through the window we can see a landscape which, although undoubtedly imaginary, is portrayed with great realism . The artist's interest in nature is evident in his detailed treatment of the landscape and in the drawing of the birds, three flying and one perched on the window sill. They inevitably bring to mind Dürer's studies of animals: as a pupil of Wohlgemut, Dürer may have worked with him on the illustration of books on plants and animals.

The genre of portraiture was widespread in Germany and the Netherlands, where the new commercial and professional middle classes in the cities became important patrons of easel painting – unlike southern Europe, where the most important patrons remained the Church, the monarchy and the aristocracy. The differences in social and political structure distinguishing northern and southern Europe also made their way into art: although northern and southern Europe made similar progress at the technical level, and even maintained a degree of interaction, from the point of view of subject matter and style the two regions went in different directions. The northern artists, following the requirements of their wealthy middle-class clients, who were proud of their city and of their own prosperity (as was probably the case with Levinus Memminger), developed a subject matter of private and contemporary themes. In contrast, the artists of the south tended to depict epic narratives and subjects to the greater glory of their powerful clients.

Portrait of Levinus Memminger, c. 1485 Oil on panel, 33.7 x 22.9 cm

Austrian Master

ACTIVE AT THE TYROLEAN COURT AROUND 1485

The Thyssen-Bornemisza Museum contains a magnificent collection of 15th- and 16th-century German portraits, some by anonymous masters, but no less outstanding for that, as demonstrated by the present work. The sitter is probably Kunigunde of Austria (1465–1520), daughter of Emperor Frederick III. In 1487 she married Duke Albert IV of Bavaria.

Portraits of this type conform to standard conventions: the sitter is represented slightly less than half-length, almost frontally but with a slight turn to the side, with the hands and arms in front of the body either crossed or slightly raised in the centre and sometimes holding an object. Usually the figure is painted against a plain background of a dark colour, which serves to emphasize their features and other elements.

This portrait is characterized by soft contours and a muted tonality in which Kunigunde's plain clothes contrast with her extravagant hair arrangement, whose style is seen in other German portraits of the late 15th century. Around her enormous plait of hair is placed a great head-piece of gold, pearls and precious stones with small figures which must have been a remarkable display of goldsmithery. The detailed execution of the headpiece reveals the artist's dedication and powers of observation, but artistically the rest of the painting is more interesting from the point of view of its technique. Worth noting is the smooth modelling of the shadows which create the rounded volumes of the face, neck and arms, and the delicacy with which the painter has depicted the sheen on the dress, which is of a soft, silky material.

Portrait of Kunigunde of Austria, c. 1485
Oil on panel,
45.5 x 32 cm
(Pedralbes)

The collection of German 15th- and 16th-century portraits in the Thyssen-Bornemisza Museum represents a gallery of human types and is an exceptional record of the appearance of members of society of the time, painted wearing their finest hair ornaments, clothes and jewels.

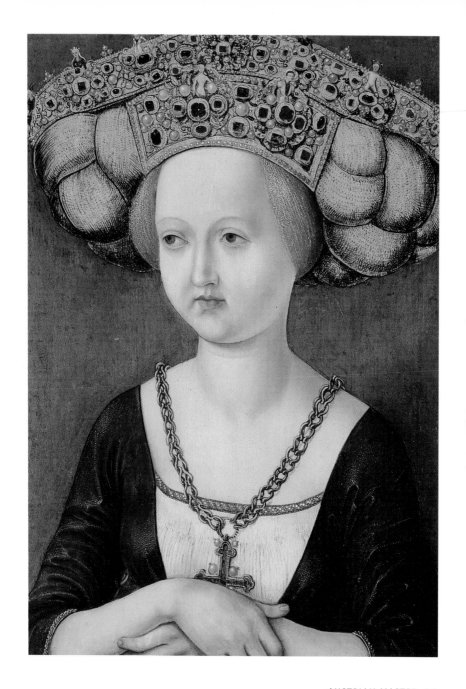

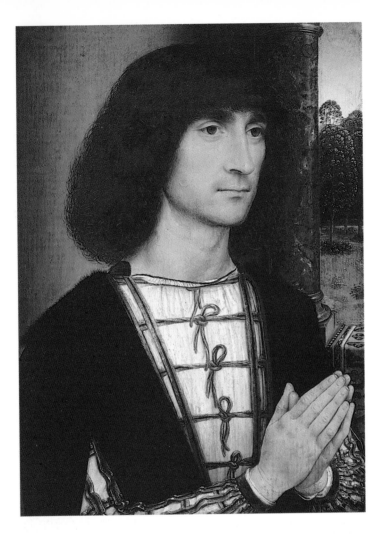

*Portrait of a young
Man praying*, c. 1485
Oil on panel,
29 x 22.5 cm

▸ *Marian flowerpiece*,
c. 1485
Oil on panel,
29.2 x 22.5 cm

Hans Memling

SELIGENSTADT, FRANKFURT, 1435–BRUGES, 1494

Hans Memling was the most important follower of Rogier van der Weyden. He lived and worked in Bruges from 1465 and achieved great fame in his own lifetime, due principally to his portraits, which equalled the quality of his master's. In other respects, Rogier's theatricality is tempered in Memling's work in favour of a greater decoratism, more interested in the visual appearance of the subject than in its meaning. It may be for this reason that his work comes closest to the classicizing idealism of the Italian painters of his age.

HEMLING

The present work represents a second phase in the evolution of the portrait in the Netherlands. While earlier portraits restricted themselves almost exclusively to the face, here most of the upper body is shown, including the arms, and the figure is situated in a realistic setting. A characteristic feature of Netherlandish painting is the window opening on the right, through which the viewer can see a landscape, which directs the gaze into the background and lends depth to the composition.

"This painting serves as an example of how to portray landscape elements and contemplative subjects in devotional painting."
FRIEDRICH WILHELM SCHLEGEL, 1805

On one side of this panel we see a young man praying, while on the reverse we find a vase of lillies and irises, symbolizing the Virgin and painted with great delicacy and simplicity. This allows us to speculate that the panel formed part of a diptych: a standard format for portraits, with the donor or patron on one side in an attitude of prayer, and the *Virgin and Child* on the other (hence the vase of flowers).

The portrait is harmoniously conceived, bathed in a gentle and uniform light. Memling has reproduced the various textures of the objects with great technical skill: the different materials, the rug, the marble of the column. The foreshortening of the praying hands is very well achieved and the face, modelled in gentle tones, has a meditative and contemplative expression, as if the sitter were in front of a vision of the Virgin.

Master of the Virgo inter Virgines

ACTIVE LAST QUARTER OF THE 15TH CENTURY

This artist is considered to be one of the founders of the Dutch school which, towards the end of the 15th century, began to develop a separate character to that of the Flemish school due to different political and cultural circumstances – circumstances which would accelerate the distinction and split between the north and the south, which was under Spanish rule.

The artist's highly individual style has moved away from the formal characteristics of artists such as van Eyck and van der Weyden. The forms have become rounder, the drapery falls in gentler and softer folds. The representation of the human body suggests a familiarity with Italian art, which had become widely disseminated in the Low Countries at the end of the 15th century. This Italian influence does not extend to the general arrangement of the composition, however, which consists of various independent groups placed around the scene without any illusion of a real spatial setting or use of the laws of perspective.

The panel is notable for its multicoloured and busy composition, accentuated by the use of bright and highly saturated colours characteristic of this artist. The scene is full of figures in counterbalanced poses and movements, which gives it an impression of action and also a certain confusing quality. The artist has depicted a night scene, following the Gospel accounts, outlining the precisely and sharply drawn figures against a dark landscape, which contrasts with their brightly coloured clothing in shades of reds and golds. These chromatic contrasts and the general emphasis on line in the realisation of the forms create an impression of colourful inlaid marquetry. The canvas seems to be filled with circulating, at times violent movement, as seen in the foot of the thief on the right hand cross, depicted in sharp foreshortening, and in the soldiers in the foreground with the prominently-placed horses. The artist's feeling for narrative led him to place in the background a small scene of Christ bearing the cross on his way to Calvary, while in the middle ground he has represented the Virgin Mary comforted by St John and the Holy Women.

The Crucifixion, 1487
Oil on panel,
78 x 58.5 cm

Domenico Ghirlandaio

FLORENCE, 1449–1494

"If you, oh Art, had been able to paint the character and virtue of the sitter, there would not be a more beautiful painting in the world." Translation of the inscription appearing within the portrait of Giovanna Tornabuoni

Domenico Ghirlandaio was a famous artist in his own day, although this fame diminished after his lifetime. He worked mainly in Florence, where he ran a large studio with Michelangelo as one of his apprentices. He also worked on the decoration of the Sistine Chapel. In his large frescoes he used his primarily religious subjects as a pretext to portray the donor, his family or friends, often life-size, and thus became the leading portrait painter of the Florentine aristocracy. Particularly relevant to the present painting is Ghirlandaio's fresco cycle for the choir of Santa Maria Novella, commissioned by the Tornabuoni family and featuring many portraits of family members. The fresco depicting the Virgin Mary visiting her cousin, St Elizabeth, includes a portrait of Giovanna Tornabuoni, who is depicted full-length but in a very similar pose and wearing similar clothes to the Thyssen-Bornemisza painting. The fresco figure is also painted in full profile with a serene, almost expressionless beauty, probably dictated by the seriousness of the scene and the place for which it was intended. The fresco was executed after the panel.

The sitter is Giovanna degli Albizzi, who married Lorenzo Tornabuoni in 1486 and died in 1490, two years after this portrait was painted. Ghirlandaio's restrained and elegant style is fully evident here, in a work which uses an idealized realism of a type which was probably preferred by the artist's clients. The face is painted with delicacy and sweetness, as are the clothes and other elements. However, Ghirlandaio also knew how to combine his brilliant attention to detail and the overall decorative effect with the austerity of the plain niche setting, which allowed him to emphasize certain elements which probably have symbolic significance: the book may refer to the piety of the sitter, as may the beads which are probably a rosary. The brooch in the niche is related to the one which Giovanna wears hanging from a cord. The rich and luxurious clothes indicate her aristocratic status and, rather than distracting our attention, frame and highlight her beauty and expressionless face. A label painted on the background completes the meaning of the painting: it reproduces an epigram by Martial and the date of the painting.

Portrait of Giovanna Tornabuoni, 1488
Oil on panel,
77 x 49 cm

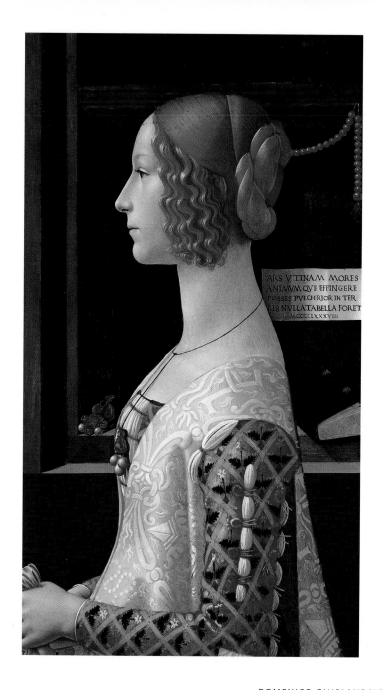

The image on the painting's plaque reads:

ARS VTINAM MORES
ANIMVM QVE EFFINGERE
POSSES PVLCHRIOR IN TER
RIS NVLLA TABELLA FORET
MCCCCLXXXVIII

Bramantino (Bartolomeo Suardi)

MILAN, 1465–1530

This impressive figure of Christ, expressing a contained and dramatic intensity, has a compelling effect on the viewer. Bramantino has skilfully combined light with dark, and minute detail with a broad overall conception of his theme. His *Risen Christ* has all the power required for this subject without having to resort to the depiction of violence or blood. The figure's total pallor, accentuated by the shroud, seems to give out a light which has no obvious source, but comes from within. Most impressive, however, is the face, its gaze half distant and half focused on the spectator, and the expression of suffering and compassion. In the background on the left a nocturnal landscape lit by moonlight counterbalances the emotional tension of the foreground. Emerging from the darkness on the right are some sketchy architectural forms of a classical nature.

Bramantino, who was probably a pupil or follower of Bramante, shows in his work the influence of Mantegna and also the Ferrarese school, characterized (as we saw earlier in the work of Cosmè Tura and Francesco del Cossa) by a hard and angular line, which in some ways comes closer to Flemish realism than to the idealized beauty of Italian art. This is certainly evident in this depiction of Christ. Stylistic influences aside, Bramantino has achieved a highly refined manner of painting through his use of the oil technique, with subtle plays of light and shade achieved through glazes which allow him to define the anatomy of the body, the tonal gradations of the skin and the liquidity of Christ's reddened eyes.

The Risen Christ,
c. 1490
Oil on panel,
109 x 73 cm

Francesco di Giorgio Martini

SIENA, 1439 – C. 1502

Francesco di Giorgio Martini was a multifaceted artist who embodied
the spirit of Renaissance Humanism: an architect, sculpture, miniaturist
and painter. He preferred to work as an architect and a designer of forti-
fications, as in his work at Urbino, and he collaborated on the building
of Siena cathedral. He also wrote a treatise on civil and military archi-
tecture.

His painted œuvre is sporadic, and employs a soft and delicate
style which may recall Botticelli, although some experts have seen the
influence of Verrocchio in the lightness, grace and elegance of the
poses, together with the high degree of finish. Notable in this painting
are the modelling of the hands and faces, and the lyrical poses of the
Virgin and Child and the background figures. The painting falls into the
style of the late 15th century, in which the aesthetic of the preceding
years starts to acquire a degree of mannerization, here evident in the
tendency to exaggeration in the delicate and stylized forms.

The Virgin is seated in the foreground, gently supporting the Child
on her lap. Behind Him are placed four figures in front of a flat and un-
defined background of a striking red, which is decorated with a printed
black design of curving tendrils. One of the figures, probably a female
saint, holds a lily, a symbol of purity. The artist's technical skill is evi-
dent in the transparency of the haloes, which are subtly painted as if
they were fine lace. In the same way, the Virgin's clothes, with their fine
folds following classical tradition, are painted with great precision and
detail.

The Virgin and Child
with St Catherine
and Angels, c. 1490
Mixed technique
on panel, 62 x 42 cm
(Pedralbes)

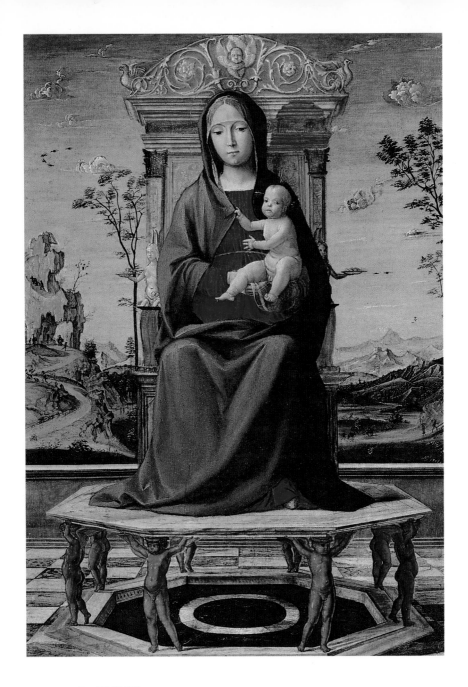

Lorenzo Costa

FERRARA, C. 1460 – MANTUA, 1535

Lorenzo Costa was the third great artist to emerge from the Ferrarese school in the second half of the 15th century (he was younger than Cosmè Tura and Francesco del Cossa). He began his career in Ferrara but later moved to Mantua, where he painted at the court of Isabella d'Este.

The two works by this artist in the Thyssen-Bornemisza Collection are in different styles, probably due to their different techniques and the supports on which they are painted. *The Bentivoglio Family* is a canvas dated 1493 which depicts a group of people singing around a musical score. The group includes professional musicians as well as the family and also the artist himself in the lower left corner. The painting is one of the first known group portraits of the Renaissance. Although the forms are hard and sharp and the movements of the figures rather conventionalized, the artist succeeds in making the figures individuals. The upper part of the painting bears the signature and date and also an inscription naming all the figures portrayed.

The style of the *Virgin and Child Enthroned* is very different, and results in a much more finished and harmonious painting. It includes many typical elements of 15th-century painting, such as the use of linear perspective to create the spatial setting, reinforced by the architectural elements; the classical style referring to antiquity; the calm monumentality of the Virgin; and the luminosity of the bright, clear and glowing colours.

The background, separated by a smooth parapet, takes the form of a broad landscape which recalls the work of Filippo Lippi and which looks forward to the interest in landscape shown by artists in the following century, beginning with Venetians such as Giovanni Bellini.

LAVRENTIVS
COSTA

◄ *The Virgin and Child Enthroned*, c. 1495
Oil on panel, 49.5 x 36.5 cm

The Bentivoglio Family, 1493
Oil on panel, 105 x 82 cm
(Pedralbes)

Gerard David

OUDEWATER, C. 1460—BRUGES, 1523

Gerard David is the last of the great Bruges masters. In the 16th century Bruges lost its position as the economic centre of the Netherlands, and was superseded by Antwerp. Bridging the two centuries, David painted religious subjects which combined the style of the great Netherlandish masters with a delicacy and sensibility derived from Italian artistic trends. His style nevertheless remains rather old-fashioned for its time.

The *Crucifixion* in the Thyssen-Bornemisza Museum is probably an early work and reveals the influence of van der Weyden, van Eyck and Campin. The compositional formula is typical of *Crucifixion* paintings of the time, with a group of figures on each side of the cross and an ample landscape in the background. On the left is the Virgin with St John and the three Marys, while on the right is a group of soldiers. The Crucified Christ stands out high up in the centre, isolated from the other elements in a frozen and rigid pose. The two groups flanking the cross are treated differently: Mary's group is painted sombrely; the figures are suffering, but their expressions are restrained, just as the group as a whole is self-contained – quite unlike the colourful, animated group of soldiers on the right, disordered and somewhat motley in their varied and rather ostentatious clothes. In this way David has aimed to present the two different worlds of Christians and pagans. In the foreground the scene is completed by the two dogs playing with a skull. According to tradition, the skull belonged to Adam, who was buried on Calvary Hill.

The background landscape is one of the elements which characterizes David's work. Many critics consider it to be his most important legacy to art, as his attitude to nature would contribute to the later formulation of the separate genre of landscape painting. Although landscape in David's painting is not yet as important as it is in that of Patinir, it marks a new departure. David pays great attention to the landscape in his compositions, and apportions it a meaningful role. The present work includes an extensive mountain landscape with a walled city, whose temples suggest that it may be Jerusalem.

The Crucifixion, un-dated (last decades of the 15th century) Oil on panel, 88 x 56 cm

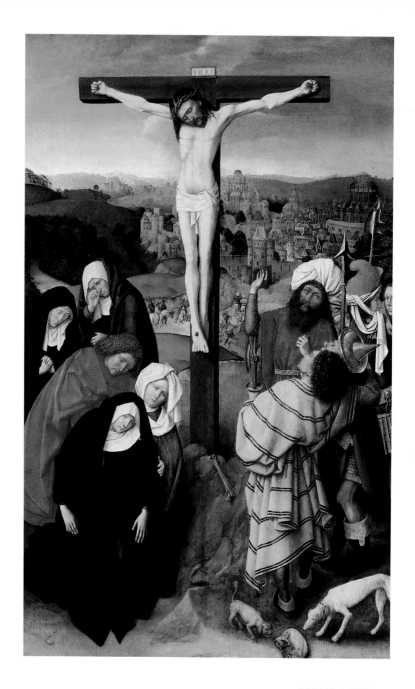

*Portrait of a young
Man*, after 1490
Oil on panel,
30.5 x 28 cm

Andrea Solario

MILAN, 1465–1520

Solario belongs to the generation bridging the 15th and 16th centuries and was highly regarded in his own day for his portraiture, whose merits can be appreciated in the Thyssen-Bornemisza painting. Falling stylistically into the Quattrocento tradition, the present portrait is not only executed with a high degree of technical expertise, but also succeeds in capturing the personality of the sitter and his thoughtful and reflective nature.

ANDREAS·D·
·SOLARIO·

The spread of the use of oils resulted in technical improvements in the quality of materials and in the representation of the fall of light on objects and flesh. The austerity of the portrait, similar to the work by Antonello da Messina discussed above, is emphasized by the dark, almost black colour which surrounds the face, on which all the light falls. The surrounding black is only broken by the line of white of the collar and the lighter line which marks the opening of the sitter's outer garment. The long, carefully groomed hair conforms with late 15th-century fashion, which had moved away from the richness and luxuriousness of clothing of the earlier part of the century towards a much plainer style, possibly in line with the spiritual mood of the times.

Stylistically, the painting relates to the Quattrocento in its presentation of the sitter in half profile and half-length format. In the opening years of the next century, portraits would increasingly show more of the sitter, who would in addition be accompanied by more incidental details. This work, however, remains characteristic of the style of the late 15th century.

Juan de Flandes

DOCUMENTED IN SPAIN FROM 1496 – PALENCIA, C. 1519

Trained in Ghent and Bruges, Juan de Flandes came to Spain to work in the service of Queen Isabella of Castile. His Flemish mode of painting gradually become less linear under the influence of Italian art, eventually taking on a style which used soft lyrical forms in a manner very similar to that of Gerard David. His gifts as a portrait painter make him one the greatest of his generation.

While he also produced important altarpieces, his role as court painter was to portray the queen and, without doubt, other members of the royal family. This portrait may depict Catherine of Aragon, Infanta of Spain and daughter of the Catholic kings. Catherine married Henry VIII of England, who subsequently divorced her and thereby precipitated the religious schism between England and the Papacy. The Thyssen-Bornemisza Collection also has a portrait of Henry VIII by Holbein which is hung close to this panel.

The portrait is exceptionally well executed, resulting in a harmonious work of great beauty. The attention to detail characteristic of Flemish art, here evident in the painting of the hair and the decoration of the dress, in no way detracts from the unity of the composition, which seems to be painted under a veil which blends and softens the outlines.

The skilful colour combinations heighten the golden tone of the Infanta's skin, while the light falls on her from the front left, lighting up her white dress and her red hair which is tied up with various bands. Her shadow falls on the wall behind, which also shows another shadow in the upper part and on the right, as if the light was falling on the Infanta from a small window very close to her.

Portrait of an Infanta,
c. 1496
Oil on panel,
31.5 x 22 cm

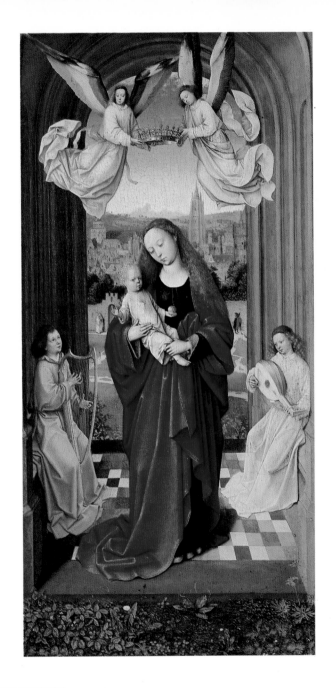

The Master of the André Madonna

ACTIVE IN BRUGES AT THE END OF THE 15TH CENTURY

At the end of the 15th century Netherlandish painting began to be in-
fluenced by the art of the Italian Renaissance. Nonetheless, the purely
Netherlandish tradition passed down from Jan van Eyck, Rogier van der
Weyden and Petrus Christus was still practised by some painters, in-
cluding this anonymous master, named after his panel of the Virgin
now in the Musée Jacquemart-André in Paris.

While the style is old-fashioned for the period, this is still a strik-
ingly beautiful and superbly executed painting. Clearly influenced by
van Eyck, the artist retains the Netherlandish interest in even the most
minute detail, and in a certain stylization of the figures. Van Eyck's influ-
ence is also evident in the sculptural quality of the figures, which are
clearly outlined against the background. It is also seen in the way the
draperies fall onto the ground in sharp folds, and in the decorative
wings and elaborate robes of the angels in the archway holding the
crown. Also Eyckian is the broad landscape in the background, which in-
cludes a late-medieval walled city. A bright and rather cold light bathes
the scene and gives the figures a distant elegance most characteristic of
this artist.

PAGES 124/125:
Detail of illustration
pages 220/221

PAGES 126/127:
Detail of illustration
page 234

*The Virgin and Child
with Angels*, c. 1500
Oil on panel,
62 x 31 cm

The 16th Century

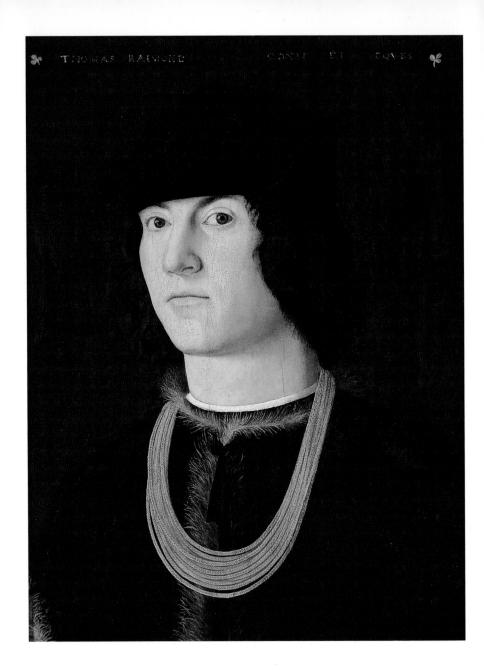

Amico Aspertini

BOLOGNA, 1474–1552

Amico Aspertini was a Bolognese artist whose work spans the late 15th and early 16th centuries. In his own time he was famed as a portraitist. This example demonstrates the continuing use of 15th-century formulae as well as new developments in the genre. The profile view typical of Early Renaissance portraits – as employed in Ghirlandaio's portrait of Giovanna Tornabuoni, for example – has here given way to an almost frontal pose. The body is still shown less than half-length and the artist retains the use of a dark and neutral background.

The advances being made in the representation of the human image combined the imitation of nature with the development of a canon of ideal proportions, used in the search for a definition of ideal beauty. The influence of Leonardo, who established his compositional laws on the basis of harmony and beauty, was all-important in this respect, as were the new ways of understanding nature and the first experiments with chiaroscuro made at the end of the 15th century. Leonardo's influence and his revolutionary way of painting can be appreciated in the work of almost all the artists of his own generation and later, albeit blended with local trends.

Some of these features are evident in this portrait of Tommaso Raimondi, a jurist and poet from Cremona. The panel demonstrates the artist's mastery of the technique of painting in oils, which were much more flexible than tempera and allowed for far more precise tonal gradation. The play of light and shadow on the face models it and gives it volume, while light also creates the different textures of the clothes, skin and hair, etc. Tommaso's expression, looking directly at the viewer, represents another advance with respect to earlier portraits. By looking straight out, a dialogue is set up with the viewer and the character portrayed thus gains in verisimilitude and expressiveness. The artist is also clearly interested in portraying his sitter as an individual, albeit by accentuating only his more flattering features.

"A capricious man with a strange personality ..."
VASARI on
ASPERTINI, 1550

Portrait of Tommaso Raimondi, c. 1500
Oil on panel,
41.5 x 32.5 cm

Giovanni Antonio Boltraffio

MILAN, 1467–1516

G B.

Boltraffio was a pupil and collaborator of Leonardo in Milan and Leonardo's influence is clearly evident in this portrait of an unknown lady. The proportions of the face and the ideal of beauty which it reflects are very close to Leonardesque prototypes: the oval face, large nose, small mouth and large melancholy eyes. This influence is evident not just in the formal elements and the use of chiaroscuro, but also in the psychological penetration of the sitter's character, who seems to be stifling a smile (as do Leonardo's sitters). However, some features differentiate it from the older artist's work, such as the use of a harsher *sfumato*, which gives the bust a more sculptural character.

The sitter clearly wished to be depicted as St Lucy, holding up the saint's attribute: a pin with an eye on the end. Portraits of this type, known as "portraits in the holy manner", remained customary until the Baroque (Zurbarán, for example, painted them), and were commissioned by young aristocratic women who wished to invoke their patron saints in order to follow their virtuous example. The sitter's piety is underlined here by the cross around her neck.

This bust-length portrait, which retains a late 15th-century format, has a classical beauty, the forms elegant and finely proportioned and emphasized by the simplicity of the dress and the ornaments, as if to highlight the beauty of this young Renaissance woman who had no need of brocades or head-dresses which would merely hide her natural charm. The hair gathered at the nape of the neck falls gently on either side of the face, adorned with a fine band and a transparent veil which is only just perceptible from the line of its white edge. Thus the neck and bust are left bare, perfectly modelled and with the skin firm and pale.

Portrait of a Lady as
St Lucy, c. 1500
Oil on panel,
51.5 x 36.5 cm

Fra Bartolomeo

FLORENCE, 1472–1517

BART FLORN
ORDPDICATOR

Baccio della Porta assumed the name of Fra Bartolomeo when, in 1500, he entered the convent of San Marco in Florence, where until very recently Savonarola had been Prior. Painting at the beginning of the 16th century, his work shows the influence of Leonardo and also takes up some of the features of Perugino's painting, which he may have known through his friendship with Raphael. Savonarola's teaching, which called for a stricter adherence to Catholic doctrine in the face of liberalizing humanistic trends, made its mark on Fra Bartolomeo, who, like Botticelli, burned all his non-religious paintings. His religious works followed Savonarola's dictates and disseminated the new religious iconography: for example, he was one of the first artists to substitute timeless robes for the fashions of his own day, in order to distinguish between his celestial and earthly figures.

The Holy Family with St John the Baptist clearly shows the influence of Umbrian artists, particularly Perugino, in the broad landscape, painted with attention to detail and in pale colours, which extends into the background of the painting. The slender trees with small spreading leaves are typical of the artist. Fra Bartolomeo had a complete mastery of the rules of perspective and geometry, which he applied with rigour to his balanced compositions, as we can see in the present work which has its vanishing-point in the centre of the painting. The buildings on the right, which recede into the background creating a diagonal, are balanced by the mountains on the other side. The composition is formed from an elliptical cone whose peak is situated in the lake, and springs from an ellipse which occupies the whole of the canvas and is the base for the composition of the two figures in the foreground. Here the monumental figure of Joseph is balanced by those of the Virgin and St John the Baptist, framing the Infant Christ in the centre. Crowning the scene and closing the ellipse are three brightly coloured angels. The delicate and stylized manner of representing the figures shows the influence of Umbrian art and early Raphael, while the treatment of the light and shade may suggest Leonardo.

The Holy Family with St John the Baptist,
c. 1506/07
Oil on panel,
62 x 47 cm

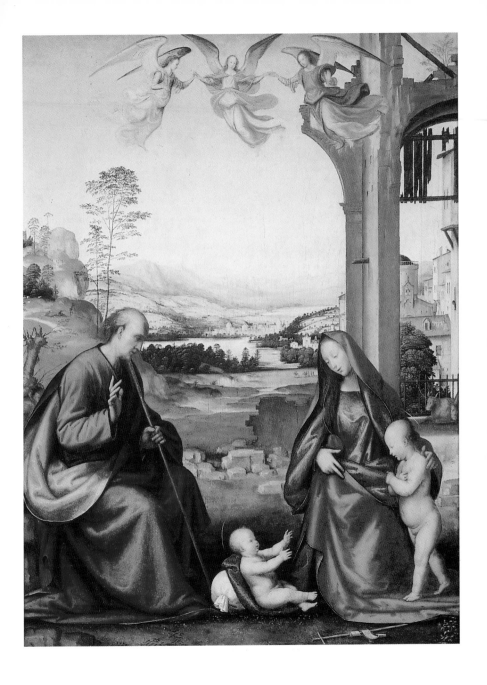

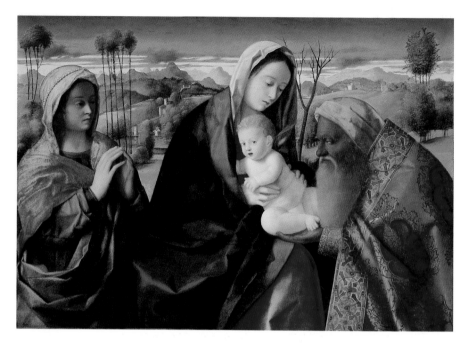

Sacra Conversazione,
c. 1505–1510
Oil on panel,
62 x 82.5 cm

Giovanni Bellini

VENICE, 1430–1516

Like Leonardo, Giovanni Bellini produced most of his œuvre in the
15th century, but he also lived into the first part of the next century.
Both artists were agents of stylistic change and paved the way, through
their innovations, for the arrival of the Cinquecento. Giovanni Bellini
belonged to a family of artists (he was the son of Jacopo and brother
of Gentile, an artist also represented in the Thyssen-Bornemisza Collec-
tion). He was the founder of the Venetian school of painting, which had
its own distinctive character and which was to produce remarkable re-
sults well into the 18th century. Artists such as Giorgione, Titian and
Sebastiano del Piombo trained in Bellini's studio.

The present painting exhibits the defining characteristics of Venet-
ian painting, particularly with regard to the handling of colour. Bellini
shows his genius as a colourist in his bold combinations of different
tones. The carefully thought-out composition is structured by the differ-
ent planes of landscape, against which the figures are outlined. Notable
is the gentle chiaroscuro with which the artist creates the faces and the
lively arrangement of the whole, accented, or rather completed by the
way the Infant Christ turns His head to look directly out at the viewer
as if part of the same reality.

The scene portrays the Virgin and Child and two figures who are
difficult to identify: a woman praying and a figure who could be St Si-
meon. The painting may be a *Sacra Conversazione* ("holy conversation"),
a subject developed at the end of the 15th century, but the figures, rather
than conversing, seem to be united in a mystic communion. Their atti-
tudes and expressions convey great peace and a meditative mood which
bathes the whole painting: the landscape in the background is harmo-
niously formed from subtly graduating tones. There are no sharp con-
trasts and the light and shade is gently blended, creating a chromatic
melody achieved through the rendering of the diffusely filtered atmo-
sphere. With it the scene gains in depth and spirituality.

IOANNES
BELLINVS.

*"Although he (Gio-
vanni) is old, he is
still the best painter."*
ALBRECHT DÜRER,
during his second
trip to Venice in
1506

Albrecht Dürer

NUREMBERG, 1471–1528

The first 30 years of the 16th century in Germany were a time of artistic splendour often referred to as "the Dürer era", and were years in which this artist played a key role, together with Holbein, Cranach and Altdorfer. Dürer is the prototype of the Renaissance artist, even more so than the Italians themselves. He actively promoted the new role of art as one of the liberal arts, and occupied a position comparable with its new status as a humanist, intellectual and gentleman. As well as being a painter, Dürer was a scholar and theoretician of the science of painting. The large number of prints which he produced were vital in the dissemination of the principles of Renaissance art. In addition, Dürer conferred on drawing the status of a finished work of art. He became familiar with Italian art at an early stage and was fully able to assimilate its lessons and create his own style as a consequence.

Christ among the Doctors, dated to his second Italian stay (1505–1507), is a masterpiece of Western art created from a new pictorial language. On the basis of Dürer's complete technical mastery, it fuses the ideals of perfection, beauty and harmony with the German interest in representing the appearance of the visible world. In the painting we can appreciate the underlying structure which is firmly and decisively drawn. Over it, the handling of the paint is brilliant and extremely varied; in some places it is thinly applied and opaque, in others it is fluid and loose, depending on the texture and definition which the artist wishes to give the different parts of the painting.

Dürer was a master of portraiture and the representation of the human figure. Here we can appreciate not just the quality of the outward appearances of the figures, but also the depth of the psychological analysis and the strong individual characterization. The image of the young Christ, with His delicate face and hands, is juxtaposed against the features and facial expressions of the doctors, some of them depicted with caricature-like exaggeration. The centre of the composition is filled with a marvellous study of hands, which recall the drawings of Leonardo da Vinci, whom Dürer met in Italy.

"... my panel is completed, as is another painting which is quite unlike any other I have done until now ..."
DÜRER in a letter to Pirckheimer, 23 September 1506

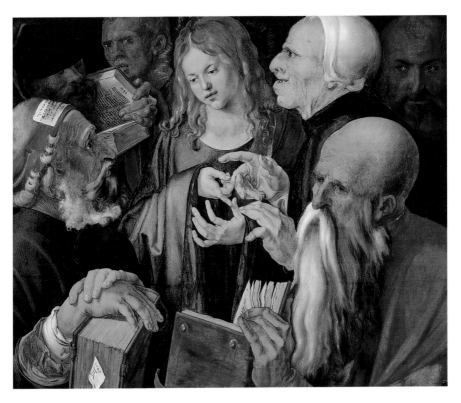

*Christ among
the Doctors*, 1506
Oil on panel,
64.3 x 80.3 cm

Jan Provost

MONS, C. 1465 – BRUGES, 1562

Jan Provost belongs to the first generation of 16th-century Netherlandish artists, but his style nevertheless remains firmly indebted to the Flemish tradition of the 15th century. While the 1500s saw the spread of Italian classicism and the Mannerist style throughout Europe, the strength of the Flemish legacy meant that it survived and developed along a different path to classicism and that the two trends co-existed.

Jan Provost was connected with the city of Bruges, where he received numerous commissions. This *Portrait of a Female Donor* very possibly formed part of a triptych, comprising a central panel devoted to a religious subject and two wings bearing the portraits of the donors, who were probably husband and wife. This would explain why the woman is shown in prayer and slightly in profile. The male portrait would have been symmetrically reversed, with both spouses looking towards the religious scene painted in between them.

The painting relates to 15th-century Flemish art both stylistically and thematically. The woman, painted half-length, is of a type of beauty very much in the line of artists such as Memling, with an oval face, clear forehead and delicate features. The whole panel is drawn with precision and an interest in detail. The garden in the background, the ornamental elements and the details of the clothing are all meticulously executed. The light falls from the left, directly illuminating the face, and is spread in a uniform way across the whole scene. Overall, the painting is calm and serene, partly as a result of the very subtle tonal gradations in which a few warm colours predominate over the browns and earth tones, without any strong contrasts.

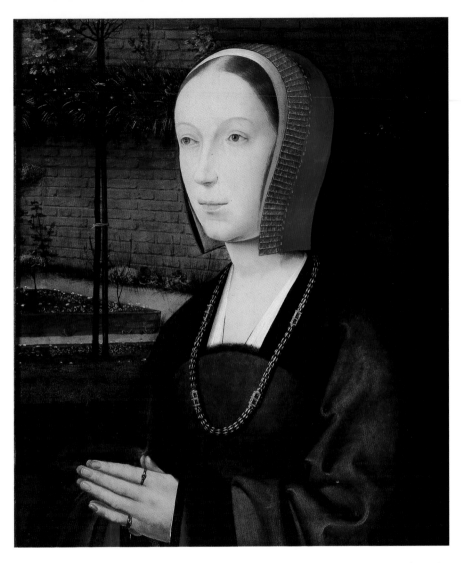

*Portrait of a Female
Donor,* c. 1505
Oil on panel,
53.5 x 46 cm

Abraham and Hagar,
undated
Oil on panel,
94 x 131 cm

Jan Mostaert

HAARLEM, C. 1472 – 1555

Mostaert, together with Provost, is one of the two artists represented in the collection whose work testifies to the survival of the Netherlandish tradition into the 16th century, in the face of the increasing influence of the Italian Renaissance. The work reproduced here is most notable for the extensive landscape in which the scene unfolds, and for the everyday character of the events portrayed.

The panel describes the moment when Abraham bids farewell to Hagar, the handmaid of his wife Sarah and mother of his son Ishmael. The narrative sense and the naturalism inherent in Flemish art have led the artist to portray, in a wealth of detail, various elements of the story at the same time – from the incident when Ishmael attacks his half-brother (Sarah's son), leading him to be cast out, to Hagar and Ishmael on their journey, during which an angel appears to show them the right way. The narrative gives the artist the chance to paint an extensive landscape which forms the backdrop to the entire story. On the left is the house, represented as a contemporary farmhouse. In the centre, the rocks which form the setting for the main scene are dotted with farm animals. On the right are fields with, behind them, a mountain range which loses itself in the distance. The artist uses colour to unify the composition through a range of earth and greyish tones, while a pale unifying light falls on the whole scene.

The importance which Mostaert gives to the landscape links him to Patinir, while the everyday characterization of the figures (particularly Hagar), and their integration into their environment, point towards the path upon which Brueghel would soon embark and which was to be one of the distinguishing features of Dutch painting.

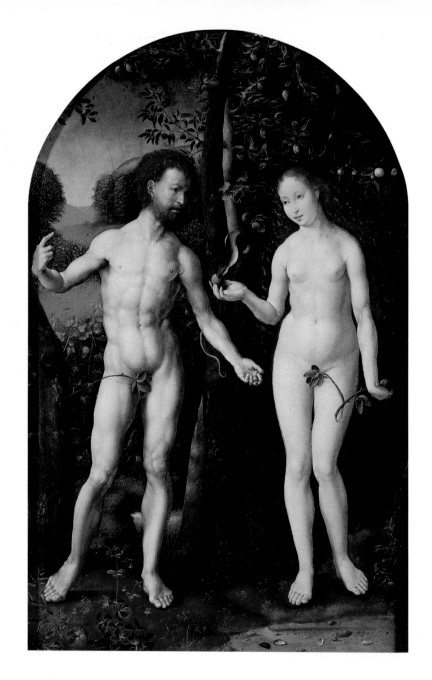

Jan Gossaert

MAUBEUGE, C. 1478 – MIDDELBOURG, 1533 OR 1536

Jan Gossaert, called Mabuse after his place of birth, belongs to a group of Flemish artists (along with Jan van Scorel, Joos van Cleve and Maerten van Heemskerck) who came to be called the Romanists, due to their assimilation of the aesthetic of the Italian Renaissance. Gossaert, the oldest of the group, was a key figure in the introduction of classicism into the Netherlands. As part of the entourage of Philip of Burgundy, he travelled to Rome and made studies of its ruins and buildings, executing a series of drawings which were reflections on classical forms.

His style, which blends Italian form with Flemish characteristics, also shows the influence of Dürer, whose engravings carried the classical canons of art across all of northern Europe. In fact, this *Adam and Eve* is inspired by an engraving by Dürer dated 1504, even though Gossaert simplifies the composition, omitting the wealth of anecdotal details to be found in the print.

The composition is well balanced, organized around the central axis of the tree with the two figures on either side. Gossaert uses the subject to paint one of the first nude studies in Netherlandish art. The classical inspiration is evident in the choice of the subject, the pose of the figures and the anatomical detail. The physical type nevertheless differs from the canons of classical beauty, above all in the facial features which are closer to northern types. In this regard it is Adam's face which is perhaps closest to the realism characteristic of northern art: it serves to give the figure an expressive force more pronounced than that seen in Eve, who is more idealized.

There is also a notable difference between the soft female anatomy and the more defined masculine one. Even the effects of lighting on the two figures are different: in Adam the light creates strong contrasts with highlights and coloured shadows, while in Eve a filtered light bathes her skin uniformly, softening the outlines. Nonetheless, the draughtsmanship is evident in both figures, defining the forms which are cleanly outlined against the background.

"He was the first to introduce here from Italy the taste for including nudes in paintings of historical or poetical subjects."
LODOVICO GUICCIARDINI
in his *Descrittione di tutti i Paesi Bassi*, 1567

Adam and Eve,
c. 1505–1507
Oil on panel,
56.5 x 37 cm

Follower of Michael Pacher

Michael Pacher was active in the second half of the 15th century in the Austrian Tyrol. He travelled to Italy a number of times and his style is influenced by Italian art. The present work is very close to Pacher's style, to the extent that it was until recently attributed to him. Following an analysis of the picture in 1991, however, it was re-attributed to a follower, probably a member of Pacher's workshop, which employed a large number of artists to assist on the many commissions which Pacher received.

The painting depicts a *Sacra Conversazione* ("holy conversation"), a subject which first appeared in Quattrocento Italy and which is a depiction of the Virgin and Child with saints, arranged in a manner that suggests a conversation or some other relationship between the figures. The elongated panel encloses, within an elliptical composition, the Virgin and Child and, seated on the base of the Virgin's throne, St Margaret (on the left) and St Catherine (on the right). The two saints are identified by the symbols of their martyrdom – the dragon and the wheel respectively. St Catherine receives the wedding ring from Christ, representing her Mystic Marriage with the Infant Christ, while St Margaret holds a cross which symbolizes glorification of God and the consecration of her life to the Christian faith. Completing the scene, the Virgin is being crowned by two angels, painted with a three-dimensionality which clearly recalls Italian art.

The artist has enjoyed portraying all the individual elements, making much of the rich clothes and head-dresses, the gold-embroidered, brocaded textiles and the background in the form of a tapestry with a foliate pattern. However, along with this taste for detail there is also an interest in giving the scene an overall unity, organized around the two main figures and with the aim of creating a lifelike impression. This is achieved largely through the handling of the light: it is markedly directional, falling from the right onto the figures and creating strong contrasts of light and shade. Thus, while St Margaret's face and hands are fully illuminated, St Catherine is half in shadow.

The Virgin and Child with SS Margaret and Catherine, c. 1500
Oil on panel,
166 x 76.5 cm

The Virgin and Child with a Bunch of Grapes, 1509/10
Oil on panel,
71.5 x 44.2 cm

Lucas Cranach the Elder

KRONACH, 1472 – WEIMAR, 1553

Cranach, one of the leading German painters of the 16th century, developed a style whose plainness and spirituality owed much to the doctrines of Martin Luther. From 1505 he was painter to the court of the Duke of Saxony in Wittenberg. There he met Luther, who became a friend and for whom Cranach provided illustrations in support of religious reformation. He is considered the creator of a new Protestant iconography and of a canon of physical beauty totally different to the Italian classical ideal. In addition his work is seen to embody the religious mood of the times.

The Virgin and Child with a Bunch of Grapes is painted in a pre-Protestant style. The Virgin is holding a bunch of grapes which the Infant Christ is eating. Behind the figures lies an extensive mountainous landscape and above it a brilliant blue sky. The mountains in the background take on a blue hue, a device used to represent the effects of atmosphere on a distant landscape. The cold and monochromatic tones of the landscape serve to emphasize the strong colours of the main figures. The Virgin, dressed in traditional red and blue, has her hair covered by a delicate veil which amply demonstrates Cranach's skill in the handling of oils. Her sad and thoughtful expression, together with the presence of the bunch of grapes, are a forewarning of Christ's Passion: the Virgin already knows what her son's destiny will be. The forms in the painting are defined in a rather hard manner, while the pronounced accents of light and shade create a strong chiaroscuro.

Portrait of Charles V,
1533
Oil on panel,
51.2 x 36 cm

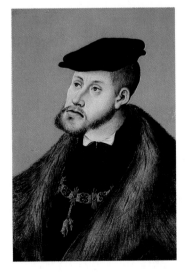

Another group of religious works are the two panels, painted on both sides, depicting a total of four saints. These are very probably the wings of a triptych whose central panel is now lost. It was commissioned by the Duke of Saxony, who is portrayed with his wife in the lower half of the panels. One of the inside pan-

Reclining Nymph,
1530–1534
Oil on panel,
75 x 120 cm

*"[I] am the nymph
of the sacred foun-
tain. Do not interrupt
my sleep [as] I am
resting."*
Translation of
the inscription
appearing within
Reclining Nymph

▶ *SS Elizabeth
and Anne,* c. 1514
Oil on panel,
left wing, 85 x 31 cm,
right wing,
85 x 30.6 cm
(Pedralbes)

els depicts St Elizabeth, Mary's cousin and the mother of St John the
Baptist. Below her and shown praying in much less than life-size pro-
portions, is the Duke. The other panel depicts St Anne, the Virgin's
mother, with the Duchess. The saints are identified by their names writ-
ten in their haloes. The outer side of the wings depict St Christopher
with the Christ Child on his shoulders, and St George and the Dragon.

The four saints are painted with great individualization, but apart
from their attributes are provided with little in the way of setting. They
are painted against a plain background which silhouettes their whole
body, as characteristic of Cranach's style, in which figures are precisely
drawn and brightly coloured. While these images of saints are not
strictly speaking portraits, they can be seen within the conventions of
that genre as they are similar to Cranach's portraits which use the de-
vices mentioned above and which won him great renown. Cranach was
one of the first artists to paint full-length portraits which, in composi-
tion and structure, are similar to these panels.

In addition to religious subjects and portraits, Cranach also paint-
ed mythological scenes which drew on the new Protestant thinking, re-
sulting in some very unusual interpretations of classical mythology, as

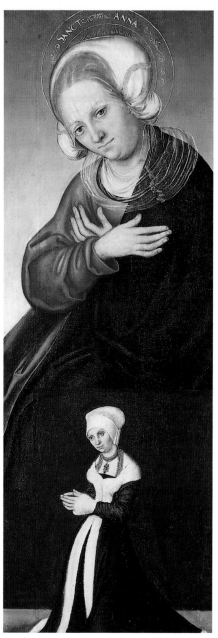

can be seen in the present work, *Reclining Nymph*. The subject is probably taken from the story of the nymph Castalia, who turned into a spring, although it could also be related to the *Fountain of Life*, the title of an allegorical painting by Cranach which refers to contemporary morality and to the new understanding of the concept of Redemption. In the present painting, as in other mythological works by the artist, Cranach has developed a canon of female beauty which is totally at odds with the classical ideal and is charged with a powerful eroticism. The slender reclining figure is outlined against a dark, grass-covered ground which highlights her pale skin. Behind her, arranged on a series of receding horizontal planes, is the fountain and in the background a wood with deer; in the foreground are some partridges and, hanging from a tree, a bow and a quiver of arrows, which make reference to hunting. In the upper part of the painting appears an inscription which (translated) reads: "[I] am the nymph of the sacred fountain. Do not interrupt my sleep [as] I am resting". The Castalian spring originated in one of the numerous caves on Mount Parnassus (the mountain of the Muses, Apollo and Dionysus near Delphi), and was the daughter of the River Aqueleous. Another version of the story recounts how, in order to avoid the attentions of Apollo, who was pursuing her, the nymph Castalia, a girl from Delphi, threw herself into a spring, which was therefore given her name.

Our last work by Cranach is an example of his portraiture. The sitter is Charles V who, far from being idealized, is shown in a way which exaggerates his pronounced lower jaw. He is depicted as Emperor, wearing around his neck a heavy gold chain with the Order of the Golden Fleece. The image is very austere and was probably completed with the aid of assistants. The most striking element is the face, whose features are finely drawn to the extent that they assume an element of satire. It should be remembered that Emperor Charles V defended religious unity led by the Papacy and fought against the Lutheran reformation.

SS Christopher and
George, c. 1514
Oil on panel,
left wing, 85 x 31 cm,
right wing,
85 x 30.6 cm
(Pedralbes)

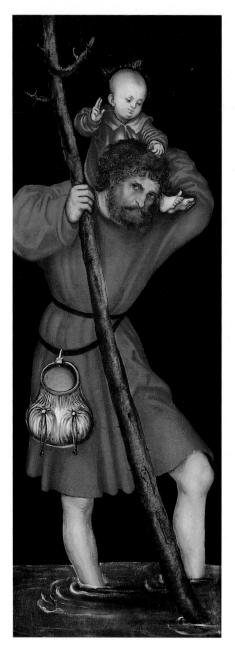
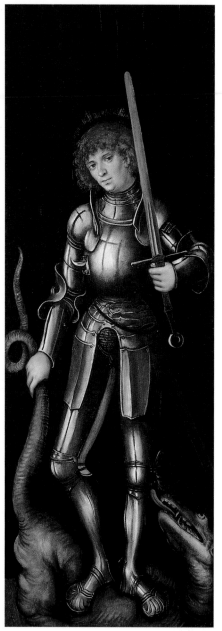

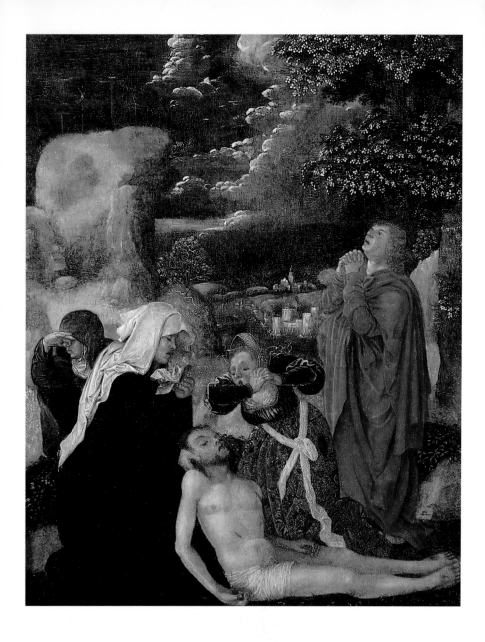

Ulrich Apt the Elder

AUGSBURG, C. 1460 – 1522

Ulrich Apt, son and father of painters, worked in Augsburg, which alongside Nuremberg was one of the leading centres of artistic production in 16th-century Germany. From Augsburg came important artistic families such as the Holbeins.

The present work shows the influence of Italian art on German painting. While this influence had been minimal in the 15th century, the 16th century saw the Italian style spread throughout the whole of northern Europe. Ulrich Apt's work shows a synthesis of the two models. On the one hand, the dramatic facial expessions are essentially German in style and recall the work of one of the great 16th-century German painters, Matthias Grünewald. On the other hand, an Italian feeling is evident in the proportions of the figures and in a looser and less detailed handling, which subordinates the individual elements to the overall composition. A rapid and nervous brushstroke prevails in a way which is out of character with previous German painting.

It is night in the present painting, emphasizing the tragic and dramatic nature of the scene, in which the dead Christ has just been taken down from the cross for burial. In the painting are St John, Mary Magdalene and the Virgin, while in the middle ground the artist has painted one of the holy women who assisted at the burial, seemingly holding her nose against the smell of the corpse. In the background is a landscape with Calvary Hill, on which the crosses can only just be made out. The sky is partly covered by stormy clouds and the leaves of the tree in the foreground reflect the silvery moonlight.

The Lamentation,
c. 1510
Oil on panel,
44.2 x 35.6 cm

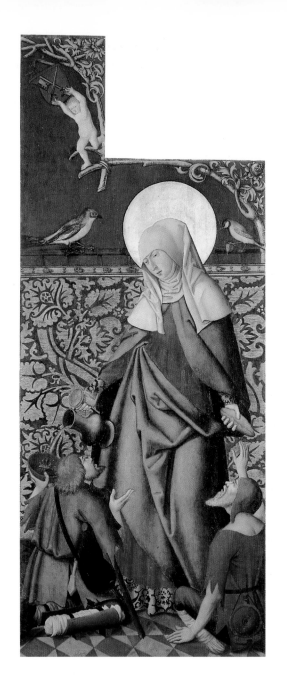

German Master

ACTIVE IN SWABIA AROUND 1515

This panel shows how the influence of Gothic art, which had persisted in German religious art throughout the 15th century, was still present in the painting of the new century. This continuing tradition is evident in the use of the gold ground and in the iconography and treatment of space.

The work forms part of a group of two panels which are painted on both sides and which would have formed the wings of a triptych whose central panel is now lost. *St Elizabeth giving Bread and Wine to the Beggars* thereby constitutes one of the outer wings, and would have been visible when the triptych was closed. On its interior is a portrayal of *The Adoration of the Christ Child*. The other wing features *The Presentation in the Temple* on the inside and – complementary in its composition to the *St Elizabeth* panel – *St Anne with the Virgin, the Infant Christ and a Donor* on the outside.

While the interior scenes are clearly narrative in character and unfold within architectural settings (although still retaining gold grounds), the outside scenes are more sculptural in style, depicting the groups of figures against a flat ground which is painted to look like a tapestry. Nonetheless, the delight in detail and the tendency towards naturalism mean that the artist has depicted the tapestry as if it were a curtain, hanging from a bar on which are perched some birds. Nor is the present panel untouched by the influence of Italian Renaissance art, which began to felt in German painting from the end of the 15th century; it appears here in the Italian-style *putti* (little Cupids or naked children in imitation of classical antiquity), who hold up a coat-of-arms in the upper part of the panel. Also notable is the floral motif which decorates the upper section, imitating an interlacing creeper of leaves and flowers.

St Elizabeth giving Bread and Wine to Beggars, c. 1515
Oil on panel,
159.5 x 65.5 cm
(Pedralbes)

Vittore Carpaccio

VENICE, 1460/65 – 1525/26

VICTORIS
CARPATIO

"Better death than dishonour"
Translation of the inscription appearing within *Young Knight in a Landscape*

This painting is one of the jewels of the Thyssen-Bornemisza Collection. In it Carpaccio introduces – even before Cranach – the full-length portrait. The composition aims to represent the still unidentified sitter in the fullest possible way. A complex iconographical programme fills the painting and surrounds the young knight, who is placed in a landscape in which every element has a meaning. The canvas is lent a certain enigmatic quality by its range of symbols taken from nature (plants and animals), which have proved difficult to decipher, as if the artist and the patron had wished to create a riddle or a message which was only comprehensible to a learned and cultured viewer. According to iconographical tradition, certain plants and animals have specific meanings: thus a dog is a symbol of fidelity, an eagle one of strength, a stork one of filial piety, and a peacock one of the immortality of the soul. Without doubt the aim of the painting was to extol the virtues of a Christian knight, an idea reinforced by the motto on the piece of paper which appears at the lower left, which (translated) reads: "Better death than dishonour".

Another thought-provoking element is the representation of the walled city on the edge of the lake. Carpaccio, who worked in the circle of the Bellini and was a follower of their *vedutà* tradition, contributed, with his idealized visions of the city, to the creation of the myth of Venice evolved by the Venetian painters of the 16th century and maintained until modern times. Almost all his paintings use the city of Venice as their backdrop, rendered more or less freely and drawing upon a diverse range of architectural forms limited not just to the classical tradition, but also including medieval buildings and others suggestive of Oriental architecture. Overall, his urban compositions are an allegory of the complexity of the Venetian cultural scene, something also evident in the present work, in which we see a certain enthusiasm for introducing into an apparently realistic scene a large quantity of rather obscure and even extravagant details (for example, the rider in the middle ground who has a real peacock on his helmet), giving the painting a strange and almost dreamlike character.

Young Knight in a Landscape, 1510
Oil on canvas,
218.5 x 151.5 cm

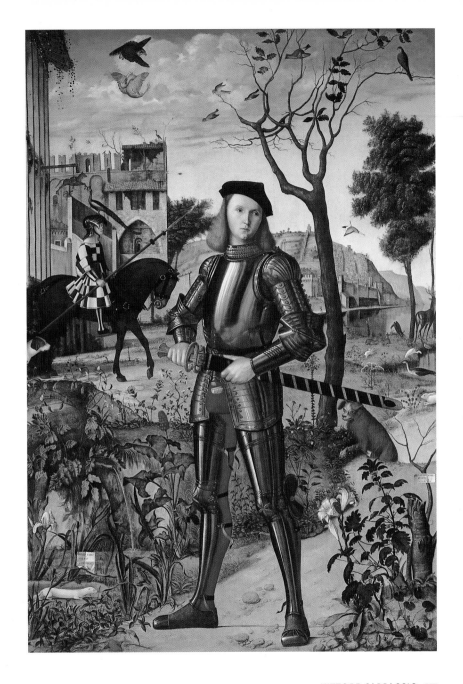

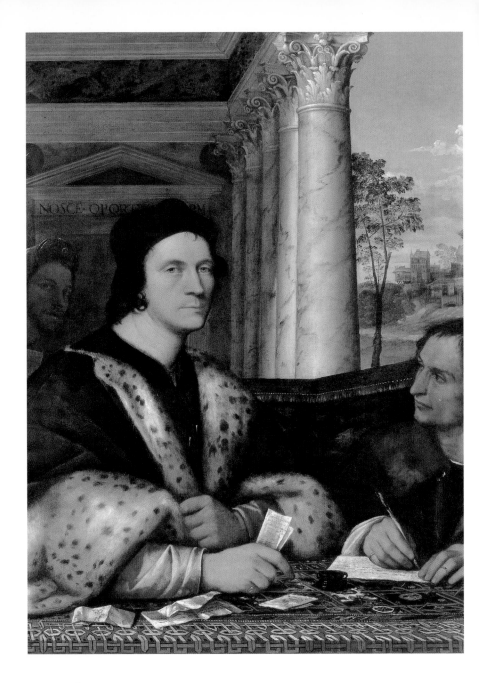

Sebastiano del Piombo

VENICE, 1485 – ROME, 1547

Sebastiano del Piombo trained in the workshop of Giovanni Bellini in Venice, where he was a contemporary of Giorgione (1475/80–1510). In around 1510 he moved to Rome, and apart from occasional trips away spent the rest of his life there. He brought to Roman art the new Venetian pictorial language, sense of colour and interpretation of the classical idiom. Sebastiano worked with Michelangelo, from whom he took his use of drawing as the basis of his compositional structure, as well as the monumental conception of his figures. He achieved great fame in Rome for his paintings, which expressed a classicism different to that of Raphael.

·SEBASTIANVS·
VENETVS·

The *Portrait of Ferry Carondelet* is an outstanding work of its kind. Sebastiano's technical mastery is evident in the elaboration of the forms, the naturalness of the figures' poses, their expressions and gestures. The treatment of light is clearly subjective and deliberately dramatic, serving to highlight the principal figure of Carondelet, while his two secretaries on either side are in shadow (one of them barely distinguishable). The position and pose of each secretary similarly make clear the relationship between the seigneurial upright figure of Carondelet, dressed in his luxurious fur-lined coat and expressing a powerful presence which is visually enhanced by the large area of his body, and the secretary seated on a lower level to denote his servant status, looking at Carondelet as he takes down a dictation.

"To the honorable, loyal and beloved Ferry Carondelet, Archdeacon of Besançon, Imperial Councillor and Commissioner in Rome." Translation of the text on the sheet of paper which the principal protagonist holds in his hand

Behind the figures and also in shadow is a classical-style portico with Corinthian marble columns, a coffered ceiling and in the background a pediment. On the right the depiction of the evening landscape reveals Sebastiano's Venetian origins. The golden-tinted clouds and sky lend this section of the canvas the character almost of an independent landscape.

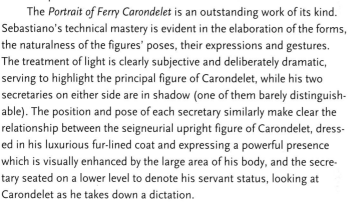

Portrait of Ferry Carondelet and his Secretaries, c. 1510–1512 Oil on panel, 112.5 x 87 cm

Raphael

URBINO, 1483 – ROME, 1520

"Here lies Raphael, who in his lifetime inspired great Mother Nature with fear of defeat, and whose death caused her death as well."
CARDINAL PIETRO BEMBO, epitaph on the tomb of Raphael in the Pantheon, Rome

Portrait of a Young Man, c. 1515
Oil on panel,
43.8 x 29 cm

Raphael, together with Leonardo and Michelangelo, was one of the artists who brought the classicizing language of art to its peak and who inspired the use of the term High Renaissance to describe the first decades of the 16th century. While Leonardo exerted his influence around the turn of the century in Florence and Milan, Raphael and Michelangelo turned Rome and in particular the Vatican into the undisputed capital of classicism.

Raffaelo Sanzio trained in Urbino with Pietro Perugino, then travelled to Florence, where he studied the work of Leonardo, from whom he took the compositional formulae which he would employ both in his religious paintings and in his portraits. Once in Rome, he brought to fruition the move towards classicism begun by the Quattrocento, and cemented its application to religious subject-matter. Raphael thereby also brought about a transformation of the genre of portraiture and of secular subject-matter through a style which came to be seen as the essence of classicism and which was disseminated throughout Europe.

The young man painted here may be Alessandro de'Medici, illegitimate son of Lorenzo de'Medici, Duke of Urbino. If this is the case, the portrait can be dated to around 1515, that is to say the last decade of the artist's life – a date supported by the stylistic characteristics of the work. Notable are the soft colour harmonies which prevail throughout the painting and the loose brushstrokes, rapid but also fluid, which give the overall work a certain mistiness, softening the contours of the already childlike face. The sitter looks directly at the viewer, his head turned slightly above his upper body, seen in profile. The psychological characterization is impressive, infusing the portrait with a strong sense of personality, despite the element of idealization. These aspects and the flexible arrangement of the body and its pose confer on the painting a high degree of naturalism.

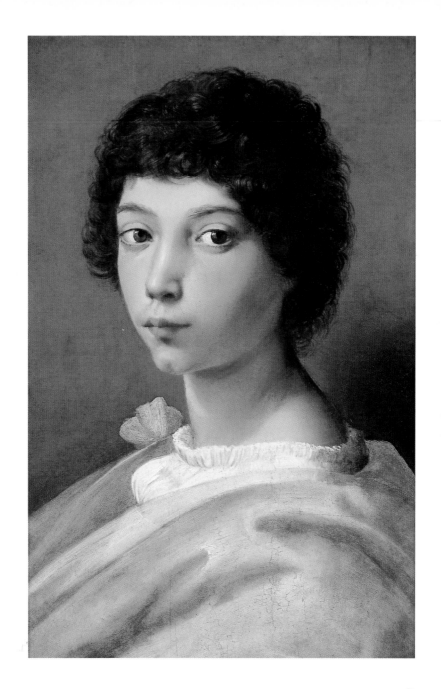

Portrait of a Young
Woman known as
"La Bella", c. 1525
Oil on canvas,
95 x 80 cm

Palma il Vecchio

SERINALTA, NEAR BERGAMO, 1480 – VENICE, 1528

IACOBVS · PALMA

Palma il Vecchio was one of the great Venetian painters of the circle around the leading figures of Giorgione and Titian, who were his exact contemporaries. His paintings are full of vitality, colour and movement, with large figures who fill the canvas with their presence.

This *Sacra Conversazione* derives its iconography from Titian, but also contains echoes of Giovanni Bellini, the founder of the Venetian school. This type of imaginary sacred scene in a landscape setting evolved during the 1510s. The figures are placed in the foreground, taking up most of the composition, which is seen frontally in a frieze-like arrangement. The scene is organized into a triangular composition whose axis is formed by the Virgin and Child. Beside them in the foreground are St John the Baptist and a donor (probably Francesco Priuli, Procurator of the Venetian Republic and a patron of Palma Vecchio). Closing the composition are St Catherine (on the right with her palm of martyrdom and spiked wheel) and Mary Magdalene (on the left). The compositional structure is reinforced by the lighting, which is designed to emphasize the figures of the Virgin and Child.

The same approach to colour and the treatment of the figure is evident in the magnificent portrait of an unknown woman, aptly named "La Bella", with her enigmatic gaze and amply-proportioned body. Her red, blue and white silk draperies highlight the marble tones of her skin. In one hand she holds a casket, which may be a jewellery box or part of a hair ornament which she will use to gather up the abundant tresses she is touching with her right hand. The significance of the portrait continues to evade us, as the sitter has not yet been identified, nor has it been possible to decipher the inscription on the ledge below the figure.

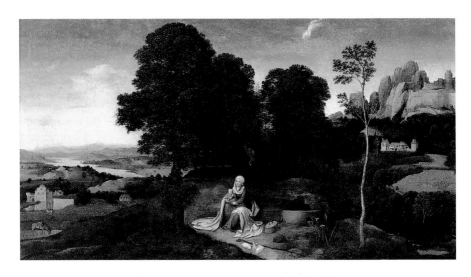

Landscape with the
Flight into Egypt,
c. 1515/16
Oil on panel,
31.5 x 57.5 cm

Joachim Patinir

BOUVIGNES, 1485 — ANTWERP, 1524

Patinir is considered to be the first landscape artist of the Renaissance.
Like many painters of the period, he uses landscape to create a suitable
setting for the figures in his scenes. But although he integrates his
narrative within them, his landscapes become more than mere back-
grounds, and begin to assume their own autonomy. For the most part,
Patinir maintains an equilibrium within his paintings between the pres-
ence of the figures and the landscape, and only in a few – including the
present work – is he bold enough to shift this balance in favour of his
vision of nature. His detailed technique is typical of Flemish artists,
but his novelty lies in his creation of space and depth through subtle
gradations of light and colour, as well as a certain effort at capturing
the atmosphere of the scene.

The landscape towards the background increasingly takes on
bluish-grey tones which help it to achieve the effect of receding into
space, while the Virgin and Child are painted in stronger, warmer tones
nearer the foreground. Patinir's characteristically high viewpoint creates
a panorama seen from a bird's-eye view, with a very distant horizon
and a sense of boundlessness. The figures are totally integrated into the
natural setting. The Virgin and Child, although emphasized by the light,
are in fact situated on a second plane, and in front of them Patinir has
placed two trees, one large and leafy, the other slim and delicate. The
different elements in the landscape are treated as the real protagonists:
the atmosphere, the woods, the sky and the mountains. The artist re-
veals to us the power and beauty intrinsic in nature.

This interest in nature has its forerunner in late-medieval illumina-
tions of the seasons and the months of the year. It was taken up in the
16th century by Patinir, who was primarily a religious painter, and by
Pieter Brueghel, who used an iconography based on agricultural labours
and country festivals. It would finally crystallize into the Dutch land-
scape painting of the 17th century, in which the subject is treated as
totally independent.

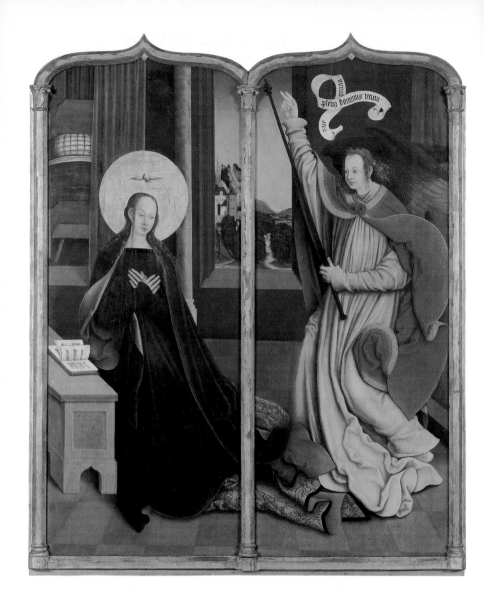

Bernhard Striegel

MEMMINGEN, 1460–1528

Bernhard Striegel was an artist at the court of Emperor Maximilian I, for whom he executed a large number of commissions, above all portraits, the genre to which – alongside religious works – he dedicated a large part of his time. Striegel's work suggests the influence of 15th-century Netherlandish artists of the manner of Dierk Bouts, although his style is also partly dependent on the work of contemporary German artists such as Dürer and Holbein.

"Hail, thou that art highly favoured, the Lord is with thee." Translation of the inscription on the banderola which waves above the Archangel

This present *Annunciation* shows his stylized manner, which makes somewhat mannerist references to 15th-century Flemish art. The organization of the interior in which the figures are located is undoubtedly old-fashioned: the bench placed on a diagonal and receding towards the background; the bedroom seen through an opening with a curtain across it; and the window looking out onto a landscape are all elements derived from Netherlandish painting of the previous century.

Contrasting with the plainness of the setting, however, is the decorativeness of the figures, particularly Gabriel, whose draperies fall into complex folds and waves. These lend the composition a sense of movement which is more decorative than realistic, even if it can ostensibly be justified as a reference to the fact that the archangel has just arrived to announce to Mary that she is to be the mother of the Messiah. The banderola which waves above the archangel is inscribed in Latin (the educated language of that period) with Gabriel's greeting to Mary: "Ave gratia plenam dominus tecum" (Hail, thou that art highly favoured, the Lord is with thee). This iconography of the archangel depicted in motion, with billowing robes and as if having just alighted on the ground, would become established over the course of the 16th century, replacing the calmer and more respectful pose used in earlier painting. The Museum also possesses other works by this artist: *Portrait of a Gentleman* and *The Annunciation to SS Anne and Joachim*.

The Annunciation,
c. 1515–1520
Oil on panel,
118 x 50 cm
(Pedralbes)

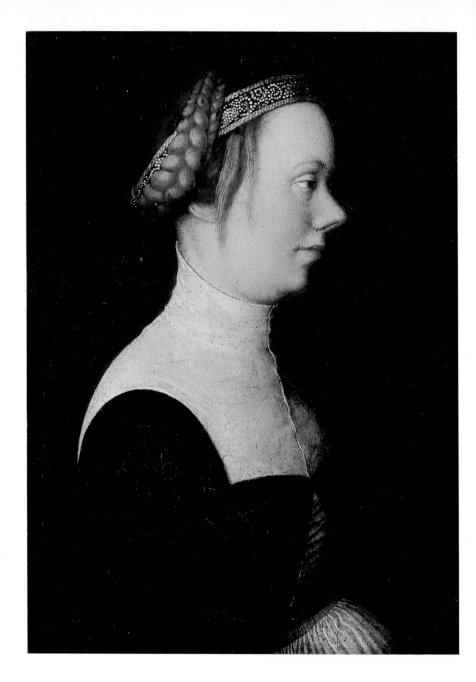

Hans Holbein the Elder

AUGSBURG?, 1465 – ISENHEIM?, 1524

Another important family of 16th-century German artists were the
Holbeins, of whom the most outstanding was Hans Holbein the
Younger, son of the present artist and the most brilliant portraitist in
northern Europe. From these two portraits by his father we can see
that at least some of his talent was inherited.

These two panels reveal the artist's interest in depicting the physi-
cal characteristics of his sitters, both of whom have rather pronounced
features. Art historians have generally assumed the portraits to form a
pair, possibly showing a husband and wife. However, it is odd that they
should be depicted in different formats and poses, with the woman in
profile and the man in less than full profile, his body slightly turned. It
would be more usual for them to be painted looking at each other in
symmetrical poses.

As mentioned earlier, northern painting developed to accommo-
date a clientele drawn from a new social class – that of the urban pro-
fessional and commercial middle class. An abundance of portraits has
come down to us portraying unidentified sitters, al-
though we can deduce from their clothes and appear-
ance that they were prosperous burghers who com-
missioned their portraits to be hung in their own
homes. In response, artists in the north began to
strive towards ever more realistic and personal like-
nesses of their clients. In the Mediterranean coun-
tries, on the other hand, where commissions tended
to come from the established rulers, the monarchy or
the Church, portraits served as a public statement
of authority in which accuracy of appearance was
secondary to symbolic significance. These two por-
traits are characteristic of the period: they are half-
length, with a dark empty background, and despite
their apparent simplicity show great attention to detail
in the decoration on the clothes and in the hair.

◄ *Portrait of
a Woman*,
c. 1518–1520
Oil on panel,
23.6 x 17 cm

Portrait of a Man,
c. 1518–1520
Oil on panel,
23.7 x 17 cm

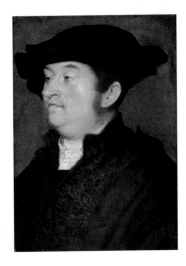

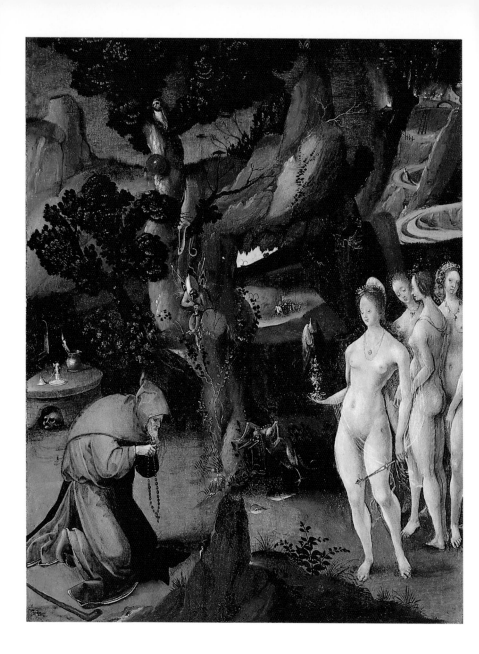

Jan Wellens de Cock

LEYDEN, C. 1490 – ANTWERP, BEFORE 1529

One of the genuine contributions of northern humanism to art was the creation of an iconography based around madness and monsters, totally at odds with Italian classicism. This iconography often appeared in religious paintings, carrying a moralistic message. The monsters and fantastic beasts which reflected and symbolized man's hidden passions and desires had their forerunners in the Middle Ages, and were propelled into the 16th century by an artist who would develop a unique pictorial style: Hieronymous Bosch. Bosch was not unique, however; Brueghel also depicted monsters in paintings such as *Dulle Griet*.

In the present painting Jan Wellens de Cock shows a considerable debt to Bosch, who had also painted a series of *The Temptations of St Anthony*. The subject was a frequent one during this period in history, reflecting the profound religious changes being wrought by Luther and Calvin, each of whom – one via Protestantism and the other via Catholicism – sought to promote a return to the original values of Christianity. St Anthony was a fine example of this, as he sold all his possessions, divided his money among the poor and became a monk and hermit. In the desert he underwent numerous temptations by the devil, whom he defeated, and was considered an example of uprightness and the rejection of worldly pleasures.

This painting shows one of Antony's temptations, that of lust, which takes place in a dark and frightening setting, within a rocky landscape filled with monstrous beings. The female figures, contrasting with the ugliness of the rest of the scene, reproduce the ideal of northern beauty, albeit with a certain exaggeration of the forms.

The Temptations of St Anthony, c. 1520
Oil on panel,
60 x 45.5 cm

Jan de Beer

ANTWERP, C. 1475 – C. 1536

These two panels form a pair and relate two episodes from the life of
the Virgin. Stylistically they are heavily indebted to the Early Netherlan-
dish painters, such as Jan van Eyck and the Master of Flémalle. The
artist has returned to the art of nearly one century earlier in order to
represent his subject, as we can see from his use of the interior of a
late Gothic house, a minutely detailed technique, the angular folds of
the draperies, the figural types and his way of conceiving the space in
perspective.

In particular, the artist has treated *The Birth of the Virgin* as a do-
mestic scene, filling the room with details and everyday objects. Various
women surround St Anne as they perform their tasks. The same hap-
pens in the *Annunciation* scene. The artist has thus aimed to give the
religious subject a realistic and everyday feeling, emphasizing the hu-

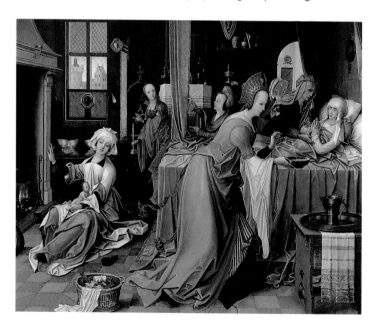

*The Birth of the
Virgin*, c. 1520
Oil on panel,
111.5 x 131 cm

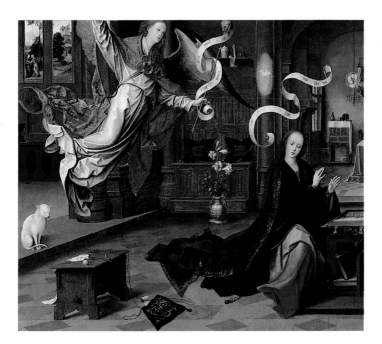

The Annunciation,
c. 1520
Oil on panel,
111.5 x 131 cm

man side of the protagonists. The compositional structure of the two panels is fairly similar. The figures are situated on a plane which is horizontal to the viewer, integrated into a space which is constructed from a careful although rather exaggerated application of perspective, defined by the architectural elements. The recession into depth is blocked at the back by a wall parallel to the viewer, who can nevertheless glimpse the world outside through a window, a standard device in Early Netherlandish painting.

The whole ensemble displays a certain mannerism in comparison to its forerunners, in the accumulation of anecdotal details, the decorative nature of the folds of the draperies which form playful waving patterns, and the gestures of the figures, which are somewhat exaggerated to give a sense of spontaneity and movement. This type of painting, which delights in decoration and wealth of detail, was developed at around this period in Antwerp by a group of little-known painters, among them de Beer. They are sometimes referred to as the Antwerp Mannerists.

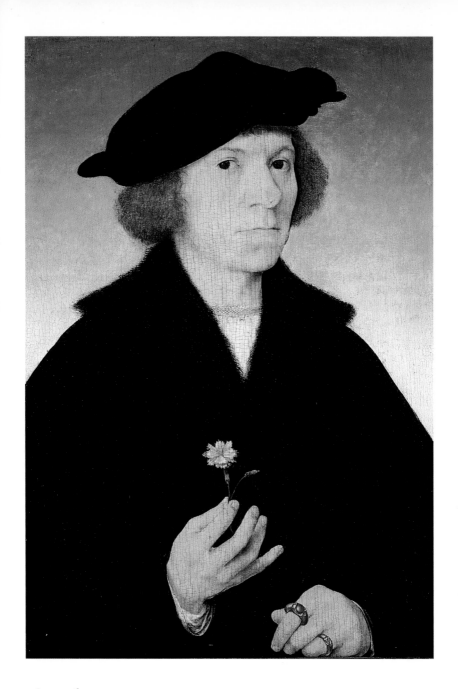

Joos van Cleve

CLEVE, C. 1480 – ANTWERP, AFTER 1541

Together with Gossaert and Heemskerck, Joos van Cleve was a leading figure among the Romanists – the artists who introduced Italian classicism to the Netherlands, contributing to the final demise of lingering Gothic tendencies.

◄ Self-Portrait, c. 1519
Oil on panel,
38 x 27 cm

Cleve's Italian affinities are evident in *The Infant Christ standing on the World*, which depicts the young Jesus holding the Cross, symbol of the Passion. This iconography would enjoy great popularity in the 17th century. The figure of the Christ Child, arranged in slight contrapposto, recalls antique, secular depictions of Cupid, and the treatment is purely classical in terms of proportions and pose. In addition, light is used to model the figure in a gentle, Leonardesque chiaroscuro, while the figure itself is strongly contrasted against the blue background, emphasizing its nudity.

The Infant Christ
standing on the World,
c. 1530
Oil on panel,
37 x 26 cm

In contrast, the *Self-Portrait* falls more in line with the artist's native tradition – as practised with supreme mastery by his Flemish contemporaries. The realism which characterized portraiture in the Netherlands is obvious here in a work of great seriousness, which captures not just the artist's appearance but also his character. Notable are the expressive hands outlined against his austere black clothing. Finely drawn and modelled in a soft chiaroscuro, they give the portrait movement and naturalness, contrasting with the serious and static character of the face.

The *Self-Portrait* also expresses the new role of artists in society. Following Dürer, who was possibly the first artist to paint himself, 16th-century artists thought of themselves as intellectuals and humanists, given that art – which had attained the status of a humanist discipline – was considered a branch of knowledge equal to the other liberal arts (philosophy, music and poetry).

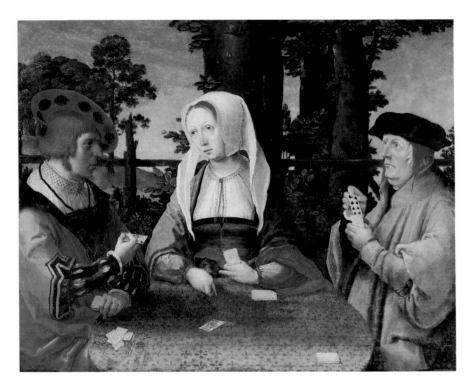

The Card Players,
c. 1520
Oil on panel,
29.8 x 39.5 cm

Lucas van Leyden

LEYDEN, C. 1494–1533

Scenes of everyday life appeared in art from the 1500s onwards and were to prove a fruitful source of inspiration in the Netherlands in the following century. In the 16th century the most important artist working in this genre was Pieter Brueghel, who worked in a style far removed from the precepts of classicism. But other artists, such as van Leyden, were also interested in this genre (which was generally considered a humble one), although unlike Brueghel they interpreted it in a more Italianate manner.

Indeed, *The Card Players* is a good example of the combination of Italian Renaissance tendencies with the artist's native Flemish inheritance. The fundamental approach to the composition, in which the figures in the foreground are set against a highly abbreviated landscape, the broad handling, and the controlled lighting, exploited for its chiaroscuro effects, may all derive from Italian influences. It has not been the artist's aim to produce a Flemish copy of an Italian original, however. Rather, he has constructed a scene using figures whose poses and features are realistically portrayed and totally devoid of idealizing intent. Furthermore, the seemingly anecdotal nature of the subject-matter is also far removed from classical precepts. The three figures seem totally involved in the game, exchanging eloquent looks. The rivalry or competition is between the two men who are staring intently at each other and are about to show a card. In contrast, the woman seems to be waiting for this to happen, with a gesture which may be conciliatory.

All this has led to the suggestion that the subject of the painting may not be the obvious one of card players, but may in fact refer to a secret political alliance at the highest level. In this case, the figure on the left would be Emperor Charles V and on the right Cardinal Wolsey, and both would be entering into a secret agreement between Spain and England against Francis I of France. The woman in the centre would be Margaret of Austria, sister of Charles V and regent of the Netherlands.

Hans Maler

ACTIVE IN ULM, C. 1510–1530

This portrait of Queen Anne is one of the most important of the distinguished group of German portraits on display in the Thyssen-Bornemisza Museum, a group which demonstrates the importance of the genre of portraiture in the modern era, starting from the 15th century. In fact, the Museum possesses key 15th-century examples, such as the portrait of Kunigunde of Austria, referred to above, which is comparable with the present work.

Queen Anne of Hungary and Bohemia was initially betrothed to Emperor Maximilian I, although she eventually married his brother, the Archduke Ferdinand, in 1521. A few years later, in 1525, she became Queen of Hungary and Bohemia on the death of her brother without heir. This portrait, datable around 1519, is very possibly a commission from the Archduke Ferdinand, for whom Maler worked at the ducal court in Innsbruck. Maler was a famous portrait painter and also depicted members of the Fugger family, who were the most important and influential bankers in Germany.

The painting represents the high point of this particular style of portraiture: it is crisply executed and reveals a high degree of realism, although it still retains 15th-century elements, such as the use of the half-length format with the body slightly turned to one side, the neutral background, interest in the decorative potential of the clothes and hat, and the position of the hands crossed over the chest. Nonetheless, the painting is conceptually modern and indicates the artist's knowledge of Dürer's portraits. This modernity can be seen in the figure's attitude, which is more realistic, a feature enhanced by the lighter handling and more curving, gentle shapes and volumes, which give the painting an overall harmony lacking in earlier portraits.

Queen Anne of Hungary and Bohemia, c. 1519
Oil on panel,
44 x 33.3 cm

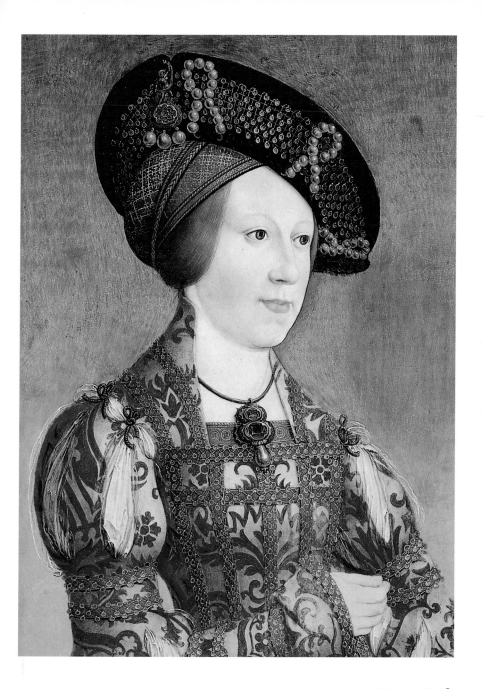

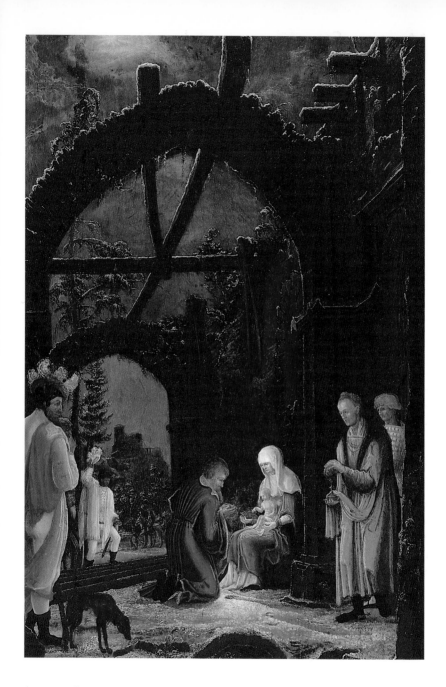

Master of the Thyssen Adoration

ACTIVE AROUND 1520

In this interpretation of the *Adoration of the Magi*, the traditional stable has been replaced by the ruins of a church. The protagonists are placed in a large open space, the imposing architecture serving to reduce the statur of figures. The Virgin with the Infant Christ in the centre are receiving a gift from one of the Kings; on the right another King comes forward holding a chalice; in the background, dressed in white, the dark-skinned Balthasar enters. The other figure in the foreground may be one of the Kings' retinue, as iconographically he cannot be Joseph.

Although the Gothic style of the ruins may seem old-fashioned, the composition, organization of the individual elements and figures, as well as the style of execution place the painting in a firmly Renaissance context, possibly influenced by Albrecht Altdorfer, with whose workshop this master may have been connected. Compositionally the painting is resolved in the Italian Renaissance style, creating a three-dimensional space by means of architecture seen in linear perspective, with the vanishing-point on the left. The figures are placed within this coherent space. A faint light comes from the sun which is partly hidden by the clouds. It lights up the ruins from above, creating a slight suggestion of backlighting and producing white sparkles on the snow on the beams, arches and trees which the artist has so carefully painted. The figures stand out against the earth tone of the walls: they are brightly coloured and lit from a different source, which seems to emanate from the Infant Christ himself, symbolizing His role as the future Saviour ("I am the Light of the World").

This painting has been central to the identification of an anonymous master to whom another series of works has been attributed, and who is thus known as the Master of the Thyssen Adoration.

The Adoration of the Magi, c. 1520
Oil on panel,
62 x 44.5 cm
(Pedralbes)

Albrecht Altdorfer

REGENSBURG?, C. 1480 – REGENSBURG, 1538

Albrecht Altdorfer was one of the great German masters of the 16th century. Although remaining within the orbit of Dürer's influence, Altdorfer began a trend in painting which focused on the representation of nature, which he interpreted – in an almost Romantic style – as something living and moving. This development became known as the Danube school and Altdorfer was its principal representative.

In his works, both the ostensible subject of the scene and the figures appearing within it are little more than accessories to the chief protagonist, landscape. For this reason Altdorfer is considered the first painter to think of landscape as an independent genre. His highly individual interpretation of landscape, full of drama and subjectivity, led him to develop a nervous technique and a distinctive palette.

Very few portraits by Altdorfer are known and the Thyssen-Bornemisza example is therefore of especial interest. The technique and style of his landscapes are also evident in this painting, whose strong colour contrasts give the work a particular expressive force. The artist's distinctive eye for colour is obvious, from the neutral background through the shot colour of the dress in green and flesh pink, to the pure white of the chemise which is contrasted with the black edging of the dress. The dark background is difficult to read, but one can just make out some lighter patches which may or may not be the folds of a curtain. The face is created with firm underdrawing and modelled by a chiaroscuro which highlights the volumes.

Overall, the image of the woman is a strange one, despite the apparent normality of the sitter, who has the air of a countrywoman. The cold light which illuminates her and the contrast with the background, with its sketchy and barely decipherable shadows, contribute to this mood.

Portrait of a Woman,
c. 1522
Oil on panel,
59 x 45 cm

German Master of the School of Lucas Cranach the Elder

Lucas Cranach ran an important workshop in Wittenberg, which produced a second generation of painters following closely in his style, including his sons Hans and Lucas the Younger (also represented in the Thyssen-Bornemisza Collection). The way in which oil paint is handled in the present portrait, and the plainness of the composition, are typical features of this school.

The woman, whose is aged 26 according to the inscription in the upper part of the painting, is depicted somewhat more than half-length with her hands folded and her body slightly turned to one side. Her pose suggests that, as in the case of other, similar portraits, there would have been a matching portrait of a man, probably her husband. The plain white head-dress is typical of German fashion of the time. Together with the general austerity of her dress, it suggests the new currents of thought which accompanied the Protestant Reformation.

The painting is created from large areas of strongly contrasting colour: red, green, white and black. Despite this, and despite the almost total lack of decorative elements, the artist has paid close attention to the woman's few embellishments: the rings, belt and other parts of her dress are rendered in great detail, although not with the minuteness which painters of previous generations would have deployed. The artists of 16th-century Germany embraced a broader, more hierarchical view, seeking to focus the viewer's gaze on the face and its expression without distracting the viewer with incidental detail.

The 16th century also saw the perfection of portraiture in Germany. Influenced by Dürer, the desire to faithfully reproduce the world of experience meant that, in addition to capturing external appearances, artists sought to capture the personality of the sitter, emphasizing the lifelikeness of the image.

Portrait of a Woman aged 26, 1525
Oil on panel,
61.6 x 38.8 cm

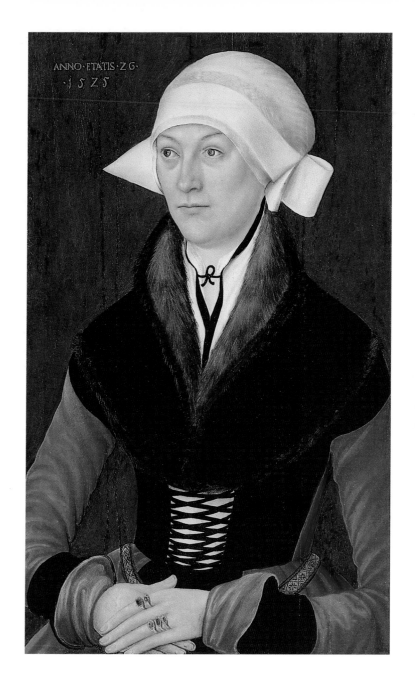

ANNO·ETATIS·Z G·
·1 5 Z 5

Adam and Eve, 1531
Oil on panel,
147.5 x 67.3 cm

Hans Baldung Grien

SCHWÄBISCH-GMÜND, C. 1484/85 – STRASBURG, 1545

Hans Baldung, nicknamed "Grien" after his fondness for the colour
green in his early work, was one of the most adventurous and daring
of Dürer's pupils. He painted a wide variety of subjects from religious
paintings to portraits and allegorical works. The two paintings in the
Thyssen-Bornemisza Collection are brilliantly executed with regard to
draughtsmanship and modelling and display one of Baldung's special-
ities – the treatment of the nude, particularly the female nude.

The *Portrait of a Lady* is a technical tour-de-force, from the detail in
the rendering of the ornament and clothing to the colour contrasts and
the quality of the white flesh. The palette is a limited one, consisting of
little more than black, orange and cream, with infinite tonal gradations
within these colours produced by the strong light which completely illu-
minates the figure, leaving no room for shadows but rather producing
strong contrasts of juxtaposed colours.

The effect of inlaid marquetry which the portrait produces is also
to be found in *Adam and Eve*, a magnificent study of male and female

Portrait of a Lady,
1530 (?)
Oil on panel,
69.2 x 52.5 cm

nudes. The subject of the painting is original sin, which is conveyed not
just through the use of the traditional symbols – the
serpent and the apple – but also by Adam's eloquent
pose, holding Eve firmly and possessively with a look
that leaves nothing to the imagination. Grien makes
the consequences of the Fall clear: our first fathers, ex-
pelled from Paradise, lost the innocence of pure souls.
In addition to their expressive capacity, the male and
female bodies, both well-proportioned and idealized,
are realised with great precision and possess a sculp-
tural power which equates with the work of the great-
est masters. The woman has soft, round forms and
a pale and taut skin. The man, with darker skin, dis-
plays the painter's knowledge of anatomy as Grien
defines the muscle structure and the different parts
of the body, which he models with light and shade.

Maerten van Heemskerck

HEEMSKERCK, 1498 – HAARLEM, 1574

Martijnus. Van.
Heemskerck c&

While the painting of the southern Netherlands was dominated by a naturalistic approach, in the north artists like Heemskerck and Scorel developed an intellectualized style, frequently adopting a cryptic pictorial language suggestive of Mannerism. In Heemskerck's case he produced engravings on allegorical subjects (such as the *Triumph of Patience* and the *Triumph of War*) which were heavily laden with symbolism. This erudite approach is evident in the present *Portrait of a Lady Spinning*. The image of the spinner symbolized a virtuous woman, as described in the Old Testament Book of Proverbs. At the same time, the woman's elegant clothes, the sumptuous distaff and the coat-of-arms on the wall are clues to her aristocratic origins (the arms have been identified with various noble families of the time).

The work combines sobriety with an interest in detail, setting the scene with only the most necessary elements, all of which relate to the main subject of the painting. Hanging on a bare wall is the shield, mentioned above, which identifies the sitter, while the bobbin on the left and the sewing basket on the right refer to the woman's task. The spinning wheel is prominent in the foreground. Behind the distaff, the woman's arms are emphasized by her ample white sleeves which light up the middleground.

Heemskerck's technical mastery is evident not just in the minuteness of the brushstroke, but also in the general composition and the characterization of the face. The crisply defined volumes and forms convey a strong impression of three-dimensionality and space, particularly with regard to the figure. The painter uses very deliberate lighting effects which create zones of strongly contrasted light and dark. Particularly noteworthy are the hands in foreshortening, as well as the face and the front of the chemise. The lighting is of a type which looks forward to the luminist trend within 17th-century Dutch art, which depicted domestic interiors generally lit by artificial light and whose greatest exponent was Vermeer.

*Portrait of a Lady
Spinning,* c. 1531
Oil on panel,
105 x 86 cm

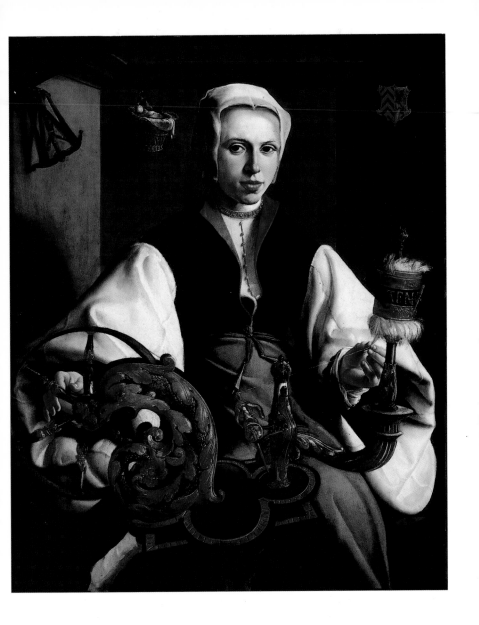

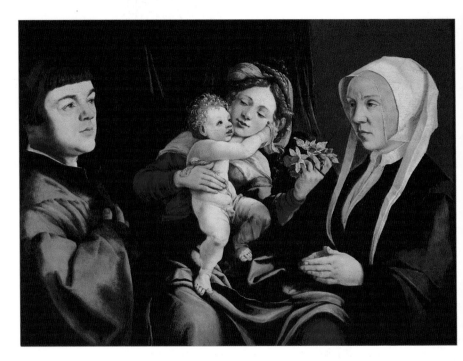

*The Madonna of
the Daffodils with
the Christ Child and
Donors*, c. 1535
Oil on panel,
55.5 x 76.2 cm

Jan van Scorel

SCHOORL, 1495 — UTRECHT, 1562

Jan van Scorel was another of the Romanist painters who introduced classicizing Italian tendencies into northern art. He was also an artist from the north of the Netherlands, which in the 16th century began to assume a separate identity to the south in the wake of the religious upheavals. The doctrines of Calvinism, and more generally the change of mentality, gave rise to a process which culminated in the independence of the northern Netherlands in the 17th century. In art these differences also became increasingly pronounced, manifesting themselves as two differing styles which were already defining themselves in the 16th century. In northern art, the tendency was towards a more intellectualized and idealized approach.

Initially the most striking feature of this panel is the contrast between the realism, austerity and sobriety of the donors and the idealization, spontaneous movement and freshness of the group formed by the Virgin and Child. In fact, the image of the Madonna and Child in a loving and playful pose, the mother looking openly and without reserve at her child, shows the influence of the great Renaissance masters such as Raphael (although this is not entirely true of their facial features). In contrast, the two donors and in particular the woman, with her typical Dutch head-dress, are startling in their severity, in their dark clothes devoid of all ornament, and in the absence of communication between them. The compactness of the group adds to the strangeness of the composition, as it highlights this lack of relationship between the donors themselves and between them and the Madonna and Child.

All the figures are painted with great skill, notably in the defined volumes created from the strong contrasts of light and shade, even though the light falls on them in an irregular way. Both the man and the Madonna and Child are elaborated with strong backlighting which results in areas of complete darkness. In contrast, the woman is lit in a softer way and her shadows are less dramatic. Her figure reveals Scorel's skills at elaborating tonal gradations and reproducing different effects of light.

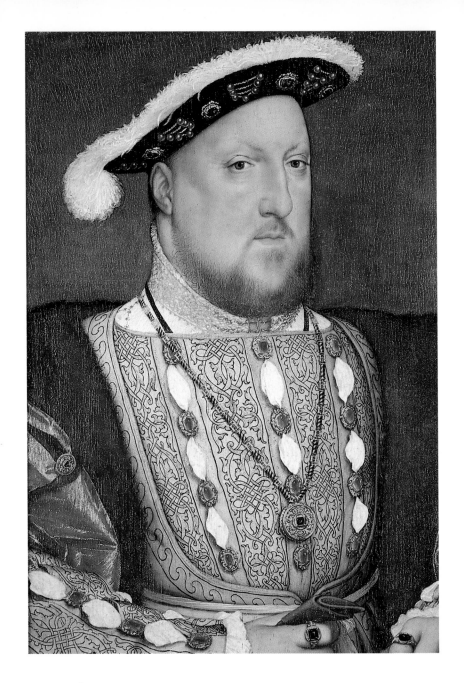

Hans Holbein the Younger

AUGSBURG, 1497/98 – LONDON, 1543

Son of the artist Hans Holbein the Elder, whose work is represented in the Museum by a pair of magnificent portraits, this artist was, along with Dürer, the most important and most international artist of 16th-century Germany. Many consider him to be the most gifted portraitist for his ability to capture both the physical appearance and the inner character of his sitters. The end of his career coincided with the end of the great era of German painting.

Hans Holbein the Younger enjoyed international fame as a portraitist, particularly owing to the series of portraits he made of Erasmus of Rotterdam, which he painted while he was in Basle in the 1520s. This fame allowed him to travel to France, where he worked at the court of Francis I, and later to London, where he eventually became painter to Henry VIII. He painted various versions of Henry, both alone and with his wives, although his most characteristic portrait is of the king alone, an impressive, richly dressed figure with a powerful physical presence.

The Thyssen-Bornemisza portrait of Henry VIII is one of the jewels of the collection. In it the king is represented from very close up, in the style of portraiture of the opening decades of the 16th century. The artist's skills are clearly evident: his technical abilities allow him to convey in minute detail the textiles, jewels and details of the hat, while his gifts for observation and psychological penetration mean that he has been able to capture the personality as well as the physical likeness of the sitter. This work falls within the type of courtly portrait which was being painted in Europe at the same period by artists such as Bronzino in Italy and François Clouet in France.

This portrait of Henry VIII is hung next to a supposed portrait of his first wife, the Infanta Catherine of Aragon, painted by Juan de Flandes in 1496 when she was still a child.

IOANNES HOLBEIN

"His colours are more delicate than Dürer's, he wields his brush with greater skill, and his firmness rarely tips over into hardness."
JOHANN WOLFGANG VON GOETHE, 1810

Henry VIII of England,
c. 1534–1536
Oil on panel,
28 x 20 cm

Barthel Bruyn the Elder

WESEL?, 1493 – COLOGNE, 1555

Bruyn the Elder was a popular portraitist whose works show the influence of Dutch artists. His religious works draw upon the Netherlandish painting tradition of the 15th century, while in his portraits he comes closer to his Dutch contemporaries, such as Joos van Cleve and Maerten van Heemskerck.

The similarity of format, size, palette and composition of the present two portraits make it possible that they depict a couple, identified as members of the Weinsberg family from the coat-of-arms which appears on one of the man's rings. The man and woman adopt almost symmetrical poses: leaning on what could be a marble table and probably seated, with their bodies slightly turned towards each other. The position of the arms and hands is practically the same, with the right hand slightly raised, the left lower and – an odd feature in both – the thumb held inside the clothes. The clean handling which crisply defines the outlines suggests Dutch painting.

The virtuoso technique is more obvious in the female portrait, in the detail of the jewels and other ornaments, as well as in the magnificent foreshortening of the hand which holds some carnations and is surrounded by a maroon cuff edged in gold. The women is also more strongly lit, with a greater contrast of light and shade which is accentuated in the modelling of the face. The man is more softly lit and is striking above all for the strong characterization and realism of his face.

The Thyssen-Bornemisza Museum also houses a religious painting by Bruyn the Elder which shows his rather old-fashioned tendencies, drawing on 15th-century stylistic and iconographic sources.

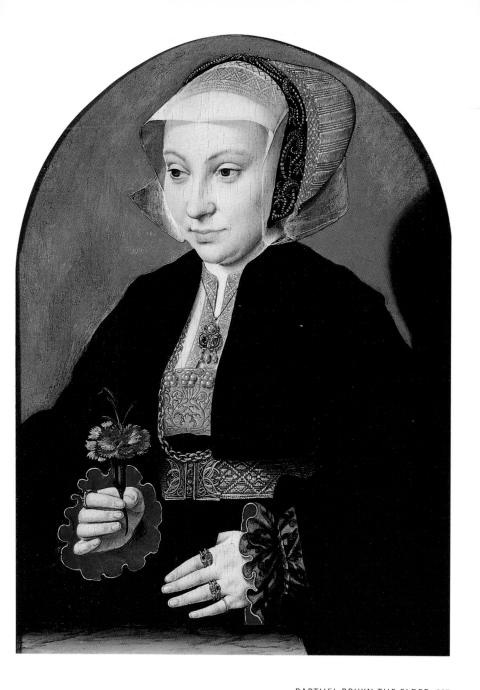

Lucas Cranach the Younger

WITTENBERG, 1515–1586

Son of Lucas Cranach the Elder, this artist trained in his father's workshop as did his brother Hans, also represented by a number of works in the Museum. In the two brothers' works we see a notable dependence on their father, to the extent that the attribution of their works has often been called into question.

In line with the standard conventions of German portraiture in the first half of the 16th century, the sitter is shown slightly more than half-length (portraits would gradually come to show more of the body), and slightly turned to one side, and is set against a plain, strong blue background. A clean bright light falls uniformly on the sitter, making the ivory quality of the skin of her hands and face stand out against her dark clothes and the background. The artist pays attention to details, without giving them too much emphasis. The rings, the belt, the collar and the net of pearls holding up her hair are painted delicately and without showiness, giving the whole work great elegance. From her clothing, which is simple but nevertheless richly lined with fur and decorated with some massive gold chains, it is likely that this lady was a member of a leading aristocratic family or some German court. Given Cranach's closeness to the Dukes of Saxony, the painting was at one point considered to be a portrait of the Duchess Elizabeth, although this is no longer thought likely.

Her slightly turned pose suggests that, in common with many other portraits of this period including examples in the Museum, this painting formed a pair with a male portrait, specifically with one which dates from the same year and is now in the Museo de São Paolo, Brazil.

Portrait of a Woman,
1539
Oil on panel,
61.5 x 42.2 cm

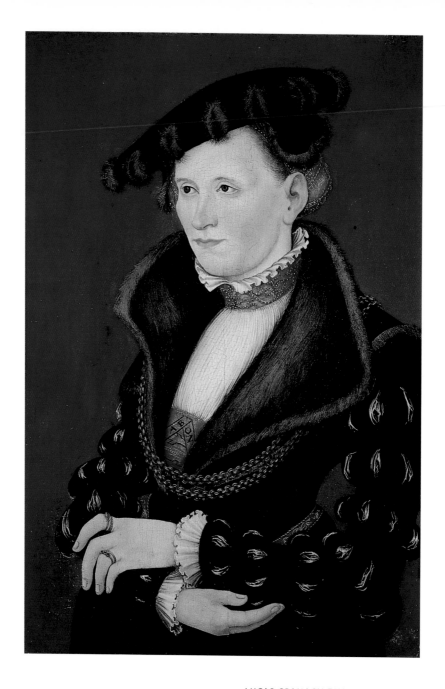

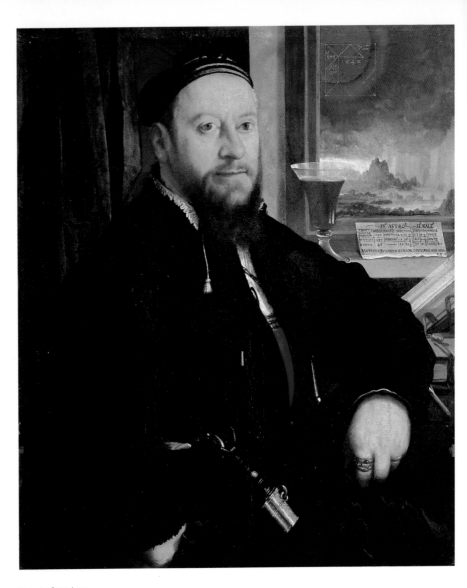

*Portrait of Matthäus
Schwarz*, 1542
Oil on panel,
73.5 x 61 cm

Christoph Amberger

NUREMBERG, C. 1505 – AUGSBURG, 1562

Breaking away from the usually plain background of German portraits, Amberger here draws upon a compositional structure normally found in Netherlandish painting. He places the sitter in an interior, with a window through which we can see a stormy and mountainous landscape painted in soft blue tones, which become blurred as they recede into the background. The sitter is seated and looks out at the viewer, leaning on the edge of a table. The various objects around him refer to his profession. Matthäus Schwarz was accountant to the Fugger family, Germany's leading financiers, and was also the author of number of treatises on economics. The fact that other artists such as Hans Maler and Kels also painted him suggests that Schwarz enjoyed a fairly elevated social position.

Christoph Amberger was a noted portraitist whose patrons came from the upper classes. He worked in the service of Emperor Charles V, whom he painted and for whom he restored Titian's portrait of the Emperor now in the Prado Museum. In around 1525 he went to Italy, which may have influenced his painting, as suggested here by Amberger's skilful use of chiaroscuro to give his sitter a solid physical presence, at the same conferring upon him a great dignity. The artist's principal aim is to achieve a realistic representation, and he renders all the elements within the painting in great detail. Thus the first thing to attract the viewer's attention is the glass of wine on the sill and the masterly way in which Amberger has rendered the transparent nature of the glass. Equally remarkable is the painting of the piece of paper with astrological information, some of which can be made out. We should note, too, the books on the table, the metal object attached to Schwarz's belt and the details of his clothes.

The dignified way in which the sitter is presented amongst the tools of his profession make this portrait an example of the importation of Mannerist portraiture into northern Europe.

Domenico Beccafumi

VALDIBIENA, 1486 — SIENA, 1551

Domenico Beccafumi was one of the first and most important Tuscan artists to work in the Mannerist style. He began his career painting in a style close to artists of the turn of the century such as Fra Bartolomeo and Perugino. After a period in Rome his work shows the influence of Michelangelo and Raphael.

Mannerism is the name given to the pictorial trend of the second half of the 16th century which evolved out of the classicism of Leonardo, Raphael, Michelangelo and Giorgione, whose extraordinary genius had set them up as paradigms of the classical tradition. Their followers developed a highly intellectualized art which reflected a continual rethinking of the aesthetic and technical canons of the classical style.

Beccafumi's work is an early example of the Mannerist style of the 1530s and 1540s. The composition is based on a triangular structure, marked out by the Virgin and Child, which opens out behind with the figures of St Jerome and the infant St John the Baptist. The use of *contrapposto* (a balanced but asymmetrical pose derived from Michelangelo) can be seen in the figure of the infant Christ. Similarities to the style of Parmigianino, the Mannerist painter *par excellence* and also from Siena, are evident in the elegance and stylization of the figures, particularly in the Virgin's long and graceful neck and in her hands with their fine and delicate fingers. Idealization is also characteristic of Beccafumi and of Mannerist painting in general. The forms, created from gently curving lines, adapt themselves to the shape of the round tondo format.

The clearly-defined palette is combined with a heavy chiaroscuro which creates strange contrasts of light, resulting from the artist's study of the effects of light on colour and its expressive variations. Beccafumi uses typical Mannerist colours in the lime green and blue of the Virgin's robe, as well as the pale pink of her dress and the touches of orange. Also following the pale colour scheme, the artist has made the Virgin's hair blonde. The two children, Christ and the St John the Baptist, are depicted as classical putti. Their faces with their delicate, finely proportioned features are derived from Raphael.

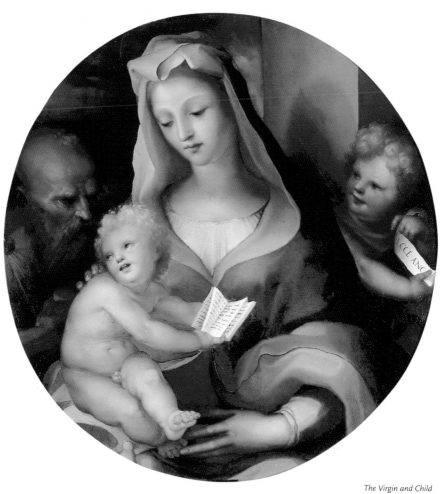

*The Virgin and Child
with SS John the
Baptist and Jerome,
c. 1523/24
Oil on panel,
diameter 85.5 cm*

Agnolo Bronzino

MONTICELLI, 1503—FLORENCE, 1572

Bronzino was one of the best interpreters of the sophisticated and elegant Mannerist style, which made him highly esteemed as a portraitist among the aristocracy and with royal patrons. His elegant, chilly portraits offer a refined and distant image of the ruling classes.

This refinement and elegance is evident in the present *St Sebastian*, portrayed not bleeding from his wounds, but more in the manner of a god of classical mythology or a young, slender Apollo. He is identified by the arrow which he holds in his hand and by the second arrow which cleanly penetrates his side without drawing blood. Bronzino is undoubtedly referring here to the miracle of St Sebastian's martyrdom. According to hagiographical accounts, St Sebastian, who defended Christians against the emperors Diocletian and Maximian in the 3rd century A. D., was condemned to be tied to a post and shot to death with arrows (as the saint is normally depicted). Despite the fact that his body "looked like a hedgehog", however, he did not die, and a few days later reappeared before the emperors without a scratch on him, once more defending the Christians. He was again condemned and beaten to death.

The subject is an excuse for a stylistic exercise often found in Mannerist art, in which the artist, using a clear and precise draughtsmanship which defines the outlines, produces an anatomically impeccable study. A sharp cold light falls on the nude torso, describing the volumes with precision: the neck, the collarbones, the shoulders and the arm are carved out as if they were a marble sculpture. Even the features, with the large, finely outlined eyes and the half open mouth, are treated in a sculptural way. Only the cloak, which surrounds and defines the edges of the torso, is painted in a more pictorial and less precise manner. The black background further emphasizes the strongly lit figure.

St Sebastian,
c. 1525–1528
Oil on panel,
87 x 76.5 cm

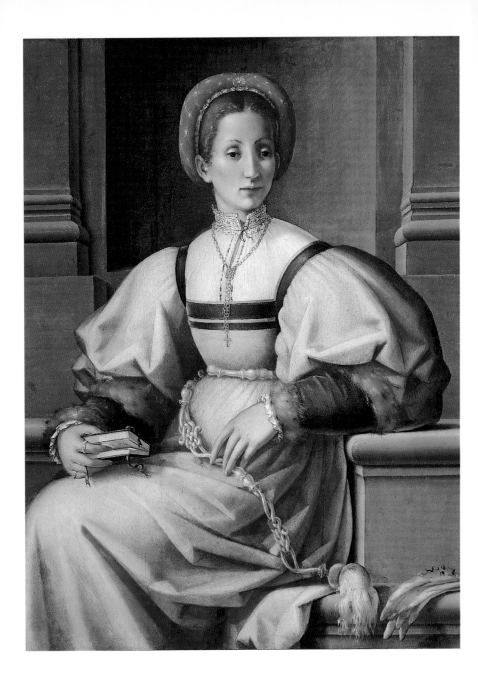

Pierfrancesco di Giacomo Foschi

FLORENCE, 1502–1567

Foschi was a Florentine Mannerist painter whose work reflects the in-
fluence of Bronzino and in particular the slightly older Florentine artist,
Pontormo. For Foschi, as for the other Mannerists, classicism was a
discipline which was governed by strict rules. For that reason his paint-
ing, as with that of Bronzino and other Tuscan artists of this circle, suf-
fers from a certain coldness and distance, as can be seen in this por-
trait. This concept of classicism as an erudite artistic programme led
to the foundation of the Accademia Fiorentina del Disegno in 1563, initi-
ated by Foschi with Vasari, Bronzino, Antonio da Sangallo and others.
In encouraging the perpetuation of classical precepts, however, it
brought about a loss of originality.

Thus the present *Portrait of a Lady* is the response to a predeter-
mined aesthetic and formal programme which was accepted as the para-
digm of the classical ideal with regard to harmony, proportions, natur-
alism and decorum. The sitter, painted almost full-length, is seated on
a stone plinth behind which rise up two pilasters, with what seems to be
a niche in-between them. The plain architectural background in the style
of the period infuses the painting with a sense of solemnity and isola-
tion which accentuates the sitter's expression, half way between serious
and sad. With lowered eyes, she fixes her gaze on no particular spot, as
if absorbed in her thoughts, perhaps inspired by the book which she is
holding.

The figure is depicted in slight contrapposto, with the head turned
in the opposite direction to the body, conforming with Mannerist taste.
This pose, initially conceived to give naturalness and movement to the
figures, was so constantly repeated that it reached a point where it be-
came purely a convention and no longer conveyed the spontaneity
which was originally intended. This was, in fact, to be the ultimate des-
tiny of Mannerism, which by refining the figure to such an extent, left
it empty of content.

Portrait of a Lady,
1530–1535
Oil on panel,
101 x 79 cm

Lorenzo Lotto

VENICE, 1480 – LORETO, 1556

Lorenzo Lotto developed a highly expressive style of painting. His work shows the influence of many of his contemporaries, and evolved from a detailed and descriptive style which looked back to the Quattrocento towards a broader, more painterly style in line with the art of the new century.

LAVRENT.LOTVS

For this reason the Thyssen-Bornemisza *Self-Portrait*, which shows connections with Titian's style, is probably a late work by the artist. The focal point is the subject's face, and in particular the penetrating gaze which he fixes on the viewer. The handling is loose, constructing the face from almost sketchy areas of paint which are more precisely defined only in the nose and eyes. The rest is formed from large areas of colour – the green background and the black of the hat and coat – without this in any way lessening the three-dimensionality and solidity of the figure.

The sitter's pose, turned towards the right and almost in profile, together with his way of looking sideways as if into a mirror, has led to the suggestion that this is a self-portrait. The first artist known to have depicted himself was Dürer, who travelled to Venice several times around the year 1500 and whose work influenced that of Lotto. The self-portrait implies a statement by the artist about his new status in society, as a humanist, intellectual and creator on the same level as scholars and scientists. This concept was a fundamental principle of Renaissance culture, and took firm shape in the Cinquecento when art, considered another way of analyzing and learning about Nature and reinforced by its development of a theoretical system, became a canon of knowledge on the same level as the other sciences and liberal arts. Thus the artist assumed the social status appropriate to his intellectual milieu.

Self-portrait, undated
Oil on panel,
43 x 35 cm

Ridolfo Ghirlandaio

FLORENCE, 1483 – 1561/62

Ridolfo Ghirlandaio was the son of Domenico Ghirlandaio and, like his father, ran an important workshop in Florence, where he was greatly esteemed as a portraitist. The present painting is a portrait of an unidentified gentleman and is considered to be a late work by the artist. It takes up the approach to portraiture introduced by Leonardo da Vinci, whom Ghirlandaio had met in Florence, and which represented a great step forward in the genre.

The figure, seen from the front, is represented half-length, whereby the face and the hands stand out against the black of the sitter's clothing, echoed in the hat of the same colour. The sitter's gaze is turned directly to the viewer, which – in conjunction with the skilful portrayal and strong characterization of the sitter – implies an attempt to depict not just the man's exterior appearance but also his personality. The plump hands, one of which holds a folded document and rests on a book, help to reinforce the characterization of this gentleman.

The impression of volume is achieved through a pronounced chiaroscuro, produced by a light which slants in from one side, and which in this case also serves to add expressiveness to the portrait, as it reinforces the hardness of the features and the penetrating gaze. The palette is a very limited one, consisting of blacks, plus the brown tones and the skin colour, counterbalanced by the two touches of greyish-white in the collar and the piece of paper. The plainness of the picture – the sitter's only adornment is a ring on his left hand – helps to underline the individualization which characterizes such Leonardesque portraits, devoid of all ostentation and pretentiousness.

Portrait of a Gentleman of the House of Capponi, undated
Oil on panel,
83 x 61 cm

Titian

CADORE, C. 1490 – VENICE, 1576

Titian trained with Giovanni Bellini and from 1508 worked with Giorgione. This collaboration revealed his remarkable gifts as a painter, and on the precocious Giorgione's early death he took over the painter's mantle. In 1513 Titian's workshop was the most important in Venice, elevating the city to the same artistic level as Florence and Rome. Whereas the schools of Florence and Rome placed their emphasis on drawing, however, the Venetian school was distinguished by its approach to colour. In 1516 Titian was made Official Painter to the Republic of Venice. Such was his fame that from 1532 he was painter to Charles V and Philip II, for whom he painted official portraits, now in the Prado Museum, in which he developed a new type of aggrandizing image which enjoyed enormous success and would be later used by Rubens, van Dyck and Velázquez.

Titian's œuvre was extremely diverse, and included religious and mythological paintings as well as portraiture. Starting from the approach to colour of Bellini and Giorgione, Titian developed his own style in which monumental compositions expressed both erudition and sensuality. In addition, he drew on certain aspects of Raphael and Michelangelo's work, taking the physical solidity of their figures and their potential for movement, thereby introducing an innovative sense of action and tension into his own work.

In religious painting he blended Christian sentiment with Antiquity, updating iconographical traditions, as in the case of the present *Virgin and Child*, who are devoid of all solemnity yet graced with a monumentality which relates them to the work of Michelangelo. The figures are captured while moving: the Virgin bends towards the Child while He embraces her, in a tender and protective pose which places most emphasis on her role as a mother. Titian's brushstroke, one of his most characteristic features, becomes looser, creating forms in a masterly way from bold strokes of colour.

Titian was also innovative in the genre of portraiture and, on Raphael's death, become the most highly sought-after portraitist of the

TITIANVS

"I forget to ask you / For a thing which I have much coveted. / I have thought to write to you about it many times. / I have long desired a painting by the famous Titian, / Whose work I have always admired. / Painted among flowers, roses and greenery / I would like a depiction of Spring, /With all the beauty with which Nature endowed her."
GUTIERRE DE CETINA, *First Letter. To Don Diego Hurtado de Mendoza*

The Virgin and Child, c. 1545
Oil on panel, 37.5 x 31 cm (Pedralbes)

*Portrait of Antonio
Anselmi*, c. 1550
Oil on canvas,
75 x 63 cm
(Pedralbes)

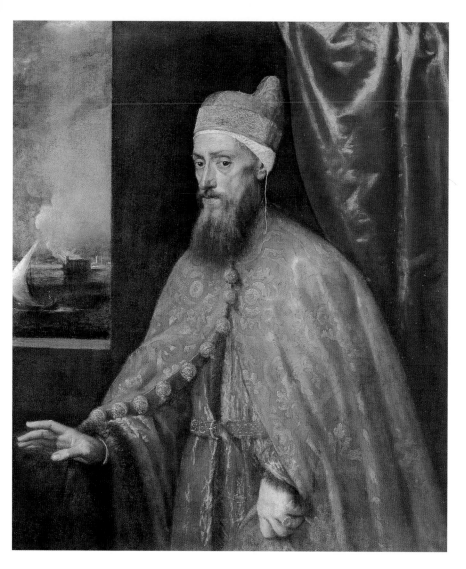

*Portrait of Doge
Francesco Venier,*
c. 1554–1556
Oil on canvas,
113 x 99 cm

age. In this *Portrait of Antonio Anselmi*, a writer, friend of the artist and Venetian Senator, we can appreciate Titian's mastery in capturing the physiognomy and character of the sitter. The painting is extremely simple, increasing its expressive force by means of the dark area which surrounds the face. Titian thereby takes to its furthest extreme the idea of portraits set against dark backgrounds and looks forward to Baroque formulae. The face, which is almost in profile, is lit from one side, painted with a loose brushstroke which creates forms from colour. The rest of the image is barely sketched in and blends in with the background.

As official painter to the Venetian Republic, Titian received a commission to paint the new *Doge Francesco Venier*, who was elected in 1554 and died in 1556. This represents a new type of portrait in which dignity of office is combined with individual characterization. The rich clothing, the cap of office and the heavy curtain which falls behind the sitter, together with his solemn pose, all convey the impression of a high official of State. The face is that of a wise old man, intelligent and energetic. A window looks out to sea where there is a sailing ship and a building in flames, possibly referring to Venice's resistance against the Turks.

The last work, *St Jerome in the Desert* was painted at the end of Titian's life and is an eloquent example of his artistic preoccupations. It represents the culmination of his career during which he moved towards an ever looser brushstroke, the use of more diluted paint and the representation of nature in movement, as a means, too, of reflecting the state of mind of the figure depicted. This penitent St Jerome before the image of the crucified Christ is a profound and pious painting which opens the way to Baroque art.

St Jerome in the Desert, c. 1575
Oil on canvas,
135 x 96 cm

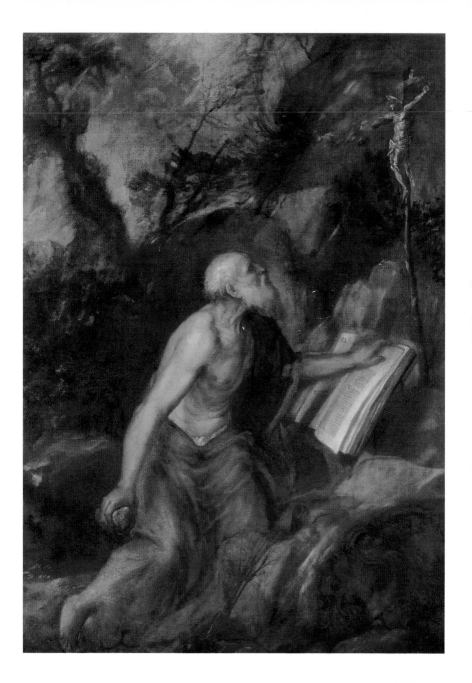

Tintoretto

VENICE, 1518–1594

IACOBVS
TINTORETVS

Jacopo Robusti, known as Tintoretto (his father was a dyer), was one of the supreme Mannerist painters and the most innovative artist of the Venetian school in the second half of the 16th century. His style, as he himself described it, was a fusion of Michelangelo's drawing with Titian's colour.

His works go beyond those artists, however, in their dynamism, colour, composition and sensuality, as we can see in the present pair of canvases, *The Meeting of Tamar and Judith* and *The Annunciation to Manoah's Wife*, which describe two episodes in the Old Testament.

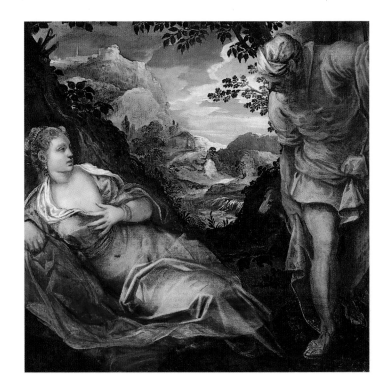

*The Meeting of
Tamar and Judith,*
c. 1555–1558
Oil on canvas,
150 x 155 cm

These bold compositions place the figures in the immediate foreground of the composition, to the extent that they almost seem to emerge from the pictorial space. The V-shaped compositions leave a space in the centre for a dramatic landscape which recedes into the far distance. The anatomical types and the monumentality of the figures recall Michelangelo, although Tintoretto has given them a rather soft and sensual feel. A masterly creator of space, he constructs depth with the alternation of brightly lit and shadowy planes. The figures gleam with colour, illuminated by a cold light which moulds the volumes from chiaroscuro effects. The artist uses a range of cold but bright colours of rather metallic hue, creating the volumes through the juxtaposition of swiftly-applied, loose brushstrokes and tonal variations. The execution is rapid and the resulting effect sketchy.

Tintoretto's genius as a painter can best be appreciated in his magnificent *Paradise*, a work of colossal dimensions which is a scaled-

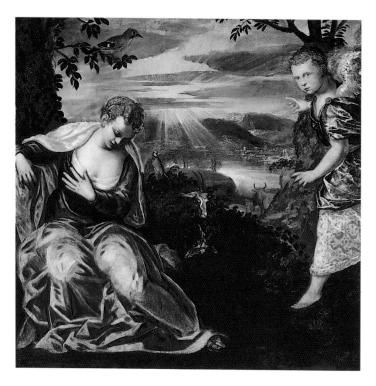

The Annunciation to Manoah's wife, c. 1555–1558
Oil on canvas, 150 x 155 cm

down canvas version of the composition in the Council Chamber of the Palazzo Ducale in Venice. Tintoretto creates a moving and direct vision of this religious subject, far removed from the precepts of classicism, using a complex and dynamic composition which centres on the Coronation of the Virgin, situated in the middle of the upper part of the work and portrayed as if seen from below. The spatial organization is complex, with a huge number of figures crowded into an undefined, almost irrational space. The illusion of depth is created through the inclusion of a foreground which is in shadow, with the figures backlit. This foreground is not continuous but rather distributed across bands of figures which arch across the canvas and converge upon the main scene: the Coronation of the Virgin.

The light which the canvas radiates seems to come from the Holy Spirit, so that the figures situated further into the painting directly receive this light, creating a luminous background against which the foreground figures are outlined. The enormous ensemble offers a highly varied repertoire of poses and gestures, moving figures, anatomical

Paradise, c. 1583
Oil on canvas,
164 x 492 cm

studies and backlighting. Overall, the painting is a display of Tintoretto's artistic abilities, the energy and imagination with which he imbued his works, and the particular sensibility with which he interpreted religious subjects.

Finally, we turn to the two portraits of Venentian Senators. While Titian was the portraitist of the glory and power of Venice, it has been said of Tintoretto that he was the Republic's moral conscience. The two Senators are depicted as serious, austere and severe. Their penetrating gaze is fixed on the viewer. Both are dressed in the ermine-lined robe of office and seem to emerge from the darkness; indeed, the black backgrounds seem to reinforce the sombre way in which they are depicted. Painted with a loose brushstroke, the execution is subordinated to the overall vision. The draperies and their details are characteristically sketchy in their execution, while the volumes are created from the juxtaposition of large areas of colour, as seen in the robe in the bust-length portrait, where red and black strokes create the folds.

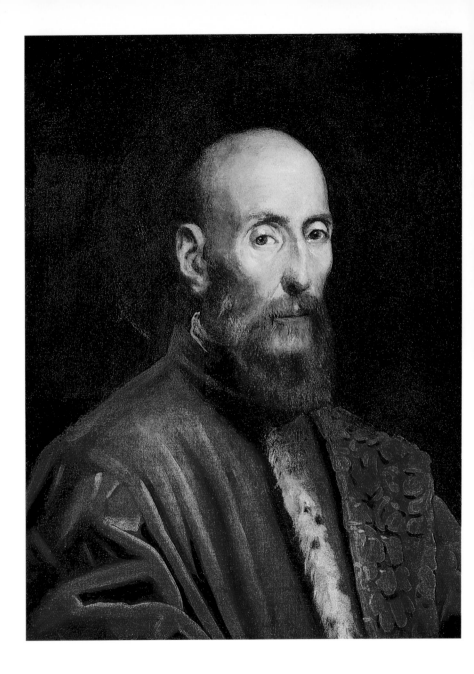

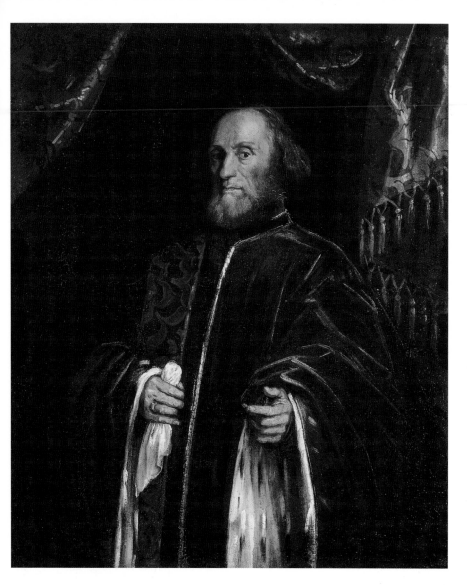

◄ *Portrait of a*
Senator, c. 1570
Oil on canvas,
118.5 x 100 cm

Portrait of a Senator, c. 1580
Oil on canvas,
63 x 50 cm
(Pedralbes)

Pastoral Scene,
c. 1560
Oil on canvas,
139 x 129 cm

Jacopo Bassano

BASSANO, 1515 – 1592

Jacopo da Ponte, better known as Bassano, was another great Venetian Mannerist who developed a new way of painting which was greatly acclaimed in his own time. The present scene is typical of the works which issued from his studio. Starting from the techniques of Titian and Tintoretto, Bassano went on to evolve a highly personal manner, both stylistically and thematically.

His great contribution to painting was his treatment of religious subjects as if they were genre or everyday scenes, coming close in this respect to the artistic traditions of the north. Bassano preferred to paint those religious subjects which would allow him to introduce peasants and animals, as in the present case, as well as fruits, vegetables, pots and pans. The figures are modelled with pronounced chiaroscuro and bold areas of colour, which create strongly three-dimensional forms. As in the present painting, Bassano generally places some figures with their backs to the viewer and others kneeling down with the soles of their feet facing outwards.

This pastoral scene actually depicts the Parable of the Sower, who is placed behind the group of women and children looking after the animals and preparing the meal. The subject offers the artist the chance to depict a genre scene with an ox, sheep, a dog, and, in the foreground, a group of objects such as a copper pot and a bowl. The expressive and spontaneous character of the scene gives it a great naturalness, reinforced by the integration of the group into the landscape, which plays an important role in the painting. Also typical of Bassano's style is the use of a mountainous landscape with a stormy sky.

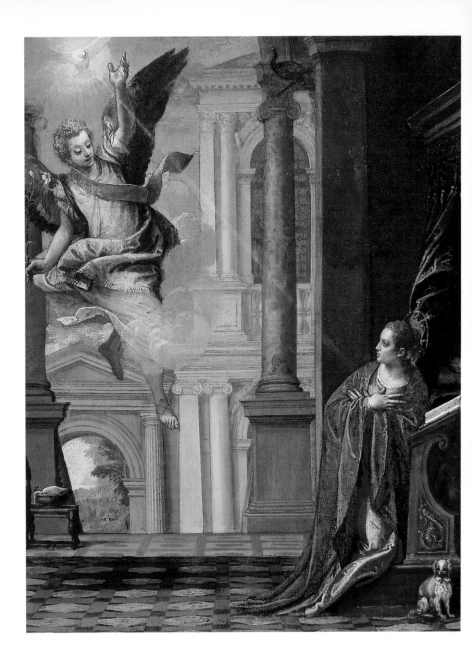

Paolo Veronese

VERONA, 1528 – VENICE, 1588

Paolo Caliari, known as Veronese, represents the classicizing trend with-
in Venetian painting of the second half of the 16th century. His work can
thus be seen as the counterpart to the emotional tendency personified
by his contemporary Tintoretto, although each undoubtedly also exerted
an influence on the other.

As can be seen in *The Annunciation*, Veronese had a complete mas-
tery of perspective, creating magnificent illusionistic architectural set-
tings in the most refined classical style. Here space is divided into two
distinct fields. The foreground, where the Annunciation is taking place,
is demarcated by the patterned tiling on the floor. Where this floor ends,
we encounter a space open to the light, in which stands an ensemble of
monumental architecture offering a glimpse of countryside through an
arch. The classicism is obvious not only in the architecture but also in
the balanced composition and the contained character of the scene,
accentuated by the cold tones and by the poses of the two protagonists.

The same restrained and rather distant pose appears in the *Por-
trait of a Woman with a Lapdog*, emblematic of the wealth and luxury of
the Venetian aristocracy, which Veronese well knew
how to evoke in his paintings. The elegance and the
rather distant manner of the sitter recalls Mannerist
portraiture. The detail of the lapdog (which also ap-
pears in *The Annunciation*), together with the sitter's
refined clothes, evokes the pleasurable world of the
Venetian aristocracy, which was to become one of the
key elements of the myth of Venice. It could be said
that Veronese is more interested in recording the sit-
ter's external appearance and thereby her social status
than in expressing her individual personality. Although
this "superficiality" results in some rather cold por-
traits, lacking expressiveness, they are nevertheless
of value in that they reveal the new tastes of Venetian
aristocratic society at the end of the 16th century.

PAVLVS
VERONENSIS

◄ *The Annunciation*,
c. 1560
Oil on canvas,
110 x 86.5 cm
(Pedralbes)

*Portrait of a Woman
with a Lapdog*,
c. 1560–1570
Oil on canvas,
105 x 79 cm

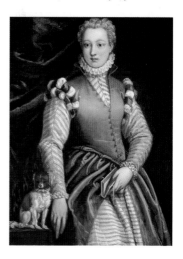

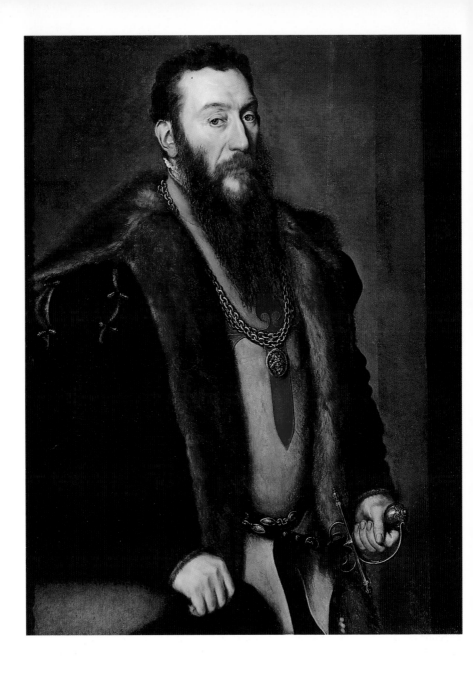

Anthonis Mor

UTRECHT, 1517 – ANTWERP, 1576

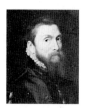

Antony Moro.

Anthonis Mor, also called Antonio Moro or Anthonis van Dashorst Mor, was above all a magnificent portraitist, working at the court of Charles V and Philip II in the Spanish Netherlands. A pupil of his uncle Jan van Scorel, from 1549 he enjoyed the protection of Cardinal Granvella, with whom he travelled to Rome. This trip brought him into contact with the works of the great Cinquecento masters and with Mannerism. He combined the sharp eye for a close likeness characteristic of Netherlandish painting with the portrait style of Titian, which glorifed the symbolic importance of the person portrayed. His works fuelled the spread of a new type of portraiture which was greatly esteemed in the royal houses of Europe, and in which the sitters, painted full-length and with the attributes of their rank, have an air of authority and dignity .

This portrait of Giovanni Battista di Castaldo belongs within that convention. The sitter was an illustrious Neapolitan soldier who fought in the service of Charles V and took part in important military actions such as the Battle of Pavia and the victory at Mühlberg. He is shown standing with his sword at his side and the cross of the Order of Santiago on his breast. The dignity of his character, looking out at the viewer with a lofty and distant expression, is reflected in his pose and deportment as well as in his plain but luxurious dress.

The handling is very painterly and follows Titian's style, using little precise drawing, although at times the brushstroke becomes finer to depict the ornamental details (for example, the hilt and belt of the sword and the heavy gold chain). The figure is outlined against a neutral background whose sole feature is the sketchily-rendered table, which we recognize as such because the sitter leans his hand on it. The overall simplicity of the painting further emphasizes the physiognomy of the sitter, which Mor has treated with care. The face reflects the details of the skin, with its varied tones and colour gradations, and the features are highly individualized. What is striking above all is the serious and shrewd expression of Castaldo's eyes, marked by the experiences of life, which look out at the viewer and give the portrait an extraordinary force and realism.

Portrait of Giovanni Battista di Castaldo,
c. 1550
Oil on panel,
108 x 82.5 cm

Adriaen Tomasz Key

ANTWERP?, C. 1544 – C. 1589

Little is known about the artist, who worked as a portraitist in the city of Antwerp during the second half of the century and in whose work we can see the influence of William Key and Anthonis Mor.

At the time when Key painted this work, the northern Netherlands were in full revolt against Spanish rule and against the Spanish king Philip II. The confrontation was started in 1566 by William of Orange and would last nearly a century, until 1648, when Spain recognized the independence of the Republic of Holland under the so-called Peace of The Hague. In 1579, the year this portrait is dated (as visible upper left), William of Orange took part in the formation of the Union of Utrecht, in which the northern Netherlandish provinces declared themselves Calvinist, resulting in a religious schism. That same year he published his *Apologia*, which attacked the rule of the Spaniards and gave rise to the "Black Legend". Philip II saw William as a serious enemy and a threat to his imperialist and religious aspirations, and in 1584 William was assassinated.

The present portrait therefore depicts the 46-year-old sitter at a crucial moment in his life. With the naturalism typical of the painting of the North, the artist offers an objective vision of William, devoid of any idealization. The weather-beaten face with marked lines and a large nose directs its gaze at the viewer – a device often used at this period to give the portrait greater realism. The handling is precise and the underdrawing is important in the definition of the forms, also achieved by the tonal gradations of the skin.

The large white ruff which was fashionable in the late 16th century and the brocaded jacket are drawn with precision and detail. The ruff frames and emphasizes the face and creates the main focus of light in the painting, while the rest of the figure – the hair, cap and clothing – almost blends into the dark background.

ADRIANVS·
THOMÆ·KEIj

Portrait of William I, Prince of Orange, called "Wiliam the Silent", 1579
Oil on panel,
45.3 x 32.8 cm

*The Massacre of
the Innocents*, 1586
Oil on panel,
77.5 x 108 cm

Lucas van Valckenborch

LOUVAIN, C. 1535 – FRANKFURT, 1597

This work marks the chronological conclusion of the Netherlandish painting of the 16th century and heralds, both stylistically and thematically, the new trends which would emerge in Holland over the course of the 17th century, and which would result in a distinctly Dutch style separate from the Baroque prevailing in the rest of Europe. This style would embrace independent genres such as scenes of everyday life and landscape painting.

Valckenborch was a Flemish artist and a pupil of Pieter Brueghel the Younger, whose style he follows very closely in this painting. The subject is the massacre of the children carried out on the order of Herod, following the prophecy that a child born in Bethlehem would be the new king of the Jews and would bring Herod's rule to an end (in the chronology of the infancy of Christ, the Massacre results in the Flight into Egypt, a very popular subject in 16th- and 17th-century painting). At first sight, however, the very small scale of the figures in the painting makes it difficult to identify what they are doing and gives the painting more of the character of a scene of daily rural life.

The scene takes place in a characteristically Netherlandish landscape. The painter has aimed to emphasize the non-essential elements such as the houses, trees, snow and sky and has relegated the figures to a secondary role. The main point of the story is therefore integrated within the overall composition, in contrast to the classicizing aesthetic, where the landscape generally serves as a backdrop to the story. Valckenborch is by no means unaware of the drama of his subject, however; in fact, he emphasizes it in his depiction of a cold and blustery day with heavy storm clouds, giving him the chance to experiment with tonal gradations in greys and whites and to unify the colour of the sky and earth through the tones of the snow. This winter landscape is related to the theme of the seasons of the year which dates from the late medieval period and which was taken up and developed by Pieter Brueghel the Elder. It would also be a motif frequently painted in the 17th century.

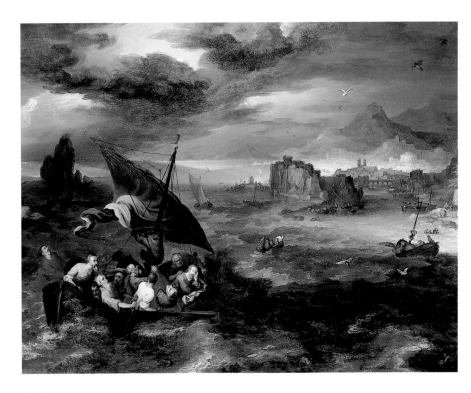

*Christ in the Storm
on the Sea of Galilee,*
c. 1596
Oil on copper,
26.6 x 35 cm

Jan Brueghel the Elder

BRUSSELS, 1568 – ANTWERP, 1625

At the end of the 16th century a growing interest in the study and representation of nature developed in the Netherlands. The artists who started this trend were Patinir, who painted religious subjects, and Pieter Brueghel the Elder in his paintings of country labours and the seasons of the year. Both artists used their subjects as an excuse to depict extensive landscapes. Alongside landscape, other subjects considered of minor artistic importance at the time, such as scenes of daily life and still lifes, formed the new category of "genre painting". This growing interest in small-format genre paintings, which were issuing from Flanders and Holland, came from the new wealthy urban middle classes, who acquired them to hang in their homes. As a consequence, many painters specialized in the genre. Jan "Velvet" Brueghel was the most important representative of this genre in Flanders. The son of Pieter Brueghel the Elder, his paintings included scenes of popular festivals, still lifes and landscapes with figures (including the present work).

Jan Brueghel, whose descriptive powers were greatly valued in his own day, here deploys his masterly and highly detailed technique to evoke a panoramic view of a bay lashed by a storm. A great colourist, capable of producing delicately nuanced areas of colour – hence his nickname of "Velvet Brueghel" – he has here constructed a broad composition with a distant horizon where green and blue tones predominate, reflecting the effects of the stormy sky on the landscape. The gradations of colour reproduce the rich atmospheric effects and create the sensation of depth. Against a greenish background the red tunics of the disciples add warm notes of colour. Each man is occupied in trying to keep the little boat afloat, apart from Christ who seems calm: in an expressive pose He leans His head on His arm and seems to be thinking or sleeping. The scene is completed with numerous other elements: the other boats returning to shore, the small figures dotted along the shoreline, the birds in the sky and the city in the distance, in which we can make out a castle, church, bridge and windmill – all within the tiny format of this copper panel.

PAGES 236/237:
Detail of illustration
page 260

PAGES 238/239:
Detail of illustration
page 293

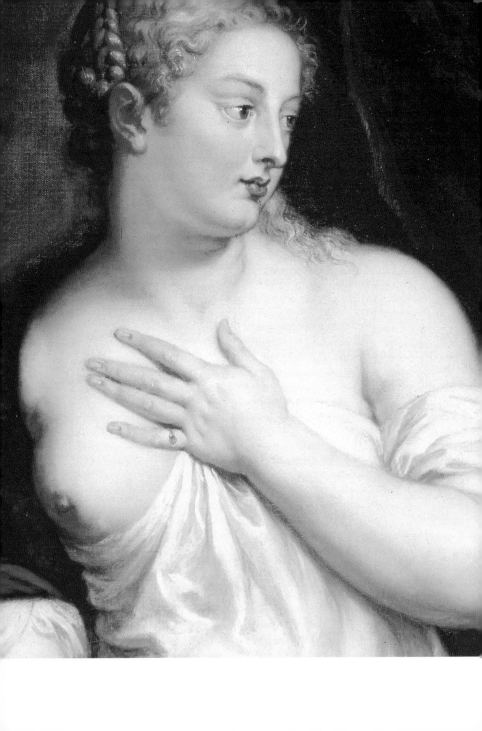

The 17th Century

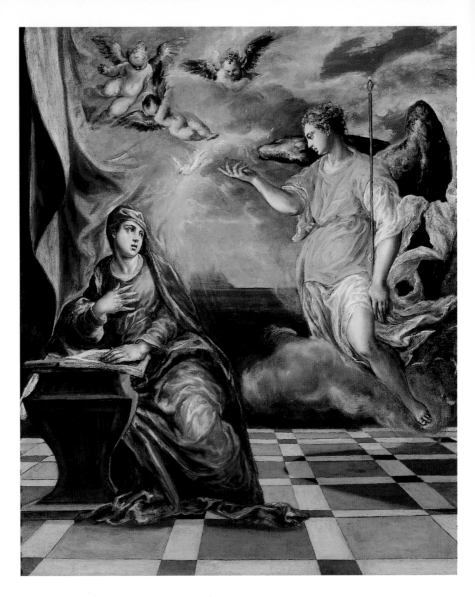

*The Annunciation
(Italian period),*
c. 1567–1577
Oil on canvas,
117 x 98 cm

El Greco

CANDIA, CRETE, 1541 – TOLEDO, 1614

Born in Crete, which was at that time under Venetian rule, Domenikos Theotokopoulos was trained in his native city, where the methods of painting he learnt were still based on the traditions of Byzantine art. In 1568 he moved to Venice and shortly after that travelled to Rome. These Italian years were decisive in his development as an artist, as he arrived at a moment of great artistic innovation. El Greco absorbed Venetian and Roman influences, as can be seen in *The Annunciation* painted in 1565–1577, in which the palette, spatial conception and general dynamism recall the work of the great Venetian painters of the period. Space is created by the orthogonals of the receding floor tiles as in works by Tintoretto and Veronese, although other spatial references are rather lacking. On the left, a large curtain only serves to reinforce the predominance of pure colours in the painting: next to the red the artist places the blue of the Virgin and the yellow of the angel, all within a generally light tonality. El Greco's distinct personality and pronounced spirituality are already evident in this early work, in the rapid and nervous line and the emotional quality which it transmits.

Δομήνικος
Θεοδοκόπουλος ἐποίει

Around 1577 El Greco travelled to Spain, where he settled permanently in Toledo. There he established a large workshop, producing major altarpieces as well as easel paintings. He tried unsuccessfully on a number of occasions to enter the service of Philip II at El Escorial. However, his style brought him great success in the scholarly and ecclesiastical circles of Toledo and its surrounding region, and even in Madrid, where he was commissioned to paint the now lost altarpiece of the Colegio de Nuestra Señora de la Encarnación. *The Annunciation* of 1596–1600 is a preparatory study for the painting now in the Prado which was at the top of that altarpiece. In it, as in the painting of *Christ holding the Cross*, El Greco's mature pictorial language is fully expressed.

The differences between this and the earlier *Annunciation* are obvious. In the later painting, the artist has abolished all reference to a real spatial setting, enveloping the whole in a supernatural atmosphere which heightens the spiritual values and religious feeling of the work.

"I have found a man, a great, unbelievably gifted man: Greco. A man from Rembrandt's day and yet as close to us as a contemporary."
JULIUS MEIER-GRAEFE, 1910

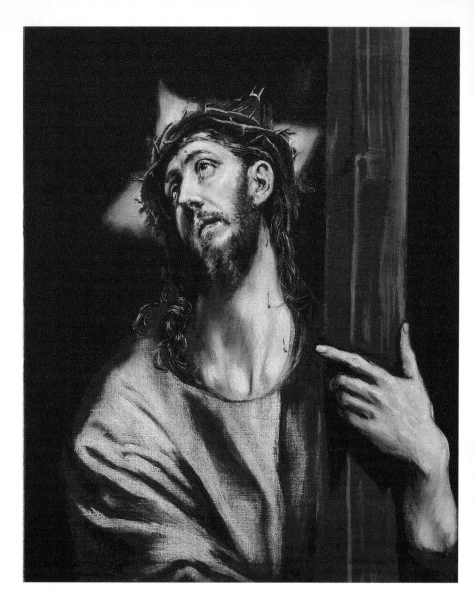

*Christ holding the
Cross*, c. 1602–1607
Oil on canvas,
66 x 52.5 cm

The Annunciation,
1596–1600
Oil on canvas,
114 x 67 cm

This is further accented by the extreme stylization of the figures, whose proportions are distorted to achieve a greater lightness and spirituality. The figures float in space, filling it with trembling movement and colour. In the lower part, Mary listens to the good news brought by the archangel Gabriel, while in the upper part is a glory of angels, often used by El Greco in his religious paintings.

The small putti found in the other *Annunciation* here become a group of musical angels. Between the upper and lower figures the Holy Spirit irradiates light onto the Virgin. The treatment of both groups is identical, however; there is no distinction between the heavenly and earthly spheres, as the artist deliberately removes the *Annunciation* from any specific setting in time or space in order to emphasize the supernatural nature of the event.

The same can be said of the *Christ holding the Cross*, which El Greco treats in an emblematic way. His intention was to create a symbol of Jesus as God the redeemer of humankind. He does not show the pain and suffering experienced by Christ as a man, but rather a much more spiritualized iconography. Christ is the Son of God with the symbols of His sacrifice. The painting allows for a detailed analysis of El Greco's style: it involves stylization, whitish flesh tones, distortion of the anatomy and volumes in search of a greater expressiveness, the latter further heightened by the look on Christ's face, the fractured shapes and a loose and pastose handling. El Greco's highly personal style did not create a school of followers, and for many years he was considered a strange and exaggerated painter of little merit.

The Immaculate Conception,
c. 1607–1613
Oil on canvas,
108 x 82 cm

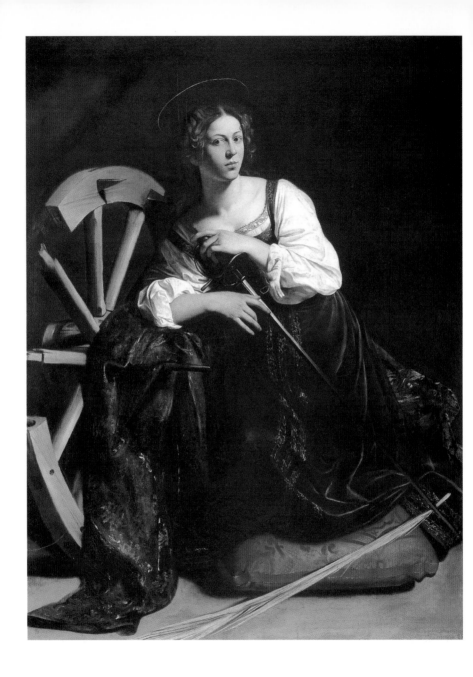

Caravaggio

BERGAMO, 1571 – PORT' ERCOLE, 1610

At the end of the 16th century two different artistic tendencies rejected the artificiality of Mannerism and sought clearer and more direct modes of expression, albeit by different routes. These two trends were represented by Caravaggio, who opted for naturalism in Rome, and the Carracci family, who embraced classicism in Bologna. With their work the new Baroque style emerged, spreading throughout Europe from 1630.

Michelangelo Merisi, known as Caravaggio after the town from which his family originated, was one of the great masters of western art. His personal artistic language represented a fresh and original approach to composition and subject matter, influenced – as with all Baroque art – by the spirit of the Counter-Reformation and using the painted image as a means to propagate Christian values and the supremacy of the Catholic Church. Caravaggio travelled to Rome under the patronage of Cardinal del Monte, who commissioned the present painting. Del Monte, a patron of the arts and sciences, surrounded himself with a circle of scholars and intellectuals including Galileo. It was within this ambience of philosophical and rational thought that the new trend towards realism in painting developed.

As can already be seen in this early work, Caravaggio introduces two important elements into the depiction of a religious subject: a sense of naturalism derived from his use of real models drawn from the ordinary working classes, plus a typically Baroque sense of drama which arouses powerful and immediate emotions in the viewer. This latter is reflected in the gestures and expressions of the figures and in the use of tenebrism, with its strong shadows, and also in the staging of the figures within enclosed settings against dark backgrounds so as not to divert attention from the principal episode. Caravaggio's exaggeratedly realistic style, using working-class models drawn in great detail and with little concession to beauty, brought him much criticism as his work was considered indecorous. But although he had few followers in Italy, his influence was felt in Spain, France and the Netherlands.

"Ribera, Vermeer, Georges de La Tour and Rembrandt could never have existed without him. And the art of Delacroix, Courbet and Manet would have been utterly different."
R. LONGHI, 1920

St Catherine of Alexandria, c. 1597
Oil on canvas,
173 x 133 cm

Ludovico Carracci

BOLOGNA, 1555–1619

Lo. C.

As noted above, Baroque art was born in two Italian cities – Rome and Bologna – as a consequence of the rejection of Mannerism. In Rome, Caravaggio began the trend towards naturalism, while in Bologna the Carracci brothers ran a highly successful workshop whose underlying aesthetic was a return to 16th-century classicism with its implications of rule and order. In contrast to Caravaggio, who attracted many critics during his lifetime, the Carracci's classicism was extremely successful amongst aristocratic circles and produced a school with numerous followers. Annibale Carracci headed the workshop, which also included his gifted cousin Ludovico, painter of the present work.

The scene is subordinated to a geometric compositional order, marked out by the strict classical architecture of the background which structures the pictorial space into horizontal and vertical bands. The protagonists – the Virgin, the Infant Christ, the elderly Simeon stretching out his arms to the Child, the prophetess Anna with her prophecy inscribed on the marble tablet, and Joseph on the left – are arranged in an orderly way in the foreground with stately gestures and poses. However, the influence of Roman art leads Ludovico Carracci to introduce some more dramatic elements, such as the contrasts of lighting which create large areas of shadow, and the tense gesture of the prophetess Anna which adds a note of unease. The forms arise out of a draughtsmanship which traces their contours with precision, as can be seen above all in the figure of the Virgin, who stands out from the other figures through the more intense light falling on her. The white cloak which covers her head, the sleeves and the cloth on which she presents the Infant Christ are drawn with great sharpness, and the composition as a whole is predominantly linear. Ludovico's painting aimed to revive the balance and harmony of the Cinquecento style, with its deeper roots in greco-roman art. In 1580 this interest led him to found, together with his cousins Annibale and Agostino, an Academy in Bologna for the study of life drawing, history and mythology. Among Ludovico's pupils were important artists such as Guercino, Preti and Crespi

The Presentation in the Temple, c. 1605
Oil on canvas,
122 x 91.5 cm

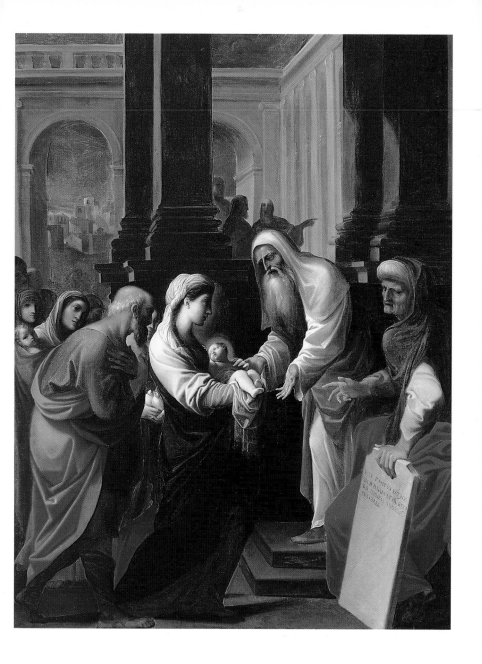

Tommaso Salini

ROME, 1575 – C. 1625

Tommaso Salini was a Roman artist and contemporary of Caravaggio, whose influence in the present work is obvious, despite the fact that the two artists were enemies in their lifetimes (Caravaggio's strange and aggressive nature earned him many such foes). This painting was executed in the year of Caravaggio's death and shows many characteristics of his late work. The lighting, known as "tavern lighting" because of its artificial and highly focused quality, results in a most pronounced chiaroscuro to the extent that part of the figure blends almost completely into the dark background. A firm draughtsmanship dominates, crisply delineating the carefully elaborated forms. The different areas of the painting pass from light to dark with abrupt contrasts and no intermediary gradations. This effect of tenebrism gives the work a highly dramatic, theatrical feeling.

The young man is depicted in a spontaneous unstudied pose. His general appearance suggests him to be a working-class model, while his carefree smiling expression is brilliantly captured. However, it is not so much the figure that gives this painting its character as the representation of the group of cabbages and other vegetables in the foreground, which are painted in great detail and given considerable importance within the composition. In fact, Salini is remembered as an excellent painter of fruits, vegetables and other objects from nature. The trend towards naturalism initiated by Caravaggio was accompanied by the rise of a new type of painting, the still life, of which Caravaggio himself bequeathed us a number of examples. From the emphasis placed on the vegetables and the wine flask in the present painting, it could almost be ascribed to this new genre.

Young Peasant with a Flask, c. 1610
Oil on canvas,
99 x 73 cm

Domenico Fetti

ROME, 1589–VENICE, 1624

Born and trained in Rome, in 1614 Fetti moved to Mantua to work in the service of Duke Ferdinando Gonzaga. He also worked in other parts of Tuscany and in Venice. Fetti painted mythological and religious subjects, infusing them with an anecdotal flavour which links him to the Bassano brothers. His work also reveals the influence of the so-called *bamboccianti*, a group of Flemish and Dutch artists based in Italy in the 17th century, whose genre scenes of peasants in landscapes populated by small-scale figures were highly esteemed.

While Caravaggio's influence can be detected in Fetti's naturalistic way of depicting the figures and the use of a pronounced chiaroscuro, thr latter's style is closest to the Venetian school in his use of colour and his conception of landscape, as well as in his loose brushstroke. He uses a warm palette with nuances of brown and gold, against which the pink of the Samaritan's robe stands out. The painting depicts the parable of the Good Samaritan from the Gospel of St Luke: a Samaritan, finding on the road a man who has been attacked and badly wounded by robbers, takes him up on his own donkey and looks after him until he recovers. Before the Samaritan arrived, a priest and a Levite had already passed by without helping the wounded man. These two figures are shown leaving the scene on the left between the trees.

During the course of his life, Fetti painted numerous works based on the parables in the Gospels. The Museum houses another work by him of the same size and style which forms a pair with *The Good Samaritan* and represents the Parable of the Sower.

The Good Samaritan,
c. 1610–1623
Oil on panel,
59.6 x 43.7 cm

Le Valentin

COULOMMIERS, 1591 — ROME, 1632

M Valentin

During the first decades of the 17th century, painting in France was still dominated by Mannerist tendencies. A number of young French artists who travelled to Rome to study, however, came under the influence of Caravaggio's naturalism and tenebrism, creating a group known as the French Caravaggisti who, on returning to their own country, introduced the Baroque style. The most outstanding of these artists was Le Valentin (also known as Valentin de Boulogne), of whose short life we know little, although we do know that he was in Rome in 1616. There he specialized in paintings of everyday subjects, although he also produced some religious works, including this one, which is based on the biblical account of the victory of the young shepherd David over the giant Goliath.

The canvas closely follows Caravaggio's naturalistic approach, both in terms of form and content. A strong chiaroscuro governs the scene, highlighting the figure of David. The artist has created a compact group of half-length figures situated behind a table on which David has rested the decapitated head of Goliath, all set against a dark background which could be a wall and which serves to block any recession into depth, creating a very shallow foreground space.

The artist does not avoid the gory aspect of the scene and there are even traces of blood on the table. The features of the figures themselves are probaby based on real models. They are represented in spontaneous and expressive poses which the tenebrist treatment helps to accentuate. David's expression is tense and grave, while the soldier on his right shows his surprise at the giant head.

The characteristics of the different materials and textures are picked out by the light, which highlights the gleaming surfaces of the swords, helmet and breastplates, for example. While the soldiers are dressed in 17th-century fashion, David is shown in a more timeless garb, his breast almost bare and with a lambskin tied around his shoulder in reference to his work as a shepherd boy.

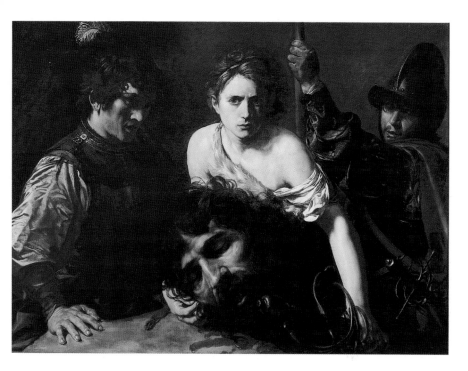

*David with the Head
of Goliath and two
Soldiers*, c. 1620–1622
Oil on canvas,
99 x 134 cm

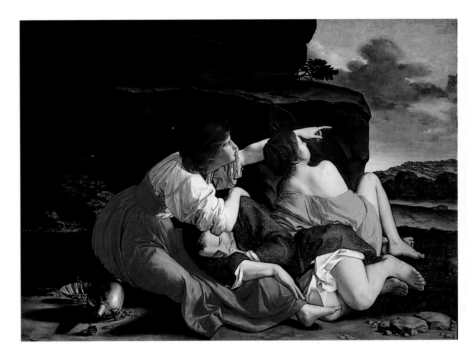

Lot and his Daughters,
c. 1621–1623
Oil on canvas,
120 x 168.5 cm

Orazio Gentileschi

PISA, 1563 – LONDON, 1639

A follower of Caravaggio, Orazio Gentileschi painted in Italy and elsewhere in Europe, disseminating his own interpretation of tenebrism. Born in Pisa, he moved when still very young to Rome. There he subsequently met Caravaggio, who was to have a profound influence on his style, which was originally tied to Mannerism. He also worked in Genoa, Turin and Paris. In 1626 he travelled to London on the summons of Charles I, and was one of the first artists to introduce the Caraveggesque style into England.

As we can see in the present canvas, Gentileschi took from Caravaggio his crisp draughtsmanship, linear emphasis and clean, smooth surfaces, as well as his theatrical compositional style. However, he uses a very gentle chiaroscuro and lacks Caravaggio's drama; in general his paintings are lyrical in character. This is evident in *Lot and his Daughters*, which avoids the shocking aspect of the story. The scene is taken from a passage in the Book of Genesis: after the destruction of Sodom and Gomorrah Lot made his home in a cave with his two daughters. The two women decided to make their father drunk in order to sleep with him and thus ensure the continuation of the family, as there were no other men left. The picture refers to the story in a delicate way, showing Lot asleep, leaning on one of his daughters in general disarray. On one side a flagon and a cup or scalloped bowl refer to Lot's drunkenness.

"… as Longhi pointed out, he [is] the most pertinent forerunner of certain aspects of Dutch painting."
A. PÉREZ SÁNCHEZ, 1970

The arrangement of the figures is very interesting, particularly that of the two daughters, one shown completely from behind and both looking at an indeterminate spot in the background, possibly at the rain of fire which had fallen on the two cities. The artist has created a compact and coherent group with regard to the poses and the relationship between the figures, as well as in the colour rhythms and lighting effects. The figures are presented very naturalistically in spontaneous and lifelike attitudes. The effects of light falling on them create subtle tonal gradations. In addition, the landscape in the background adds clarity and perspective to the scene, giving it an entirely different feel to the tenebrism of Caravaggio.

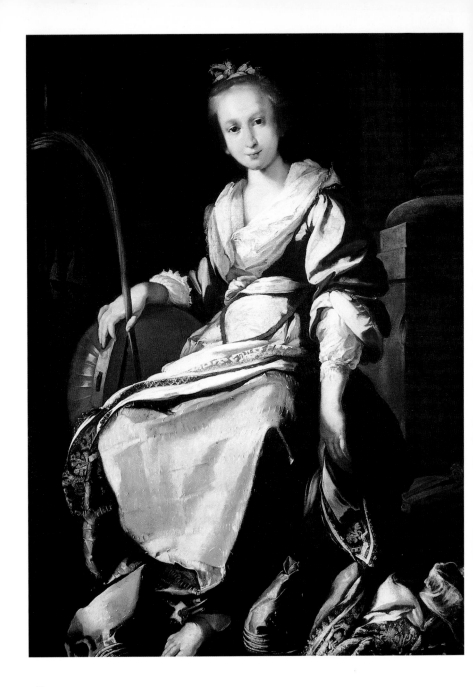

Bernardo Strozzi

GENOA, 1581 – VENICE, 1644

In the 17th century paintings became increasingly constructed on the basis of the effects of light on forms. Artists were fascinated by reflections and shadows and in general by the potential for tonal gradations offered by light, as well as by its intrinsic sculptural qualities. Strozzi was amongst those who followed this route, as can be seen in this *St Cecilia*, one of his most characteristic works.

Active in Genoa until 1630 when he moved to Venice, by the time he came to paint this work Strozzi may have already encountered the work of Rubens, which was to influence his own style profoundly. *St Cecilia* appears to reveal elements of the Flemish artist's work, such as the lightness and rapidity of the brushwork, the painterly tone and the large scale of the figures. The saint is richly dressed in keeping with her status as the daughter of a noble family, who was martyred for publicly defending Christianity and for refusing to worship pagan gods. The texture and gleam of the silks and the sumptuous quality of the brocades are rendered with great skill.

In this *St Cecilia* we note the artist's interest in colour, evident even before his move to Venice. Soft and delicately graduated pastel tones are emphasized by the light against a dark background, in which the viewer can only just make out the base of a column, giving the images a dramatic and theatrical feeing very much in line with 17th-century taste. Strozzi also uses chiaroscuro in a way which recalls Caravaggesque tenebrism, creating strong contrasts of light and shade in the folds of the dress. The face is treated differently, however, with a gentle tonal modulation, creating a sweet and clearly idealized aspect, reflecting the saint's virtuous character. Overall, the painting is decorative but at the same time restrained, in line with academic precepts.

Prete Genuese p.

St Cecilia, 1623–1625
Oil on canvas,
150 x 100 cm

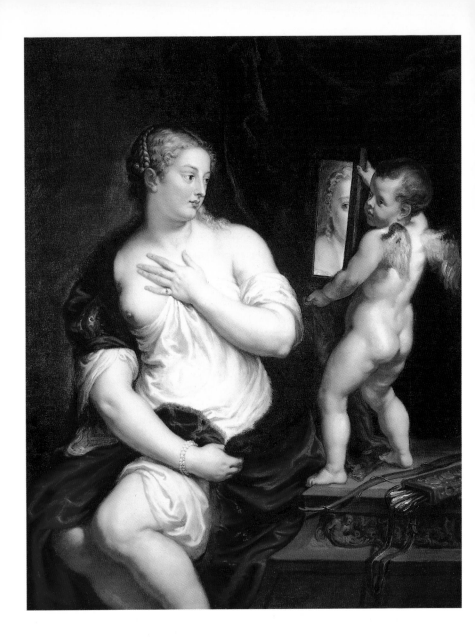

Peter Paul Rubens

SIEGEN, 1577 – ANTWERP, 1640

Rubens' painting has been considered the prototype of the Baroque style. His work, filled with vitality, dynamism and colour, is one of the most brilliant manifestations of the triumphal Baroque mode, associated with the taste for pomp and ceremony in Catholic Europe. The four works by his hand in the Thyssen-Bornemisza Collection are good examples of this style and also of the different genres in which he worked: religious painting, mythology and portraiture. They also demonstrate the various techniques which he employed according to the nature of the subject.

The paintings were all executed shortly after Rubens settled in Antwerp, having previously spent a number of years in Italy, largely in the service of the Duke of Mantua. From Mantua Rubens travelled to Rome and Venice, studying the works of the great Italian artists such as Michelangelo, Raphael, Titian, Tintoretto, Correggio and Caravaggio. A scholarly and cultivated man, Rubens – like other of his artist contemporaries, such as Velázquez – undertook diplomatic missions. Thus in 1603 he was sent as ambassador to Spain, where he spent one year. Following his move to Antwerp, where he worked as court painter to the Spanish Archduke Albert, Rubens would return to visit Spain in 1626.

Venus and Cupid provides an introduction to his mythological work and also to his ideal of female beauty. Although it is a copy of an original by Titian, Rubens develops his own characteristic style of splendid and opulent female beauty which has brought his work universal fame. He uses a rich and contrasting palette of light tones, while the looseness of the brushstroke and the bright and uniform lighting serve to soften the contours, giving the painting a feeling of gauzy lightness.

This characteristic is more pronounced in the *Virgin and Child with St Elizabeth and the Infant St John the Baptist*. In this work the brushstroke is looser, more agile and more obvious. The group provide the opportunity to paint flesh tones, from the Virgin's delicate pallor to the glowing pinks of the children and the more weather-beaten face of the elderly St Elizabeth. The vitality and life of Rubens' art is here reflected

"Then comes Rubens, who had already forgotten the traditions of simplicity and grace. He created a new ideal through sheer force of genius. Strength, striking effects and expressiveness are pushed to their limits."
EUGÈNE DELACROIX

Venus and Cupid,
1600–1608
Oil on canvas,
137 x 111 cm

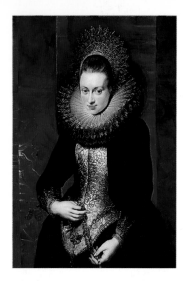

*Portrait of a Lady
with a Rosary,*
c. 1609/10
Oil on panel,
107 x 76.7 cm

in the composition and the poses of the figures, as well as in the brilliant colouring of the clothes and skin tones. The group is balanced by the coldness of the background, which is painted in subtle gradations of blues and greys.

The Blinding of Samson, which is a preparatory study for a later painting, accentuates the drama of the subject through the twisting poses of the figures, their violent movements and the disorderly crowding of the figures in a type of composition frequently used by the artist. The subject is an episode from the Old Testament, which relates how Delilah arranged for a group of Philistines to blind Samson. The painting reproduces the moment of his blinding. Delilah, in the foreground with her back to the viewer, is depicted in violent foreshortening in her attempt to separate herself from Samson.

Finally, the marvellous portrait of an anonymous lady shows a completely different side to Rubens' work, indicative of his technical mastery, which enabled him to adapt himself to whatever genre was required. This expressive and realistic portrait is painted in a very detailed technique which takes pleasure in depicting the decorative elements of the sitter's dress. Despite their richness and profusion, however, these do not distract from her face, which stands out not simply in chromatic counterpoint, but above all because of the personality which it exudes.

► *The Virgin and Child
with St Elizabeth and
the Infant St John
the Baptist*, c. 1618
Oil on canvas,
151 x 113 cm
(Pedralbes)

PAGES 264/265:
*The Blinding of
Samson*, 1609/10
Oil on panel,
37.5 x 58.5 cm

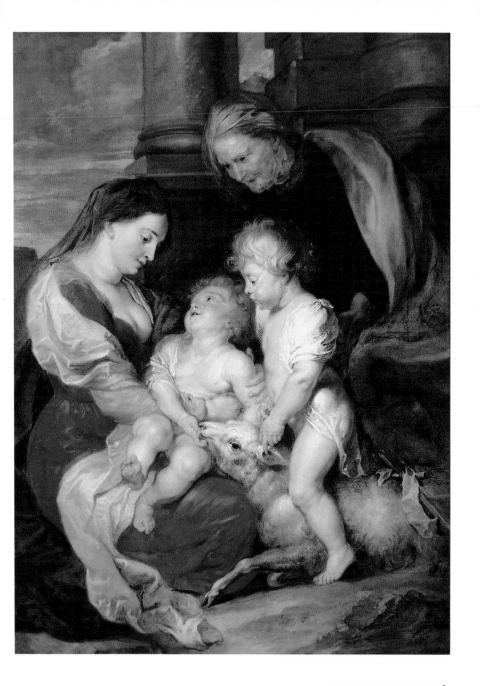

Ambrosius Bosschaert the Elder

ANTWERP, C. 1573—THE HAGUE, 1621

The subject of flowers in vases, closely linked with the still life, has its origins in the art of the Middle Ages, in which flowers were frequently depicted within religious paintings, sometimes with symbolic meaning. Their considerable decorative value meant that they were still used in Renaissance art, but it was only in the 17th century that a separate genre of flower painting developed. In Holland it developed parallel to so-called genre painting – scenes of daily life, landscapes and still lifes – and was the domain of specialist painters such as Bosschaert.

Painted in a highly detailed and meticulous way, this painting reproduces with great exactness a large number of different types of flowers as well as various insects (butterflies, flies, a caterpillar, etc). Aiming for the same realism as Dutch artists, Bosschaert depicts a bunch of wild and cultivated flowers with the accuracy of a botanist. This scrupulous attention to detail also extends to the vase, identifiable as Chinese porcelain of the Wan Li type. The whole composition has an exquisite quality due both to the costly vase and to the flowers within it.

The painting focuses totally on the vase, which is cleanly outlined against a plain background, painted in delicate greens and browns which harmonize with the flowers. The vase is placed on a dark surface which may be a table. The flowers are striking for their variety, bright colours and varied shapes, arranged in front of a layer of darker leaves and branches which seem to be in shadow. The fall of the light creates strong contrasts which serve to highlight each one of the different types of flowers. These contrasts also give the mass of flowers a coherent sense of volume.

Chinese Vase with Flowers, a Shell and Insects, 1607 Oil on copper, 68.6 x 50.8 cm

*Mountainous Landscape
with a Castle,* 1609
Oil on panel,
45.6 x 63 cm

Roelandt de Savery

COURTRAIT, 1576–1639

Savery initiated a genre which was to enjoy great success in 17th-century Holland. While landscape had begun to take on greater prominence in the 16th century, it still generally appeared as the background to a historical or mythological painting. However, in the 17th century – often called "the Golden Age of Dutch Landscape" – it evolved into an independent art form and reached new heights of artistic expression. Savery was one of the pioneers of the genre in Holland, where he arrived having worked in Prague in the service of Emperor Rudolf II. The Emperor sent him to the Tyrol around 1604 to make sketches for his landscapes, and these inspired numerous works. From 1619 Savery lived in Utrecht, where he remained until his death.

R · SAVERY

The present painting reproduces a mountainous spot in the Tyrol. Savery's paintings are based on the sketches which he made out of doors, but in transferring them to panel in his studio he probably made some changes in order to give his composition a suitable balance. Savery distributes the colours to achieve the sensation of depth, with a gradation of tones from dark brown to green and blue leading the eye from the elements closest to the viewer to the mountains in the far distance. The shadowy, almost backlit foreground is a Mannerist device which also evokes spatial depth.

Also notable are the diffused paintstrokes which aim to create a unified atmosphere and an impression of an overall ensemble, rather than simply the representation of numerous separate elements as was previously the tendency in northern painting. At the same time, the landscape envelops the viewer in a poetic and rather fantastical atmosphere which was to become another feature of Dutch 17th-century landscape in the work of Seghers.

Master of the Monogram IDM

These two works are painted by an artist in the circle of Joos de Momper. They depict two probably imaginary views of the Italian countryside. As described earlier in the context of the work of Jan Brueghel, the genre of landscape became an important one in Flanders in the 17th century. These two paintings may form a pair. Their dimensions are almost identical and their compositions are symmetrically conceived. Their foregrounds both feature buildings at the edge of the picture which extend the full height of the painting. Below them, a small inlet acts as a natural harbour to some little boats, from which some men are unloading sacks. In the centre the river flows peacefully into the distance, reflecting the trees and houses along its banks. A fairly low horizon situated about half way up the canvas provides space for a broad and luminous sky dotted with some golden-toned clouds.

The paintings have a high level of finish and are technically extremely well executed. They are created on the basis of a precise and detailed draughtsmanship with which the artist creates a series of picturesque details of daily life set within a broad landscape full of anecdotal details. The paintings are nevertheless subordinated to a compositional order and a chromatic harmony which unifies the overall ensemble. This is one of the factors indicating that they may depict imaginary views.

Joos de Momper travelled through Switzerland and Italy, painting landscapes which he imbued with a bright Mediterranean light. Although a question mark still hangs over the attribution of these two paintings, de Momper's style is certainly evident, and they were undoubtedly painted by an artist of his circle. There are also stylistic similarities with contemporary Dutch landscape painters such as Salomon van Ruysdael, who developed landscape as an independent genre with few figures and distinct from the painting of historical, religious or mythological themes.

View of a River Port with the Castel Sant'Angelo, undated
Oil on panel,
50.2 x 94 cm

View of a Village on the Bank of a River, undated
Oil on panel,
49.8 x 94 cm

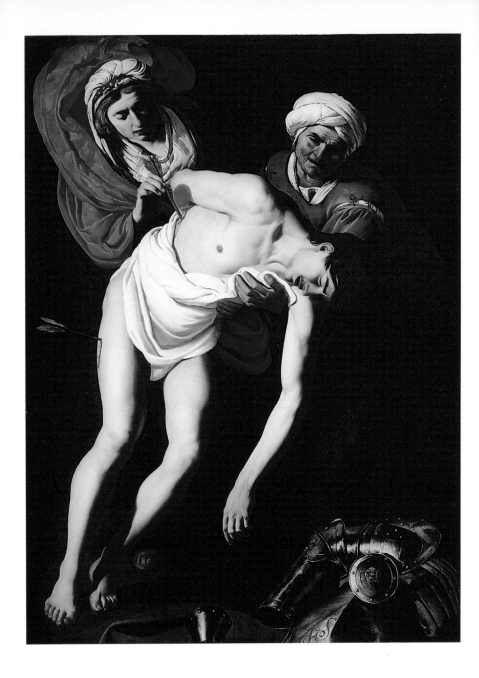

Dirk Jaspersz van Baburen
(attributed)

DUURSTEDE, C. 1595 – UTRECHT, 1624

The different trends within 17th-century Italian painting spread throughout Europe, mainly via the foreign artists who went to Italy to study, drawn by the artistic splendour of the various centres such as Rome, Venice and Bologna. In Flanders and Holland, parallel to existing artistic traditions and the presence of masters such as Rubens and van Dyck, the impact of Caravaggio gave rise to a school of Caravaggist painters who assimilated the artist's tenebrism and dramatic intensity, which was in many ways compatible with the naturalism and interest in detail intrinsic to Netherlandish painting. It was less Caravaggio's realism which exerted such an influence upon the North than his dramatic and theatrical way of conceiving the scene.

The present canvas is an example of this meeting of styles and has been attributed to Baburen, an artist about whose life little is documented, although we do know that he went to Rome. His work certainly exhibits the Caravaggesque tendencies discussed above: he creates the scene with a strong and artificial chiaroscuro which lights up the body of St Sebastian and the upper bodies of Saint Irene and her maid, leaving the rest of the pictorial plane in shadow. Only in the foreground can we make out the slain saint's armour.

The martyrdom of St Sebastian was a frequent subject of Renaissance painting as it provided an opportunity to paint anatomy. The saint was normally portrayed bound to a column, standing, his body pierced by arrows. Baroque artists aimed at more complicated compositions with more intense emotional effects, and representations of St Sebastian rapidly evolved towards the present type, suggestive of a Lamentation or Descent from the Cross. The scene gains in dynamism through its X-shaped composition and in expressiveness through the depiction of the saint's weakness and suffering, and the impression of the weight of his body supported by the maid.

St Sebastian attended by St Irene and her Maid, c. 1615
Oil on canvas,
169 x 128 cm

Gerrit van Honthorst

UTRECHT, 1592–1656

Hont horst

Gerrit van Honthorst was a member of the Utrecht school, responsible for the spread of Caravaggism throughout Holland, as discussed in more detail in conjunction with Ter Brugghen, another member of the group. Here Honthorst, in common with the work of other artists of the school, has softened Caravaggio's dramatic lighting, dispensing with the black background which sharply outlines the figure. The artist uses a directed light in order to focus on the central area of the figure, leaving the hand and the violin backlit.

The figure's pose is dynamic and creates a three-dimensional space from the arrangement of the outstretched arms, leaving an empty space between them and the body. The realistic representation is achieved through a highly detailed technique which relies on draughts-manship, creating firmly defined outlines and clean surfaces with an emphasis on the different textures and qualities of the materials and the reflections, especially those on the glass of wine, in the eyes and on the wood of the violin.

The image has great expressive force, basically achieved through the characterization of the face with its unrefined features, and in the spontaneous gesture which suggests the effects of the wine. The subject of the drinker as well as the artist's approach to this theme suggests the influence not so much of Caravaggio as of one of his followers, in particular Manfredi, who was an imitator of Caravaggio and seems to have invented the subjects of drinkers, taverns and soldiers.

Various interpretations of the painting have been suggested, some of them allegorical. One suggestion is that the painting is related to the iconography of love, wine and folly (derived from scenes of bac-chic revelry). Another suggestion is that it is an allegory of Taste and that the canvas forms part of a series dedicated to the Five Senses.

*The Happy Violinist
with a Glass of Wine,
c. 1624
Oil on canvas,
83 x 68 cm*

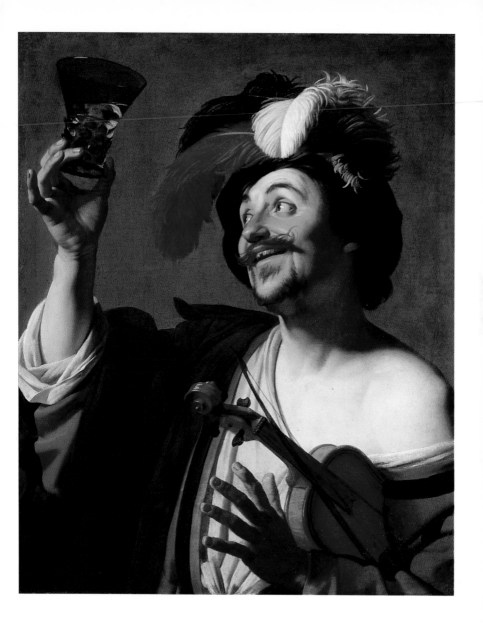

*Young Man playing
the Lute*, c. 1625
Oil on canvas,
97.8 x 82.6 cm

Jan Hermansz van Bijlert
(attributed)

UTRECHT, 1603 – 1671

Bijlert was connected with the Utrecht circle of Caravaggists, who included Honthorst and Ter Brugghen, and like them spent time in Rome around 1621. The present painting has been dated to roughly that period, although it is not a documented work and must therefore be considered as attributed to Bijlert.

The Italianate features of the painting combine with characteristics native to its country of origin. The chiaroscuro is timidly applied, particularly in the modelling of the face and the hand holding the lute, while the painter also prefers a pale, neutral background to make the figure stand out. Painted in warm and harmonious tones, the figure, despite the realism of the face which might suggest a portrait, has an extravagant and rather exotic air. This could refer to the sophistication of the Italian courts of the period, in particularly the courtly style of Venice which, by the 17th century, was a city given over to luxury and sensuality. Iconographically the painting is related to Michiel Sweerts's *Boy in a Turban*.

The painter has aimed at a spontaneous and unusual pose for the young man, who is seen sideways leaning against a table and turning to look directly at the viewer. The pose and gesture are resolved quite naturally. Nonetheless, the realism of the unsophisticated face contrasts with the elegance of the clothing, although it is difficult to know if this is intentional or not. We should note the artist's change of mind which can be seen by the naked eye above the hat, which is decorated with ivy leaves but may originally have had feathers.

*Landscape with armed
Men*, c. 1625–1635
Oil on canvas,
36 x 54.3 cm

Hercules Pietersz Seghers

HAARLEM, 1589 — THE HAGUE, 1633/38

Hercules Seghers was one of the most original landscape artists of the first decades of the 17th century. A pupil of Gillis van Coninxloo and a contemporary of Hendrick Avercamp, his work is influenced by the late 16th-century Flemish Mannerists, although Seghers is more interested in the visionary and fantastical aspects of their work – as seen in the paintings of Savery – than in their realist side.

In his imaginary paintings of the Dutch countryside, as in the present painting, he achieves a great sensation of space, being one of the first artists to portray panoramic vistas. Seghers employs soft tones, with browns in the foreground and greens and blues in the background, another link with the Mannerist tradition. However, there is also a clear intent to capture natural tonalities rather than simply to submit to compositional convention. To achieve the impresion of depth and space, the artist alternates planes of light and shade, a device much used by later realist landscape painters. In his works Seghers reveals his interest in light and its effects on the landscape.

The present work also reveals characteristics common to other Dutch landscape painters with regard to its marked horizontality, the large sky and the presence of groups of houses and a city in the background outlined on the horizon. The painting's realism does not deceive, as this is in fact an imaginary view. The imaginary character of Seghers' landscapes left its mark on other landscape painters such as Koninck and Allart van Everdingen, and even on Rembrandt, to the extent that some of Seghers' landscapes have in the past been attributed to Rembrandt.

"... pregnant with whole provinces which the painter gave birth to in limitless spaces."
SAMUEL VAN HOOGSTRATEN on the landscapes of Seghers, 1678

Hendrick Ter Brugghen

THE HAGUE OR UTRECHT, C. 1588 – UTRECHT, 1629

Ter Brugghen was one of the leading members of the Utrecht school, a group of Dutch painters who had studied in Italy and whose work was strongly influenced by Caravaggio. Along with Ter Brugghen, other important members of this school were Honthorst and Bijlert. The three painters lived in Italy in the early decades of the 17th century. The Utrecht school was subsequently responsible for spreading Caravaggio's style throughout Holland, even influencing artists such as Rembrandt, Hals and Vermeer.

This painting depicts a passage from Genesis: it describes the moment when Esau returns home tired and hungry after a day in the fields. There he finds his brother Jacob eating a stew. Through hunger and exhaustion he accepts Jacob's proposal that he should sell him his birthright in exchange for the lentil stew. The two brothers are placed in the foreground on either side of the plate of stew, while behind them are their parents, Sarah and Isaac. Painted at the end of Ter Brugghen's life, the canvas features a number of Caravaggesque elements: its realism, the theatrical composition and the strong chiaroscuro. The artist's realistic approach results in lifelike and individualized features which seem almost like portraits; in addition, the kitchen implements emphasize the domestic nature of this biblical subject, creating a still life in the centre of the painting and highlighting the principal motif (the bowl of stew). The composition also follows Caravaggesque precedents: an enclosed and constricted setting, blocked by the back wall placed parallel to the viewer and in which the figures are painted on a monumental scale, occupying the entire pictorial space.

The treatment of light is based on Caravaggesque tenebrism, with its strong contrasts and dramatic and theatrical effects. However, Ter Brugghen has also investigated some new ideas. Here he uses a centre of light – the candle – which is within the picture and very close to the front picture plane. The result is a range of highly contrasted lighting effects which give the painting a warm and vibrant interior light, surrounded by a shadow which creates a feeling of intimacy.

*Esau selling his
Birthright,* c. 1627
Oil on canvas,
106.7 x 138.8 cm

*Still Life with
Crockery and Cakes,*
c. 1627
Oil on canvas,
77 x 100 cm

Juan van der Hamen y León

MADRID, 1596 – 1631

Juan van der Hamen was a Spanish artist and a member of an aristo-
cratic family originally from Brussels who had settled in Spain. He was
generally known as a portraitist, although he was also a notable painter
of still lifes and one of the most important artists of the Madrid school.
His sober style is characteristic of the Spanish manner and is close to
the still lifes of Zurbarán and Juan Sánchez Cotán.

This serious and austere painting represents a group of objects
which are arranged in an orderly fashion on a table top. Van der Hamen
has chosen everyday objects which are far removed from the luxurious
and exquisite pieces which predominate in Dutch still lifes. It would
seem that the painter in fact wished to avoid such things, showing a
table with food and objects normally found in a simple home. In the
foreground, creating the central motif of the composition, are some
cakes and rolls, while to the right is a cheese mould and on the left
some cups and jars.

These elements are rigorously arranged and clearly separated
from each other in order to create empty spaces between them. The
composition is markedly horizontal, reinforced by the shape of the
canvas. The various objects are painted in a precise, even slightly hard
way, as is characteristic of van der Hamen's style. A powerful chiaro-
scuro serves to model the volumes, and whereas the highlighted areas
of the objects stand out clearly against the black background, other
areas in shadow blend into it. Although the various qualities and tex-
tures of the objects are certainly rendered, as we can see above all in
the glassware, the whole painting tends to the matt, as if the artist were
not aiming at brilliance in the reflections but rather at a certain austerity
and dryness. This falls in line with the sober and ascetic approach of
the early Spanish Baroque, as represented above all by Zurbarán.

St Casilda, c. 1630
Oil on canvas,
171 x 107 cm

Francisco de Zurbarán

FUENTE DE CANTOS, 1598 – MADRID, 1664

Zurbarán was born in a village in the Spanish province of Badajoz and became one of the most important artists of the Seville school. During the 17th century Seville was one of the most active artistic centres in Spain and was also the birthplace of Velázquez and Murillo. Zurbarán's naturalism brought him, around 1630, numerous commissions from throughout Andalusia. His austere, simple style was particularly suitable for transmitting the spirit and message of the Counter-Reformation, which called for a return to a pure and ascetic religiosity. His religious paintings combine the mystical nature of the subject with a profound sense of humanity in accordance with the renewed precepts of the faith.

The painting of *St Casilda* follows a typology invented by Zurbarán and repeated in other paintings of martyr saints. The saint is represented full-length in half profile, with the appearance and rich clothing of a young woman of the 17th century. She is shown taking part in a procession, set against a dark background. The naturalism of the image and the realism with which the face is painted, bring the saint close to contemporary everyday life. The only reference to her status as a saint and her martyrdom is a fine white line suspended in the air above her head, which could be a halo, and the flowers gathered in her skirt: St Casilda, who secretly converted to Christianity, was discovered taking bread to some Christians, at which moment the bread miraculously tranformed itself into flowers.

Christ on the Cross, c. 1630
Oil on canvas, 214 x 143.5 cm

Christ on the Cross uses a similar compositional format, this time accentuated by a pronounced chiaroscuro. Silhouetted against a black background lacking any suggestion of specific setting, we see the body of Christ in an iconographical interpretation widespread in the 17th century: Christ still alive, eyes open and looking at the sky, legs parallel and feet resting on a ledge projecting from the cross.

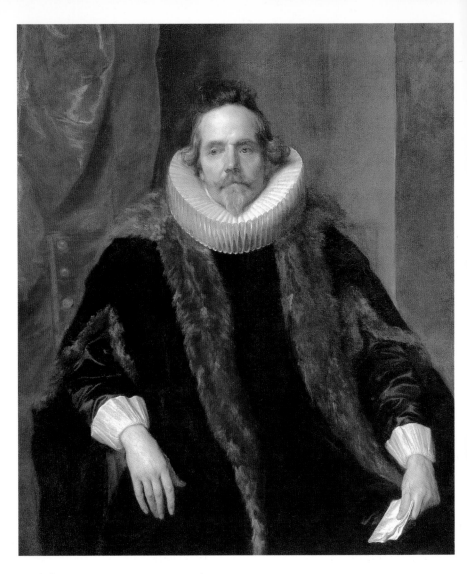

*Portrait of Jacques
Le Roy*, 1631
Oil on canvas,
117.8 x 100.6 cm

Anthony van Dyck

ANTWERP, 1599 – LONDON, 1641

Anthony van Dyck was the most important Flemish Baroque painter after Rubens, his master. Although he painted mythological and religious works, his greatest talents lay as a portraitist, the genre which brought him fame during his lifetime. Between 1620 and 1622 van Dyck was in England in the service of King James I. Subsequently he travelled to Italy, returning to Antwerp in 1627, where he was named court painter to the Archduchess Isabella.

This portrait of Jacques Le Roy dates from van Dyck's Antwerp period. The sitter was a leading figure in Flemish society, a member of the Brabant Chamber of Commerce and its president in 1632. He also held public office in the service of the Spanish monarchy in the Netherlands. Van Dyck gave all his portraits a notable elegance, emphasizing the dignity of his sitters. As a consequence he became the preferred portraitist of the aristocracy and the political classes. His style was based equally on Rubens and on the Venetian painters, characterized by strong colour and a loose and rapid brushstroke.

In general, however, his compositions and the general tone of his work is more restrained than that of Rubens. In the present portrait we can see how the artist deploys a narrow colour range with great skill, balancing the warm tones of the flesh and the curtain with the whites and the black. The sitter exudes a sense of dignity, which the artist has achieved in part through the serious and thoughtful expression and in part through the bulk and carriage of his figure and the elegance of his hands.

In addition to his ability to capture a lifelike appearance, it was the aristocratic tone of his portraits which brought van Dyck fame, and shortly after completing this canvas he moved to London, where he worked as court painter. He remained there until his death, evolving a type of portrait which included decorative elements and a landscape background. His work had a profound influence on painting in England.

José de Ribera

JÁTIVA, VALENCIA, 1591 – NAPLES, 1652

Jusepe de Ribera

José de Ribera was originally from Valencia, although shortly after 1610 it seems that he was in Naples, where he may have met Caravaggio. In 1615 he is documented in Rome. Shortly after that he returned to Naples, where he lived the rest of his life working in the service of the viceroys of Spain. While his style draws on Caravaggesque tenebrism both with regard to form and content, he created his own distinct way of painting as well as developing some highly influential iconographical types.

In the two works by Ribera in the Thyssen-Bornemisza Collection we can see characteristics of the naturalistic strand of Baroque art, which he developed to an extreme. Both *St Jerome* and the *Lamentation* have a theatricality which impacts emotionally upon the viewer. The feelings of the characters can be instantly read in their expressions. Another identifying characteristic of Ribera's work is his extremely realistic mode of presentation, as can be seen here in the aged body of St Jerome, the pale face of Christ and the face of his grieving mother.

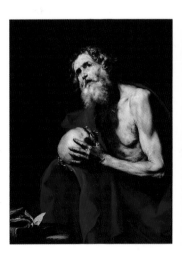

The penitent
St Jerome, 1634
Oil on canvas,
126 x 78 cm

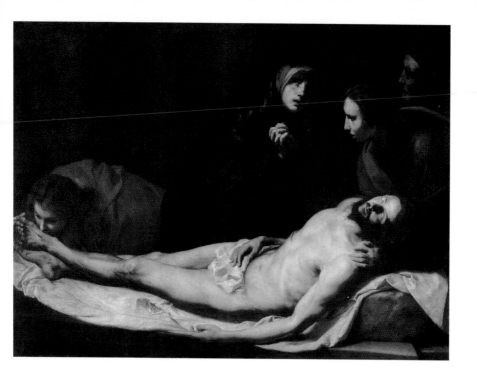

These figures are placed against a dark background, limiting our view to the foreground plane, in which a few elements are sufficient to create the setting. In the case of *St Jerome* they are a book (the Holy Scriptures) and a skull, the attributes of the holy hermit, while in the *Lamentation* one can make out a stone ledge on which the figure has been placed.

The light focuses on the essential elements in a deliberately expressive way, for example, the figure of Christ lying on the sudarium, the body intensely illuminated and the figures around Him in darkness. Light also falls on the clenched hands and face of the Virgin and on the face of St John. Ribera balances the composition by counterbalancing the horizontal line created by the body of Christ with the verticality of the other figures. The artist has conceived of the *Lamentation* with a dramatic intensity rarely surpassed elsewhere.

The Lamentation,
1633
Oil on canvas,
157 x 210 cm

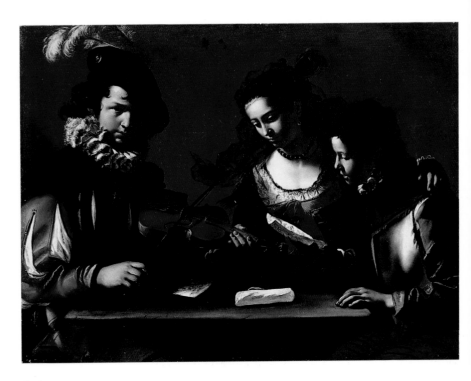

The Concert,
1630–1640
Oil on canvas,
107 x 145 cm

Mattia Preti

TAVERNA, 1613 – LA VALLETTA, 1699

One of the innovatory aspects of Baroque art was the use of new subjects such as the still life, everyday scenes, and landscape. Albeit never achieving the popularity they enjoyed in the Netherlands, scenes from daily life increasingly found their way into Italian art, as in the present example. The new genre also appeared in Spain, and slightly later, France. Italian artists such as Jacopo Bassano had taken the first steps towards genre painting almost 100 years earlier, but it was Caravaggio and his followers who properly initiated the new trend, as witnessed by Tommaso Salini's *Young Peasant with a Flask* discussed above.

Mattia Preti's *Concert* is a work which has a bearing on the artistic links between Italy and the Netherlands. Its style is strongly influenced by Caravaggio, particularly in its formal aspects: the strong chiaroscuro reaches an extreme degree in the faces of the three figures, to the point where the colour of their skin, where caught by the light, takes on whitish and yellowish hues which accent the contrasts. The artist exploits textures and surfaces for their highlights and reflections, all purely for the purposes of pictorial display. At the same time, the painting also demonstrates the interest in depicting everyday life so characteristic of the art of northern Europe, and takes pleasure in painting the details of the clothing and objects. It thereby treads a very different path to that of the grandiloquent tendencies of religious and mythological painting.

Preti was a pupil of Ludovico Carracci and was also linked to the Bologna Academy. But if his easel painting reveals the influence of Caravaggism, the frescoes of traditional subjects which he executed for churches and palaces maintain the classicist tradition. Indeed, we can appreciate this classicist element of Preti's art in the balanced composition and calm mood of the present canvas. However, the painting is also connected with the work of the Utrecht Caravaggists, who assimilated Caravaggio's formal devices, applying them to more light-hearted subjects and dispensing with the pathos of the master's work.

Simon Vouet

PARIS, 1590–1649

The Rape of Europa, c. 1640
Oil on canvas,
179 x 141.5 cm

Simon Vouet introduced a decorative Baroque manner of classicist origins into French art. Like Le Valentin and other young French artists active in the first half of the 17th century, he trained in Italy, where he lived between 1613 and 1627. He returned to France on the command of Louis XIII, who named him his official painter. From that point on he was extremely successful, above all in the design and execution of major iconographical programmes for decorative schemes in palace interiors.

The canvas of *The Rape of Europa* may have formed part of one of these cycles, a possibility supported by its subject, style and size. Characteristic of Vouet's mature style are the luminosity and movement which he gives to the composition, dynamic and open in different directions almost like a star. Precisely drawn, this painting has a pronounced linearity softened by the harmony of its pale palette, which tends to pastel tones and which unifies the whole. A focused light falling from the left illuminates the scene, creating soft effects of coloured shadows.

Vouet painted in almost every genre but his success as a decorative painter led him to dedicate himself principally to stories from classical mythology. In this case the subject is a theme from Ovid's *Metamorphoses*. Jupiter, who has fallen in love with Europa, the daughter of the King of Tyre, changes himself into a white bull and appears on the seashore where Europa is playing with the maidservants. The bull is so gentle that Europa sits on its back, at which moment the god seizes his chance to make off with her. Hence the human expression of the bull, which is something between astute and smiling. Mythology and mythological painting are full of these episodes of gods who have changed their forms into animals in order to seduce young women.

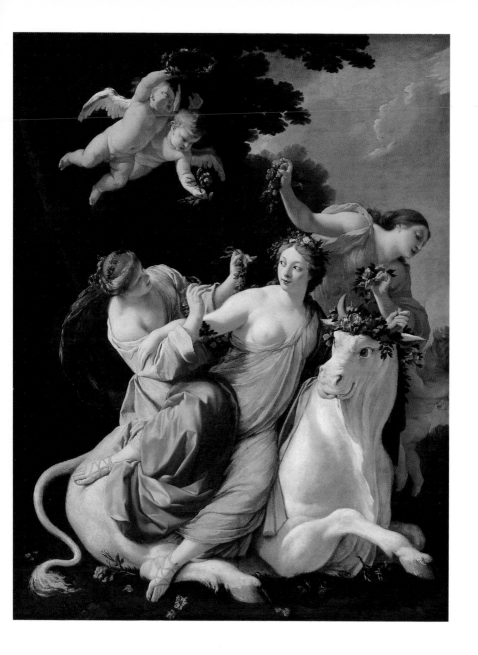

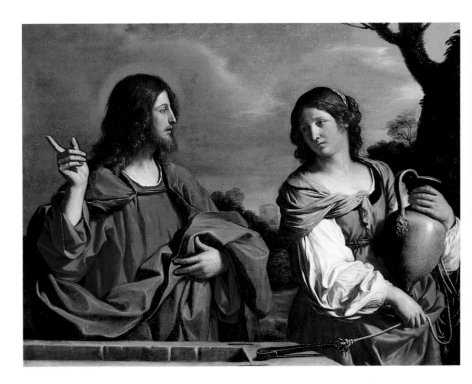

*Jesus and the Samaritan
Woman at the Well,*
c. 1640/41
Oil on canvas,
116 x 156 cm

Guercino

CENTO, 1591 — BOLOGNA, 1666

Giovanni Francesco Barbieri, called Il Guercino, was one of the most
important classicist painters of his time. He was a pupil of Ludovico
Carracci at the Academy of Drawing which Carracci founded in Bologna,
and there learned the classical precepts which were to form the basis of
his style. However, following a stay in Rome around 1622, his work also
took on certain naturalistic elements, particularly with regard to formal
aspects, as we can see in the present painting. The scene is composed
along classical lines, evident in the ordered and rhythmically balanced
composition. Equally classicist is the idealized appearance of the fig-
ures. The artist introduces the technique of chiaroscuro in order to em-
phasize the volumes, however, and also pays considerable attention to
realistic detail in his portrayal of the Samaritan woman, holding her
pitcher, and gathering up the rope from the well and wrapping it around
her arm. The composition recalls 16th-century formulae, presenting the
figures in three-quarter length behind the ledge of the well which serves
as a border, and with a low-horizoned landscape behind.

Guercino is known to have studied Venetian painting, and this is
evident in the present picture in his bold use of colour (particularly in
the figure of Christ) and his painting of the landscape and sky with
dense, dark clouds. He also plays with the effects of light and atmos-
phere on forms. Thus, while the landscape in the background is very
sketchy, in the foreground the forms are crisply rendered. The artist has
also aimed to represent the different natures – human and divine – of
Christ and the Samaritan woman. Christ has a timeless air and a dignity
and seriousness achieved through his upright posture, the austere
weight of his draperies and the absence of decorative elements. In con-
trast, the Samaritan woman is captured in the middle of a daily chore,
seen in slight foreshortening and wearing more realistic, "earthly"
clothes. Going beyond the idealization of both figures, the almost
statue-like presence of Christ (whose hand gesturing upwards seems to
say "My kingdom is not of this world") is abruptly juxtaposed with the
everyday picturesque character of the Samaritan woman.

Guercino

"Guercino is a sacred
name and in the
mouths of children
as well as the aged."
JOHANN WOLFGANG
VON GOETHE, 1816

Diego Velázquez

SEVILLE, 1599 — MADRID, 1660

Ɔ.Ɗ Ꝟelaſq͏ꭓꭓ

Diego de Silva Velázquez was the most important artist in 17th-century Spain. During his career, most of which was spent in Madrid in the services of the Spanish monarchs Philip IV and Marianna of Austria, he painted virtually every kind of subject: religious and mythological paintings, still lifes, landscapes, nudes and portraits. He was above all a great portraitist, interested in capturing the psychology of his subjects as well as their dignity and humanity.

His style is based on a detailed naturalism which has its roots in Caravaggio. Velázquez developed this style during his early years in Seville. From 1623 he lived in Madrid, where he evolved a painting of great fluency, modelled from effects of light and atmosphere. His brushstroke became increasingly looser and more obvious as he abandoned the linearity of his earlier works. Numerous trips to Italy on behalf of the king served to further enrich his painting.

In his last phase, to which the present portrait belongs, Velázquez adopted an almost Impressionist technique in which drawing has disappeared completely and the forms are resolved through the juxtaposition of areas of colour. Throughout his career Velázquez studied atmospheric effects and as his technique advanced he achieved a complete mastery of space through the use of aerial perspective. The bust-length portrait of Marianna of Austria illustrates many distinctive characteristics of the artist's style, as seen in the sketchy nature of the forms and volumes, the gentle tonalities in silver and bluish tones, the creation of forms from juxtaposed brushstrokes and the realism with which the face is painted. The canvas is thought to be a preparatory study for the image of the queen which appears in the mirror in _Las Meninas_, the artist's masterpiece.

Portrait of Marianna of Austria, Queen of Spain, 1655–1657
Oil on canvas,
66 x 56 cm
(Pedralbes)

Village Scene with Men drinking, c. 1631–1635
Oil on panel,
63 x 95.9 cm

Adriaen Brouwer

OUDENAERDE, 1605 – ANTWERP, 1638

Adriaen Brouwer represents the link between Dutch and Flemish genre painting. He lived in Antwerp and Amsterdam and seems to have been a pupil of Frans Hals, although Rubens' influence is also evident in his work. His paintings introduce us to the world of Dutch genre painting, which enjoyed great success in the 17th century.

Brouwer painted almost exclusively subjects of taverns and drinkers, which he used to point out the negative effects of alcohol. His paintings show the squalid side of tavern life, filled with grotesque figures drinking and smoking to excess. It would seem that he himself inhabited this milieu, living a life of indulgence which eventually led him to prison. He died of the plague aged thirty-two.

The present painting portrays an outdoor drinking scene set on the outskirts of a village. Brouwer uses a range of cool tones and a technique of hard but generalized outlines with little detail, in which the marks of his brush are visible. A bright light falls uniformly over the landscape background, while in the foreground the stable with the horse, the group round the table, and the bushes on the right are painted with a certain degree of chiaroscuro, and also backlighting in the bushes.

The artist presents a realistic scene within a spacious panorama, with a distant horizon which leaves room for a broad sky painted in a most harmonious palette which moves from blue to a yellow which is almost white, blending with the flat plain on the horizon. Rubens' style can be detected in this background, particularly in the way of painting the trees. Brouwer's work influenced artists such as Steen and David Teniers the Younger, although their tavern scenes have a more light-hearted and relaxed character than those of Brouwer.

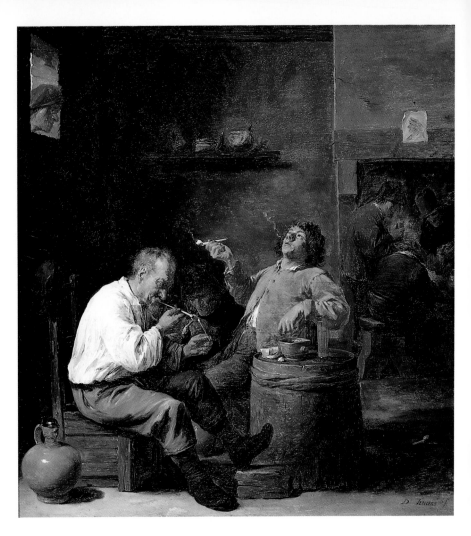

*Smokers in an
Interior*, c. 1637
Oil on panel,
39.4 x 37.3 cm

David Teniers the Younger

ANTWERP, 1610 – BRUSSELS, 1690

Like his father-in-law Jan Brueghel, whose work shares certain similarities with his own, David Teniers specialized in genre painting. In 1647 he moved to Brussels, where he was appointed court painter to the Archduke Leopold and curator of the archducal collection. With the rise of genre painting in Flanders and Holland, patronized by the new, urban middle-classes, many artists started to specialize in particular subjects, which they repeated numerous times for their different clients.

Teniers focused on the depiction of everyday scenes and interiors, to which he applied his marvellous powers of description. *Smokers in an Interior* is highly realistic, both in the representation of the figures and in the humble and unrefined setting; the artist delights in reproducing such objects as the pitcher, the mortar and the flagon in the foreground. The subject of smokers became very popular in the Netherlands as tobacco, imported from America, was a great novelty. In this genre Teniers is considered to be a follower of Brouwer, although his smoking scenes are rather more light-hearted in mood. Notable is the precision of his draughtsmanship and the subtle and harmonious application of colour, using greyish-brown tones throughout.

Chromatic harmony is also evident in the *Village Festival*, one of Teniers' most popular subjects. A large group of standing figures provides an opportunity to deploy a range of poses, gestures and relationships. The artists conveys the cheerful carefree atmosphere of a country festival. The landscape is painted with a careful eye for atmospheric effects, which are used to unify the tones and soften the outlines of the most distant forms. The low, flat horizon provides space for a broad sky which lights up the scene. The foreground is consequently seen in clear focus; standing out within it is the group of copper and earthenware utensils on the left, which are arranged like a still life. Over the earthy tones which predominate in the lower half of the panel, Teniers introduces small touches of red, blue and white in the clothing of the figures, adding a lively note to the scene.

PAGES 302/303:
Village Festival,
c. 1650
Oil on panel,
45 x 75 cm

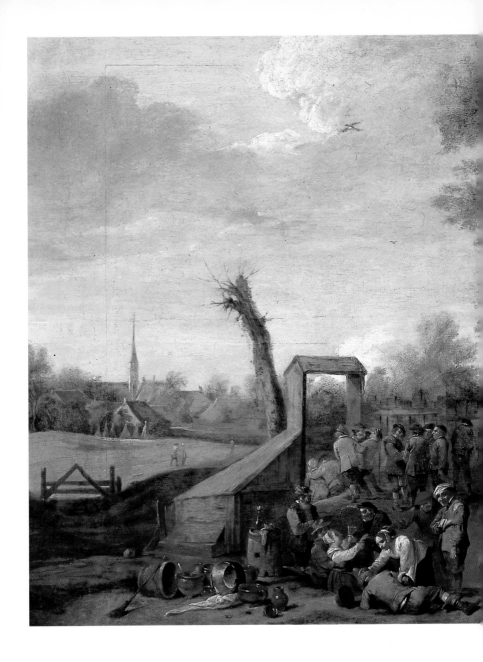

Rembrandt Harmensz. van Rijn

LEYDEN, 1606 – AMSTERDAM, 1669

Rembrandt was the most important Dutch artist of the 17th century and one of the greatest geniuses of western painting, outstanding for his audacious technique and approach to composition, his highly personal use of light, his brilliant and fluid handling of the brush and his innovative treatment of his subject-matter, as well as for the profound humanity which his figures express.

Rembrandt painted in numerous genres, but throughout his life was most in demand for his portraits, both of individuals and of groups (a type of portrait developed in the Netherlands in the 17th century). Only Frans Hals enjoyed comparable fame in this genre. Alongside his commissioned portraits, Rembrandt also painted several portraits of members of his family (including his mother and his wife Saskia), but above all, he painted himself. His extensive œuvre has been calculated at around 600 works, of which 60 are self-portraits. From 1629 until his death he depicted himself at every stage of his career, looking at himself with honesty and a growing self-analysis, during periods both of prosperity and of economic and personal crisis.

The Thyssen-Bornemisza portrait is dated around 1643, the year after the death of his wife Saskia, at a time when Rembrandt's clients began to dwindle in number, a situation which did not recover, even though he continued to receive some important commissions to the end of his life. The artist depicts himself with a serious and meditative expression, looking directly out at the viewer. Against a dark background and dressed in a black coat edged with fur, the light is concentrated on his face, which it models in soft chiaroscuro. The loose and paint-laden brushwork is characteristic of Rembrandt's style and evokes forms whose outlines are blurred. In the lower part of the painting, the lines of a briefly sketched hand can just be made out in the darkness. The portrait is outstanding for its serious and intense mood and for its unflinching psychological penetration, aspects of Rembrandt's art which initially brought him great fame but which resulted in a lack of commercial success at the end of his career.

Rembrandt

"*His painting knew no outlines or boundaries; he used wild, unconnected strokes and dabs of his brush, together with powerful areas of shadow, without going as far as pure black.*"
FILIPPO BALDINUCCI, 1681

Self-Portrait, c. 1643
Oil on panel,
72 x 54.8 cm

*Still Life with a Fruit
Pie and various
Objects,* c. 1634
Oil on panel,
43.7 x 68.2 cm

Willem Claesz Heda

HAARLEM, 1594–1680

Still life became an extremely important and much-painted genre in 17th-century Holland, and numerous different ways of interpreting the subject developed, amongst them some with a moralizing intention and representing a reflection upon life and its pleasures. Heda was one of the best painters of still lifes of serving tables and food, to which he gives a monumental feel and at the same time a certain compositional restraint, which suggests to us that we should apply a similar restraint towards our consumption of the food.

Heda's style is characterized by its use of a monochromatic palette of green, grey and silvery tones. His compositions are balanced and never overcrowded, depicting a tabletop on which various items of food, objects and luxurious vessels are casually but carefully arranged. Pewter (a metal used for jugs and plates), silver and glass were the materials most painted by the artist.

Heda repeated this composition numerous times with some variations, but his style is always instantly recognizable. On a table partly covered by a somewhat crumpled white cloth, he arranges the remains of a meal, such as a pie and a half-peeled lemon whose peel forms a prominent curl against the dark background. Heda frequently included another plate, jug or upright glass as well as a silver goblet on its side. Due to the type of food and their modest quantities these paintings were often known as "breakfast" still lifes. Heda succeeds in creating a monumental still life in which a limited number of elements are arranged horizontally on the tabletop, forming compact compositions with a diagonal structure. Each element is depicted in detail, both in itself and in relation to the other objects around it. Heda renders with great precision the highlights and textural properties of each element, at the same time bringing them together to form a coherent whole through the application of a uniform tonality.

Jacques Linard

PARIS REGION, C. 1600 – PARIS, 1645

Holland was not the only country in which artists painted still lifes. The genre appeared all over Europe, flourishing in Italy, France and Spain, although artistic production in these three latter continued to be dominated by large-scale paintings of religious and mythological subjects, commissioned by the royal houses and, in the case of Italy, the Papacy.

Taking his inspiration from Dutch and Flemish still-life painting, Linard specialized in still lifes of flowers. Little is known of his origins or training, although he is documented in Paris from 1626, where he seems to have spent the rest of his life.

The present work reflects his mature style. Linard generally painted very simple and well-ordered compositions, structured around a geometrical axis. In this case he has symmetrically arranged a bunch of flowers in an Oriental vase, the central axis marked by the large red flower which is outlined against the black background. Linard's way of painting the flowers and his colours recall artists such as "Velvet" Brueghel and Ambrosius Bosschaert, although his compositions are much calmer. The lively palette and the decorative quality of the sprays of flowers contrasts with the plainness of the stone ledge and the black background.

*Chinese Bowl with
Flowers*, 1640
Oil on canvas,
53 x 66 cm

*Winter Landscape
with Figures on
the Ice*, 1643
Oil on panel,
39.6 x 60.7 cm

Jan Josephsz van Goyen

LEYDEN, 1596 – THE HAGUE, 1656

Alongside Salomon van Ruysdael, van Goyen is the most important of the landscape painters of the mid-1600s, and is characterized by his great realism. Both artists painted the same types of landscape, although in a different technique. Van Goyen employs a loose and nervous brushstroke which gives his landscapes the sensation of movement found in nature and in real life. From 1630 onwards his style developed towards a less detailed manner of representation and towards a more monochrome palette, using brown and golden tones in gentle contrast with greys and silvers.

This winter landscape is typical of his style and of landscape painting of this period. The composition is notably horizontal, accentuated by the flat line of the horizon, well defined and brightly lit. The viewpoint is slightly high, although van Goyen uses a low horizon which allows him to paint an ample sky with scattered clouds. As a contrast to the pale background, the foreground is in shadow.

Winter scenes in art have their origins in the late Middle Ages in the representations of the seasons of the year. The subject was subsequently taken up by Pieter Brueghel, the great 16th-century painter who depicted popular subjects and peasants working. Following Brueghel's approach, this scene has a narrative interest and represents people in a wide variety of activities, although the figures and the various incidents are not as detailed as they would have been in previous centuries.

The wide format and the flat horizon create a composition structured into two horizontal bands corresponding to the sea and sky. This type of structure would become very common in Dutch painting as it reflected the actual flat landscape of the country.

Salomon Jacobsz van Ruysdael

NAARDEM, C. 1600–HAARLEM, 1670

A famous member of a family of artists, Salomon van Ruysdael was the uncle of Jacob van Ruisdael – possibly the most important representative of classical realism in Dutch landscape painting – and, along with van Goyen, one of the first generation of realist landscapists. These pioneers broke away from international trends, opting to paint specific locations in the Dutch countryside. Their pictorial style was dominated by an interest in depicting the overall atmosphere of the scene without losing its spatial coherence. This led them to adopt a monochrome palette, a characteristic feature of this type of "tonal painting", as it became called. At the same time, these artists adopted an objective vision and a correspondingly new viewpoint; landscapes were no longer seen from above, but in a way that gave the viewer the sensation of being at ground level. This has the effect of bringing us much nearer to the subject, to the extent that we seem to be immersed in it.

The above characteristics are demonstrated in the three paintings reproduced here. They all share the compositional structure which was the major innovation of this generation of painters: the ground-level viewpoint opening out to a low horizon situated considerably less than half-way up the canvas. This results in the creation of broad skies in which the artist depicts the beautiful tonal gradations of the clouds, their fantastical forms and the effects of sunlight on them, as we can seen in *Sailing Boats near a Village* which captures the red light of sunset. The scene is predominantly horizontal, balanced by various verticals such as the sails of the boats.

The three paintings show the development of Ruysdael's style towards bolder compositions, in which the zones of land or sea occupy ever less space and the area of sky becomes ever larger. At the same time, the artist abandons the tonalism of his early work. In the earliest painting, *A River with Fishermen*, the trees on the left occupy an important part of the painting and emphasize the area of land in the foreground. The green and grey tones which the artist used in his "tonal"

View of Alkmaar from the Sea, c. 1650
Oil on panel,
36.2 x 32.5 cm
(Pedralbes)

period are still present, but accompanied by some yellow and brown touches.

The artist achieves atmospheric effects by blurring the outlines and making the palette lighter and gentler towards the background. The air is rendered as clean and clear with a fresh and damp feel. The water reflects the land, trees and boats in its brilliant and limpid surface, which is hardly stirred by the various elements floating in it (the ducks, fishing nets and boats). In addition, Ruysdael employs the very widespread device of a foreground in shadow leading to a brightly lit and pale horizon – something we also see in his other two paintings in the collection.

View of Alkmaar from the Sea is undoubtedly the most impressive painting of the three owing to its bold composition. It uses an almost square format in which the water occupies only a small part. The marked horizontality is balanced by the sails of the boats in the foreground. The canvas centres on the meeting of the sea and sky, and the lighting effects this implies. Thus the sea in the foreground lies in

Sailing Boats near a Village, 1645
Oil on panel,
51.5 x 83.6 cm

the shadow of a large cloud, while in the background it gleams in the direct sunlight.

Sailing Boats near a Village is a later work in which the artist adopts an almost Expressionist style in order to render the effects of the sunset on the clouds and the sea. Although employing a similar line, Ruysdael's style is here more schematic and less detailed than in his earlier works. The artist uses a firm and rapid brushstroke which is visible in many parts of the painting.

Ruysdael was a great painter of river landscapes and sea views, a fully independent sub-section of the genre of landscape. Holland owed all its economic might to the sea, which had enabled Amsterdam to become the principal European port of commerce for the West Indies, protected by an important naval fleet.

*Landscape with
Sunset,* after 1645
Oil on panel,
48.3 x 74.9 cm

Aelbert Jacobsz Cuyp

DORDRECHT, 1620–1691

While most 17th-century Dutch landscape artists tended towards real-
ism in their paintings, from the second half of the century an imaginary
landscape of Italian influence started to develop. Throughout the cen-
tury many Dutch artists had been attracted to Italy as the cradle of clas-
sical art. Many of them travelled to Rome, absorbing a type of idealized
landscape with typically Mediterranean light, as painted by artists such
as Claude Lorrain. Although he never went to Italy, Aelbert Cuyp fol-
lowed the style of Italianate artists such as Jan Both, painting imaginary
landscapes in the Roman style, as reflected in his treatment of light and
in the inclusion of shepherds, travellers and animals.

The composition recalls those of realists such as Jan van Goyen
and Ruysdael, whose horizontal-format landscapes are characterized
by a low horizon and trees silhouetted against a sky occupying a large
proportion of the pictorial plane. Cuyp's work is very much in the Italian-
ate taste, however, reproducing the golden light of the sunset, which
casts elongated shadows and floods the scene with a warm tonality.
His sky – as seen in the present painting – typically assumes an orange
hue which is reflected in the landscape. The result is a sun-filled scene
with an atmospheric brilliance and lightness of totally Mediterranean
feel. Each element in the painting is subordinated to a compositional
order and to the portrayal of an idyllic landscape in which every aspect
is pleasing.

Cuyp's technique is highly finished and reveals his complete
mastery of the representation of figures and volumes. Very characteris-
tic of his style are the reflections of white light on foliage, as well as
the inclusion of animals in his landscapes, a subject painted by other
contemporary Dutch landscape painters.

Jacob Isaacksz van Ruisdael

HAARLEM, 1628/29 – AMSTERDAM, 1682

Jacob van Ruisdael is considered one of the greatest landscape painters in the history of art. Coming from a prestigious family of artists, he was trained by his father Isaack van Ruisdael and his uncle Salomon van Ruysdael. He belonged to the second generation of realistic landscape painters in 17th-century Holland, a generation which gave their landscapes great expressive force and a profound naturalism. He was a prolific artist who painted a wide variety of landscapes: the plains of the Dutch countryside, the dunes, seascapes, marshes, ponds, woods and hills. Some are in a proto-Romantic style in which the trees, hills, castles, churches, windmills and other elements acquire a heroic dimension.

View of Naardem is an early work by Ruisdael. Despite this, one can clearly see the characteristics which would define his style and that of his generation: landscapes in which realism predominates, with wide vaults of sky and a mastery of lighting and atmospheric effects. Ruisdael

View of Naardem,
1647
Oil on panel,
34.8 x 67 cm

uses a greater chromatic contrast than was the norm in this genre. The very low horizon gives way to a broad sky scattered with large clouds which cast very dark shadows on the ground, alternating with strongly lit areas (the yellow fields of corn and the ruins of a church in the background). Without having to use the device of parallel planes, Ruisdael succeeds in creating the impression of depth. The contrasts of light bring tension and vitality to the scene.

We find the same features in *Road through Corn Fields near the Zuider Zee*, a work painted around 15 years later. Ruisdael's style has developed towards a more dynamic and Baroque approach which is also more emotionally intense. The lighting contrasts are stronger and are complemented by greater contrasts in the treatment of the sky. Great clouds stand out against the intense blue, tinted with the different

Road through Corn Fields near the Zuider Zee, c. 1660–1662
Oil on canvas,
44.8 x 54.6 cm

colours which indicate the presence of the setting sun. This same sun casts dramatic light on the wheat fields in the middle-ground and on the church tower, which glows in an orange light. In contrast, the foreground is very dark, although boldly structured with a snaking path which creates depth as it winds into the background.

Ruisdael introduces into landscape painting portrayal of the violent side of nature, in contrast to the calm which dominated the work of the previous generation. In a composition which is typical in its use of a low horizon, a boat among the shadows in the foreground heels over in the strong wind. In the background other similarly wind-tossed boats are barely sketched in. The real protagonist of the painting are not the sailing boats but the grandeur and force of nature: the wind and the stormy sea. Ruisdael thereby transmits the pathos of nature.

*"... he bequeathed
to us a portrait of
Holland not so much
familiar as intimate
... admirably faithful
and one which does
not age."*
EUGÈNE FROMENTIN
ON RUISDAEL

This same heroic vision of landscape, conceived as a classical drama, appears in his *Winter Landscape*. The subject had already been painted by other artists such as van Goyen and van de Cappelle, in an important progression which would culminate with this work by Ruisdael. Using a more dramatic approach than his predecessors, Ruisdael emphasizes the bad weather with the black clouds which darken the whole scene. The small figures skating and playing on the ice form part of the scenario, without assuming greater importance than the large warehouse in the centre of the painting or the great snowy tree on the left.

Winter Landscape,
c. 1670
Oil on canvas,
65.8 x 96.7 cm

*Moonlight with a
Road beside a Canal,*
c. 1647–1650
Oil on panel,
35.6 x 65.5 cm

Aert van der Neer

AMSTERDAM, 1603/04 – 1677

Aert van der Neer specialized in winter scenes and night and dusk views. Specialization was normal among painters of small-scale easel works, who sold their paintings in markets rather than working on commission, a situation which was possible owing to the large pool of clients created by the prosperous Dutch middle classes of 17th-century Holland. Many landscape painters set out to develop one or more sub-sections within the genre of landscape, creating an ample repertoire of subjects. This specialization meant that they perfected the subjects which they treated repeatedly, achieving great technical mastery.

This painting is characteristic of van der Neer's work. In his paintings it is not easy to determine the exact hour of day at which the scene is painted. Nevertheless, his paintings usually show dusk scenes and he repeatedly painted autumn afternoons in which the sun suddenly sets, taking by surprise the various figures at their work or on their way home. These compositions employ a similar layout to the present one: a river or canal in the centre of the painting, bordered by banks which recede in parallel lines into the picture. On either side is a road with figures and houses.

Van der Neer's principal innovation, however, was the use of a coloured light in shades of yellow and silver to convey effects of atmosphere and lighting: the moonlight on the water, the darkness which covers the land, and the light of dusk which pervades the cloudy sky. Van der Neer worked within the realist tendency and aimed at reflecting the natural beauty of the Dutch landscape. His paintings depict the outskirts of Amsterdam, and the present panel is a view of the River Vercht as it passes through the suburbs of the city.

Bartholomeus Breenberg

DEVENTER, 1598—AMSTERDAM, 1657

Bartholomeus Breenberg belongs to a group of Italianate painters who travelled as young men to Rome in 1619 and stayed there for seven years. We have no finished paintings from this period, but a large number of landscape sketches and drawings have survived, together with drawings of ruins and buildings in Rome and its surroundings.

The present painting is exceptional within the artist's œuvre, which was mainly dedicated to imaginary landscapes, narrative in character and including small figures and mythological or religious motifs. It is thereby close to the work of another Italianate Dutch artist, Jan Both, who was undoubtedly the first to paint an imaginary view of a port, a sub-genre which developed in the closing years of the 17th century and was very successful in Holland.

Breenberg composes an idealized view of the Eternal City, represented by some of its most famous monuments, which the artist had sketched from life numerous times. In the foreground on the left are the ruins of the Temple of Isis and Serapis (then known as the Portico of Nero), creating the vertical structure that dominates the composition. Behind it a series of architectural elements, identified as the Porta San Paolo, compose a diagonal which lends depth to the pictorial plane. In the background is an obelisk and a port.

Breenberg employed considerable freedom in bringing together this imaginary panorama. The result is an idealized synthesis of the city which was both the cradle of classical Mediterranean culture and its greatest legacy. Among the elements he includes is Michelangelo's statue of *Moses*, which at that time was considered to be equal in quality to the sculpture of Antiquity. The statue is shown in reverse, which might suggest that Breenberg copied it from an engraving.

Idealised View with Roman Ruins, Sculptures and a Port, c. 1650
Oil on canvas,
115.6 x 88.7 cm

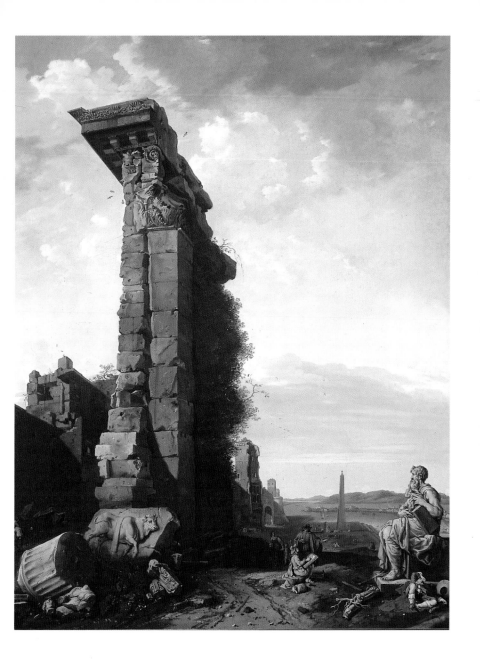

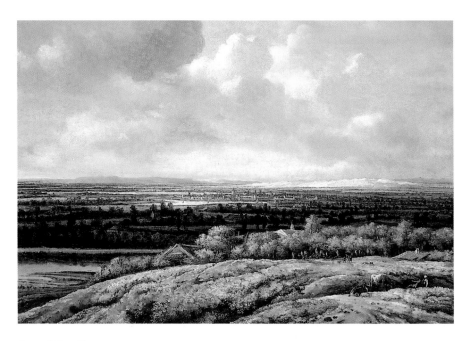

*Panoramic View with
a City in the Back-
ground*, 1655
Oil on canvas,
83.5 x 127.5 cm

Philips Aertsz Koninck

AMSTERDAM, 1619–1688

Philips Koninck specialized in panoramic views, in which broad tracts of land are seen from a high viewpoint. This bird's-eye view had been developed a century earlier by artists such as Pieter Brueghel, who used it to portray sweeping landscapes in which every element was treated separately. Koninck and also Hercules Seghers succeeded in creating grand vistas which had a unified and realistic appearance and atmosphere.

On a hill in the foreground we see some peasants with their cattle, some hunters and behind them the carriage of a nobleman. In the foreground the natural world with its human and animal figures is painted with a degree of detail that decreases in the distance. One of the innovations of the panoramic view was the depiction of large stretches of land conveying a sense of infinity, not bounded by trees, mountains or cities. Earlier landscape artists would have framed such panoramic views with trees placed on both sides in the foreground, together with a hill or castle. Koninck, however, aimed to offer a more direct and realistic vision.

The composition is structured in horizontal bands, reinforced by the interplay of light and shade, a reflection on the ground of the clouds which fill the sky. The artist's technique and his powers of observation allow him to develop this extensive landscape through the patches of land created by the trees and bushes and by the rivers and canals which snake across the plain. This device serves as a perspective tool which creates the impression of depth and spatial recession. Equally skilled is the representation of atmospheric effects, painted in green and greyish tones and gently contrasted with the yellows and browns confined to the foreground.

Jan van de Cappelle

AMSTERDAM, 1624/25 – 1679

Coming from a wealthy family, Cappelle was able to dedicate his life to painting without having to make it his livelihood. He was a prominent art collector and owned several works by Simon de Vlieger and Rembrandt. Cappelle was principally a landscape painter, developing a type of scene known as a "parade" in which he depicts a gathering of large boats on a calm sea, normally near a port, where they have assembled for an official event. The paintings show majestic ships surrounded by smaller boats, with the Dutch flag visible in a display of the importance of the navy to a country whose main source of income was maritime commerce. This subject of parades would be further developed by van de Velde.

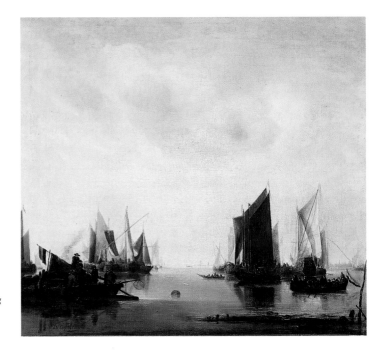

Seascape with Sailing Boats, after 1652
Oil on canvas,
67.3 x 58 cm

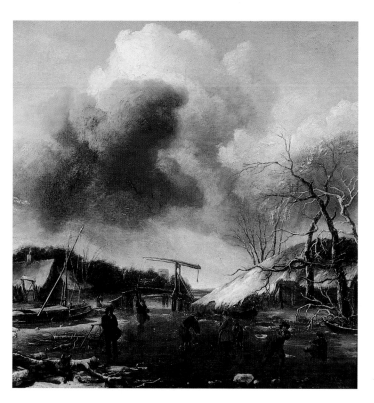

Winter Landscape,
undated (c. 1660)
Oil on panel,
41 x 42.2 cm

Using a compositional scheme typical of realist landscapes, the scene is portrayed from a low viewpoint under a huge sky. Cappelle was extremely skilled in painting the effects of light and atmosphere, as well as the quality of the water and reflections on its surface, using gentle tones from silvery greys to yellows and golds. The artist creates a clear and luminous tonal harmony in a cool colour range. He also painted a number of winter scenes which employ this same grey and silvery palette. Cappelle continued the thematic tradition of artists such as van der Neer and van Goyen, but with fewer figures described in less detail. The principal subject is the cold and grey atmosphere of the harsh Dutch winter. While Cappelle's winter landscapes convey atmospheric effects, they are not merely descriptive, but also possess a pathos, or melancholy feel reminiscent of the works of the great masters such as Jacob van Ruisdael.

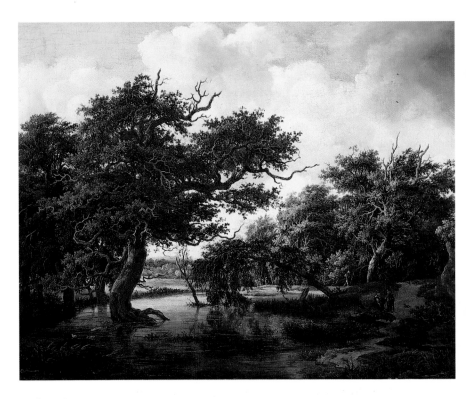

Marshy Wood, c. 1660
Oil on canvas,
68.9 x 90.2 cm

Meindert Lubbertsz Hobbema

AMSTERDAM, 1638–1709

Hobbema was a pupil of Jacob van Ruisdael and together with him was
one of the most important of the realist landscape painters. His work
reveals his debt to his master, whom he followed closely in his early
works to the point that many of them are impossible to distinguish
from those by Ruisdael. Little by little, however, he developed his own
style. His paintings depict local scenes in which the vegetation is less
dense than in Ruisdael's compositions, and, generally speaking, his
landscapes lack the romantic tone which characterized his master's
works. The mood of Hobbema's landscapes is usually one of calm.
Hobbema was especially admired by 17th- and 18th-century English
collectors, and his work consequently exercised an important influence
on British landscape painting.

Marshy Wood dates from a period when Hobbema was starting to
move away from Ruisdael's style. Although the subject is inspired by a
print by his teacher, Hobbema uses a thicker brushstroke and the trees
are rendered in a highly personal manner, with twisted trunks and a very
detailed drawing of the branches and foliage in a nervous style. The
artist's brush becomes subtle and highly detailed in the foreground,
capturing the nuances of light as they fall on the trees and the vibra-
tions and reflections in the water.

The dark and shady foreground is outlined against a luminous
sky with yellowish clouds and against a brighter background landscape
which is lit directly by the sun. The pond is bordered by a road with vari-
ous figures whose small size helps to give the scene scale and construct
the spatial planes as they recede into depth. Indeed, their small dimen-
sions make the trees seem monumental, something only the compari-
son between them allows us to appreciate.

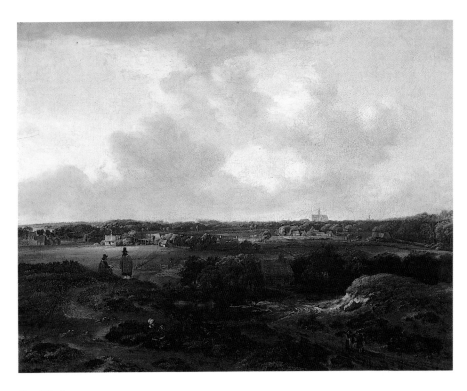

*View of Haarlem
from the Dunes,*
c. 1660–1670
Oil on canvas,
65.3 x 84 cm

Jan Vermeer II van Haarlem

HAARLEM, 1628–1691

A landscape artist specializing in panoramic views, Vermeer's style was very much influenced by Jacob van Ruisdael and Philips Koninck, as can be seen in this work. From these artists he derived above all his use of the high viewpoint and the panoramic view. From Ruisdael he also derived his understanding of space as well as his stronger palette, which contrasts the sky with the green fields, where touches of red and white draw our attention to specific points. The fields mark the fall of light: narrow shafts fall on the scattered groups of houses in the landscape and on the rocks to the right at the edge of the road, in the style of Ruisdael. By these means the artists aims to capture the way the light falls on the land from the small clear patches of sky in between the clouds.

However, the most interesting aspect of this panoramic view is the pair of figures, one of whom could be the artist himself. The two men stand with their backs to the viewer and are sketching *en plein air*. The tradition of depicting artists at work outdoors was a way in which artists meditated on their own activity, and was also to some extent a way of praising it. To sketch directly from nature in order to later transfer the sketch to the finished canvas or panel was the normal practice of such landscape painters. With this inclusion of the artists themselves at work the painter is conveying the message that their works were inspired by real life.

At the same time, their poses with their backs to the viewer encourage our gaze to follow theirs into the background. This background has an almost flat horizon which creates a line of colour contrasting with the sky. Silhouetted against the horizon but faint in the misty distance is a church, probably St Bavo's cathedral of Haarlem.

Willem van de Velde the Younger

LEYDEN, 1633 – LONDON, 1707

W. V. V. J.

Willem van de Velde the Younger is considered one of the best Dutch marine painters, whose fame and popularity lasted well into the 19th century. From a family of painters, he worked with his father Willem van de Velde the Elder when both father and son were in the service of King Charles II in England.

The present painting can be considered of the "parade" type developed by Cappelle shortly before. On the smooth surface of the calm sea a number of stately ships are arranged in a diagonal line, which gives depth to the scene. The perfection and detail with which van de Velde delineates the scene are outstanding. The artist was principally a "portraitist" of ships, representing these vessels in great detail, encouraging the viewer to linger over the smallest details – the masts, sails, coats of arms on the prow, flags, etc.

The painting depicts the Dutch fleet off Goeree, where it was protecting its commercial fleet from possible English attack. Some of the ships on the canvas have been identified: on the left we see the *Vrede* and next to it near the centre the *Drie Helden Davids*; slightly further back is the flagship the *Eendracht*. As we have noted in the context of other seascapes in the collection, maritime commerce with the Indies and with Africa was Holland's principal source of income, and the port of Amsterdam was the entry point for merchandise destined for all parts of Europe. Holland's naval power was therefore a subject for celebratory paintings.

Willem van de Velde II also painted the naval victories of the Dutch over the English. It would seem that some of his paintings, including the present one, were based on drawings of boats by his father, who witnessed the actual events depicted.

*The Dutch Fleet
in the Goeree Straits
(Guinea),* 1664
Oil on canvas,
96.5 x 97.8 cm

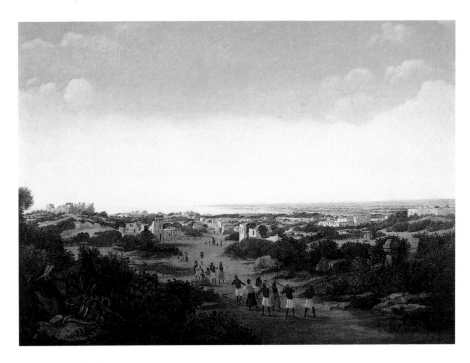

*View of the Ruins of Olinfa
(Recife), Brazil,* 1665
Oil on canvas,
79.8 x 111.4 cm

Frans Jansz Post

LEYDEN, 1609 – HAARLEM, 1680

The Dutch were great travellers, journeying to all parts of the globe in search of new sources of wealth and trade. In the wake of this commercial expansion, a new, exotic type of landscape began to appear in Dutch art, one different to the naturalistic genre depicting specific locations in the Dutch countryside. Part of Brazil was a Dutch colony in the 17th century. This led to the foundation of the Dutch West India Company to oversee trading operations. The organization of the company, which had its headquarters in the northeast of Brazil, was entrusted to Count Maurits Nassau-Siegen, a statesman and renowned soldier. In his retinue travelled Frans Post, who had been commissioned to draw the flora, fauna and topography of the New World.

F. POST

The present painting shows the ruins of the city of Olinfa, burned by the Dutch in 1631, with the sea in the background. Post's trip to Brazil lasted from 1637 to 1644. He may have painted a first version of the subject there, repeating it at least four times after his return to Holland. Brazilian landscapes formed an important part of his repertoire once back home.

Post's paintings serve a documentary purpose and therefore tend towards a detailed but simple and direct vision of the landscape, resulting in an almost "naive" effect. He nevertheless follows the conventions of Dutch landscape painting, using markedly horizontal compositions organized in layers of land and sky with nature playing a more important role than human beings. The exotic character of Post's works separates them from the realistic trend in Dutch landscape. His paintings, in particular those he executed while in Brazil, use a lighting and a palette of intense colours combined with leadish tones, as characteristic of the Tropics, which are not found in the Dutch landscape.

*Family Group
with a Servant in
a Landscape*, c. 1648
Oil on canvas,
202 x 285 cm

Frans Hals

ANTWERP?, 1581/85 – HAARLEM, 1666

Hals was born in Antwerp in the Flemish province of the Netherlands, but his family subsequently moved for religious reasons and are documented in Haarlem by 1591. The artist mainly dedicated himself to painting the Dutch middle classes and was the inventor of the group portrait, an important genre which saw numerous developments throughout the 17th century, particularly in Holland, where it was much sought-after by civic corporations such as professional guilds, military orders, town councils, etc. The present work portrays a middle-class family: the parents with their children, a negro servant in the background and a dog. Their poses seem to be spontaneous, portrayed just as they are, resulting in an agreeable and relaxed atmosphere, despite the dignity of the subjects. There is nevertheless a hidden intention behind the scene: the pose of the man and wife holding hands and seated side by side, probably on a tree trunk, is a symbol of fidelity.

Realism and a lack of formality are the distinguishing features of this painting. Its technique of large, loose and vigorous brushstrokes contributes to this feeling of spontaneity and dynamism, as if the picture were an instant snapshot. Despite the laden brush, whose strokes can clearly be seen, Hals manages to reproduce with great delicacy the subtle transparencies of the ruffs and the embroideries and fastenings, as well as the textures of the silks and velvets. The background landscape contributes to the informal mood. Typical of Baroque painting is the way in which one part of the canvas opens out onto a distant horizon, while the other part is sealed by dense woodland which frames the figures. The broad landscape is related to panoramic views by other Dutch artists such as Koninck (a pupil of Hals) and Seghers, and characterized by low and luminous horizons, a vast sky scattered with white clouds, and a city in the background. Landscape painting as an independent genre rose to its greatest heights in 17th-century Holland.

"I work to maintain my good reputation. The painter must keep secret the servile and laborious work required to achieve the likeness demanded by a portrait."
FRANS HALS

Isaack van Ostade

HAARLEM, 1621–1649

Aʋ. OSTADE

A painter of genre scenes, but primarily of landscapes, in this work Isaack van Ostade combines the two types of painting, creating a very realistic and intimate composition. *Traveller at a Cottage Door* is also the first of number of paintings we shall be discussing which reflect the pride of the Dutch, recently liberated from Spanish rule, in their country and their nation. This new type of Dutch genre painting, in its representation both of daily life and of landscape, was a hymn of love and patriotic pride. While the subjects it treated were familiar, the particular focus given to them is new. Ordinary men and women are portrayed with the same respect and dignity which one would normally expect to see in a history or mythological painting. At the same time, artists were moved by the prevailing mood of realism to paint the world as it appeared before them, or to compose the scene using elements taken from this reality.

The present painting illustrates an anecdotal scene from rural life, namely the meeting between a traveller, probably a seasonal agricultural labourer, and the inhabitants of a cottage in a wood. The prevailing note is one of realism, arising both out of the fact that the figures are perfectly integrated within their surroundings, and also from the naturalism of their poses: their looks and gestures indicate that they are enjoying a gentle conversation.

The whole scene is bathed in a golden light, evoked through the use of a limited but warm palette of chestnut browns, earthy-greys and yellows which produce an impression of overall spatial unity. At the same time, the skilful nuances of light and shadow and the open sky visible in the top left corner create the sensation of a coherent and broad three-dimensional space.

Traveller at a Cottage Door, 1649
Oil on panel,
48.3 x 39.4 cm

*The old Fish Market
on the Dam,
Amsterdam,* c. 1650
Oil on panel,
55 x 44.8 cm

Emanuel de Witte

ALKMAAR, 1617 – AMSTERDAM, 1692

E·De·WITTE

Within the genre of scenes of everyday life, Emanuel de Witte specialized in the description of public places, such as churches and markets. His painting is characterized by the representation of large architectural spaces filled with small figures. He uses a warm palette in a range of earthy-grey and brown tones and deploys interesting contrasts of light and shade.

This market scene, as is usual in this type of painting by de Witte, has a group of fish in the foreground painted in sufficient detail as to be easily identifiable and forming a sort of still life. A ray of light falls on a series of details which attract the viewer's attention and form the focus of the painting, the rest of which is painted in almost monochrome shades of greyish brown. Alongside the group of large fish in the foreground, the woman with the basket and white bonnet and the child on the right also stand out. The artist is painting a normal market day, with customers buying fish and strolling around in a casual fashion, offering us a vision of a moment of real life.

De Witte also specialized in church interiors, spaces whose unique architecture gave him the opportunity to study the effects of light, including areas in shade and rays which filter through stained-glass windows. This painting reproduces the nave of a Gothic church with the choir in the centre, in an intermediate plane of shadow.

The artist reproduces the details of the architecture and the different effects of light, the lengthy shadows and the light which enters through a window and strikes part of a column in the choir. De Witte aims to capture the effects of space and depth through light and atmosphere. In line with the taste of his day, however, he also introduces small figures who lend the scene life and vitality.

Interior of a Gothic Church, c. 1669
Oil on panel,
52.1 x 40.2 cm

Jan Havicks Steen

LEYDEN, 1626–1679

Steen was a genre painter who specialized in scenes of village festivals and popular customs, following a trend initiated by David Teniers the Younger. His cheerful and light-hearted paintings are filled with figures engaged in numerous anecdotal activities which set them in context and contribute to the realism of the overall representation. Steen worked in various Dutch cities including Utrecht, The Hague, Delft, and Haarlem, before returning to Leyden around 1670. In Utrecht he met Jan van Goyen, whose daugther he married in 1649.

Steen's style evolved towards paintings with a smaller number of figures who occupy a larger amount of the pictorial space and have greater individual characterization. His self-portrait is an example of this development. The artist paints himself with a sense of humour, looking at the viewer with a smile while he plays the lute. His clothes refer to theatrical costume, another subject which Steen cultivated throughout his career. On the table on the right we see a flagon of wine, some papers, an open book and what could be a sketch for a painting. The artist also painted tavern scenes, a subject referred to in the present work, which might well be set in such a venue.

The present work employs a warm palette and a uniform lighting, with the figure standing out against the black curtain in the background. The loose brushwork in the manner of Hals can be clearly seen, creating sketchy forms. Small touches of white on the collar, cuffs, knees and papers on the table interrupt the earthy and golden tones which predominate in the painting.

Self-Portrait with a Lute, c. 1652–1655
Oil on panel,
55.3 x 43.8 cm

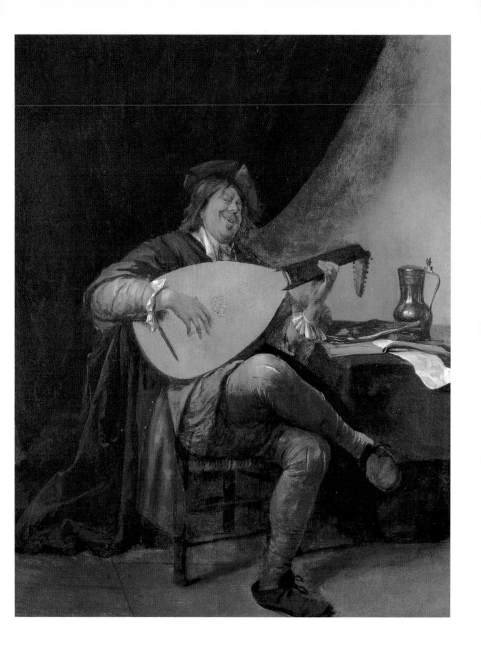

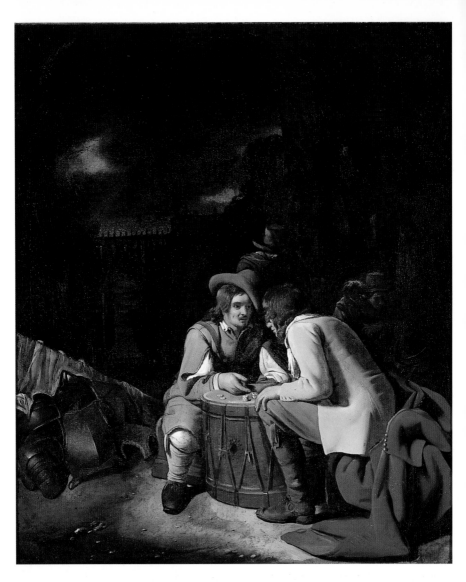

Soldiers playing Dice,
c. 1655
Oil on canvas,
76.4 x 61.8 cm

Michiel Sweerts

BRUSSELS, 1624 – GOA, 1664

Sweerts began his artistic career in Brussels, leaving for Rome in 1646. He remained there until 1654, painting genre works in the circle of the *bambocciati* (Dutch and Flemish artists living in Italy who painted small views of the Italian countryside with figures). On his return to Brussels in 1654 he opened an academy of drawing and evolved towards a type of genre painting which was closer to the intimate domestic style of painters such as Vermeer and Peter de Hooch. The two works reproduced here, reveal his skills as a draughtsman and illustrate his approach to lighting derived from tenebrism.

Boy with a Turban contains many reminiscences of Italian art, particularly in the idealization of the figure. It has been suggested that the painting is allegorical, the posy of flowers possibly referring to the sense of smell, in line with iconographical formulae for the five senses which became popular in the 17th century. The figure has been firmly delineated and realised in a harmonious range of bright but cold colours against a black background. The pose is slightly foreshortened so that the body and hand are turned in one direction while the head turns the other way, emphasized by the direction of the gaze. The turban gives the sitter an exotic look, as does the melancholy gaze. Both elements contribute to the painting's enigmatic feel.

Boy in a Turban,
c. 1656–1658
Oil on canvas,
86.7 x 74 cm

The same approach to lighting is found in *Soldiers playing Dice*. The scene is set outside on a dark night, so that the background appears barely sketched in, realised in dark tones which blend into the black. Against this background, two figures are illuminated by a focused light source. The foreground is painted in greyish-brown tones, against which, sharply and precisely drawn, the yellow riding coat and the red cape stand out as the real subjects of the painting.

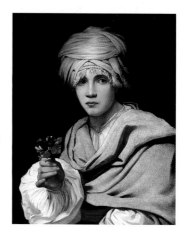

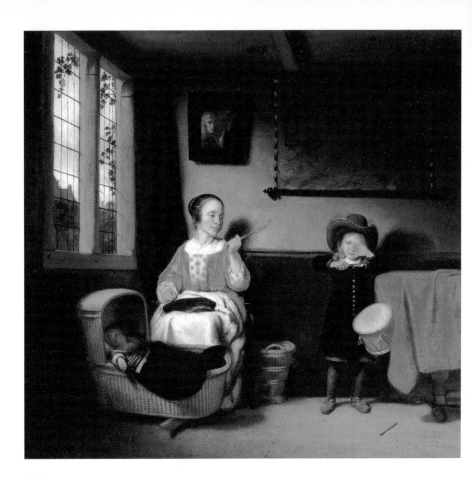

The Naughty
Drummer Boy,
c. 1655
Oil on canvas,
62 x 66.4 cm

Nicolaes Maes

DORDRECHT, 1634—AMSTERDAM, 1693

A portraitist and painter of domestic scenes, Nicolaes Maes began
his career as a pupil of Rembrandt, from whom he learned to capture
the psychology of his sitters and a tenebrist technique. In his mature
period, however, to which these two paintings belong, he moved away
from Rembrandt's style and adopted a more detailed technique with
a greater interest in anecdotal details.

In this domestic interior we can nevertheless see an attention
to lighting evident in the way the light enters through the window and
illuminates the centre of the scene, leaving other parts of the room in
shadow and fusing the shadows of the mother, the child and the cradle.
The scene depicts a subject very similar to that painted by Pieter de
Hooch, although the treatment is different, with a greater emphasis on
the anecdotal element, setting up a story around the child's disobedi-
ence and the mother's scolding. Maes produces a truly realistic repre-
sentation of daily life. On the wall, in addition to the map, is a mirror
in which we can see the reflection of the artist painting, implying that
the figures portrayed may be Maes's wife and his children.

The domestic feel and the simplicity of the first painting are in
strong contrast to the cold elegance of the two portraits. From the
1660s, Maes was influenced by the French style of portraiture, charac-
terized by a refined and distant air. These two portraits show a married
couple. Using cold tones, Maes produces two stylized images with ele-
gant hands and much attention to the ornamental details, which he
paints with great meticulousness. The bodies of the two figures are
slightly turned in symmetrical and stiffly upright poses, looking out at
the viewer. Through their gazes, poses and gestures Maes has aimed
to imbue these figures above all with a sense of dignity, not just em-
phasizing their personalities but also their elevated social status.

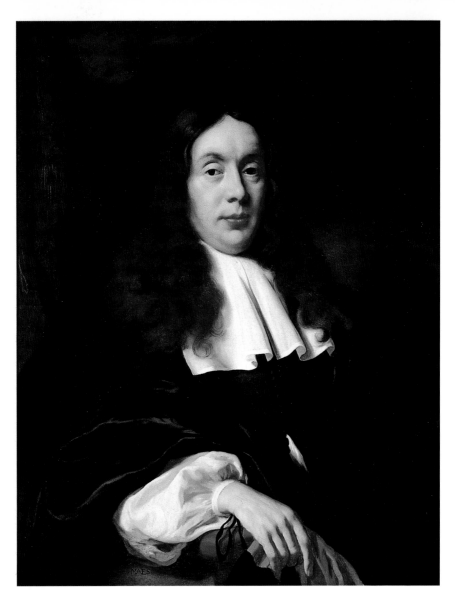

Portrait of a Man,
c. 1666/67
Oil on canvas,
91.4 x 72.7 cm

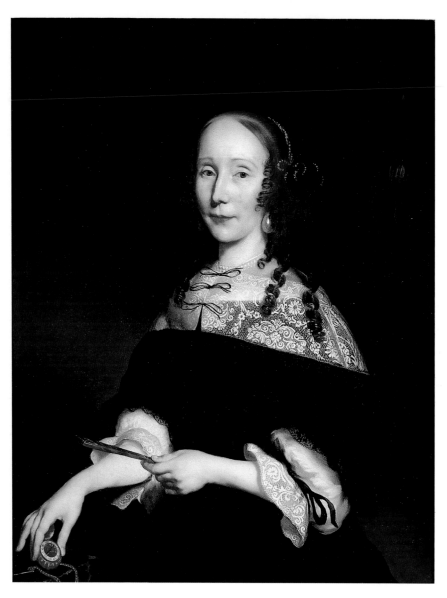

Portrait of a Lady,
1667
Oil on canvas,
91.7 x 72.4 cm

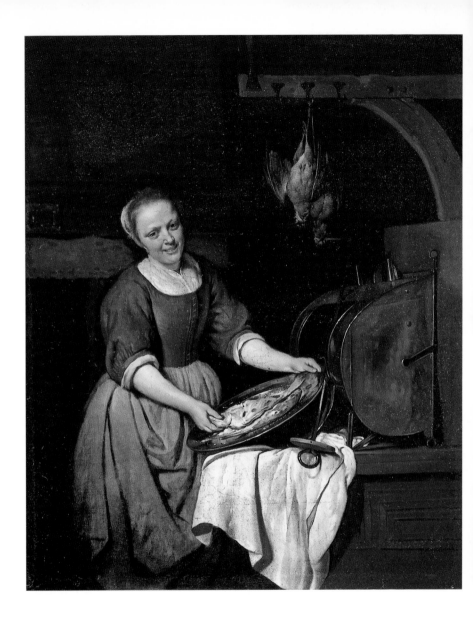

Gabriel Metsu

LEYDEN, 1629–AMSTERDAM, 1667

Metsu was another Dutch artist who painted scenes of domestic interiors, spending almost his entire career in Amsterdam. Although he occasionally painted mythological and religious works, he mainly specialized in paintings of markets and kitchens, of which the present work is an example. Metsu was probably a pupil of Gerrit Dou, but his work resembles above all that of Ter Borch and Hooch.

His subjects usually represent interiors with a few agreeable-looking figures depicted as clean and tidy and within an ordered environment. His working-class figures are depicted with a dignity and importance which places them on a level with middle-class or aristocratic subjects. Here a woman, showing us a tray with two fish and illuminated by a bright light, stands out against a dark, earth-toned background. The tones of the room are very homogeneous, harmonizing into a warm colour range.

Metsu avoids excessive detail and introduces only the elements needed to identify the room as a kitchen: the chimney in the background, the hanging partridges and a sort of portable metal oven. Against the dark colour range of the foreground, the white cloth and the blue pinafore stand out, as well as the figure's face and arms. The naturalism and respect for reality are essential elements in this type of work, produced as a testimony of the customs and habits of a society rather than as genre painting.

The theme of kitchens was a natural development from the representation of domestic scenes; these gave rise to depictions of game, fish, kitchen utensils and fruit and vegetables which would subsequently become separate compositions, leading on to the genre of still life. Indeed, the partridges, fish and kitchen utensils occupy a pre-eminent place in *The Cook*, constituting its principal axis.

G Metsu

"The subtlety of Metsu and the enigma of Pieter de Hooch depend on there being much more air around the objects, shadow around the light, stability in volatile colours, blending of hues, pure invention in the portrayal of things, in a word: the most wonderful handling of light and shade there has ever been ..."
EUGÈNE FROMENTIN

The Cook,
c. 1657–1667
Oil on canvas,
40 x 33.7 cm

Willem Kalf

ROTTERDAM, 1619 — AMSTERDAM, 1693

The concept of the still life originated from a desire to imitate nature in such a way as to deceive the viewer into believing that the depicted object was actually real. In the Renaissance this impelled artists to try and improve on the still lifes of Antique painters, none of which had survived but which were known from descriptions by classical writers praising their lifelikeness. The most famous of these was Pliny's description of a painting by the Greek painter Zeuxis of some grapes which were so realistic that birds flew down to peck at them.

As a result, in the 16th century a series of artists achieved such a high level of technical competence that they were able to imitate nature closely. However, it was not until the 17th century that fruits and flowers began to be painted as independent subjects, and it was in Holland that this genre reached its greatest degree of refinement and perfection. The desire of cultivated and scholarly collectors to own works of the type which had so pleased classical collectors seems to have been a major factor in the development of this genre, which allowed artists to display their powers of illusionism.

Kalf's paintings are among the most sophisticated of Dutch still lifes. Taking a much more Baroque and decorative approach than Heda, he filled his paintings with sumptuous and exquisite objects which would only have been found in the most aristocratic and wealthy circles. The three paintings in the Thyssen-Bornemisza Collection are similar in composition. Using a vertical format and a dark background, the objects are arranged on a table or marble sideboard, partly covered with an Oriental carpet which is casually folded back at one end. On it are a few pieces of fruit and flowers and a series of precious objects such as the nautilus cup which appears in all three paintings, and the pieces of Chinese porcelain which experts have identified as very rare examples belonging to collectors of the artist's day.

The presentation is highly theatrical in all three works, with a subjective treatment of light which highlights some areas in order to darken others. The technique is meticulous and highly detailed, rendering the

Still Life with an Aquamanile, Fruit, a Nautilus Cup and other Objects, c. 1660 Oil on canvas, 111 x 84 cm

fruit and objects in an extremely illusionistic manner, with great atten-
tion paid to the reflections and textures, distinguishing between the
various surfaces (smooth, wrinkled, shining or matt) and defining the
drawing and the decorative elements despite the overall darkness of the
canvas. Kalf's technical mastery is brilliantly displayed in his rendering
of the transparent glasses against a black background, achieved with
highlights and white and gold reflections, conveying the natural trans-
lucence of the liquid they contain.

Kalf's virtuoso technique can further be seen in his skilful combi-
nation of colours, as part of which he distributes brilliant hues judi-
ciously across the canvas, and often creates a bright zone of pale

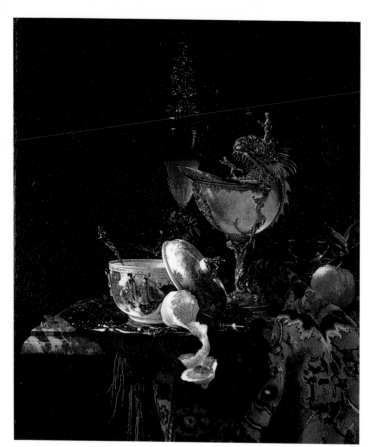

*Still Life with
a Chinese Bowl,
a Nautilus Cup
and other Objects,*
1662
Oil on canvas,
79.4 x 67.3 cm

colours in the centre which attracts the viewer's gaze. Around it, the
tones are less brilliant and become darker as they recede into the back-
ground. Some art historians have seen a hidden meaning in these
works, in particular in the presence of the watch (which appears in two
of the canvases), which might suggest the idea of the passing of time
and the transience of life.

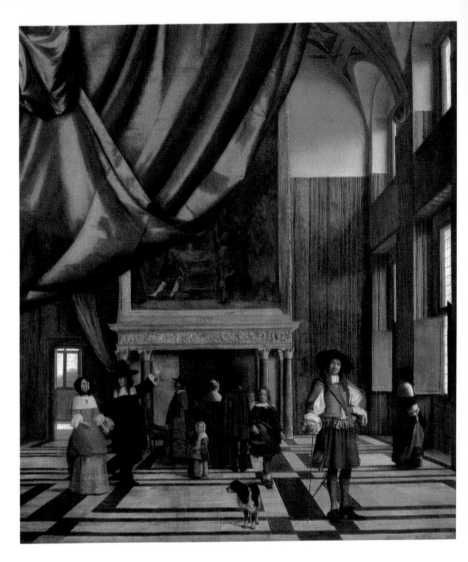

*The Council Chamber
in Amsterdam Town
Hall, c. 1661–1670
Oil on canvas,
112.5 x 99 cm*

Pieter de Hooch

ROTTERDAM, 1629 – AMSTERDAM, 1684

The great flowering of Dutch genre painting took place in the second half of the 17th century, following the years of repression under Spanish rule which eventually concluded with the independence of Holland in 1648. During this period and thanks to the economic boom which the Dutch provinces enjoyed, artists received numerous commissions for small-scale easel paintings from wealthy, urban, middle-class patrons who wished to have themselves, their homes and their activities depicted.

These two paintings show very different interiors, but both reflect the lives of Dutch burghers. In one, we are invited into the intimacy of the domestic world, represented by a woman sewing next to a window with her daughter, seen from behind, in front of her. This type of scene, relating to the activities of the housewife, was also painted by other artists such as Maes and Vermeer (the most important representative of the genre). The artist describes the room and its furniture with great precision, sketching in the second room visible through the doorway and the interior window. The clothes, the painting, the chair and the bench are all a valuable historical record of society at that time.

Interior with a Woman sewing and a Child, c. 1662–1668 Oil on canvas, 54.6 x 45.1 cm

Equally important from a documentary viewpoint is the painting of *The Council Chamber of Amsterdam Town Hall*, in which a number of figures are seen walking and chatting: there is even a dog. They may be a group of visitors, but whatever the case they provide a remarkable testament to contemporary fashion. The plain architecture, although it has a monumentality appropriate to a public building, serves as a reminder of the political, social and intellectual differences between the north of Europe and the Catholic south, with its opulent courts and excessively ornate tastes. De Hooch specialized in architectural interiors, and both paintings demonstrate his skilful structuring of space, his confident handling of perspective – reinforced by the flooring – and his coherent evocation of depth.

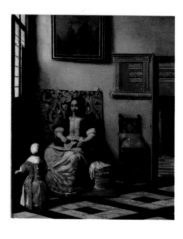

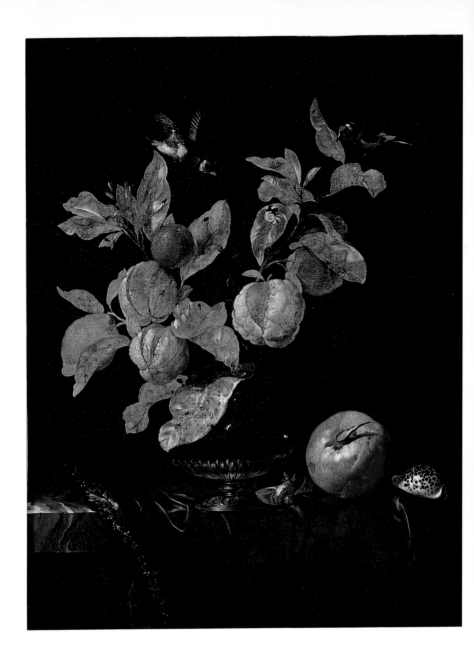

Willem van Aelst

DELFT, 1627—AMSTERDAM, C. 1683

In this interesting painting we encounter once again the illusionism and the desire to imitate reality which we saw in the works of Kalf. Aelst, too, was a painter who specialized in still lifes of fruits and objects, in compositions of which the present work is a typical example. He spent part of his life outside Holland, working in France and Italy, and his Italian training may explain the unique delicacy and harmony which we experience in his works.

This still life, which takes the form of a vase of flowers with fruit, is notable for its highly finished manner and for its contrasts of predominantly cool tones. The leaves and the lemons are sharply outlined against the black background, as if the painting were a piece of marquetry. The artist's decorative sense, which is particularly obvious in compositions of this type, is also evident in the balanced and harmonious organization of the various elements, as well as in the skilful arrangement of the colour masses. The two goldfinches perched on the branches and flying overhead give movement and life to the image.

The work is indicative of a refined taste which avoids overloading. However, if we look more closely we can see that the image conveys instability. The vase, with its silver or copper base and glass body, is placed right on the edge of the table, slightly projecting over the edge; the silky cloth seems to be very slippery in texture and the branch of lemons must be quite heavy. It seems, too, as if the flying bird is about to land or peck at the juciest lemon, which would make the vase and its contents tip over. The picture actually captures the instant before this disaster occurs.

Still Life with Fruit,
1664
Oil on canvas,
67.3 x 52.1 cm

Jan Davidsz de Heem

UTRECHT, 1606 – ANTWERP, C. 1683/84

F. D De Heem

Specializing in still lifes and flower pieces, Heem's œuvre is character-ized by a number of Baroque-style paintings featuring a profusion of different elements. His work reveals a debt to Flemish artists such as Frans Snyders, who painted large and typically Baroque still-lifes filled with game, live animals, fruit, and flower, in complex and overladen compositions. But Heem was also influenced by the work of other artists, such as Heda, which caused his style to become progressively more detailed and less overloaded.

In this panel Heem portrays a group of flowers, fruit and small animals, precisely delineated and in brilliant colours. Against a black background and standing on a table or pedestal is a clear glass vase, through which we can see the stalks of the flowers in the water. The attention to minute detail and the virtuoso style which this artist displayed is evident in the reflection of a window on the surface of the vase, also visible on the skin of the cherries in the foreground.

Near to them are some acorns, raspberries and ears of corn as well as other fruit, mixed in among the flowers in a deliberate disorder which gives a dynamic feel to the composition. The painting is com-pleted with a snail, caterpillars and butterflies, as if the artist wished to represent every element in a garden. The lighting is artificial and is used to highlight the parts which most interest the painter. Once again we are in the presence of an exercise in technical ability deployed in the imitation of nature.

As has been suggested with regard to numerous other still lifes, this painting may also have an allegorical meaning arising out of the elements within it. Thus the lilies may represent the Virgin, the ears of corn the Resurrection and the peonies the passing of life. Read in this way, the insects may also have some reference to life and death.

Still Life with Flowers in a Glass Vase and Fruit, c. 1665
Oil on panel,
53.4 x 41 cm

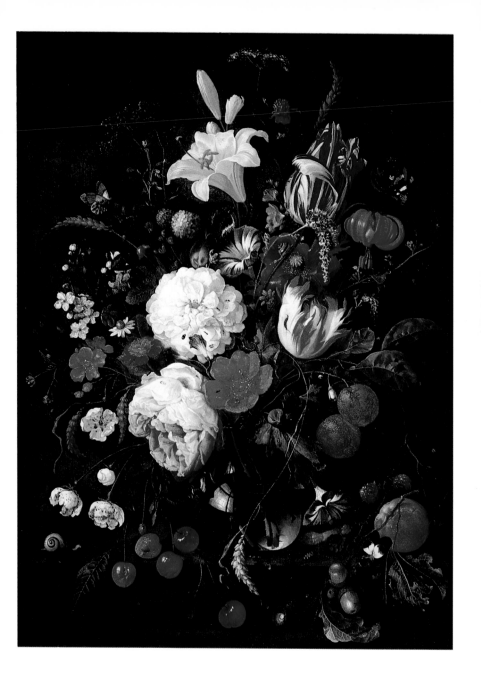

Pieter Jansz Saenredam

ASSENDELFT, 1597 – HAARLEM, 1665

Genre painting in Holland embraced all areas of life: scenes from daily life, domestic interiors, still lifes, seascapes, landscapes, architectural views and urban scenes. The Dutch were proud of their nation and its many different faces, and genre paintings were in great demand amongst the middle and upper classes. Like many artists, Saenredam chose to specialize – in his case, in paintings of architecture ranging from urban views and famous buildings to church interiors.

Settling in Haarlem, the artist visited other parts of Holland, including Utrecht, making detailed sketches and drawings of buildings and town centres wherever he went. He used these drawings on paper to later elaborate his paintings on canvas in the studio. There are at least two paintings of the St Mary's in Utrecht: this one, in which the church is viewed from the front, and another side view. Both show the artist's detailed style and the topographical character of his architectural paintings.

Utilizing a bright light and a transparent atmosphere, Saenredam paints the church's main façade, with firm and geometrical underdrawing to accentuate the vertical careful attention to detail. The building is outlined against a whitish sky with a few white clouds. The viewpoint from the ground allows for a low horizon with a landscape that is made to terminate relatively close to the front picture plane by a dense group of trees. This compositional structure serves to underline the monumental nature of the church. Characteristic of Saenredam is the inclusion of a small group of isolated figures, which he uses to give his architectural compositions scale.

P.ᵣ Saenredam

The West Front of St Mary's Church, Utrecht, 1665 Oil on panel, 65.1 x 51.2 cm

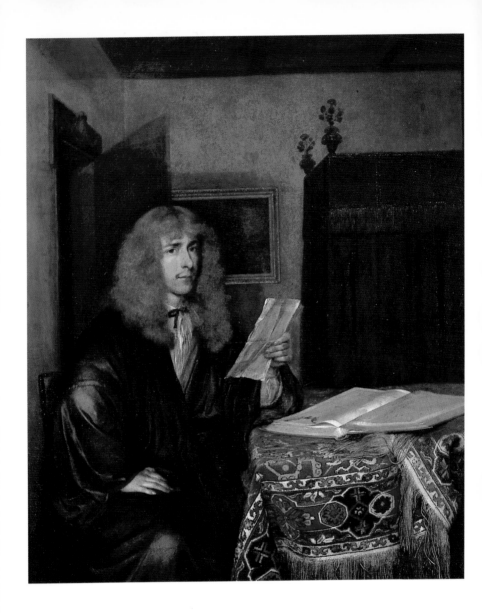

Gerard Ter Borch

ZWOLLE, 1617 – DEVENTER, 1681

Gerard Ter Borch was trained in Amsterdam and Haarlem, but at an early stage began a series of trips around Europe which gave him the opportunity to see first-hand the work of the leading painters of the 17th century. He visited England, Italy, France, Germany and Spain, even though his style reflects no particular influence, but rather stays within the general lines of Dutch genre painting with its taste for detail and realistic representation.

Ter Borch is perhaps the most refined of the painters of domestic scenes, depicting the good taste and decorum of the Dutch bourgeoisie. He was also a reasonably successful portraitist. His portraits, as we can see in the present work, have the same character as his genre paintings. They include incidental details and portray their subjects within domestic interiors.

This anonymous sitter, probably a member of Amsterdam high society, is seated in a room with a table on which we can see what is probably an Oriental carpet or rug (curiously, one of its corners is folded back to reveal the underside, whose design is identical to that on the front, thus indicating the quality of the carpet). On the table is a map which some art historians have interpreted as a map of the Netherlands. In the background, a bed with a canopy and a half-open doorway assist in lending the scene a sense of depth. Using the device of aerial perspective, the painter executes the foreground in great detail, elaborately recreating the patterns on the carpet, while the forms become more blurred towards the background, which is also darker. Ter Borch tended to light his figures and their immediate surroundings strongly, leaving the rest of the scene in darkness or semi-darkness and painted in much more subdued tones.

Portrait of a Man
reading a Document,
c. 1675
Oil on canvas,
48 x 39.5 cm

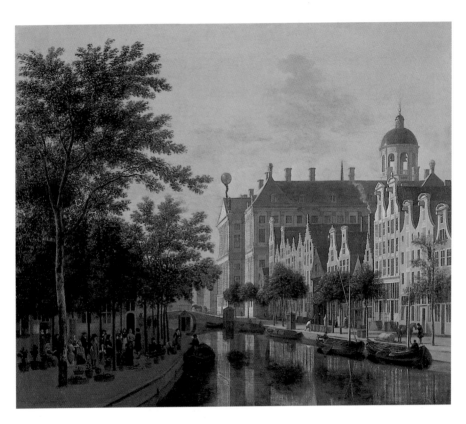

*The Nieuwezijds
Voorburgswal,
Amsterdam*, 1686
Oil on canvas,
53.7 x 63.9 cm

Gerrit Adriaensz Berckheyde

HAARLEM, 1638–1698

Painters of buildings and urban scenes also followed the realist tendency of the period. They painted views of cities, their streets and most important monuments, conveying the image of active and prosperous communities. In many cases these paintings are of great documentary value for what they tell us about the cities of the period.

Gerrit·
Berck·Heyde

In this case Berckheyde has painted Amsterdam on a flower-market day. On the right a line of sunny houses are typical of the style of Dutch middle-class homes. High and narrow and arranged over several floors, they have steep roofs against the rain and stepped gables. In the background is the Town Hall, which was designed by Jacob van Campen, the most important representative of Dutch classicism in architecture, and built between 1648 and 1665. The building stands out from the rest through its monumentality, scale and style. It was, in its day, the grandest public building in Europe, designed and decorated to express Amsterdam's pre-eminent position and thereby indicative of the political and economic importance which city councils held in the Dutch political system.

The artist also reveals an interest in representing spatial depth through a perspective organized by the buildings and the canal, and in capturing the light and its effects on the various elements: the lengthy shadows and the slant of the golden light thereby suggest a summer evening. In the centre we see the glassy waters of the canal with the buildings along its bank reflected in bright colours. The realism and the depiction of the everyday are important elements in the painting, as demonstrated by the group of people beneath the tree, chatting and strolling by. On the far bank of the canal are a series of moored barges and other figures busy moving goods.

Claude Lorrain

CHAMAGNE, LORRAINE, 1600 – ROME, 1682

Claudio f

Claude Gellée, known as Lorrain, was born near Nancy in France. From 1613, however, he is recorded in Rome, where he spent most of his career, which he dedicated to the painting of landscapes. Although landscapes were starting to assume some autonomy a full century earlier, in the works of the Venetian school and above all Giorgione, Lorrain nevertheless represents one of Italy's earliest and most important exponents of landscape painting as an independent genre. Starting from the classicist tradition, he elaborated an idealized landscape which would give rise to a whole school and which can be considered close to the art of Nicolas Poussin.

In the present painting the subject of *The Flight into Egypt* is barely noticeable, and simply serves as an excuse for a landscape bathed with the golden light of dusk, with orange-tinted skies – yielding to an intense blue at the top – and a light mist which envelops everything and softens all the outlines. Lorrain's style influences his treatment of space, which is conceived in terms of light and atmosphere. The composition follows a type widely employed within the classicist landscape tradition: it is structured on the basis of a vertical axis which divides the painting into two parts; on the right a backlit group of trees focuses the attention on the foreground and frames the episode *of The Flight into Egypt*; on the left, the landscape opens up to offer a view of a distant horizon. The alternation of darker zones in the foreground with lighter ones in the background is a Mannerist device much used by Lorrain.

An imaginary landscape, not being subject to the constraints of a real view, is organized according to a predetermined compositional structure. The classicist landscape painters, who included Poussin, developed a type of landscape which evoked the classical world, with ruins dotting the countryside and pastoral scenes. They thereby sought to represent an idyllic world, agreeable and warm, set in a Golden Age lost in the past, whose myth would endure throughout the 18th century and which was identified with the Arcadia of the Greek poets.

*Ideal Landscape
with The Flight into
Egypt,* 1663
Oil on canvas,
193 x 147 cm

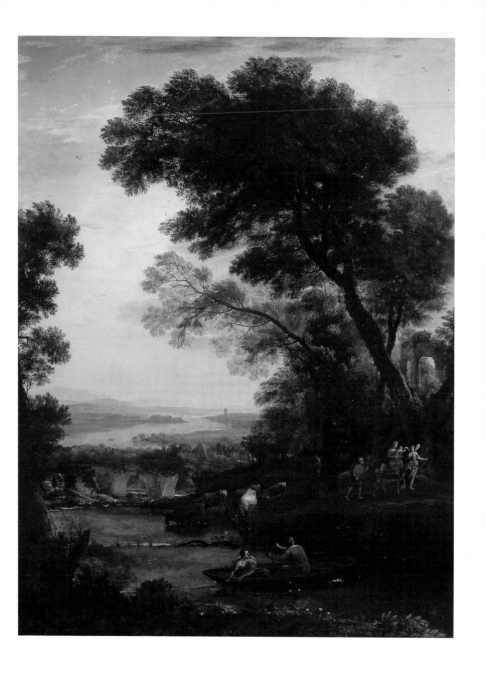

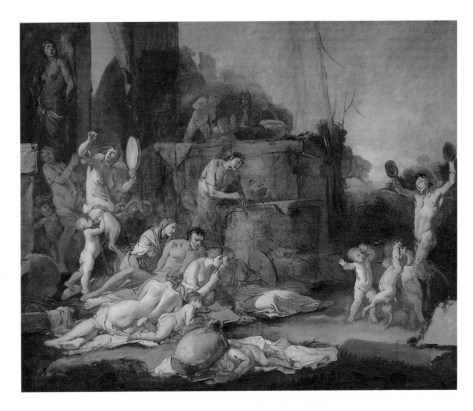

Bacchanal,
c. 1660–1665
Oil on canvas,
81 x 100 cm

Giulio Carpioni

VENICE, 1613 – VICENZA, 1679

Decorative painting in the classicist style enjoyed great favour in aristo-
cratic Italian circles, where patrons commissioned major iconographical
programmes to decorate their palaces. A large number of artists there-
fore dedicated themselves to this type of painting, most of them follow-
ing the aesthetic precepts of the great masters, resulting in an eclectic
style which mixed the realist tendencies of Caravaggio with the lingering
influence of 16th-century Mannerism and the idealism of Poussin.

In general, these decorative programmes portrayed mythological
subjects drawn from classical literature, closely in line with artistocratic
tastes. For these lovers of the good life, an educated elite familiar with
classical literature, poetry and music who liked to surround themselves
with works of art that delighted the eye and stimulated the mind, myth-
ological subjects allowed for the creation of an idyllic world of unreal
beings, in which human passions were depicted under the guise of fic-
tion and artists therefore enjoyed fairly free moral license. In addition,
mythology presumed a body of knowledge and was a sign of the culti-
vated status of the person who commissioned the work.

Carpioni's painting should be understood in this context. It repre-
sents a bacchanal, a celebration in honour of Bacchus, god of wine and
of mystic delirium. Such celebrations had a licentious and orgiastic
character. In the painting we see groups of fauns and nymphs, some
dancing, others reclining, within a setting of classical ruins and an ideal-
ized landscape. The composition is arranged in two parts: the more
crowded and confused scene on the left contrasting with the relative
openness of the right side.

The painting is unfinished, which allows us to see the artist's cre-
ative process. The figures and architectural and decorative elements in
the foreground are drawn in a sketchy way to define their outlines. Over
this the volumes have begun to be filled in and the details applied through
colour. The landscape in the background is painted straight in, using
large areas of colour which would have been given more detail in the fin-
ished work. The oil is applied in thin glazes and with very little impasto.

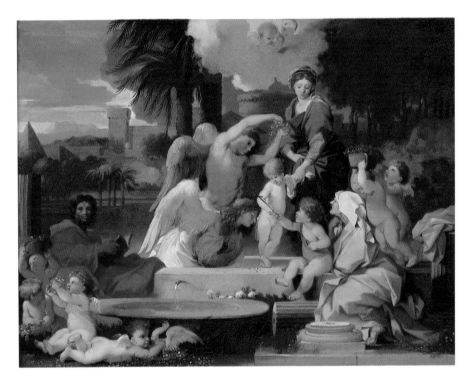

*The Holy Family with
St Elizabeth and the
Infant St John the Baptist,*
c. 1660–1670
Oil on canvas,
39 x 50 cm

Sébastien Bourdon

MONTPELLIER, 1616 – PARIS, 1671

Sébastien Bourdon represents the classicist and idealizing trend initiated by Nicolas Poussin, his contemporary and the leading French artist of the 17th century. Like Poussin, and like many other French and European artists, Bourdon made the obligatory study trip to Italy – to Rome, where he met Poussin, and to Venice, all of which influenced his style. In Venice he specialized in genre painting and in landscape in imitation of Claude Lorrain. Around 1640 he returned to France, and after some years in the service of Queen Christina of Sweden, he settled in Paris, where he acquired a great reputation. His painting of these French years shows its most obvious debt to Poussin, as reflected in the present work, which is characteristic of his late style.

The Holy Family is portrayed in an imaginary landscape surrounded by angels and cherubim. The classicist and idealized treatment of the scene reflects the idealist tendency which developed in France at the hand of Poussin and which remained widespread throughout the 18th century. This idealism drew on Antiquity, creating around itself a myth of a Golden Age which was lost in the beginnings of time, a happy era in which human beings lived at peace with each other and with nature.

The character of the present Holy Family is imbued with this idea, presented in an idealized setting filled with celestial beings, whose only obligation is to contemplate the Infant Jesus, standing by a fountain, playing with the infant St John the Baptist, who is sitting next to his mother St Elizabeth, Mary's cousin. The idealization of the figures is obvious, including that of Joseph who, instead of being an elderly carpenter, is a young man reading a book. The iconography is drawn from mythological painting, and the imaginary landscape in the background possibly refers to an idealized view of somewhere in Asia Minor (it includes palm trees, an oasis and some pyramids in the distance, together with a fortress). It is also significant that the group of figures is placed on the ruins of a building, which from its style would seem to refer to classical antiquity.

Bartolomé Esteban Murillo

SEVILLE, 1617–1682

Murillo was the leading artist in the Seville in the second half of the 17th century, displacing Zurbarán. In his art he introduced a new style linked to the triumphant Baroque manner and counterbalancing the austerity and drama of the naturalist trend which had dominated the first half of the century. His work is primarily religious, and introduces a new iconography which downplays the drama of the subject in favour of a gentle and sentimental intepretation. Murillo painted numerous works on the subject of the Immaculate Conception and the Virgin and Child, creating a model which was widely imitated in following centuries. He also painted genre compositions of street urchins.

A notable feature of this beautiful canvas is the gentleness with which Murillo treats the figures and their interrelationships, creating an emotional link between the viewer and the work. The technique helps to reinforce this mood. Based on highly skilled drawing and a light and fluid stroke, the artist deploys a rich and subtle palette of warm and golden tones, as well as spatial effects created on the basis of light and atmosphere which establish the different planes within the pictorial space.

The scene is structured on a harmonious compositional base derived from classical models. The principal figures are gathered together in a pyramidal arrangement, with the Virgin depicted in slight contrapposto. With their interlocking gazes and gestures, they form a completely self-contained group, which stands out from the rest of the composition through its more finished handling and through its reds and blues (always filtered) that contrast with the greyish-brown and golden tones in the background. Another group of figures completes the scene, arranged in a space suggesting a celestial plane. On the right, a group of saints with their martyrs' palms are delicately painted with a great sense of harmony. In the background is a city, which the artist has barely sketched in to give the feeling of distance. Here we see St Rosalina preaching. Above the central group a few little cherubs play in the clouds.

The Virgin and Child with St Rosalina of Palermo, c. 1670
Oil on canvas,
190 x 147 cm

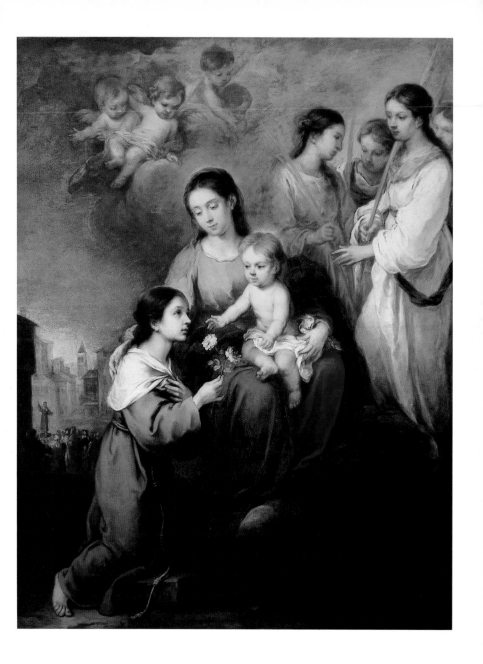

The 18th Century

Sebastiano Ricci

BELLUNO, 1659—VENICE, 1734

J Ricci

The 18th century in Italy represented a high point of artistic achievement, particularly in Venice where the late Baroque reached its culmination. Sebastiano Ricci initiated the 18th-century Venetian style which had its stylistic starting-point in the decorative Baroque of the previous century. His work includes references to the great compositions of Luca Giordano, the Carracci, Correggio and even (albeit in a generalized way) Raphael.

These two paintings are a pair depicting mythological scenes taken from Ovid. They show the sea god Neptune and his wife Amphitrite and the marriage of Bacchus, god of wine, with Ariadne, daughter of Minos, king of Crete. The paintings are undated, but judging by their style and subject matter it seems likely that they were painted during Ricci's Roman period. Ricci travelled throughout his life, working in the major Italian cities as well as in England, France and the Netherlands, but always returning to Venice.

The two paintings have similar compositions, arranged in a circular form around the two female figures, who are the main protagonists of the scenes and whose pale flesh stands out from the rest. The colours are strong and bright, accentuating the vitality of the compositions which are constructed with open forms and in movement.

Bacchus and Ariadne,
c. 1691–1694
Oil on canvas,
94 x 75 cm

PAGES 378/379:
Detail of illustration
page 422

PAGES 380/381:
Detail of illustration
page 394

Ricci's style is rhetorical and flamboyant, but at the same time has a refinement and delicacy which leads on to the Rococo. His paintings are generally of light-hearted subjects with the figures in very varied poses, rendered with great naturalness. All the figures in

*Neptune and
Amphitrite*,
c. 1691–1694
Oil on canvas,
94 x 75 cm

these two paintings are captured in movement, involving a number of
foreshortened and contrapposto views which are smoothly integrated
within the overall composition as well as perfectly related with each
other.

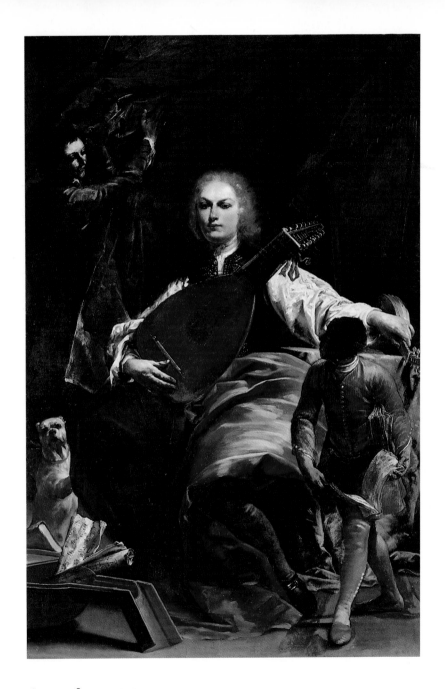

Giuseppe Maria Crespi

BOLOGNA, 1665–1747

Crespi was a Bolognese painter who was trained in the academic trad-
ition of the Bolognese school, continuing the heritage of the great
Baroque artists such as the Carracci and Guido Reni. In Crespi's youth
this school was at its height, but its influence began to wane towards
the end of the 17th century as the artistic spotlight shifted to Rome and,
by the 18th century, Venice. Crespi imbued his works with an anti-aca-
demic spirit which expresed a particular liveliness derived from the nat-
uralistic Roman Baroque style, as well as from Venetian art. His work,
which was varied in both subject matter and type (he painted easel
paintings as well as large frescoes, portraits, genre scenes and religious
works), represented a new approach within Bolognese art. One artist
whom he greatly influenced was his pupil Piazzetta.

This portrait of *Count Fulvio Grati* is a good example of his work,
demonstrating Crespi's preference for strong contrasts of light and
tonal effects as well as his inclusion of incidental detail. The result is
a crowded and grandiose composition whose overall effect is quiet the-
atrical. The count wished to be portrayed surrounded by instruments,
reflecting his interest in music. He sits in the centre of the composition,
occupying a large amount of the canvas and with his arm supporting a
mandolin, while his other holds a lute. His legs are covered by a large
cloth. Behind him a shadowy figure pulls back a curtain to reveal a harp.
In the foreground are a negro servant and the case of the lute which
contains some musical scores. On the left we can see a dog peeping
out.

The mass of figures and objects is further emphasized by the bril-
liant colouring and the detailed style, but the overall effect is not one of
confusion, as Crespi uses a subjective light to highlight a series of ele-
ments and obscure others, thus creating a visual order. The strongly il-
luminated face surrounded by dark and shadowy tones gives the sitter
the necessary importance, while light also emphasizes the mandolin,
the dog and the pieces of music.

Count Fulvio Grati,
c. 1700–1720
Oil on canvas,
228 x 153 cm

Pierrot content, c. 1712
Oil on canvas,
35 x 31 cm

Jean-Antoine Watteau

MALENCIENNES, 1684 — NOGENT-SUR-MARNE, 1721

The 18th century in France saw a highpoint in painting with the appearance of a rich and cultivated bourgeoisie who were gradually making their way in society. The result was a change in taste manifested in a new sensibility and the appearance of new subjects, far removed from the rhetoric and the heroic ideals of Baroque art. This new style was the Rococo, whose earliest and most brilliant French exponent was Watteau, followed by Boucher and Fragonard. These three artists spanned the entire century up to the French Revolution of 1789.

Watteau was the painter of the *fête galante* ("feast of courtship"), and his work reflects this playful world, rather frivolous but also intimate and delicate, and one which has been seen as representing a flight from a much less agreeable reality. Also appearing within *fête galante* painting are subjects taken from the theatre and the *commedia dell'arte*, as here in *Pierrot content*. Watteau's style was admired by his contemporaries for its great skill in reflecting the new reality of his times, and he was without doubt the artist who best conveyed the contradictions of his era beneath the light-hearted surface of his works. The 18th century saw a succession of political crises beginning with the War of the Spanish Succession (1701–1714), which involved the whole of Europe, particularly France, and which is reflected in the painting *The Rest*. It was also a period of social tensions in France under the Absolutist rule of Louis XIV, who was depleting the country's wealth while maintaining a sumptuous court and financing his expansionist ambitions.

With his technical mastery and acute sensibility for colour, Watteau developed a type of sketchy and evanescent painting which gives all his scenes a dreamlike quality, achieved through his use of a light and abbreviated brushstroke. His paintings, which are almost all set out of doors, reproduce an autumn landscape of pastel tones, surrounded by dark shadows, in which he places figures who seem to be in meditative and thoughtful states of mind. His paintings thus transmit a tone of melancholy, possibly a reflection on the transience and brevity of life and its pleasures, and a premonition of the end of an era.

"Watteau is a master I hold in great esteem."
JOSHUA REYNOLDS, 1780

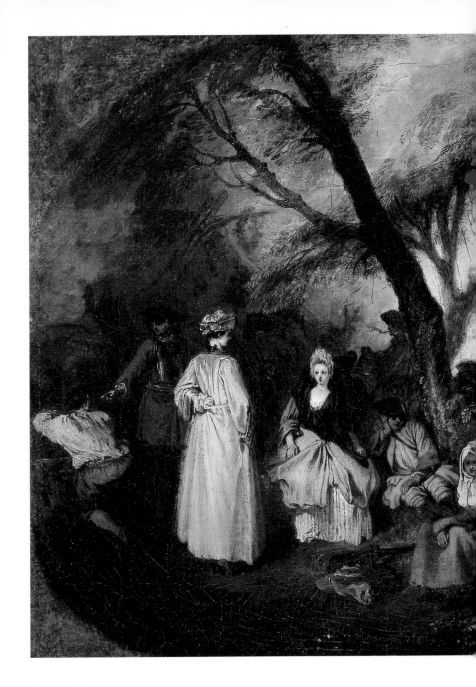

The Rest, c. 1709
Oil on canvas,
32 x 42.5 cm

Giovanni Battista Piazzetta

VENICE, 1682–1754

Self-Portrait, c. 1739
Oil on canvas,
39 x 31 cm

Piazzetta started his training in his native Venice with his father, who was a wood-carver, and with the tenebrist painter Antonio Molinari. Shortly after that he travelled to Bologna, where he became a pupil of Crespi, whose style was to be crucial for the development of his own. The two canvases in the Thyssen-Bornemisza Museum were painted in Venice, soon after Piazzetta's return from Bologna, and are thus works of his youth and early maturity in which the young artist created his compositions through the use of a strong chiaroscuro, giving his scenes a dramatic and theatrical mood.

The Sacrifice of Isaac portrays Isaac, naked in the centre of the painting, at the moment when he is about to be sacrificed by his father Abraham, who is held back by the angel. The figures have a great intensity and individuality, much use being made of their different poses. Thus Abraham is shown with his body tensed and his face contorted; in the arm holding the knife, we can see the force required to hold it back. Isaac, on the contrary, is shown as having fainted, his body limp and heavy, falling onto his father. The group is well integrated and the volumes are modelled from by contrasts of light and shade. The palette of earth tones, browns and reds is also characteristic of Piazzetta.

Considered to be one of his masterpieces, the *Portrait of Giulia Lama* again shows some of these chiaroscuro techniques, here taken to their extreme. The image emerges from a dark background, into which the less brightly lit areas are blended. Piazzetta's brushstroke is loose and agile. His use of light and shade seems to have evolved towards a composition in

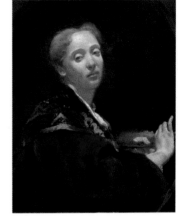

Portrait of Giulia Lama, c. 1715
Oil on canvas,
69.5 x 55.5 cm

which the forms are created solely from light and from the juxtaposition of areas of light and dark colour. In this respect the manner of depicting the face is particularly noteworthy, especially the eyes, created chiefly from the fall of light on the face. Giulia Lama was a painter and studied under Piazzetta at his academy of drawing, whose illustrious pupils also included fellow Venetian Giambattista Tiepolo.

The Sacrifice of Isaac, c. 1715
Oil on canvas,
100 x 125.5 cm
(Pedralbes)

Canaletto

VENICE, 1697–1768

Canaletto

Giovanni Antonio Canal, called Canaletto, is the most important artist
within that distinctively Venetian genre of the *vedutà*, a faithful rendition
of the Venetian landscape. The genre had its precedents in the work of
early 16th-century Venetian artists such as Gentile Bellini and Vittore
Carpaccio, but it was not until the 18th century that it became a success-
ful, autonomous genre, largely due to tourists, principally English, for
whom the city was one of the main destinations on the Grand Tour, and
who returned home with paintings such as the present ones. The Grand
Tour was essentially a trip to the main artistic and cultural centres of
Italy which became fashionable among wealthy Europeans during this
era. While a visit to Rome implied a chance to see the cradle of classi-
cism, both Antique and modern, Venice constituted its own myth, a
symbol of sensuality and courtly life with its active social life (opera
houses such as the Fenice, theatres, cafes such as Florian and casinos

*View of the Piazza
San Marco, Venice,
before 1723
Oil on canvas,
141.5 x 204.5 cm*

The Grand Canal
from San Vio, Venice,
before 1723
Oil on canvas,
140.5 x 204.5 cm

such as the Ridotto), and a general flourishing of the arts, as well as its magnificent wealth art and architecture.

Canaletto painted a huge number of topographically highly accurate views of the city, focusing on the splendour of its most important squares, such as the Piazza San Marco, but without avoiding the realistic details of urban life, as we can see in the *Grand Canal from San Vio* which places a group of cargo boats in the foreground with ordinary Venetian folk working nearby. This picturesque quality (magnificent palaces with classical arcades side by side with humble, one-storey buildings) formed part of Venice's attraction for foreigners. These two views of the Grand Canal are early works by Canaletto, executed back in Venice after a year spent in Rome, where he had begun to paint views of the classical ruins. In his views of Venice he describes the city precisely and objectively, softening it though a treatment of light which reproduces the clarity of the Mediterranean light.

Without doubt the unique nature of the city, built as an interlinking labyrinth of canals and dotted with churches and palaces, contributed to

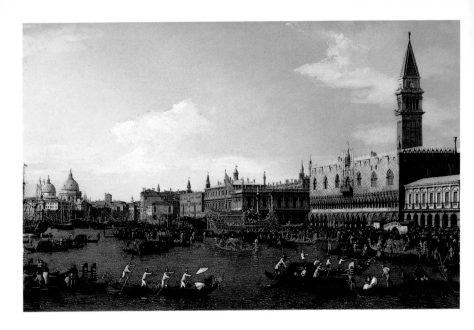

The Bucintoro,
Venice, c. 1745–1750
Oil on canvas,
57 × 93 cm
(Pedralbes)

creating its legendary character. No less important, however, were its splendid festivals and celebrations, such as the famous Carnival and the *Bucintoro* ceremony, which were theatrically staged against the backdrop of the city itself (Canaletto was himself the son of a famous Venetian set designer). *The Bucintoro, Venice* records one of the most important festivals of the Venetian Republic, that of Ascension, which commemorates the symbolic marriage of the Doge (the head of State) with the Sea.

The ceremony took place on the *Bucintoro,* the official barge which is shown here decorated for the occasion. The brilliant colouring and a more pronounced contrast of light and shade looks forward to Canaletto's mature style, which retained his meticulous brushstroke and rigorously truthful representation of the city's buildings. Here the setting is the Grand Canal at the level of the Doge's Palace. Behind it rises the Campanile of San Marco and in the background, among other buildings, the cupolas of Santa Maria della Salute stand out. The *Bucintoro,* symbol of the Serenissima, was burnt and destroyed by Napoleon's troops when they invaded and devastated the city, forcing the Doge to abdicate and ending Venetian independence, which had lasted for 1,000 years.

The success of Canaletto's work with English clients resulted in the artist's travelling to London, where he remained for ten years from 1746 to 1755, during which time he painted numerous views of the city and its surroundings, such as the *Façade of Warwick Castle*. The view in this luminous, highly detailed canvas is enlivened by groups of figures strolling on the grass and along the canal. Canaletto's work was highly influential upon 18th-century English landscape painting.

Façade of Warwick Castle, c. 1749
Oil on canvas,
75 x 120.5 cm

Giovanni Panini

PIACENZA, 1691 – ROME, 1765

Although Venice was the most important centre of artistic production in 18th-century Italy, the arts continued to thrive in other cities, too. Rome remained a point of reference, not just for artists but also for other visitors, who encountered there the synthesis of classical culture from Antiquity to Caravaggio.

Trained in Bologna, Panini was working in Rome around 1711. His compositions focused on real and imaginary architecture, which he used to recreate the world of classical antiquity, following Poussin's idealizing approach conceptually if not stylistically. In these two paintings, the religious subject is merely an excuse to produce grand settings with architectural backgrounds. The paintings form a pair and show two moments from the life of Christ: the healing of a sick person and the expulsion of the money-changers from the temple, subjects which allowed Panini to recreate classical ruins and buildings in an antique style.

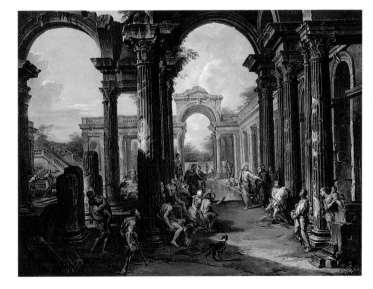

The Pool at Bethesda,
c. 1724
Oil on canvas,
74 x 99 cm

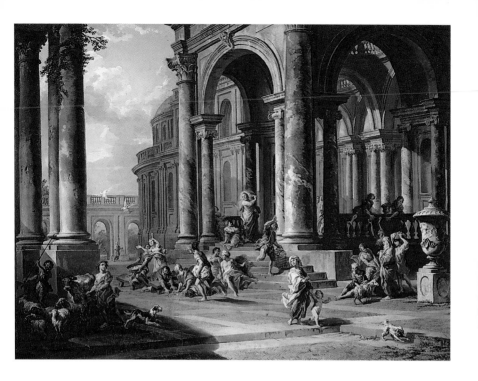

The architectural elements emphasize the perspective structure of the composition, something reinforced by the palette, which reflects the way in which distance changes an object's colour. Thus, although the paintings as a whole are executed in greenish-greyish tones, the foreground areas are rather warmer, with the outlines more defined; forms are better defined, realised with small touches of colour such as red and blue. The backgrounds, however, are painted in shades of grey. Panini also uses the light filtering through the colonnades to highlight certain parts of the compositions.

The Expulsion of the Money-changers from the Temple, c. 1724
Oil on canvas,
74 x 99 cm

*The Rest on the Flight
into Egypt*, 1725/26
Oil on canvas,
108 x 135 cm
(Pedralbes)

Giovanni Battista Pittoni

VENICE, 1687–1767

Pittoni was one of the most important exponents of the Rococo in
Venice, the principal centre of artistic production in 18th-century Italy.
In the distinctly Venetian manifestation of the Rococo style, the decora-
tive parameters of the Baroque were reinterpreted and united with the
splendour and grandiosity characteristic of the Venetian school. Influ-
enced by Sebastiano Ricci and his contemporary Giambattista Tiepolo,
the great artistic genius of Venice, Pittoni combined the monumentality
of the Baroque with classicist compositions and a light and cool colour
range which revived the palette of earlier Venetian painting.

Here the figures take up almost all of the picture space; the back-
ground is quite summary, mainly consisting of sky. Just a few palm
trees on the left and some rocks serve to indicate the location of the fig-
ures. This is because the viewpoint is an extremely low one; the figures
are portrayed as if we are seeing them from some way beneath. This
suggests that the canvas was intended to be placed high up, above a
doorway, for example, as was common in interior decorative schemes at
this period.

The artist uses a restrained chiaroscuro in some parts of the fig-
ures, but avoids tenebrist effects, with the sky creating a light and lumi-
nous background. Paintings of this type were extremely decorative ow-
ing to their gentle colours and harmonious pastel tones devoid of sharp
contrasts. Elegance and good taste were intrinsic elements in the Ro-
coco style and are certainly important factors in the present work. The
refined taste of the Venetian aristocracy appreciated this type of paint-
ing, with its lyrical poses, delicate gestures and elegant and restrained
figures. The ideal of beauty had changed from that of the 17th century:
the Virgin conforms to the 18th-century ideal, with her oval face, fine
nose, almond eyes, small mouth and white skin, all of which convey
great sweetness and grace.

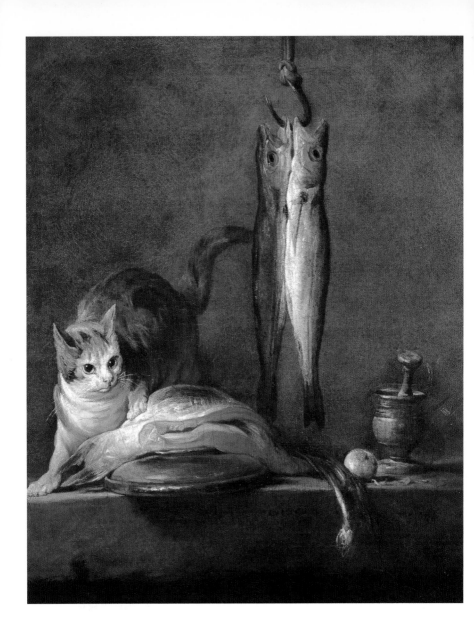

Jean-Baptiste Siméon Chardin

PARIS, 1699–1779

One of the defining traits of French painting of the 18th century in its reaction against the Baroque is the search for a new realist language, in response to a new morality which was in essence bourgeois rather than aristocratic. This search would lead in two directions: towards the *fête galante* developed by Jean-Antoine Watteau, and the scenes of everyday life painted by Chardin. While Watteau created an idyllic world dedicated to the senses and to pleasure, Chardin aimed to recreate in a simple and direct manner the values and virtues of the new bourgeoisie. He painted still lifes and scenes of everyday life, depicting a wealthy, urban middle class of professionals and merchants, extolling the virtues of order, economy and education. In this sense, he contrasts with the frivolity of the figures painted by Watteau, François Boucher and Jean-Honoré Fragonard.

His paintings, inspired by the 17th-century painting of Flanders and Holland (where the middle classes were already a powerful social group a whole century before their rise in the rest of Europe), reproduce simple, everyday objects in a direct manner, emphasizing the materiality of the objects and their realism. His contemporary, the critic and theoretician Diderot, praised him for his clarity and truth in the representation of nature.

These three still lifes reflect the values mentioned above. They are early works when Chardin was most obviously influenced by Dutch art, for example in the choice of the subject of kitchen tables with utensils and foodstuffs. Later, the artist would introduce other types of still lifes based on different objects from bourgeois interiors, as in his famous painting *The Tobacco Box*.

The pair of paintings with the cat and fish were painted in the year that Chardin was admitted as a member to the Académie, and are notable in that they are the first of his paintings to depict live animals. The arrangement of the objects obeys a rigorous compositional order whose aim is clarity and simplicity. The anecdotal element of the cat trying to make off with some food gives the impression that the painting conveys

"His paintings also possess a rather odd merit ...; nothing seems to be done on purpose."
CHARLES-NICOLAS
COCHIN, 1779

Still Life with Cat and Fish, 1728
Oil on canvas,
79.5 x 63 cm

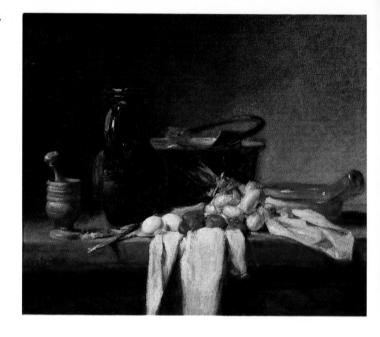

*Still Life with Mortar,
Jug and copper
Saucepan,*
c. 1728–1730
Oil on canvas,
32.4 x 39.2 cm

a specific moment in time, and for that reason brings it closer to the world of the everyday. In these still lifes Chardin employs a palette of warm and earthy tones, harmoniously combined and with gentle tonal gradations used to give body and depth to the representation. The forms and the volumes are created directly by the brushstrokes.

The third still life is painted in a notably different technique, in which the fall of light is more obvious, creating greater contrasts of light and shade and reproducing the reflections on the objects through touches of white paint. Once again the composition is ordered but without depriving the painting of its realism. Chardin transmits to us the values of simplicity and plainness, and makes us see the beauty inherent in simple things.

► *Still Life with Cat
and Rayfish,* c. 1728
Oil on canvas,
79.5 x 63 cm

Giambattista Tiepolo

VENICE, 1696 — MADRID, 1770

Giambattista Tiepolo, a Venetian artist who also had close links to the Spanish court, was one of the great figures of 18th-century Venetian art. His work represents the culmination of the decorative Baroque style, which he used to depict large compositions which explode with light and brilliant colour. His paintings are highly complex, filled with movement and a wealth of figures arranged in a wide variety of poses. They are underpinned by his extraordinary skills as a draughtsman, and his technical mastery both of the anatomy and expressions of his figures and of the handling of space, colour, light and compositional structure. A pupil of Piazzetta, Tiepolo soon abandoned his teacher's tenebrism in order to develop a bright and transparent tonal range of bold colour combinations.

GIO. B. TIEPOLO

Tiepolo was the last great illusionistic fresco painter. He created monumental compositions with fantastical settings showing gods and heroes and their entourages, all imbued with a splendour, grandeur and lavishness that represents nothing less than the swan-song of classicist painting. Tiepolo's skill and creative imagination made him greatly in demand outside Venice. In 1750, for example, he painted one of his masterpieces, the frescoes of the Archbishop's Palace in Würzburg, while from 1752 he lived in Madrid where he was summoned by Charles III. There he painted large allegorical compositions for the ceilings of the Royal Palace.

Tiepolo's oil paintings share this glorious and monumental style. In the early *Christ on the Road to Calvary*, we already find his characteristic colouring as well as his skilled draughtsmanship and his ability to formulate complex compositions. Despite its crowded character, the scene obeys a rigorous compositional order. It is structured by a diagonal which runs from the lower left corner with the various groups of figures arranged around it. This diagonal is counterbalanced by the division of the canvas into three vertical bands defined by the different characters. On the left the figures of the two standing thieves are continued by the verticals of the trees which frame the scene. On the right

The Death of Hyacinth, 1752/53
Oil on canvas,
287 x 232 cm

is the figure of Veronica, whose form is continued by the figures behind her who move up the hill towards the soldier on horseback. Placed in an empty area in the centre is the figure of Christ, crowned above by Calvary Hill.

The Death of Hyacinth is a mature work and considered one of Tiepolo's masterpieces. Its light and brilliant palette, which conveys the impression of a clean Mediterranean light, is also used to differentiate the two different groups of figures. On the right are the protagonists of the painting: the beautiful Hyacinth mortally wounded by a badly-thrown discus, and the no less beautiful god Apollo who, in love with Hyacinth, bewails the tragedy. Enveloped in ample orange and blue draperies, the flesh tones of the two figures reflect the fall of light. Tiepolo has used a fine and diluted brushstroke, creating polished surfaces and well-defined outlines. The group on the left is led by Amyclas, king of Sparta and father of Hyacinth, while behind him crowd a group of people. Their secondary role has made Tiepolo place them in the shade and paint them in earthy and subdued tones, also using a looser and more obvious brushstroke to depict the rough faces and bodies appropriate to these warriors. The scene is completed by an imaginary and fantastical architecture of classical inspiration with Mediterranean vegetation. Tiepolo exploits the large dimensions of his canvas to present the scene in the extremely foreshortened perspective of *sotto in sù* (meaning "from below to above"), with the centre of attention shifted to the lower right corner where the dying Hyacinth lies.

The Death of Sophonisba is a sketch for a much larger work, and its thickly applied and large brushstrokes indicate that it was rapidly executed. The painting shows Tiepolo's interest in the representation of space in terms of contrasts in lighting, with a foreground of rich and dark colours and a background of much lighter tones. The ample draperies form undulating rhythms which give the image vitality.

The Death of
Sophonisba,
c. 1755–1760
Oil on canvas,
48.5 x 38 cm

Christt on the Road to Calvary, c. 1728
Oil on canvas,
79 x 86 cm

Giacomo Antonio Ceruti

MILAN, 1698 – 1767

Southern Europe in the 18th century saw a shift in taste towards a less grandiose type of painting which placed an emphasis on the decorative and picturesque, as well as on a closer approximation to reality. This shift was accompanied by a change in subject matter: alongside allegorical and historical subjects, there was a new interest in scenes of everyday life (somewhat behind developments in Holland and Flanders). These two developments were themselves precipitated by changes in the social structure: the rise of a new middle class and a lower level urban aristocracy created a new pool of clients who replaced the former patrons of art – the Church and the monarchy. These new patrons saw art as a means of portraying themselves, their lives, their homes and their habits. In Italy there were two great painters of daily life: Ceruti, who primarily painted humble men and women, and Longhi, who painted the wealthier classes.

"The almost tangible rendering of age and poverty comes close to magic."
ALLAN ROSENBAUM, 1979

Ceruti represents the realistic trend which is typified in this painting of three beggars. The potentially picturesque character of the subject is counteracted by the profound way in which the three figures are depicted. In this sense Ceruti is following a tradition initiated by the great realist artists of the 17th century: just as Velázquez would have done, he paints his beggars with the same dignity and respect which he confers on the respectable and obviously well endowed sitters in the two portraits also shown here. The use of a very narrow colour range in brown and ochre tones accentuates the painting's realism and adds a dramatic tinge. The three figures are given a monumental character, taking up almost all of the picture space. Around them Ceruti has sketched in a summary setting: a table, a chair and a background wall which we can make out from the bricks in the upper right corner, where the plaster has fallen from the wall.

This austerity is characteristic of Ceruti, who avoided any decorative or ornamental element in his work. However, his technique is quite detailed and helps to emphasize the miserable state of the clothing. The light falls from the side onto the three beggars, throwing shadows which

Three Beggars,
c. 1736
Oil on canvas,
130.5 x 95 cm
(Pedralbes)

Portrait of a Man,
c. 1750
Oil on canvas,
119.5 x 95.5 cm

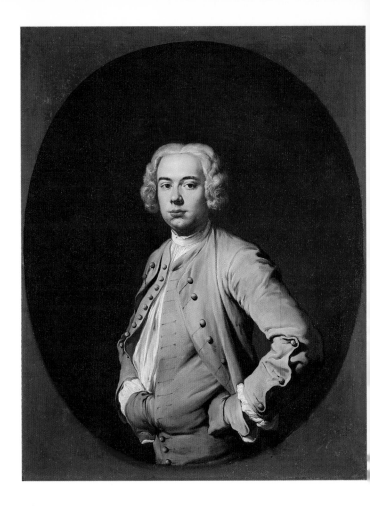

give the scene form and volume. It is an objective and sombre presentation which does not exaggerate the situation of the three figures, but which also does not trivialize their poverty.

Ceruti was highly regarded as a portraitist and this pair of oval portraits from the mid-18th century form a good example of his work. The shapes and contours are precisely and firmly drawn, the faces are strongly characterized and the figures adopt similar poses; more relaxed in the case of the man, whose upright posture gives him a certain dig-

Portrait of a Woman,
c. 1750
Oil on canvas,
119.5 x 95.5 cm

nity appropriate to his social situation, but without ostentatiousness. Ceruti's typical sobriety is also evident in these two canvases, in which the three-quarter-length figures are outlined against a smooth brown background.

Capriccio Padovano,
c. 1740–1742
Oil on canvas,
48.5 x 73 cm

Bernardo Bellotto

VENICE, 1720 – WARSAW, 1780

As a counterpoint to the realism and veracity of the Venetian *vedute* of
Canaletto and Guardi, some artists were inspired by the idealized form
of landscape painting which first emerged in the 17th century. The result
was the *capriccio*, a painting of a landscape or architectural scene which
combined real and imaginary motifs. Bellotto, a nephew and pupil of
Canaletto, soon started to paint in this genre, depicting city views with
compilations of the most important monuments; like Guardi in his late
phase, he sought to represent an idealized vedutà. Nonetheless, Bel-
lotto was also in demand as a painter of real urban views which he exe-
cuted with the accuracy of his uncle. He travelled throughout Europe,
and his most famous paintings were a series of views of Warsaw. His
capriccio paintings can be considered exercises in style in which the
artist gives rein to poetic licence.

These idealized views combine real features with imaginary ones,
with the aim of creating a coherent composition in which all the ele-
ments are resolved into a harmonious and picturesque whole. To this
end, Bellotto removes the less attractive elements, changes the loca-
tions of others and inserts a mountainous landscape to achieve a sense
of depth, whereas in fact the real landscape was a flat plain.

The painting is an early work, executed before his first trip to Rome,
and is still close to the style of Canaletto: it shares his detail and meticu-
lousness, clean and bright light, and impression of damp atmosphere
which softens the contours on the horizon. In addition, the artist uses
a strong chiaroscuro in the shadows cast by the morning sunlight. A
small picturesque touch is provided by the washerwomen and the men
on the boats in the foreground.

Michele Marieschi

VENICE, 1710–1744

After Canaletto and Guardi, Marieschi is the third most important painter of *vedute* in 18th-century Venice. As we have already noted in conjunction with those other two artists, views of the Venice were extremely popular in the 18th century, above all with the European travellers who were attracted to this centre of the arts and of courtly life.

In response to this demand, these painters reproduced different views of the city, including its squares and various canals. Here Marieschi paints a frontal view of Santa Maria della Salute, one of the city's most famous churches. It was built on the banks of the Grand Canal, the main thoroughfare for the boats and gondolas which were the city's normal means of transport. Marieschi's style is direct and faithful to reality, with the picturesque figures drawn from both the humble and aristocratic classes of the city. Thus we see gondolas conveying the wealthy in their finery next to barges transporting goods, such as the one on the left with its working men on board. Work and leisure are combined in this canvas, which aims to give a lively and bustling view of the city. In the background another group of people can be seen walking up to the steps of the church.

A clean and bright light illuminates the scene, enhancing the volumes through a gentle chiaroscuro. The cold hues of the stone, sky and water which dominate the pictorial space are counterbalanced by small touches of yellows and red and a few areas of brown. Both the palette and the attention to detail reveal the influence of Canaletto, in whose studio Marieschi worked during his youth. So famous was Venice, and so great was the demand for images of it, that at the end of his life Marieschi made a set of 21 aquatint views of the city, first published in 1741.

*The Grand Canal
with Santa Maria
della Salute,* undated
(before 1740)
Oil on canvas,
83.5 x 121 cm

Concert champêtre,
1734
Oil on canvas,
53 x 68.5 cm

Jean-Baptiste Pater

VALENCIENNES, 1695 – PARIS, 1736

Pater, together with Lancret, is the artist who follows most closely
Watteau's style and subject matter. Pater can be considered Watteau's
only pupil, studying with him when he moved to Paris in 1713. His
works fall within the Rococo style which had such widespread success
in France.

Pater specialized in *fêtes galantes* such as the present canvas,
painted in imitation of Watteau's style, although without conveying the
mysterious mood present in the latter's natural settings. Pater's paint-
ings represent in a direct manner meetings between groups of young
people, in which music and literature, together with love, provide the
entertainment. Thus, reclining on the grass on the left, a group of fig-
ures are chatting and laughing, while one of them plays a guitar and a
lady holds a book. On the right a pair are talking while a little girl plays
with a dog. The figures form a lively ensemble of gestures and poses,
as well as showing the fashions of the time. Their movements and atti-
tudes are delicate and elegant, the women with long necks, their heads
tilted and their skin of an ivory pallor.

The scene is intended to represent a spontaneous and light-heart-
ed situation in a natural outdoor setting. As with Watteau's works, it is
sketched in schematically, with the forms developed through the inci-
dence of light and atmosphere. The palette is different to Watteau's
and has moved towards cooler and paler tones, particularly in the back-
ground, which is much lighter and more neutral than Watteau's. Pater
depicts the landscape as a decorative background against which to
place his figures, who are arranged as if on a stage set, framed by the
trees on the left and the column on the right. His vision of nature is a
harmless and conventional one, an agreeable background for a "feast
of courtship".

Nicolas Lancret

PARIS, 1690 – 1743

Lancret.

Nicolas Lancret, like Pater, was a follower of Watteau, with whom he studied under Claude Gillot. From then on he imitated Watteau's style and also dedicated himself to painting *fêtes galantes*. This would seem to have resulted in bad feeling between the two men. His style and subject matter are those of the Rococo, which saw its greatest development in France.

In the present work, the theme of the *fête galante* has evolved closer to a scene from everyday life. A group of ladies and gentlemen are engaged in various activities in a garden, which is also being tended by gardeners (the group on the left). The various elements are treated in a realistic way, although the overall scene is rather unreal. The women and the gentleman with the bouquet of flowers conform to the ideal of beauty of the period, while their poses and movements aim to transmit the grace and delicacy which prevailed in Rococo art. A warm and golden light falls on the figures and the fountain, and the mood is atmospheric. The subject of the garden would become important in the 18th century as a setting for scenes of leisure and diversion, particularly gardens with intimate and remote corners such as this one, with fountains tucked away amid the trees. We should remember that the Palace of Versailles, completed in 1708, was surrounded by magnificent gardens designed by Le Nôtre, which were considered as important as the architecture itself.

The Earth, undated (c. 1730)
Oil on canvas, 38 x 31 cm

This painting may have formed part of a set of four canvases on the subject of the four seasons. The fruits being picked and handled suggest that this canvas may have represented summer.

The Toilette, 1742
Oil on canvas,
52.5 x 66.5 cm

François Boucher

PARIS, 1703–1770

Together with Fragonard, François Boucher represents the quintessence of *fêtes galante* painting and of the Rococo. His works start from the *fêtes galantes* invented by Watteau at the beginning of the century, but discard Watteau's mysterious and melancholy air in order to depict a glittering society which revolves around pleasure and the art of love. His paintings idealize and exalt certain aspects of human life and activity, thus prolonging the heroic spirit of the Baroque throughout the course of the 18th century.

Boucher, who was trained in Rome, where he lived from 1728 to 1731, was in fact strongly attracted to Baroque art and mythological painting, particularly the subject of Venus, as is evident in his art. He enjoyed enormous success in his own time, and was greatly in demand for his scenes of *fêtes galantes* and *fêtes champêtres*, as well as for interiors and mythological paintings.

The Toilette formed part of a set of paintings on the various times of day. The present painting, set in a crowded room, shows a lady dressing in the morning with her maid. Boucher's detailed technique allows him to describe accurately all the different objects which are connected with the idea of the toilette, such as the items of clothing from the little bonnets to the tiny slippers, the steaming teapot between the lady and the mantlepiece, and all the objects scattered around the room in charming disarray: the fan on the floor, the lady's other garter on the mantlepiece, a letter (a crucial element in the art of love), the cloak on the chair, the dressing-table behind, and even a cat playing with a ball of string at its mistress's feet. Boucher's painting is essentially feminine and portrays the world of women which lay at the heart of *galante* society. His works have an ambiguous character which is not devoid of eroticism, and it is this which largely accounted for his contemporary success.

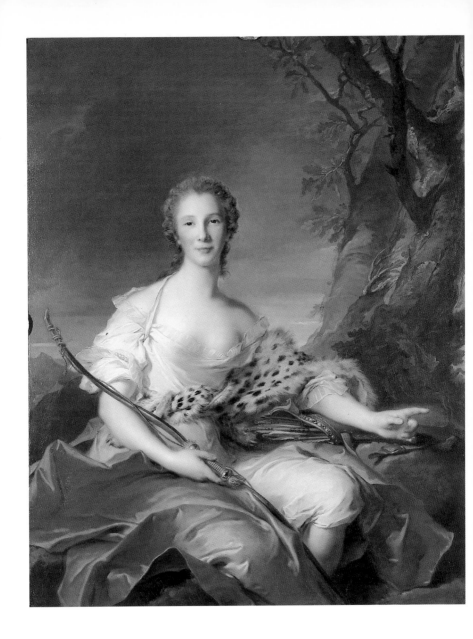

Jean-Marc Nattier

PARIS, 1685 – 1766

Nattier was a painter and engraver who, although also devoting himself
to history painting, was primarily a portraitist. He developed a type of
idealized, mythological portrait which was extremely successful with
clients, combining elegance with sophistication and skilled technique.
He thus became the official painter of the ladies at the court of Louis
XV, and consequently the fashionable painter of the aristocracy.

M Nattier.

The present work reveals a background landscape in the manner
of a stage set, painted with a loose and diluted brushstroke in which the
forms are just lightly sketched in. The cool greenish tones of the back-
ground contrast with the luminosity of the figure. She is drawn with de-
tail in a fine brush and carefully applied glazes. The various surfaces
and textures are all treated with equal perfection, contrasting the frothy
material of the white dress with the firmer and more reflective red cloak
and the softness of the leopard's skin. Overall a smooth, cold tone pre-
vails which contrasts with the sitter's red cloak and her very pink cheeks
in the taste of the time.

The portrait is essentially academic, with a tendency to idealization
and stylized and harmonious proportions. The sitter, looking directly
out at the viewer, adopts a rather affected pose which directs our atten-
tion to the right, where her hand gestures out of the picture plane. The
light falls directly on the figure, modelling the forms in gentle chiaro-
scuro and emphasizing her bosom and arms and her pale, clear skin.
Madame Bouret is portrayed as Diana, the eternally youthful Roman
goddess of the hunt, shown with her usual attributes: the bow and
quiver of arrows. Portraits of this type were very fashionable at this pe-
riod, which saw a renewed interest in the culture of classical antiquity.

*Madame Bouret
as Diana,* 1745
Oil on canvas,
138 x 105 cm

Jean-Honoré Fragonard

GRASSE, 1732 – PARIS, 1806

Fragonard

"A genius of artistic
skill, such as the
painter Fragonard."
EDMOND and JULES
DE GONCOURT, 1865

Fragonard was the last of the great Rococo painters. While Watteau's painting at the beginning of the century emphasized the intimate and exquisite, and Boucher's the sophistication and pleasures of a particular social class, Fragonard achieved the fullest expression of the world of the senses, in which he moved away from the subject of the *fête galante* and towards the realm of fantasy and the emotions.

The present work was executed during or just after the period in which Fragonard was a pupil of Boucher, whose influence is apparent both in its subject matter and technique. Years later, Fragonard would paint another work with the same title but of a very different character, in which the subject's eroticism is made obvious. That painting has become one of his most famous.

This canvas is notable for its use of colour and the effects of light. The deployment of coloured shadows and a sunlight which filters through the trees is treated by Fragonard with great technical mastery and sensitivity, creating a wealth of tonal nuances. The palette is extremely harmonious; against the cool tones of the trees and the sky in the background, the red and gold of the girl's dress stand out. The painting shows two young people with two children playing on a swing. The girl balances in the air assisted by the young man and the two children. The world of feelings and emotions pervades. The figures are perfectly integrated into the natural world, which is also shown here in its most amiable and bucolic guise, with slender trees blending into diffused masses in the background.

Fragonard was the last great artist of the Rococo, and his decorative and sentimental style reflects certain aspects of society under the *ancien régime* at a time when this was in decline in the face of new social and political attitudes. From 1780, Fragonard's fame began to wane as he was seen to represent the lifestyle of a decadent and reactionary society which the French Revolution was to bring to a violent end in 1789. In his old age, Fragonard and his art were forgotten.

The Swing,
c. 1750–1755
Oil on canvas,
120 x 94.5 cm

Pietro Longhi

VENICE, 1702 – 1785

The interest in capturing reality, as evident in the work of the Venetian view painters such as Canaletto, was complemented by a new interest in representing scenes of everyday life. The impetus came from the new urban middle class which appeared throughout Europe in the 18th century as a result of the expansion of commerce and the growth of cities. This social class demanded a new type of subject matter relevant to its own world, and thereby also precipitated a shift in aesthetic taste, away from the grandiose and heroic idiom of Tiepolo – as wielded in the service of European monarchs – and towards an intimate and delicate language which abandoned the rhetoric of allegorical painting in order to focus on a vision closer to the new social reality.

Pietro Falca, known as Longhi, was to be the chronicler of the wealthy new Venetian classes. He adopted a gallant and decorative style which employed a certain amount of irony, using a fully Rococo manner close to French artists such as Watteau.

The Tickle is perfectly representative of the new taste. In an elegant although not ostentatiously luxurious interior, the artist depicts an intimate and amusing scene. A young gentleman, peacefully resting in a chair, is about to be woken by the lady who is tickling him with a feather. Coquetry and mischievousness prevail in this scene, in which the three young women around the young man are the principal figures. Some of the details, such as the painting of three naked women on the back wall and the tray of apples, may suggest that the scene is in fact a contemporary version of *The Judgement of Paris*. Thus the three young women would be the goddesses Juno, Minerva and Venus and the young man the hero Paris who, on the order of the gods, has to decide who is the most beautiful of the three and present the winner with a golden apple. Paris, here represented as the languid young man, allows himself to be flattered before making his choice.

The Tickle, c. 1755
Oil on canvas,
61 x 48 cm

George de Marées

STOCKHOLM, 1697 – MUNICH, 1776

The work of the Swedish painter George de Marées could be described as international. His style was based on the experience he gained from his travels in Italy, the Netherlands and Germany. These portraits of the von Soyer couple, painted slightly more than half-length and facing each other – a common device in paired portraits – are executed in a loose technique (rather more obvious in the case of the wife) against a neutral background. The diluted brushstrokes soften the contours and the details, creating a vaporous atmosphere in which the faces of the sitters stand out in greater detail.

With the exception of England, portraiture in the 18th century was eclectic and derived little from the portraiture of previous centuries. There is undoubtedly a certain Rococo influence in the pastel tones and the delicate air with which these works are imbued, and they also reveal a certain degree of idealization; however, the artist pays more attention to the formal elements than to the individual character of the sitters. Their fixed gazes, looking out at the viewer, are cold and impenetrable and tell us little about their personalities, and they stand in stiffly upright poses which give them an air of distance and dignity.

The palette is gentle and harmonious, employing a soft chiaroscuro which is accentuated in some areas in order to create volume. In the composition of the bodies the artist has aimed for the sensation of movement, opening the arms in the case of the man and unfolding the pink wrap in the case of the woman. This also helps to create the impression of a coherent space, even though there are no other elements to indicate the setting.

◄ *Portrait of Maria Rosa Walburga von Soyer*, 1750
Oil on canvas, 88 x 69 cm

Portrait of Franz Carl von Soyer, 1750
Oil on canvas, 88 x 68 cm

Sir Joshua Reynolds

PLYMPTON, DEVONSHIRE, 1723 – LONDON, 1792

While England in the 17th century was not a particularly important artistic centre (with the exception of the years during which the Flemish artist van Dyck worked as court painter), the favourable political and social climate of the 18th century resulted in a period of great splendour, particularly in the genres of portraiture and landscape, headed by such artists as Hogarth, Reynolds and Gainsborough. The school of English 18th-century portraiture began with Sir Joshua Reynolds, considered the leading artist in the genre. His style shows the continuing influence of van Dyck on English art. Reynolds' skill as a portraitist, combined with his wide knowledge of different styles, allowed him to develop a varied repertoire of portrait types which he adapted to the social status and personality of his sitter.

The Countess of Dartmouth dates from the period in which Reynolds had just established himself in London, after a trip to Italy which had lasted several years. Following this trip he had built up an important clientele among the English aristocracy. This portrait, as is typical with Reynolds, imbues the sitter with great distinction, achieved through the sumptuous clothes and the expression and pose of the sitter. The exaggerated whiteness of the skin is emphasized by the white ermine and the blood red velvet of the dress. Following the fashion of the time, the cheeks are rouged.

Reynolds has used a cool and narrow palette with very few colours, and makes much of the countess's rich clothing and her jewels, arranged in a vertical line from her head to her waist. Although the handling is loose, the artist has still conveyed the different textures and qualities of the materials and furs which embellish the sitter.

"The father of English portraiture, the portait painter par exellence"
THEODOR FONTANE, 1857

The Countess of Dartmouth, 1757
Oil on canvas,
127 x 102 cm

The Apotheosis of Hercules, c. 1765
Oil on canvas,
102 x 85.5 cm

Giovanni Domenico Tiepolo

VENICE, 1727–1804

Son of Giambattista Tiepolo and Cecilia Guardi (sister of Francesco Guardi), Domenico worked extensively with his father, whose style he followed until his father's death in Spain in 1770. Domenico subsequently returned to Italy and developed his own style as a painter of popular subjects, in line with more modern tastes and the new aesthetic of the later 18th century.

The two works by this painter in the Museum belong to a period when his work closely follows that of his father. In the *Expulsion of the Money-changers from the Temple* we see the same brilliant and light palette as that used by Giambattista. With its very wide format and low viewpoint, the painting may have been intended to hang above a door. The format dictates the composition, which is structured horizontally. The canvas is dominated by a yellowish tonality, against which Christ's red and blue robes stand out. The treatment of the details varies according to the distance, with the closer elements painted in some detail and the more distant parts of the painting left quite sketchy.

While the *Expulsion*, although still following Giambattista's style, is rather dry and cold, the *Apotheosis of Hercules* is a better illustration of Domenico's abilities. The painting is a sketch for one of the now lost frescoes destined for the ceilings of the Winter Palace in Saint Petersburg. The commission was apparently given to Giambattista, but executed in colloboration with his sons Domenico and Lorenzo (although the latter played a lesser role, being a less talented artist). This sketch is very similar to another by Giambattista relating to the same fresco programme and depicting *The Triumph of Venus*. Being ceiling paintings, they have a very pronounced perspective seen from below looking up, accentuated by a strong chiaroscuro which gives the figures three-dimensionality. A sizeable gathering of angels and gods are arranged into compact groups, suspended in the air in very dynamic poses which create an open composition. The foreshortenings and contrasts of light help to create depth.

The Expulsion of the
Money-changers from
the Temple, c. 1760
Oil on canvas,
104 x 195 cm

Johann Zoffany

FRANKFURT, 1733 – STRAND-ON-THE-GREEN, 1810

Zoffany, who was of German origin, spent some years in Rome before settling in England in 1760, where he pursued his career. He painted conversation pieces – a genre developed by William Hogarth and portraying scenes of family or social gatherings – as well as theatrical subjects and portraits. His theatrical works usually represent a particular moment in a play, and are also the portrait of the actor or actress in the role. Theatre acquired great importance in the 18th century and actors had a certain standing in society. Such was the case with the actress and singer Ann Brown, here portrayed in the role of Miranda in Shakespeare's *The Tempest*. Between 1769 and 1779 Ann Brown was a player in the company of the famous actor David Garrick, a friend and patron of Zoffany, who also painted him in various scenes from the stage.

The actress is shown in the cave of Miranda's father Prospero, who lives on an enchanted island. In the background is the mouth of the cave with a waterfall which creates a focus of light. Beyond, we glimpse a small area of landscape which is painted with great luminosity. The figure is rendered in a polished and detailed technique, which is rather hard in the outlines and contours and reproduces with exactitude the richness of the silks, her transparent veil and the other elements of her costume, vaguely inspired by the clothing of ancient Greece. The light is projected obliquely, creating strong contrasts and prominent highlights on the silks.

Zoffany travelled to Italy several times and in the 1780s moved to India, where he was greatly in demand as a portraitist among the English colonists. The Thyssen-Bornemisza Museum possesses one of the group portraits which he painted in India, depicting Lord Limpey and his family.

Portrait of Ann Brown in the Role of Miranda, c. 1770
Oil on canvas,
218 x 158.5 cm

John Singleton Copley

BOSTON, 1738 – LONDON, 1815

Copley was an American portraitist and history painter who moved to London in 1774 and remained there for the rest of his life, apart from some trips to Europe. The present painting dates from his American years. At this time American painting was stylistically very close to English painting and had not established its own characteristics. In the year Copley painted this work, New England was still an English colony, although not for very much longer. In reality, a commercial battle against England had already begun which would culminate in the War of Independence (1775–1783) and the Declaration of Independence of 1776. It seems likely that Copley's departure for England was related to this situation.

John Singleton Copley

His portrait of Catherine Hill is typical of his American style. Direct and simple, his painting imbued his sitters with a distinguished but restrained air appropriate to them. This type of portrait was well received among the upper middle classes of new England. The young woman, placed almost in profile, turns her head to look directly at the viewer. She is portrayed with great naturalism; her expression is smiling and sincere, with her large and lively eyes a particular feature. Overall, the work is plain and unfussy. Copley focuses the light on the figure, painting the surroundings in a dark brown. The skilful combination of the red bodice and green cloak gives the portrait luminosity, with the rest of the composition mainly in shades of brown.

On his arrival in England, the influence of Reynolds and the English painters wrought considerable changes in Copley's style. The Museum has two other portraits from his American period, *Mrs Samuel Hill* and *Judge Martin Howard*, which share the same characteristics as this one. The three portraits offer us a typical image of members of American society in the mid-18th century.

*Mrs Joshua
Henshaw II
(Catherine Hill),
c. 1772
Oil on canvas,
77 x 56 cm*

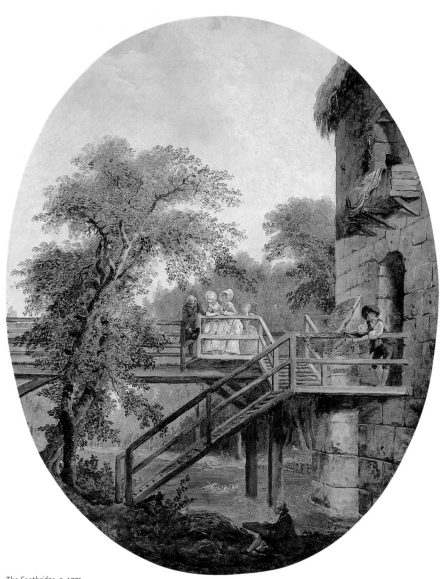

The Footbridge, c. 1775
Oil on canvas,
59 x 47 cm

Hubert Robert

PARIS, 1733 – 1808

Hubert Robert primarily painted classical ruins, although towards the
end of his career he broadened his repertoire to include street views and
paintings of parks and gardens. During the course of the 18th century
there emerged a new interest in and admiration for classical antiquity.
The scientific and academic approach embraced by the Enlightenment
gave rise to a systematic archaeology which was linked with the recovery
of the ideal of perfection in art, as personified by Greco-Roman civiliza-
tion. Thanks to its wealth of important archaeological remains, Rome
now became an obligatory destination. Robert travelled to Rome in 1754,
where he lived ten years, and where he met Piranesi and Panini, whose
paintings of ruins would have an important influence on him. Robert
subsequently introduced the genre into France. Although the subject
of ruins had appeared in art since the 16th century, it was not until the
second half of the 18th century that ruins, and in particular the ruins
of classical antiquity, were to become the main theme of a painting. In
many cases, including the present painting of *The Temple of Diana at
Nîmes*, the artist copies the remains of a real building. Paintings of ruins
also had a proto-Romantic character, insofar as they evoked a lost, idyl-
lic world. They furthermore carried nostalgic and sentimental overtones
which were at odds with the rationalism of the Enlightenment.

Another interesting element in *The Temple of Diana at Nîmes* is the
figure of the artist painting on the left. In *The Footbridge* we also see a
figure painting, almost obscured by shadows. Both are sketching from
life, and therefore convey the message that Robert's art is based on em-
pirical experience and that his scenes reproduce real life. In the second
half of the 18th century, and as a prelude to the 19th, artists throughout
Europe began to feel compelled to imitate nature, taking real locations
as their subjects rather than imaginary or idealized ones. These were
landscapes inhabited by men and women rather than wild nature. In
keeping with the spirit of the Age of Reason, what was expressed was
nature dominated by man, as in this oval canvas, which was probably
commissioned to decorate a middle-class home.

H Robert

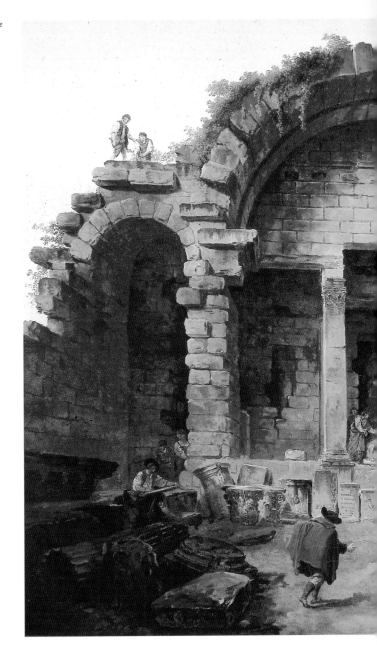

*Interior of the Temple
of Diana at Nîmes,*
1783
Oil on canvas,
101 x 143 cm

*The Courtyard of the
Customs House,* 1775
Oil on canvas,
98 x 164 cm

Nicolas-Bernard Lépicié

PARIS, 1735 – 1784

Lépicié was an academic artist who specialized in religious and history painting. Towards the end of his life when he painted the present work, he moved towards portraits and scenes of everyday life, specializing in town views.

The Courtyard of the Customs House is a highly typical work from his late period, in which Lépicié's sense of realism and truthfulness to the subject is close to that of artists such as Chardin. The scene is presented as a slice of everyday life, and employs an ordered composition structured by the arcades which are in the purest classical style, as is the building on the right – the Paris Customs House. Painted in bright tones appropriate to a sunny day, the painting conveys the bustle of the arrival of merchandise and other goods, the departure of carriages and the groups of people who have come to collect their packages or to send off and meet their relatives. The composition is executed on the basis of a detailed drawing, giving it a linear character with colour subordinated to line. The monochromatic background is defined by the architecture, while in the foreground the artist introduces small touches of carefully-chosen colour in the clothes of the figures.

The painting seems to have made up a pair with another representing the market of Les Halles in Paris. Both were exhibited at the Salon, where *The Customs House* was praised by Denis Diderot, the art critic and theoretician of the Enlightenment. The painting, executed shortly before the French Revolution, responds to the ideals of the Enlightenment in offering a clear and truthful vision of reality and of the new middle class, who were struggling to achieve the political and social privileges which until then had been the domain of the aristocracy and the clergy.

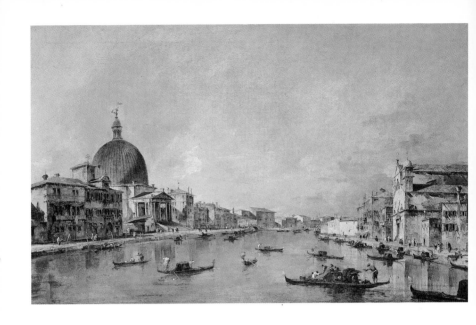

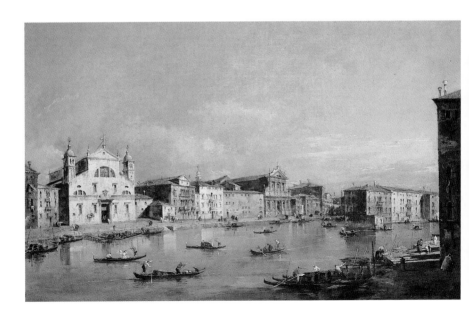

Francesco Guardi

VENICE, 1712−1793

Francesco Guardi was another leading exponent of the *vedutà*, the genuinely Venetian genre developed by Canaletto. The importance of this genre in the dissemination of the image of Venice, and the city's role as a cultural myth and obligatory destination for travellers, are discussed in the catalogue entry on Canaletto.

In his own views of Venice, Guardi − like his slightly older contemporary, Canaletto − depicted the city in a direct and realistic way, far removed from the contemporary Baroque pomp exemplified by the work of Tiepolo and his school. Although Guardi's technique differs from Canaletto in its loose brushstroke, which creates broken and less detailed forms, his vision of the city is nevertheless conceived with the same topographical accuracy.

This interest in accurately documenting the city is seen in these two canvases, which reproduce two views of the Grand Canal at the level of the church of Santa Lucia. The two views look in opposite directions, so that together they offer a complete panorama, as would be seen if one turned round more or less on the same spot. The church of Santa Lucia is repeated in the two canvases; in one seen almost from the front on the left of the composition, and in the other in a pronounced diagonal on the right.

Guardi's paintings have a melancholy air, however, due to their cool tones and their sense of decay, conveyed by the peeling walls of the buildings and the palace with its torn and dangling sunblinds. These two works were executed 60 years after Canaletto's and in different and difficult times, when a new world was in the ascendant and Venice's decline was now obvious. Guardi offers us the remains of its glorious past. This explains the evolution in his work towards the *vedutà ideata*, the idealized landscape with imaginary ruins and monuments to which he dedicated himself in the final phase of his career.

View of the Grand Canal with Santa Lucia and Santa Maria di Nazareth, c. 1780
Oil on canvas, 48 x 78 cm

View of the Grand Canal with San Simeone Piccolo and Santa Lucia, c. 1780
Oil on canvas, 48 x 78 cm

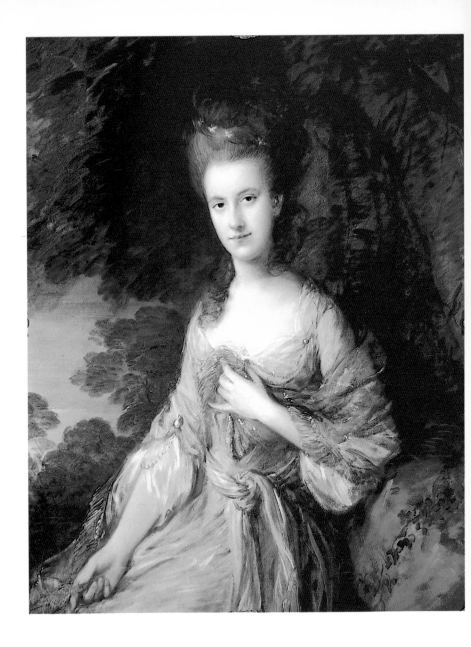

Thomas Gainsborough

SUDBURY, 1727 – LONDON, 1788

Together with Joshua Reynolds, Thomas Gainsborough was one of the artists who carried English landscape painting to its greatest heights in the 18th century. Portaiture and landscape were the two most important genres in 18th-century English art and became a symbol of national identity.

Gainsborough worked in both genres with great success owing to the quality of his work. Indeed, he combined the two genres by using landscape backgrounds for his portraits, as in the present *Portrait of Miss Sarah Buxton*. This practice, widespread in England in the 18th century, can be traced to the influence of the Flemish artist van Dyck, painting in London a century earlier. Also following van Dyck's prior example, Gainsborough developed towards a type of portrait in which, without losing his characteristic elegance and refinement, he arranged his sitters in simpler poses, as can be seen in the present work. The young woman looks at the viewer with a smiling expression which gives her immediacy. She is seated on a tree trunk or rock, which also conveys a feeling of naturalness.

The brushstroke is loose and fluid, giving the painting a sketchy feel which emphasizes its spontaneity. The face, which is painted in more detail, is framed against a dark background which brings out the whiteness of the skin, while in other areas, such as the arms, the skin reflects the blue colour of the dress, creating coloured shadows. The bluish and greenish hues combine harmoniously with the browns in a skilled combination of warm and cool tonalities. Gainsborough conveys in his portraits the elegance of the nobility and the English upper middle classes, as well as their refined customs and agreeable lifestyles.

"Gainsborough is a genius and nothing more."
THEODOR FONTANE, 1857

Portrait of Sarah Buxton, c. 1776/77
Oil on canvas,
110 x 87 cm

Pompeo Girolamo Batoni

LUCCA, 1708 – ROME, 1787

Pompeo Batoni

Pompeo Batoni lived and worked in Rome from 1727, rising to be a leading member of its artistic community in the second half of the century. In 1741 he was elected a member of the Accademia di San Luca. Rome in the 1700s remained a centre of classicism and continued to attract artists, drawn by the splendour of its cultural heritage and in particular by its antique archaeological remains. Over the course of the century, there arose a new interest in reviving a pure and ideal classical beauty, based directly on Antiquity and expressing harmony and equilibrium.

From 1780 artists such as the German Mengs, scholars such as the German archaeologist and writer Winckelmann, and sculptors such as Canova were behind the creation of a new neo-classical aesthetic which rejected Baroque tastes and the lightweight *galanterie* of the Rococo. Within this scholarly and idealizing environment, Batoni stood out as the counterpart to Mengs' intellectualism. Batoni's art is imbued with great delicacy, combined with dignity and monumentality.

Batoni was known and appreciated primarily as a portraitist in his own time. His portraits, such as that of the Countess of San Martino, endow the sitter with great dignity, monumentality and elegance, combining lively colour and strong characterization. Batoni painted most of the European princes who visited Rome, as well as three popes, but he was above all in demand with the European aristocracy, particularly the British travelling to Italy as part of the Grand Tour, owing to his creation of a new type of portrait in which he depicted the sitter against an antique, classical background. Batoni's style, however, did not completely take on the ideals of neo-classicism, and retained a delicacy derived from the Rococo tradition, conveyed through a frothy and luminous technique, as seen in the present work. Although he did not found a particular school, Batoni was famous enough to set up a large studio where he worked with three of his sons. In addition, his style was to have a great influence on one of the most important portraitists of the next generation: Sir Joshua Reynolds.

The Countess of San Martino, 1785
Oil on canvas,
99 x 74 cm

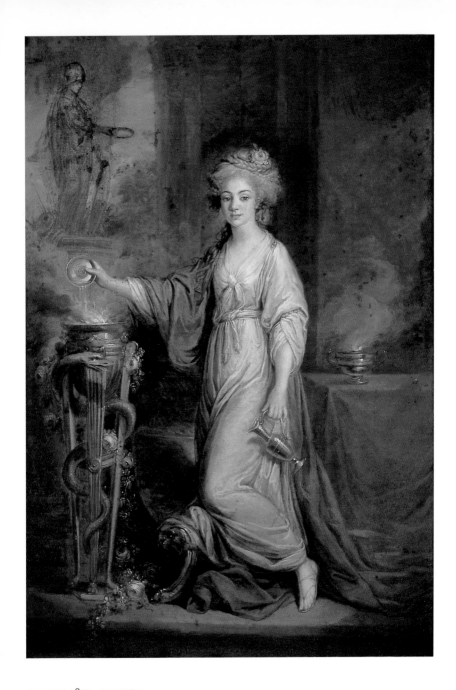

Angelica Kauffmann

COIRE, SWITZERLAND, 1741 – ROME, 1807

Of Swiss origin, Angelica Kauffmann's work is an example of the acade-
mic classicism of the second half of the 18th century. From a very young
age she lived in Italy, in Parma, Florence, Bologna and Rome. In 1766
she travelled to London, where she stayed until 1781. There she met and
became friends with Reynolds, who would have an important influence
on her style. Kauffmann painted mythological and allegorical paintings
and portraits.

This painting contains a number of elements which can be related
to Reynolds' painting and with English painting in general, making it
likely that it was painted during Kauffmann's English period or upon her
return to Italy. The type of portrait in which the sitter was shown as a
mythological character was common in England in the 18th century, and
was partly intended to convey the classical learning of the English aris-
tocracy and upper middle classes, as a sign of their distinction. The in-
fluence of Reynolds can be detected in the elegance of the figures and
their arrangement, probably inspired by Reynolds' painting of *Lady
Sarah Bunbury offering a Sacrifice to the Graces* of 1765.

In the present portrait, the young woman is dressed as a vestal
virgin – one of the maidens who looked after the Temple of Minerva
(Pallas Athena to the Greeks) – offering a sacrifice to the goddess,
whose sculpted image appears in the background. The painting is
markedly classical, pale and rather cool in its tonal values. The fore-
ground is painted with a more defined approach, showing the folds
of the draperies and the contours of the volumes. The middle-ground
is much more sketchy.

Kauffmann lived in Italy when neo-classicism was at its height,
led by the two Germans Mengs and Winckelmann, whom she painted.
This renewal of classical ideals was accompanied by a better knowledge
of the actual remains of antiquity through the development of a system-
atic archaeology. Thus Kauffmann attempts to give the scene an appro-
priate setting, not just in the sitter's clothes but also the utensils and
other items of furniture and household objects.

*Portrait of a Woman
as a Vestal Virgin,*
undated
Oil on canvas,
60 x 41 cm

Landscape with the
Palace of Caserta
and Vesuvius, 1793
Oil on canvas,
93 x 130 cm

Jacob Philipp Hackert

PRENZLAU, BERLIN, 1737 – SAN PIETRO DI CAREGGI, 1807

Hackert, who was from Berlin, was a much-travelled artist. Like many other Germans of his generation, he arrived in Italy in search of the ideals and the locations of the classical world. He devoted himself almost exclusively to landscapes, and can be considered a landscape painter within the classicist tradition. His compositions are inspired by *vedute* and remain largely unchanged throughout his career, at times resorting to rather repetitive formulae.

Philipp Hackert.

As we can see in this Neapolitan scene, Hackert's landscapes are painted with a sober objectivity and a sense of spatial order which results in clear and structured compositions. Thus the image is framed between two groups of trees at the far left and right, leaving a space in the centre in which the smoking Vesuvius is particularly prominent. A broad panorama extends from the foreground to the volcano, while on the right is the Palace of Caserta, which stands out due to its large size. Also typical of Hackert's work is the inclusion of small figures in isolated groups which animate the scene.

The technique is precise and the draughtsmanship of great purity, with well-defined outlines; the figures in the foreground are almost sculptural. In harmony with the drawing, the artist uses bright and clear colours which give the canvas a precise light and transparent atmosphere. All of this results in a certain artificiality, as well as a decorative feel very much in line with courtly taste at the time. Hackert was made painter to Ferdinand IV of Naples in 1785. It was during this period in Naples that he executed the present work, which probably depicts the gardens of the palace, designed in the English style with woods and meadows on the instructions of the queen.

PAGES 458/459:
Detail of illustration
page 526

PAGES 460/461:
Detail of illustration
page 534

The 19th Century

Francisco de Goya

FUENDETODOS, SARAGOSSA, 1746 – BORDEAUX, 1828

Goya is one of the great geniuses of painting. His work, which spans the decades between the 18th and 19th centuries, reflects contemporary Spanish society and the troubled times in which he lived, which saw the Napoleonic invasion and the War of Independence. Francisco de Goya y Lucientes lived in Madrid from 1773, the year in which he married Josefa Bayeu, whose brother Francisco was a successful and prestigious painter who helped Goya obtain a post at Court. Over the following period he produced cartoons for the royal tapestry works and in 1789, upon the death of Charles IV, was appointed painter to the court of the new monarch Ferdinand VII, whose portrait we see here. During these years Goya's painting evolved under the influence both of the political events of the time and of his own experiences, moving from a pleasant light-hearted style depicting scenes of everyday life, to a subjective vision dominated by the expression of emotion.

Goya's life and art were marked by two major events. The first of these took place in 1793 when, as a result of a serious illness, he lost his hearing. The resulting isolation had a direct effect on his painting both with regard to technique and subject matter. The second event was the War of Independence (1808–1815), which Goya experienced with great intensity, and following which he went into voluntary exile in Bordeaux from 1824 until his death. Both his paintings and his numerous engravings of the *Disasters of War* reflect the miseries and horrors of this period in history. These two events were to lead Goya's art increasingly towards a lucid vision of the dark side of humanity, and his entire mature work is a subjective interpretation of the world around him. The paintings in the Thyssen-Bornemisza Museum were executed in the last 30 years of his life and, within the confines of the genre of portraiture, clearly reflect the overall character of his work from this period.

The earliest of the three is the *Portrait of Asensio Juliá*, a painter and follower of Goya, who worked with him on the frescoes for San Antonio de la Florida. The artist stands in front of the scaffolding in the church, with some paintbrushes on the ground on the right. Working at speed,

"In nature, colour does not exist any more than line. There is only light and shadow. Give me a piece of charcoal and I will make you a picture. All painting is a matter of sacrifice and parti pris."
FRANCISCO DE GOYA

Portrait of Asensio Juliá, c. 1798
Oil on canvas,
54.5 x 41 cm

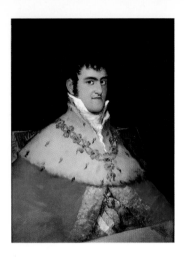

Portrait of
Fernando VII,
c. 1814/15
Oil on canvas,
84 x 63.5 cm

"Always lines, never
forms. But where do
they find these lines
in nature? Personally
I only see forms that
are lit up and forms
that are not, planes
which advance and
planes which recede,
relief and depth. My
eyes never see outlines
or particular features
or details. I do not
count the hairs in the
beard of the man who
passes by any more
than the buttonholes
on his jacket attract
my notice. My brush
should not see better
than I do."
FRANCISCO DE GOYA

the brush creates the forms with large, thick strokes. Light is important, although no longer treated realistically but rather expressively and purely for the purposes of plasticity. Thus the focus of light coming from the background and illuminating the scaffolding sets up a rhythm of light and dark areas which frame the figure. The subject himself is illuminated by a direct light, this time without contrasts, issuing from the opposite direction. At the intersection of these two light sources stands the figure of Asensio Juliá, vigorously characterized and elaborated in much stronger colour than the background, introducing cool tones of blue and white which contrast and give life to the almost monochromatic composition.

The *Portrait of Ferdinand VII* was painted just after the end of the War of Independence. This canvas is probably a preparatory study for another work. The sitter is presented in a totally unidealized manner, and it might even seem as if Goya was making obvious the monarch's deficiencies, while at the same time depicting the attributes of royalty in a somewhat exaggerated manner: the great red cloak over the frock coat with its sash, the ermine cape, and the Order of the Golden Fleece. The composition is structured on an exaggeratedly pyramidal shape which serves as the support for the not very appealing face.

The portrait of *El tío paquete* (The Old Bore) is altogether different. This small canvas was executed around the same time as the so-called *Black Paintings of the House of the Deaf Man* with which Goya decorated his own home, and is a softer version of his work of that era. Large, thick brushstrokes create sketchy forms which are blurred and melt into the background. Only the equally sketchy face stands out, due to its strong colouring in reds and whites with touches of black. Goya paints his sitter truthfully but with affection: if there is any criticism, it is of society or the injustices in life.

▶ *El tío paquete,*
c. 1819/20
Oil on canvas,
39 x 31 cm

Théodore Géricault

ROUEN, 1791 – PARIS, 1824

Alongside Delacroix, Géricault was one of the earliest and most important French Romantic artists, and was the first to break away from the classicist style established by Jaques-Louis David. In contrast to David's balance and harmony, derived from a linear style and the use of a cool palette, Géricault emphasized colour in compositions filled with movement and tension.

His work was based on a direct observation of the world around him. Géricault was an acute and analytical observer of reality. He focused on various different areas within his oeuvre, including the observation of human tragedies, misery and poverty, death in war and the mentally ill. In all his rather limited output (which included drawings and lithographs as well as oils), Géricault sought a means to express the reality which he saw before him. Alongside his naturalistic subject matter, Géricault was particularly drawn to two other genres: the horse and the nude.

The Kiss, c. 1822
Sepia wash and
charcoal on paper,
20.3 x 36.8 cm

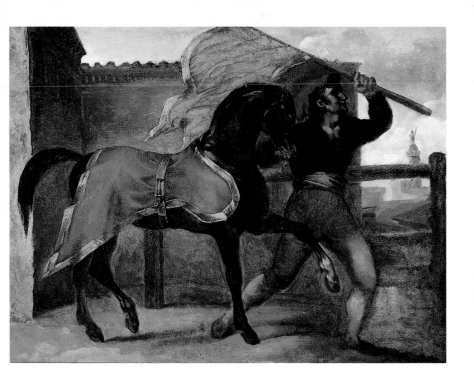

The subject of horses is related to the trip to Italy which he made between 1816 and 1817. There he made numerous drawings and sketches, which he would later use as the basis for larger paintings. This painting of a horse race was probably executed during that period. Géricault, who loved horses and knew a great deal about them, has lingered with pleasure over this study of the winner of the race. The horse combines an elegant and classical appearance with a feeling of contained strength and spirit, imbuing its entire figure with a taut sense of movement.

The nude study is a masterful composition which combines classicism, monumentality and realism. The theme of the kiss provides the artist with a chance to depict a pair of figures with great sensuality and is also a study of anatomy and the fall of light.

The Horse Race,
c. 1816/17
Oil on paper
attached to canvas,
44 x 59 cm

Eugène Delacroix

CHARENTON-SAINT-MAURICE, 1798 – PARIS, 1863

Eug. Delacroix.

▶ *The Duke of
Orléans showing his
Lover to the Duke of
Burgundy*, c. 1825/26
Oil on canvas,
35 x 25.5 cm

The Arab Rider,
c. 1854
Oil on canvas,
35 x 26.5 cm

Slightly younger than Géricault, whom he met when both were studying
with Pierre Guérin, Delacroix is considered to be Géricault's successor
and the artist who most fully expressed the French Romantic style.
Delacroix and Géricault were alike in the passionate spirit which infuses
their works and the sense of movement in their compositions, but
whereas Géricault used these to chronicle the reality of his surround-
ings and his age, Delacroix favoured literary, historical and fantastical
subjects. In this he expressed the spirit of Romanticism as it is now
generally understood: an art which rejects the everyday and the ordin-
ary, an art in which the imagination is paramount and which empha-
sizes moments of drama and tension. Delacroix's work was indeed
fundamental in shaping this conception of Romanticism.

The Romantics looked to history for their sources, but not so
much to classical antiquity as to the medieval era. Romanticism redis-
covered the Middle Ages, its stories and legends and its chivalrous
ideals, which were to be the source of some of the nationalistic values
which arose in the 19th century. *The Duke of Orléans showing his Lover
to the Duke of Burgundy* is one such story, taken
from an anecdote in French history.

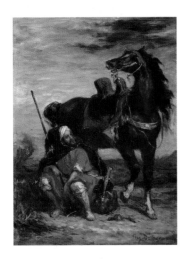

Technically, Delacroix's painting is also innova-
tory in its use of colour. Deploying a very loose hand-
ling, the artist reduces the use of black and instead
creates the shadows from complementary colours.
His trip to North Africa was fundamental for the
development of this style, which is apparent in *The
Arab Rider*, an example of his late work which was
largely devoted to Oriental subjects in line with the
Romantic fascination with "exotic" cultures. The
painting has a simple composition and setting, but
is nonetheless very dynamic, built up from strongly
contrasting areas of colour.

Sir Thomas Lawrence

BRISTOL, 1769 – LONDON, 1830

Sir Thomas Lawrence was a very successful portraitist both in Britain and mainland Europe. Considered a child prodigy, he painted portraits from a very young age and at the age of 22, following the death of Joshua Reynolds, was appointed painter to the King, further adding to his prestige. He was commissioned by George IV to paint numerous politicians and European statesmen, portraits which were highly prized by the English and European aristocracy.

The *Portrait of David Lyon* dates from his late period and looks back to the English portrait tradition of the 17th and 18th centuries, when England was a leading centre for the genre. The use of a land-scape background was characteristic of the English school. At the same time, the portrait also falls within the Romantic tradition in the elegant bearing of the sitter and in his expression, at once haughty and melan-choly, while the clothing, pose and long untidy hair are all typical of the 19th-century dandy.

The background landscape emphasizes the Romantic character of the painting, adding a sentimental note. A dark and dense wood on the left gives way on the right to a river which gleams silver in the light of dusk. A few dark clouds in the sky envelop the scene in an atmosphere of mystery and unease. The figure is outlined against a background in which the artist has played with chromatic contrasts. Thus, while the dark frock coat is superimposed on the pale evening sky, the face stands out against the dark mass of the clouds, adding intensity to the gaze which is fixed on the viewer.

The portrait, which is realised from a low viewpoint to give monu-mentality and elegance to the figure, reflects the artist's accomplished technique. The loose handling of the background becomes more precise in the foreground planes, particularly in the face, which combines acute pyschological observation with a physical likeness.

Portrait of David Lyon, c. 1825
Oil on canvas,
217 x 132 cm

Caspar David Friedrich

GREIFSWALD, 1774 – DRESDEN, 1840

Easter Morning,
c. 1833
Oil on canvas,
43.7 x 34.4 cm

Caspar David Friedrich is one of the most important Romantic painters. His work signifies the introduction of the subjective into art. In comparison with the dynamism and passionate expression of emotions found in the work of the French Romantics such as Géricault and Delacroix, German Romanticism at the hands of artists such as Friedrich showed the artist's subjective vision as directed more to a lyrical and introspective depiction of man, the search for his being, his origins, and the inner feelings of the individual.

Friedrich's subject matter is drawn from nature but is not an objective vision of it. Rather, it is a mystic one, imbued with a symbolic character derived from its relation to man: in other words, it is nature as a reflection of human values. Friedrich's painting was closely related to the intellectual circle in which he moved (and which included Goethe, Novalis and Kleist). For this reason his pictures often show figures seen from behind and contemplating the landscape, which makes sense through man's contemplation of it and through the effect which it has on him.

This was also the motivation behind paintings of times of day, such as *Easter Morning*. Night has not yet departed, the light is still pale and the atmosphere misty as a few figures walk silently into the distance. The bare, cold and soundless landscape enveloped in a light mist exudes a magical and unreal mood. The elements in the foreground are painted in great detail and with a seemingly objective approach, but this meticulousness is in fact used to convey Friedrich's subjective view of the scene, bathed in an aura of devotion and lyricism.

Ferdinand Waldmüller

VIENNA OR BRÜNN, 1793 – HINTERBRÜHL, NEAR VIENNA, 1865

Waldmüller

"The most sublime and at the same time the only study of art is the figure of man."
FERDINAND
WALDMÜLLER, 1846

Bad Ischl, 1833
Oil on canvas,
31.5 x 26.5 cm

Ferdinand Waldmüller was the most important Austrian painter of the first half of the 19th century, and the leading representative of the Biedermeier style which emerged in Austria and Germany between 1815 (the year of the Congress of Vienna) and the Revolution of 1848. For Waldmüller and the Biedermeier circle, art's only purpose was the study of nature from an objective point of view, a conviction which led him to reject any idealizing or Romantic tendency. His landscapes are an early manifestation of a naturalism which would become one of the axes of 19th-century painting, both within the genre of landscape and amongst the Realists. These latter were opposed to the symbolic landscape painting of northern Germany, encapsulated in the work of Friedrich.

Waldmüller's landscapes are a minutely detailed description of the different elements within nature and a hymn to its grandeur and pure simplicity. As in his painting of *Bad Ischl* (a village near Salzburg), his works recreate the brilliance and clarity of the atmosphere as another element within the landscape. The result is a bright and light-flooded style. The landscapes around Salzburg were a favourite subject of German and Austrian painting, due to the almost Mediterranean beauty of many of these southerly locations. Another characteristic aspect of 19th-century landscape painting evident in Waldmüller's art is the depiction of mountains, natural features which assume particular prominence in this period. The gentle hills and the steep mountains here take up a large proportion of the canvas, reducing the area devoted to the sky.

Waldmüller also painted other subjects, all with an equally realistic approach, such as still lifes, portraits and scenes of everyday life and customs. His style has often been related to the *plein air* approach of the Barbizon School, which formed in France in the mid-19th century, and in particular to Corot.

*The Schönberg seen
from Hoisernradalpe,*
1833
Oil on canvas,
31 x 25.7 cm

*The Nymph of
the Fountain*, 1855
Pastel and charcoal
on paper, 63 x 54 cm

Arnold Böcklin

BASLE, 1827 – SAN DOMENICO, ITALY, 1901

Stylistic unity in art broke down definitively in the 19th century, giving way for the first time to a series of simultaneous and different trends. Along with Gustave Courbet's Realism and Jean-Baptiste Camille Corot's landscapes, artists such as Böcklin and Gustave Moreau produced a type of painting which was half-way between classicism and Romanticism, in which the subject matter and treatment transported the viewer to a dreamy world filled with symbolism.

A.BÖCKLIN P·

Böcklin developed a very literary type of painting, with most of his works inspired by mythology. This painting is a relatively early one, in which the artist's taste for the mythological has already manifested itself, although his treatment of it is more "contained" than in his later works. Painted during his first trip to Rome, it combines neo-classical elements with other more Realist ones. The former are to be seen mainly in the treatment of the figure, while the second appear in the landscape which, although imaginary, is rendered using the loose technique of the Realist painters.

The work is a study for a painting now in Munich, and features on its reverse another drawing of a nymph fleeing from Pan, one of Böcklin's favourite mythological subjects.

"If one now traces Böcklin's work ... from its beginnings, one observes so pure a line of artistic development that one becomes convinced of the painter's great talent."
ERNST-LUDWIG
KIRCHNER, 1923

*View of the Port
of Rotterdam*, 1856
Oil on canvas,
43 x 56 cm

Johann Barthold Jongkind

LATDORP, NEAR ROTTERDAM, 1819 – GRENOBLE, 1891

After the 1848 Revolution, many European artists embraced a new understanding of art as a truthful reflection of the reality they saw before their eyes. This approach came to be known as Realism, and was chiefly represented in France, by such artists as Courbet and Corot. It also manifested itself elsewhere in Europe, however, as we see in the case of Jongkind, a Dutch painter who had close connections with Paris, which was on its way to becoming the artistic capital of Europe. Jongkind was a friend of French Realist painters such as Boudin, Corot, Daubigny and others, and is considered one of the forerunners of Impressionism, above all for his interest in the effects of light and atmosphere, as well as for encouraging Monet to paint out of doors (even though he did not do so himself).

View of the Port of Rotterdam is characteristic of his style, and is one of a number of similar views executed at various different times. In this relatively early canvas we can see the influence of of the Dutch marine painters of the 17th century. Jongkind's use of the brushstroke is still traditional, as is the type of composition and the way of representing various different elements which make up the scene. However, we can also detect a particular sensitivity in capturing the effects of light and atmosphere, here created from strong contrasts of light and dark areas. The loose brushstroke is deftly handled and creates simplified forms with solid outlines, concentrating on the reflections and highlights in the water and the clouds in the sky.

Jongkind lived an irregular and chaotic life. He travelled throughout France, Holland and Belgium, peppering masterly compositions amongst the repetitive commercial canvases with which he scraped a living; despite selling his work, he lived a miserable existence of poverty and alcoholic abuse. Here too he was a precursor of the Bohemian lifestyle lived by the artists of the late 19th century and early 20th century.

Thomas Cole

BOULTON-LE-MOORS, LANCASHIRE, 1801 — CATSKILL, NY, 1848

Born in England, Thomas Cole emigrated to the then British colony of North America when he was 17 and took up a career as a painter, specializing in landscapes and portraits. From 1825 he lived in New York, where he soon gained a reputation as a landscape painter, particularly after a trip along the Hudson River, which he undertook to paint in a number of canvases. This was the start of the Hudson River School which Cole founded and which attracted other artists such as Durand and Church, who worked in a similar style. Cole's generation initiated a truly American style of painting, which developed for the first time in the 19th century and which focused on landscape, genre painting and still life.

These first Hudson River School painters, led by Cole, developed a style of landscape painting which was influenced by Romanticism, and in which an almost religious feeling towards nature was combined with a growing sense of national identity. Thus landscapes such as the present one exalt the American landscape, which is seen as a Garden of Eden especially created for its people. Cole rejected history painting, whose influence reached America from Europe but which was remote from the ideals of the new civilization taking shape on the East Coast. Rather, he promoted landscape painting, incorporating into it the intellectual and moral issues of history painting.

The Romantic, even visionary character of this enigmatic painting presents us with a nature full of meaning. It is probably a version of another work by the artist now in Boston, entitled *The Expulsion of Adam and Eve from the Garden of Eden*. In the Thyssen-Bornemisza painting, the figures have disappeared, but the landscape remains the same, with Paradise on the right in the distance illuminated by a gentle evening light. In the foreground is fire and a precipice. This is nature as sublime, represented for its own sake without the mediation of man.

Expulsion. Moon and Firelight, c. 1828
Oil on canvas,
91.4 x 122 cm

*Fishing Party on Long
Island Sound off New
Rochelle*, 1847
Oil on canvas,
66 x 92.7 cm

James Goodwyn Clonney

LIVERPOOL OR EDINBURGH, 1812 – NEW YORK, 1867

Like Cole, Clonney came from a British family which emigrated to the New World in search of the opportunities which it offered. He was also one of the artists to develop a new and truly American style of art, reflecting the interests and reality of a people who at this time were acquiring their national identity. While Cole began the genre of American landscape, Clonney paved the way for genre painting.

The present work is a good example of this type of painting, which aims to reflect the peaceful everyday life of the East Coast in a direct way. Rural life and moments of leisure, as here, were Clonney's favourite themes. He takes pleasure in anecdotal detail and in the characterization of his figures; the tranquil nature of the scene has even encouraged Clonney to add a touch of ironic humour, evident in a certain caricaturing of the figures which is characteristic of the work of this artist. Alongside this interest in anectodal detail, however, there is also an interest in the representation of nature, here seen as a broad view of sea and sky on a clear, bright and calm day. This serene vision of the natural world comes close to the Luminism of American landscapists such as Heade, a contemporary of Clonney.

The technique is very detailed as the artist wishes to describe the various objects and elements that make up the scene, appropriate for this type of genre painting. The boat in the foreground and the three figures in it are painted with meticulous detail and crisp outlines. The mooring ropes, the planks of wood, the basket next to the boy, and the hats are all represented in the greatest detail. This same taste for incidental detail led Clonney to sprinkle the whole surface of the water with little boats right up to the horizon.

Fitz Hugh Lane

GLOUCESTER, MASSACHUSETTS, 1804–1865

Lane's panoramic view of his native city is half-way between genre paint-
ing and landscape, and introduces us to the Luminist movement, a cur-
rent within landscape painting which differed from the sentimentalism
and grandiloquence of Cole's art and the work of the Hudson River
painters. As its name indicates, Luminism was a way of painting land-
scape in terms of light and atmosphere, coupled with a highly polished
and finished technique and a calm and peaceful view of the natural
world. Lane's painting is thus an early example of the Luminist style,
which was chiefly promoted in the 1850s and 1860s and was embraced
by other artists such as Heade. These painters were not a school as
such, nor did they even perceive of themselves as a group. They simply
evolved their work out of the same concept of landscape.

Despite being overloaded with anecdotal detail, the present work
embodies – above all in its landscape elements – the characteristics of
Luminism: a style of painting which is highly finished and which pays
careful attention to reproducing highlights and reflections, depicting
an atmosphere which is flooded with brilliant daylight. In general, the
Luminist painters particularly favoured river and coastal scenes.

In the left- and right-hand foreground are two groups of figures
busy at their tasks. Although these elements are painted in great detail,
the main focus of the painting is the surface of the sea, whose colours
offer a clear contrast with the browns of the lower section of the canvas.
The gradation of colour in the water from the blue on the left to the
golden yellow and almost white on the right (echoing in a more con-
centrated way the colours in the sky) is fluidly painted, emphasizing
the limpid transparency of the water and its reflective surface.

*The Island and Fort of
Ten Pound, Gloucester,
Massachusetts*, 1847
Oil on canvas,
50.8 x 76.2 cm

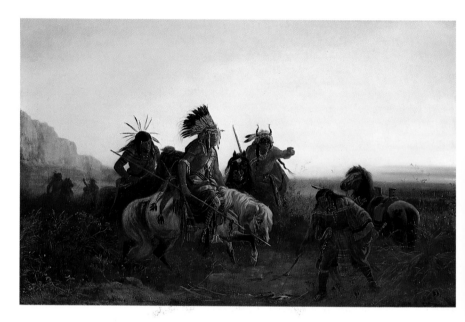

The lost Trail, 1856
Oil on canvas,
49.5 x 77.5 cm

Carl Wimar

SIEGBURG, GERMANY, 1828—SAINT LOUIS, MISSOURI, 1862

Half-way between genre and history painting, this work takes its inspiration from tales of the American Wild West. It thereby falls into a genre which was extremely popular on the "civilized" East Coast, where works of this type were seen to depict a still wild and untamed America. The way in which Native Americans were depicted varied according to the era and the degree of understanding of their different cultures.

German by birth, Wimar arrived in America aged 15 and dedicated himself to painting from the first, although that initially meant decorating caravans and commercial posters. In 1852 he returned to Germany where he trained with two Düsseldorf artists, Josef Fay and Emanuel Leutze. It was on his return to America in 1856 that he began to paint scenes of Native Americans.

The present painting dates from that same year, and seems to show that the artist had only a superficial knowledge of his subject. Later he would travel through Missouri to record the life of the indigenous peoples, and he came to be considered the most important of all the painters of the American West. However, the present work seems to reflect a vision of the Native Americans derived from the grim legends which had grown up around them. Wimar lends them a theatrical appearance and places them in exaggerated poses, while their dress relates to no known tribe of the time and is simply a product of the artist's imagination. Unlike Wimar's later works, the scene is based on literary sources rather than on first hand observation, and reflects the threatening image of the Native American Indian which pervaded the 19th century.

The figures are set within an evening landscape at dusk, thanks to which they are strongly backlit, emphasizing their expressions and gestures. Against the darker foreground is a pale sky and a glowing horizon painted in red tones. We see a plain which is typical of the American West, rising to the left of which are some typical steep and bare rock formations, tinted red by the sunset.

Frederick Edwin Church

HARTFORD, CONNECTICUT, 1826 – NEW YORK, 1900

Frederick Edwin Church was the only pupil of Thomas Cole, founder of the Hudson River School. Like Cole he had a religious concept of the landscape, which he saw as a vehicle for the transmission of spirituality and communication with God, expressing the grandeur of God's works. His paintings have a sublime character which conceptually brings them close to the German Romanticism of Friedrich.

Church's landscapes take on an unreal feeling and convey an aura of mystery and magic. However, we also find in his works a purely naturalistic interest in conveying the effects of light and atmosphere. In the 1850s and 1860s Church made a series of trips around central America and the Tropics in search of new earthly paradises, which inspired him with a vision of a splendid and uniquely American landscape, almost always presented as completely untamed, filled with exuberant vegetation and colour.

Cross in the Wilderness depicts a wild and desolate landscape developed around the central motif of the painting, the cross, which, though

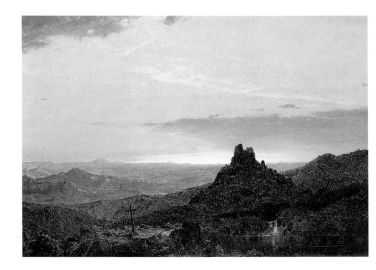

Cross in the Wilderness, 1857
Oil on canvas,
41.3 x 61.5 cm

Autumn, 1875
Oil on canvas,
39.4 x 61 cm

placed in a central position, is overshadowed and passes almost un-
noticed among the grandeur of the natural setting. The painting refers
to the hope of life after death and constitutes an elegiac memorial to
the deceased daughter of the person who commissioned it. All the
elements in the painting thus have a symbolic and religious meaning:
the cross refers to salvation, the water to the renewal of life, and the
dusk to death and resurrection (as night is followed by dawn).

The other painting reproduced here is an autumn landscape, a
season of the year often painted by Church, who exploited the possibil-
ities autumn gave for brilliant colouring, from the blue sky in the upper
left to the intense reds of the leaves. The dense mist softens the forms
in the background, fusing sky and land. Characteristic of Church and
other artists of his school is the light source coming from the centre of
the canvas, which illuminates the scene from the background in a delib-
erately theatrical way.

George Inness

NEWBURGH, NEW YORK, 1825 – BRIDGE OF ALLAN, SCOTLAND, 1894

Inness's work represents the development of American Romantic landscape painting towards a more Realist style which was inspired more directly by nature. The two paintings in the Thyssen-Bornemisza Collection illustrate this progression: whereas the early *Summer Days* is close to the style of Cole and Durand, the late canvas *Morning* represents a synthesis of Inness's new approach to landscape. This evolution was closely related to his numerous trips to Europe, where he spent lengthy periods of study and met the leading artists of his day. He was influenced by Corot and the Barbizon School, from which he derived an interest in outdoor painting and the representation of nature in all its immediacy and vitality.

Summer Days was painted immediately after his first trip to Europe and compositionally remains very close to the work of the Hudson River School, particularly Durand. It uses a foreground with various trees which are gently backlit, while the horizon gives out a brilliant and golden evening light. While all this, together with the dense, warm and

Morning, 1878
Oil on canvas,
76.2 x 114.3 cm

reddish tonalities, suggests the American Romantic landscapists, the presence of the cattle and cowboys gives the painting a contemporary and anecdotal air far removed from the pantheistic philosophy of the Hudson River painters. Here Inness is already starting to see a more homely nature and one inhabited by man.

However, it is in *Morning* that we can more easily see the change in approach. Inness's painting technique is now misty, focusing on atmospheric effects and almost exaggerating them. The influence of French *plein air* painting is also obvious in his desire to capture the time of day and its visual properties, the reflections of light and the vibrancy of nature. The frothy brushstroke and the choice of a particularly misty time of day contributes to the poetic and evocative nature of the image. The painting is typical of Inness's late style, which came closer to Symbolism than Realism.

Summer Days, 1857
Oil on canvas,
102.9 x 143.5 cm

Lake George, 1860
Oil on canvas,
56.3 x 87.1 cm

John Frederick Kensett

CHESHIRE, CONNECTICUT, 1816 – NEW YORK, 1872

Kensett belonged to the second generation of painters of the Hudson River School, a group founded by Cole. He was also a great friend of Durand, with whom he travelled to Europe between 1840 and 1847, visiting London, Paris and Italy. On returning to America he established himself in New York, where he lived an active life in artistic and academic circles. In 1870 he became one of the founder members of the Metropolitan Museum of Art. His painting, as with other second-generation painters like Cropsey, combines the grandeur of the Hudson River School with a greater interest in capturing light and its effects, thus bringing him closer to Luminism. Kensett's work developed towards a pure Luminism, but the present canvas shows him at a transitional period. The landscape he has selected has potent literary and historical connotations, as it was the setting for *The Last of the Mohicans* by James Fenimore Cooper; we thus find ourselves before a patriotic exaltation of American nature, perceived as the New Eden.

Kensett painted the landscape of Lake George on numerous occasions, capturing the different seasons and the changes of light and nature. The present work depicts the brilliant colours of an autumn day, in which the golden light is complemented by the red of the leaves which are just about to fall. Painted in some detail, Kensett has enjoyed the elaboration of the foreground, with its two trees on the right whose tops are outlined against the sky. Some ducks are taking off from the bank.

The composition is structured in two parts. On the right are the trees with the wood behind, creating a compact group which contrasts with the empty area on the left, where the lake vanishes into the distance. The atmospheric effects are well captured, from the sharpness of the foreground to the mist in the background which lightens the colours and softens the contours, unifying the whole surface of the canvas in a range of misty, earthy tones.

"Kensett did not allow himself to be influenced by the persistence of the other Luminists in using receding horizontals and preferred to compensate masses and voids in his compositions in order to create the feeling of space and to enhance its breadth and light."
EARL A. POWELL

Spouting Rock,
Newport, 1862
Oil on canvas,
63.5 x 127 cm

Martin Johnson Heade

LUMBERVILLE, PENNSYLVANIA, 1819 – SAINT AUGUSTINE, FLORIDA, 1904

This painting is one of the most representative examples of Luminism, a style which emerged in the 1860s within American landscape painting. The term describes the work of a number of artists who, although they did not form a specific group or school, all produced a type of landscape painting devoted to rivers or coastal scenes and based on the effects of light. Alongside Heade, Lane was another important Luminist and is also represented in the Thyssen-Bornemisza Collection.

Newport was a favourite location with the East Coast painters. They were attracted to the beauty of the landscape, which they began to paint from life. This canvas depicts the beach of Spouting Rock in Newport and shows characteristic features of Heade's style. Using a small and invisible brushstroke, the artist achieves a detailed description of the various elements, from the stones and rocks in the foreground to the clouds in the sky and the reflections in the water. The totally calm sea is also typical of Luminist artists, who preferred a peaceful and simple view of nature which was close to the European Realist style of *plein air* landscape. Heade's Luminist affiliations are clear, above all, in his interest in capturing the effects of light and atmosphere. Thus a clear and golden light bathes the scene, casting its golden reflection on the sea and clouds. In the transparent atmosphere we can make out the tiny sailing boats in the distance.

The horizontal composition emphasized by the shape of the canvas was frequently used by Heade and counterbalances the surface of the sea with that of the sky. The flat calm water picks up the reflection of the clouds, the rocks and the boats, which are situated at varying distances in order to help create planes of differing depths. The luminosity of the scene is emphasized by the absence of shadows; in their place are gentle tonal gradations which give volume to the different areas of the landscape. The image conveys the sensation of a midday light which falls evenly over the whole scene.

Winslow Homer

BOSTON, 1836 – PROUT'S NECK, 1910

Winslow Homer is one of the most important late 19th-century American artists; his work carried North American painting into a new phase, in which it left behind home-grown trends in order to embrace the developments taking place in Europe, and particularly in Paris, in the shape of the naturalism of the Barbizon School and the new pictorial processes of the early Impressionists.

The works in the Thyssen-Bornemisza Collection are a good example of the different styles and genres in which Homer painted over the course of his career. Homer started out as an illustrator for *Harper's Weekly*, a post he retained until 1875. *Waverly Oaks* dates from his earliest period and bears obvious similarities with the work of European artists such as Courbet and Corot. The scene is conceived with simplified forms and a very loose handling, which renders the view of the park in large areas of colour, with a particular interest in the fall of the light as it filters through the trees. The two women are represented in a schematic way, although they have a monumental, volumetric feel. Homer at this period was close to the French *plein air* painters, whose work he knew through illustrations and prints. This interest would inspire his trip to Paris two years later between 1866 and 1867, when he would come into direct contact with the Barbizon artists.

His style was not just limited to a representation of landscape, however, but also responded – again like the French painters – to an interest in the observation of his surroundings and to a feeling for modern life. In the 1870s he painted a series of interiors, mainly portraits such as the one here of *Helena Kay*, in which an intimate and introspective mood prevails. Helena Kay, a flower painter and member of Homer's circle, is painted here in a meditative pose, absorbed in her own thoughts. Homer has used the empty areas of the canvas as part of the formal structure. An earthy-grey and dark tonality predominates, concentrating the light on the face and hands of the figure and on the flower on the floor (referring to her profession). Above all the work expresses harmony and a profound sense of visual beauty.

HOMER

"He is almost barbarously simple, and, to our eye, he is horribly ugly; but there is nevertheless something one likes about him."
HENRY JAMES on HOMER

Waverly Oaks, 1864
Oil on paper attached to panel,
33.6 x 25.4 cm

Another trip to Europe, this time to England in the spring of 1881, marked a further milestone in Homer's career and gave rise to a series of watercolours and drawings which included *The Coastguard's Daughter*. These watercolours depict the life of a fishing community on the North Sea. We can see how Homer gave his characters an epic, heroic feel and was inspired to convey the harshness of their lives and their struggle for survival in face of the forces of nature. He here depicts a girl seen from a low viewpoint, elaborating her figure with a sense of monumentality but without any loss of naturalness. The loose handling of the watercolour is notable, as are the harmonies of blues and greens which convey the stormy atmosphere and the dull light typical of the northerly location. These dark tones underline the harshness of the existence led by the characters portrayed.

Portrait of Helena Kay, 1873
Oil on panel,
31 x 47 cm

The innovations encouraged by his trip to England are also obvi-
ous in his later works, in their character, their use of colour, and in their
evolution towards a loose and almost Expressionist brushstroke. This is
the period of *The Distress Signal*. The painting was made at Prout's Neck
on the Maine coast, where Homer retired after his trip to England in
1883. At this windswept and stormy spot, the subject of man's struggle
against the forces of the sea inspired Homer to create a series of works
which included the present one: the shipwreck of a boat (on the left)
and the rescue attempt in the middle of a storm. The composition con-
sists of just a few essential elements, without any distracting anecdotal
details. Homer uses a very loose and obvious brushstroke to convey the
stormy atmosphere, the dampness and the slippery deck. And in the
middle of this hostile natural setting, he focuses on the heroic acts
of the men bracing the storm.

PAGES 500/501:
The Distress Signal,
1892–1896
Oil on canvas,
61.3 x 96.5 cm

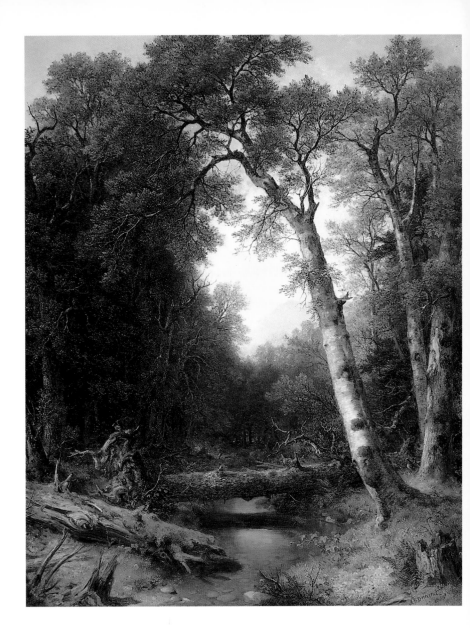

Asher B. Durand

JEFFERSON VILLAGE, NEW JERSEY, 1796–1886

Durand is the second most important artist of the Hudson River School after Cole. Like Cole, he had a pantheistic vision of nature which he imbued with a moralizing and quasi-religious sentiment. However, while Cole painted grandiose compositions transfused with the sentiment of the sublime, Durand's vision is more intimate and contained, as we can see in this painting. The technique and in particular the use of colour is highly typical of the Hudson River artists: strong colours whose contrasts create sparkling and lustrous effects.

A Stream in the Wood is also typical of Durand's subject matter, as most of his paintings depict woods. He almost invariably uses the same compositional format, comprising a few trees in the foreground, an empty middle area, and beyond these a luminous sky which casts light on the valley. Durand's paintings show nature in its wild state, without any sign of human presence, and glorify American nature as a new Eden.

Like Cole, Durand had an almost mystical view of nature which coincided with the Romantic ideal. However, his respect for nature meant that he also reproduced all its different elements with great fidelity, thus bringing him closer to Realism and *plein air* painting. His desire to remain close to his source led him to advise his pupils to work out of doors. His work, and that of his fellow Hudson River artists, is nevertheless based on a notion of the beauty of nature not as an end in itself, but rather as a vehicle through which to approximate the Divinity. This approach resulted in some paintings of almost magical atmosphere with spiritual overtones.

A Stream in the Wood, 1865
Oil on canvas,
102 x 81.5 cm

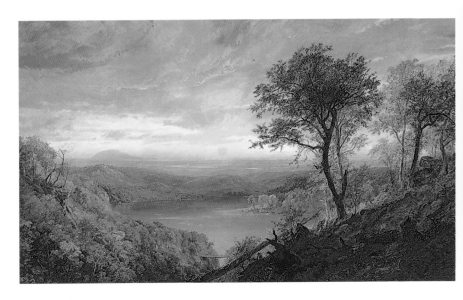

Greenwood Lake, 1870
Oil on canvas,
97.2 x 173.4 cm

Jasper Francis Cropsey

ROSSVILLE, STATEN ISLAND, 1823 – HASTING-ON-HUDSON, NY, 1900

As well as being a painter, Cropsey worked as an architect throughout his life. Painting was nevertheless his more important profession and the one to which he devoted most time. His work, as we can see in this example, is very close in style to that of Cole, and he is in fact considered the most important representative of the second generation of painters of the Hudson River School.

Lake Greenwood was one of the most frequently recurring motifs in Cropsey's work. According to the artist himself, it was here that he first started to paint, inspired by the magnificence of its landscape, and his paintings transmit this sense of the splendour of nature in its virgin state. Cropsey often used the compositional formula deployed here: a foreground with a few trees on a high patch of ground overlooking a broad panorama, with a distant horizon from which there radiates a brilliant light which floods the whole landscape, leaving the foreground slightly backlit.

The combination of the reds with the silvery grey tones produces a warm and intense colouring. This combination is repeated in the mountains, in which the warm tones of the foreground are resolved into the cooler tones in the distance. This is repeated more strongly in the clouds, resulting in a Romantic sky which gives the painting a literary and epic feel. The broad panorama seen from a high viewpoint presents a vision of the magnificence and infinite size of nature. Two tiny figures contemplate the view from the rocks on the left, confirming the idea of the immensity of nature in comparison with the scale of man.

J.F.C

"It was on my first trip to Greenwood lake, in the summer of 1843, that my paintings began to take on their own personality, and began to dress themselves with the clothes of nature and to breathe a little of their own breath."
JASPER FRANCIS CROPSEY

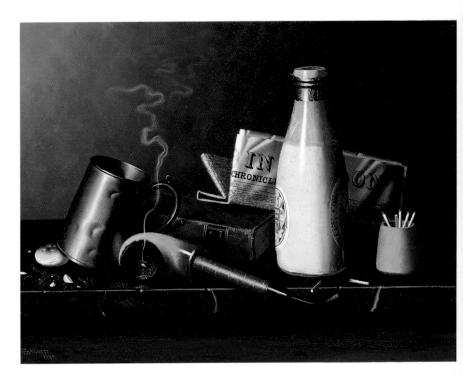

Materials for a leisure
Hour, 1879
Oil on canvas,
38 x 51.5 cm

William Harnett

COUNTY CORK, IRELAND, 1848 – NEW YORK, 1892

Still life, landscape and genre painting were the three genres most representative of American painting in the 19th century, supported by a middle-class clientele on the East coast made up of wealthy merchants, professionals and landowners. Among these patrons there was a growing interest in an art which extolled the particular values of American culture. In the last quarter of the century works of this type became more popular, expecially those painted in a hyper-realist and *trompe l'œil* style. The two main artists working in this genre were Harnett and Peto, both represented in the collection.

William Harnett was the artist who developed the *trompe l'œil* style. He arrived in Philadelphia with his family from Ireland at the age of five. He trained as a painter from a young age, and lived and worked in Philadelphia and New York. During the 1880s he spent a number of years travelling in Europe, living in London, Munich and Paris.

This painting was made prior to Harnett's trip to Europe, but although quite an early work it still shows the style and technique which would make him popular. Using a carefully arranged and balanced composition, he creates a seemingly casual image: a table (which we imagine as next to a chair which has recently been occupied by a man enjoying a few moment of leisure) bearing a number of domestic objects, such as a bottle of beer and a mug, a newspaper, a book and a pipe. Harnett's popularity lay in his use of illusionism, painting images that were designed to deceive the eye. The attention to detail with which he captures each object and its textures and reflections is combined with the sense of immediacy and instantaneity conferred by the pipe smoke, the burning matches and the breadcrumbs scattered on the table. They are the traces of a recent human presence which makes the image seem even more real.

John Frederick Peto

PHILADELPHIA, 1854 – NEW YORK, 1907

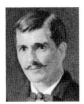

John F. Peto

While Peto's œuvre reveals him starting out from the genre of *trompe l'œil* in the manner of Harnett, it shows him arriving, in his latter years, at a style closer to the maxims of the avant-garde. Peto's influence on other American artists was minimal, however, as he spent the last years of his life as a recluse. As a result, many of Peto's paintings which are close to the style of Harnett were for a long time attributed to the latter.

The two works in the collection belong to Peto's late, reclusive period. In the first we can see the influence of Harnett, whom Peto met in 1875. This still life is close in type to *Materials for a leisure Hour* and even repeats some of the elements, such as the mug, pipe and books. Peto's technique and his treatment of the subject are very different, however. The detail in the representation of the objects here becomes a study in pictorial values, and the composition drifts more towards being

Books, Mug, Pipe and Violin, 1890–1895
Oil on canvas,
62.5 x 75 cm

Tom's River, 1905
Oil on canvas,
58.8 x 40.6 cm

a disordered and unbalanced jumble of objects. In Peto's work, everyday objects are brought together for their visual and artistic potential, for example the combination of earth, red and orangeish tones against the green of the cloth and the covers of the notebook.

This burgeoning interest in the pictorial values of materials, combined with the use of *trompe l'œil*, would find its supreme expression in *Tom's River*, which is a skilful game of deception, starting with the wooden frame with the nails which cast fake shadows, the string hanging down on one side, the texture of the old wood painted in different colours, the torn papers and the letters which are apparently scratched into the wood. This is a masterly work of deceptively simple composition which takes *trompe l'œil* to its furthest extremes.

William Merrit Chase

WILLIAMSBOROUGH, INDIANA, 1849 – NEW YORK, 1916

Wᵐ M. Chase

Chase is considered one of the most important American Impressionists. His work is close in style to that of the early French Impressionists. From 1872 to 1878 he travelled around Europe, settling in New York on his return, where he began a lengthy and fruitful career not just as a painter but also as a professor of painting at various academies. He finally founded his own academy, which was to be attended by some of the most important painters of the next generation.

One of the influences he absorbed while in Europe was the taste for Japanese prints, something widespread in artistic circles in Paris in the 1870s. Back in America, he made a series of portraits of friends and family in Japanese dress and with Japanese decorative elements, as in *The Kimono*. Chase is less interested in the sitter's appearance than in the chromatic harmonies and spatial setting, which he creates with a

"A wonderful human camera – a seeing machine."
KENYON COX on
CHASE, 1889

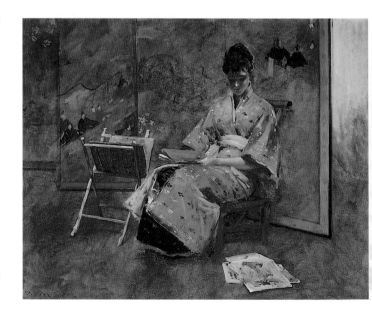

The Kimono, c. 1895
Oil on canvas,
89.5 x 115 cm

The Shinnecock Hills,
1893–1897
Oil on panel,
44.4 x 54.6 cm

very free brushstroke. The scene is compositionally quite simple, and is demarcated by the diagonal of the screen which forms the background and frames the sitter. Spatial depth is created by the edge of the screen, painted on top of a flat surface of earth tones. A golden light bathes the scene, with highlights created by lighter brushstrokes on the girl's arm and face. A profound aesthetic sense pervades the whole work.

The Shinnecock Hills is slightly earlier and is painted in a more realistic style, depicting a simple spot near Chase's house. The composition follows a format frequently found in his work: two horizontal strips represent the earth and sky, while the brilliance and clarity of the palette create a limpid and transparent atmosphere. Chase thereby switches from a fractured brushstroke in the foreground to a more defined handling of paint in the background. The simplicity of the landscape, in which very few elements stand out, indicates his search for beauty in the simplest things.

John Singer Sargent

FLORENCE, 1856 – LONDON, 1925

The son of Americans settled in Europe, Sargent worked mainly be-
tween Paris and London, earning great fame as a society portraitist.
From 1876, when he made his first trip to America, he would travel
there frequently to carry out commissions, most of them for portraits.
However, he never moved back permanently and always retained his
connections with Europe.

This portrait, executed at the height of Sargent's career, is abso-
lutely typical of his style, for which he was considered the best por-
traitist of his day. His paintings, as we can appreciate here, exude
elegance and refinement. Sargent had enormous natural talent as a
portraitist, and his style reflected the 18th-century English portrait by
artists such as Joshua Reynolds and Thomas Gainsborough. One of
the most characteristic elements of this type of portrait is the inclusion
of a landscape background.

Sargent combined the technical innovations of contemporary art
with an interest in detail derived from 19th-century art. Thus the sitter's
face is painted with detail in order to convey its accurate appearance,
although there is an undeniable degree of idealization in the depiction
of the figure. In contrast with the face, Sargent uses a very loose hand-
ling for the rest of the painting, from the gauzy dress to the sketchy
landscape in the background. This combination proved much to the
taste of high society, who found in these works a skilful combination
of innovation and tradition in the service of an accurate portrait of the
sitter.

Lady Millicent is painted here at the age of 37. Daughter of the
Count of Roslyn and wife of the Duke of Sutherland, Marquis of
Stafford, she was one of the most important women in London high
society. Sargent captures the elegance and carriage of her rank without
having to resort to a busy and detailed composition.

Portrait of Millicent,
Duchess of Suther-
land, 1904
Oil on canvas,
254 x 146 cm

Gustave Courbet

ORNANS, 1819 – LA-TOUR-DE-PELIZ, 1877

Guitave Courbet

The Stream
at Brème, 1866
Oil on canvas,
114 x 89 cm

Gustave Courbet was France's leading Realist painter. His art was closely connected to his vision of life, which was politicized and socialist, in keeping with the spirit of 19th-century Realism. Realism involved an active solidarity with the social reality of the people, who were portrayed as individuals, often with a focus on the least privileged members of society. Courbet, as with other Realist artists such as Jean François Millet and Honoré Daumier, showed the reality of life as they saw it around them, directing their interest both towards people and the landscape.

Courbet's work is principally devoted to the representation of real people in varying situations, but his art is not limited to witnessing reality; it also explores new forms of expression, particularly with regard to the use of light. An important area of his œuvre in this regard are his paintings of the landscapes where he lived or which he visited.

The Stream at Brème shows a spot near Ornans where Courbet was born and spent his youth, and to which he returned many times. In this canvas the vigorous palette and broken brushstrokes are particularly striking. Courbet was fascinated by the changing effects of the light as it fell on the various elements within the landscape. He aimed to capture the sensation of continual and fleeting movement. This dark location allows for strong contrasts between areas of darkness and brightness, reproducing the effect of light as it filters through the dense thicket of trees.

The intense green which dominates the painting, like a huge unformed mass, grows lighter in the upper part with the patch of bright and luminous blue sky, and in the centre of the composition through which flows the little stream. Overall, the painting is a lively and dynamic composition in which we can almost hear the splash of the water, the rustle of the leaves and the movement of the clouds.

Gustave Moreau

PARIS, 1826 – 1898

As we have already noted with Böcklin, Realism and Impressionism were not the only currents in art at the end of the 19th century; a number of artists were also producing a very different kind of painting, one which referred to the imaginary and thereby returned to some extent to the subjectivism and interior vision of the Romantics. These artists have been generically described as Symbolists, as their works held hidden meanings, referring to a dreamlike and subconscious world. Their work was to be a major influence on the Surrealists.

Moreau's art was inspired by biblical and mythological subjects, as in the present case. Entitled *The Voices*, the image shows Hesiod, the Greek author of the *Theogony* and *Works and Days*, with his muse. The subject is a central one in Moreau's œuvre and in the year he produced this version he went on to make at least five more. Hesiod can be identifed from his shepherd's clothing with his crook and gaiters. The muse leans on him, suspended in the air and bearing a crown of laurel. The title of the work refers to inspiration, here personified by the muse.

"We know how to tell many lies as if they were truths, but, when we also want to, we also know how to tell the truth." Words with which the Muses made themselves known to Hesiod

The composition and setting create an unreal atmosphere with little definition, containing classical echoes in the temple at the top of the composition. The decorative emphasis and the palette are both typical of Moreau, whose images have an ornamental impetus which links them to Modernism; the two figures are executed as if they comprised a piece of goldsmith's work. The surfaces are created from playful undulating forms and superimposed touches of watercolour. Secondary elements such as the adornments on the muse's dress and the clasp on Hesiod's breast acquire relevance within the context of the work. The colour also contributes to this decorative feel, based on contrasting ranges of blues and sepias, mixed with greens, reds and whites. Combined together, all these elements transport the viewer to an imaginary world in which fantasy prevails.

The Voices, 1867
Watercolour and gouache on paper,
22 x 11.5 cm

Jean-Baptiste Camille Corot

PARIS, 1796 – 1875

C. COROT ·

Promenade in the
Parc des Lions at
Port-Marly, 1872
Oil on canvas,
78 x 65 cm

Corot was one of the principal representatives of French Realist land-
scape painting, and a precursor of Impressionism. He was already 76
when he completed this painting, which synthesizes the most important
features of his art. His work was outstanding in its time, and in its de-
sire to depict nature truthfully was an important forerunner of what was
to come.

For Corot it was not possible to paint from memory in the studio,
as in order to paint nature in all its reality the artist had to capture the
effects of natural light, and above all the constant vibration of the land-
scape. For this reason he introduced the concept of empirical observa-
tion and its representation on the canvas, leaving behind preconceived
notions and conventions regarding the depiction of landscape.

To achieve his ends, Corot developed a fractured technique of im-
pasto brushstrokes, in which the forms are created by the juxtaposition
of touches of paint in different colours. Corot copied what he saw before
his eyes: the glint of the leaves as the sun filtered through them, their
fluttering in the breeze, and the constantly changing effects of light.

In the present painting Corot conveys a misty atmosphere, evoked
through sketchy forms which, while they do not permit a detailed de-
scription of each individual element, allow an overall vision of the scene
at one glance. The figures are thereby fully integrated into their natural
surroundings and are neither more nor less important than it, treated
with the same emphasis as the poplar trees with their silvery trunks.
At the time when Corot painted this work, artists such as Morisot and
Pissarro, who were considered his pupils, were already developing a
fully Impressionist language which without doubt took Corot's Realism
as its starting point.

*Woman with a Parasol
in a Garden*, 1873
Oil on canvas,
54.5 x 65 cm

Pierre-Auguste Renoir

LIMOGES, 1841 – CAGNES, 1920

Renoir was one of the leading members of the Impressionist group,
which was mainly active in the 1870s and early 1880s. The Impressionist
artists, Monet, Morisot, Pissarro, Degas and Sisley, set up the famous
Salon des Refusés in protest at the repeated rejection of their work by
the official Paris Salons. Their painting was essentially the beginning
of modern art as, following the example of Manet, they concentrated
on purely pictorial aspects and were less interested in subject matter.
Taking this approach, their painting was an investigation into the depic-
tion of the effects of light on the colour of forms, and attempted to tran-
scribe objectively the same impression and immediacy which could
be obtained from first-hand observation.

*"One morning one
of us had run out
of black; and that
was the birth of
Impressionism."*
P.-A. RENOIR

This painting dates from a period when Renoir, together with
Monet, was formulating a new pictorial language which would come
to be seen as typically Impressionist. Both artists frequently travelled to
the outskirts of Paris, to places such as Argenteuil and La Grenouillère,
in order to paint out of doors. They used a very free and impastoed
brushstroke, and through small dabs of pure, juxtaposed colour, they
created forms and reproduced the effects of light on bodies and objects.

Renoir here depicts a garden from a high viewpoint (the sky is just
detectable at the upper edge of the canvas), which allows him to paint
a broad foreground filled with wild flowers, creating a vaporous surface
with softened outlines. The landscape which he presents to us is almost
abstract; it is given a sense of depth and scale by the two figures in the
middle-ground, who are treated in a similarly schematic way as the rest
of the painting. Renoir's art would subsequently concentrate more on
figure painting, particularly of women in interiors showing the pastimes
and occupations of contemporary life.

*Crysanthemums
in a Vase*, 1875
Oil on canvas,
42.5 x 39.5 cm

Henri Fantin-Latour

GRENOBLE, 1836 – BURÉ, ORNE, 1904

Fantin-Latour was trained in Paris, where he lived and worked for most of his career. He spent a period as a pupil of Courbet, an experience which left an important mark on his work. Nonetheless, his painting does not fall within a particular style. His portraits and still lifes are decidedly Realist, whereas his mythological paintings are closer to academic painting, but with hints of Symbolism.

It appears that Fantin-Latour was never satisfied with his still lifes of flowers, which he produced for commercial reasons. He was represented by an English agent, Ruth Edwards, who every autumn would collect all the paintings he had completed during the summer, in order to sell them in England, where his still lifes and flower paintings were greatly appreciated for their detail and precision "in the Dutch manner of the 17th century".

Fantin-Latour himself confessed to a fear of becoming a "manufacturer" of still lifes. This remark is symptomatic of the conception which artists had of themselves in the 19th century and the change in relation between themselves and their clients. While in earlier centuries, artists painted on commission and following the instruction of their clients, by the late 19th century a work of art of quality presupposed initial rejection. Acquiescing to the taste of the client thus became synonymous with lesser painting of little artistic merit.

Nonetheless, Fantin-Latour produced a type of still life and flower piece in which, alongside a meticulous description of the individual elements, painted almost petal by petal, he created compositions of great volume and dynamism through his use of light. As we can see with this vase of crysanthemums, a theatrical light falling from the left highlights the yellows and reds of the blooms against the totally black background and the shadows of the vase itself, as if they were almost suspended in a void.

"They can say what they like, the still life is a good thing."
FANTIN-LATOUR
to WHISTLER, 1862

Berthe Morisot

BOUGES, 1841 – PARIS, 1895

Berthe Morisot

The Cheval-Glass,
1877–1879
Oil on canvas,
65 x 54 cm

Berthe Morisot was the first woman to join the Impressionists (she would be followed later by Mary Cassatt). Her early training was with Corot, but she then met and studied with Manet, whose brother Eugène she married in 1874. Morisot mainly painted portraits and domestic interiors; she brought an intimate vision to scenes of modern life, in the manner of Manet and similar to other members of the Impressionist group such as Degas and Renoir. Her style was principally influenced by Manet then, following his death, by Renoir, in particular his paintings of women, as in the present work.

Morisot has depicted a young woman getting dressed in her dressing-room. The sense of a fleeting moment, characteristic of Impressionist art, is evident in the woman's pose as she adjusts her corset, totally absorbed in what she is doing. The fragmentary vision of the room, sliced off on the right and thereby leaving part of the sofa out of the picture, suggests a reality existing out of the canvas, and evokes a scene taken directly from life and not subject to compositional conventions.

The painting nevertheless has a balanced structure, achieved mainly through the colour combinations. The horizontal red strip of the carpet is balanced (in the fashion of Manet) by the whites in the rest of the canvas. The horizontality created by the carpet and the sofa balance the verticality of the figure and the mirror. A fractured handling very characteristic of Impressionist painting creates the forms from small brushstrokes and produces an intimate atmosphere bathed in a warm golden light.

Edgar Degas

PARIS, 1834–1917

Degas

Edgar Degas is one of the great innovators of late 19th- and early 20th-century painting. He was connected with the Impressionist group and exhibited in a number of their independent salons held in Paris. Unlike the other Impressionists, who even while mounting their own unofficial exhibitions were trying in vain to get their works accepted into the Salon, so as to get onto the commercial circuit and make some money from their art, Degas – who lived on a private income from his family – never wanted to exhibit at the Salon.

His connections and friendships with Impressionists painters such as Monet and Pissarro had less to do with a common style than with a shared belief in a reinvention of art. Degas was not as interested in *plein air* painting and the effects of light on the retina, but like Monet and Pissarro he was a painter of modern life, depicting the world around him in a spontaneous manner which set out to convey the idea that his works were a fragment of a larger whole. His subjects were cafés, cabarets, theatres, the opera, women at work or in the street and many other scenes of modern life, including his series on horses and, above all, ballet dancers.

The two works reproduced here both employ a viewpoint typical of the artist and taken from the world of photography (which was in its infancy during this period and which contributed a great deal to Impressionist painting). The figures are sliced by the edge of the canvas – as on the left in the case of the *Swaying Dancer* – or are abruptly interrupted by the furniture (as in *At the Milliner's*), while the viewpoint is angled as if from one side. All this creates the sensation of spontaneity and dynamism, even though Degas' works were in fact thoroughly thought-out and were preceded by a

large number of sketches and preliminary studies. Degas was a great colourist and in common with the Impressionists used a wide variety of techniques, dedicating himself in his last years to pastels, which he applied with a rapid and free stroke with great verve and dazzling colouring.

At the Milliner's,
c. 1883
Pastel on paper,
75.9 x 84.4 cm

"In art, nothing should look like chance, not even movement."
EDGAR DEGAS

The Thaw at Vétheuil,
1881
Oil on canvas,
60 x 100 cm

Claude Monet

PARIS, 1840 – GIVERNY, 1926

Monet was perhaps the most important of the Impressionists and the one who took his investigations into light and its effects on the landscape the furthest. He was primarily a landscapist and painted almost entirely out of doors. His early works include human figures, but these gradually disappeared as he focused solely on the natural world. The other Impressionist painters – Renoir, Pissarro, Sisley and Morisot – considered Monet to be the leader of the group. Following the repeated rejection of their work by the Paris Salon, the official annual exhibition of the most eminent examples of Academic painting, these artists organized their own Salon des Refusés, which they mounted almost every year from 1874 to 1886. Monet and Renoir made frequent trips to the outskirts of Paris, where they painted from life, developing the quintessentially Impressionist technique of fragmented brushstrokes of pure colour. Monet's painting *Impression, soleil levant*, shown at the group's independent exhibition of 1874, was taken up by critics of the new style, and the term Impressionist was coined as a perjorative one to describe the group.

Monet's interest in light and in capturing the impression of a fleeting moment led him to execute numerous versions of the same landscape or view, painted at different times of the day and in different seasons. The surroundings of Vétheuil, a village near Paris on the banks of the Seine, were a recurrent motif in his art. In the present case he has depicted the river thawing after a harsh winter of snow and ice which caused considerable damage. Monet conceived of painting as an investigation into the visual values of nature, constituting a multitude of reflections and surfaces in movement, while the light creates a fragmented structure. Shapes and outlines are broken up and the whole scene is bathed in a harmony of grey and silver tones, transmitting the feel of a cold and uninviting winter's day. Water and reflections on water were the theme of many of Monet's paintings, and his investigations into this subject would culminate in his series of *Waterlilies*, which this work prefigures.

"For me, the subject is of secondary importance: I want to convey what is alive between me and the subject."
CLAUDE MONET

Édouard Manet

PARIS, 1832 – 1883

"[Manet] was greater than we thought."
EDGAR DEGAS, 1883

Manet was not an Impressionist artist in the strict sense of the word, although he was closely linked to the movement and subscribed to many of its artistic theories. For the slightly younger artists of the group such as Monet, Morisot and Pissarro, he was the founder of the modern movement. His art presupposed a new vision of reality, with its origins in the tradition of Courbet but with a much more radical subject matter. His works focus on the reality of contemporary life, demystifying classical themes, as in the case of his *Déjeuner sur l'herbe* and *Olympia*, with their naked figures.

For Manet, what was important was painting itself and its visual potential; the subject was simply an excuse for pictorial experimentation. At the same time, and in the same way as the Impressionists, his subjects were inspired by contemporary life and are a reflection of modern life as he saw it around him, both in parks and middle-class interiors and in the brothels and cabarets of Bohemia. Manet's gaze was cool and analytical and he omitted sentimental or moralizing aspects in order to concentrate on the visual and aesthetic possibilities in his approach to painting.

While his early works use a relatively detailed technique with an emphasis on line and firm contours, from the 1870s Manet's painting reflects the influence of Impressionism which was now reaching its height, and whose exponents had once viewed him as their own teacher. *Woman in a Riding Habit* illustrates this development in its very loose handling and its use of pure colours applied in clearly visible touches of paint. However, it is important to remember that this painting, which Manet started eight years before he died, is unfinished, and thus the sketchy effect is due to the stage of completion which it had reached and was not intended as the final result. Despite this, we can see Manet's stylistic development in the loose handling of the face and the use of pure colours. There are elements, too, which are fundamental to Manet's unique style, such as the juxtaposition of large chromatic masses which alternate light colours with dark ones.

Woman in a Riding Habit, full-face,
c. 1882
Oil on canvas,
73 x 52 cm

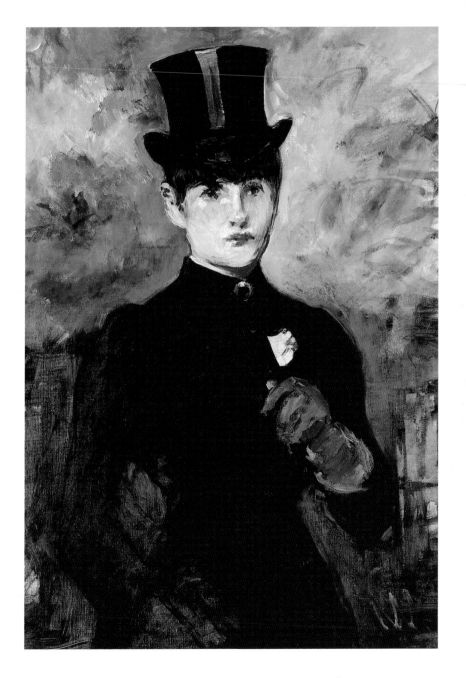

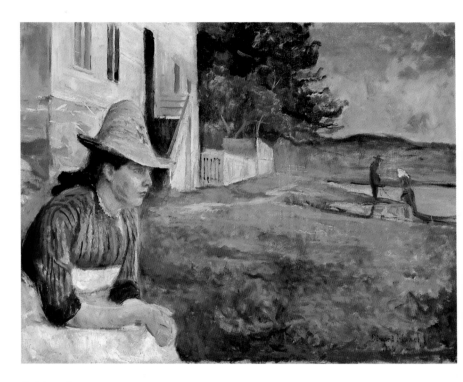

Dusk. Laura, the
Artist's Sister, 1888
Oil on canvas,
75 x 100.5 cm

Edvard Munch

HEDMARK, NORWAY, 1863 – OSLO, 1944

E.Munch)

Edvard Munch was a forerunner of Expressionism. His mature work moved away from the prevailing naturalism, engendered in Europe by Impressionism, towards a style partly derived from van Gogh and Gauguin. He combined the use of a brilliant chromatic palette and flat colours with a thick brushstroke, through which he created undulating rhythms which structured the composition. In common with van Gogh, some of Munch's paintings use an exaggerated perspective with a forced vanishing point, resulting in a vertiginous feeling.

For Munch, painting was a means of expressing the inner world combined, in his own case, with a rather hypochondriacal and nervous temperament which produced the fears and nightmares that people his paintings. However, in his more tranquil works his style has a decorative aspect based on curving lines and forms created from thick black strokes which trace arabesques across the canvas. He was a precipitating factor in the formation of the Berlin Secession, which would become a vehicle for Jugendstil, the German variant of the Art Nouveau which spread across Europe at the end of the 19th century.

The painting in the Thyssen-Bornemisza Museum belongs to Munch's early period. Having studied in Oslo, his trips to Paris from 1885 were decisive in the development of his style. The Impressionist painting he saw there at first hand was to influence his early work, as we can see in *Dusk. Laura, the Artist's Sister*, although in the present case this influence is more technical than conceptual. Thus Munch concentrates on expressing his sister's state of mind. The setting also has a symbolic character and reflects the sitter's mood. Displaced to the far left edge of the canvas, the huge space which opens around her refers to her solitude and isolation. Like her brother, Munch's sister also suffered frequent nervous attacks and was eventually confined to a psychiatric institution.

"I painted the lines and colours that affected my inner eye. I painted from memory without adding anything, without the details that I no longer saw in front of me. This is the reason for the simplicity of the paintings, their obvious emptiness. I painted the impressions of my childhood, the dull colours of a forgotten day."
EDVARD MUNCH

Vincent van Gogh

GROOT-ZUNDER, HOLLAND, 1853 — AUVERS-SUR-OISE, 1890

Vincent

Van Gogh's art was intimately linked with his own life and personality. His life was a troubled one, mainly due to his intensely-felt calling as an artist, which compelled him to dedicate his life to painting even though his style was never understood or appreciated by his contemporaries. He was isolated from the world and society, only maintaining contact with his brother Theo, who assisted him financially. The two brothers corresponded throughout their lives and their letters now provide one of the most important records of van Gogh's ideas. Mentally unstable, he was interned in psychiatric centres on various occasions, and it was during his stay in one such in 1890 that he shot himself, dying a few days later.

Van Gogh's troubled mind is reflected in his art, which had a new aim and one which was at variance with that of the Impressionists. While the latter aimed for an objective vision of nature, for van Gogh

Stevedores in Arles,
1888
Oil on canvas,
54 x 65 cm

nature was the projection of interior states of mind. Thus he interpreted reality according to his state of mind and discovered a new, expressive value in colour. He used colour to emphasize the essential and in an arbitrary way to express himself with greater force.

Les Vessenots in Auvers, 1890
Oil on canvas,
55 x 65 cm

We can appreciate these aspects of his work in the two works reproduced here. The depiction of sunset entitled *Stevedores in Arles* is a composition which is practically reduced to two colours: yellow and black. Van Gogh worked quickly and precisely, projecting his passionate attitude to painting through the thick and loaded brushstroke. This highly schematic work speaks of colour contrasts, of the reflections in the water, and of an abstract concept of the beauty of painting. *Les Vessenots in Auvers* was executed in the last months of his life. Alongside the simplicity of the forms typical of van Gogh, we find a strident use of colour and a thick brushstroke which establish the rhythm of the composition.

The Red-head in a
white Blouse, 1889
Oil on canvas,
59.5 x 48.2 cm

▶ *Portrait of Gaston*
Bonnefoy, 1891
Oil on cardboard,
71 x 37 cm

Henri de Toulouse-Lautrec

ALBI, 1864–1901

Toulouse-Lautrec has much in common with Degas, who had a great influence on his art. Like Degas, he was a painter of modern life, closely linked to Impressionism both in his motifs and in his striving for new forms of visual expression, freer and with an aesthetic closer to the reality of everyday life. More than any other artist, Toulouse-Lautrec is identified with bohemian Paris of the late 19th century. His works depict the places he frequented, such as the cabarets, theatres and cafés, the brothels and the world of medicine and hospitals.

"To think I would
never have painted if
my legs had been just
a little longer!"
TOULOUSE-LAUTREC

His style, which is basically that of a draughtsman, is well repre-sented in his portrait of *Gaston Bonnefoy*. Oil is used here almost like watercolour, applied very diluted and in fine, firm strokes which give the impression of a drawing. The sitter, whose face is depicted in some detail, is represented using thick lines to outline the forms in a manner highly characteristic of Lautrec's style. Bonnefoy was a friend of Lautrec's, and the artist probably painted him on one of his visits to Lautrec's studio, either to see his paintings or before the two men set out for the theatre. Lautrec often painted his friends and other figures of his imme-diate social circle. One such person was the young woman depicted in *The Red-head in a white Blouse*. This working girl from Montmartre fascinated the artist with her red hair and white skin, and he painted her many times. In this version she is repre-sented with her head down, her eyes covered by her hair and her face in shadow. The artist is interested not just in her features but in the purely visual and aesthetic potential of the image: light falls on the neck and blouse from behind, accentuating the con-trast between the cold tones of this area and the warmth of the red hair. Indeed, its painterly treat-ment makes the work unusual for Lautrec.

Édouard Vuillard

CUISEAUX, 1868 – LA BAULE, 1940

Vuillard was a member of the Nabis, a group of artists active in the last decade of the 19th century, and was particularly close to Bonnard, who was a great friend. These artists advocated the use of flat colours in a similar way to Gauguin. They were against the realism and illusionism of the Impressionists and wished to show that, above all, a picture is a flat surface on which the artist juxtaposes blocks of colour and organizes forms. Vuillard also worked as an illustrator and his works have a quite pronounced decorative feel.

E Vuillard

As we can see in this small pastel entitled *The Singer* (it has also been entitled *The Actress taking her Bow*), Vuillard's conceptual intention is to reproduce three-dimensionality in a markedly two-dimensional way, creating curving, linear forms and using harmonious colour combinations. His style is characterized by a great delicacy and intimate atmosphere. The composition and forms are extremely simplified and the image is resolved from flat planes of colour and a sinuous rhythm created through a firm, dark line.

Vuillard was also a painter of modern life and of the world of the stage, in particular the theatre, in which he was closely involved. The contrasts of light created by the footlights and the shadows on stage were for him a source of inspiration from which he derived dramatic visual effects. The close-up and fragmented view of the figure brings it near to the Impressionist style, particularly that of Degas, but on the other hand Vuillard's images lack the Impressionists' sense of reality. In this work we can appreciate how his interest in the purely visual potential of colour and form is more important than a realistic representation. His is a subjective vision of reality in which the visual elements acquire an autonomous expressive value independent of the subject matter.

"Vuillard ... produces with the greatest ease the most delicate things one can imagine, and always with unexpected things of exquisite forms."
MAURICE DENIS, c. 1891

The Singer, 1891
Pastel, 28 x 20 cm

Camille Pissarro

SANTO TOMÁS, ANTILLES, 1830 – PARIS, 1903

C Pissarro

*Rue Saint-Honoré.
Effect of Rain*, 1897
Oil on canvas,
81 x 65 cm

Following on from Courbet's Realism, Impressionist art investigated in depth the representation of reality, in particular landscape and city life, depicting subjects which had previously been considered trivial and unimportant, such as cafés, streets, strolls in the country, etc. The Impressionists aimed to present a direct vision of the reality of modern life and therefore painted directly from life in front of the subject, as their forerunners the Barbizon painters had done.

Born in the French Antilles, Pissarro moved to Paris in 1855. There he met Corot, whose influence on his early work is obvious. He attended the Academie Suisse, where he met Monet and Cézanne. As a result of his contact with Monet and his colleagues, Pissarro's style evolved towards Impressionism. In his works, as in those of the other Impressionists, light was the essential element. He strove to capture his subjects in an objective way, just as they fell on his retina, taking into account the fact that objects change their colour depending on the light falling on them. This light itself varies according to the time of day and the weather conditions, and all these factors together play a part in determining the colours and more generally the appearance of objects.

It was this recognition that, in 1893, inspired Pissarro to begin a series of urban views of Paris under different conditions – morning sun, mist and rain (as here) –as seen from his hotel room. In these paintings Pissarro explores the chromatic and volumetric variations which light and weather produce on objects and atmosphere. The artist uses a uniform light which is typical of his work, and envelops the scene in a silvery tonality appropriate to a moderately cloudy day. The streets are wet with rain and the air is filled with dampness.

Within the Impressionist group Pissarro was the artist who most actively propagated the new style and theories, and exercised a potent influence upon the art of the Post-Impressionists Gauguin, Cézanne and van Gogh.

Pierre Bonnard

FONTENAY-AUX-ROSES, 1867 – CANNET, 1947

Bonnard, in common with all the other important artists of his day, worked in Paris, centre of the artistic avant-garde and the social and cultural capital of Europe at the turn of the century. In the 1890s, together with Vuillard and other artists such as Ker-Xavier Roussel, Paul Sérusier and Maurice Denis, he formed the group known as the Nabis, which followed Gauguin's teachings. These artists rejected the realism of Impressionism and opted for a type of painting which focused on the purely visual values of colour and form. Like his fellow artists, Bonnard's work at this period has a high decorative content, which he also deployed in new art forms such as magazine illustration, stage sets and puppet design.

Bonnard

From the beginning of the 20th century, Bonnard's art evolved towards a more personal style in which he revived some formal aspects of the Impressionist technique. This style was to bring him great success for the rest of his career. The *Portrait of Misia Godebska* dates from this period; in it we find echoes of Renoir's painting, both in the fractured brushstrokes and in the gauzy atmosphere as well as a certain Rococo air of refined elegance and decorativism.

Misia Godebska was a leading figure in Parisian high society and the centre of a circle of artists and intellectuals. Her elegant and luxurious existence is reflected in the interior and in the pose and clothes in which she is portrayed. She was married several times, first to Thadée Natanson, publisher of the famous magazine *La Revue Blanche* (to which Bonnard contributed as an illustrator). At the time of this portrait she was married to Alfred Edwards, another wealthy publisher. Later she would marry the painter Joseph María Sert, whose name is well-known in the annals of Spanish art history.

"A painting is a collection of dabs of colour which combine themselves into a plane and finally compose the object ... over which the gaze floats smoothly."
PIERRE BONNARD

Portrait of Misia Godebska, 1908
Oil on canvas,
145 x 114 cm

The 20th Century

Portrait of a Farmer,
1901–1906
Oil on canvas,
65 x 54 cm

Paul Cézanne

AIX-EN-PROVENCE, 1839–1906

Paul Cézanne is considered to be the precursor of Cubism and of much of the avant-garde art of the early 20th century. His work developed from Impressionist beginnings to an art in which colour creates forms and volumes. He thereby moved away from a Luminist approach to develop a theory of construction in which the elements depicted regain the volume and three-dimensionality discarded by Impressionism.

Cézanne was interested in nature as the ordered construction of geometrical volumes. He himself defined his idea of painting with the famous phrase that "everything is reduced to the sphere, the circle and the cone". For Cézanne, colour produced these forms. His art was an intellectual process in which he synthesized the elements which he found in nature in order to present their quintessential form and idea rather than their individual characteristics. His painting was therefore a rational rather than an intuitive or subjective process.

The two works reproduced here belong to his last period, when his style and its underlying precepts were firmly consolidated. Cézanne considered *Portrait of a Farmer* to be one of his most important works, and one in which he worked out his pictorial code. During his last years, living in the countryside near Aix, he worked on portraits of his gardener and of local people. These works were not intended to be detailed representations of the individual but rather an image of man integrated into his environment. The image, constructed from fragments of juxtaposed colour, unites through the means of their identical treatment the figure and the landscape. Although the face is undefined, some firm strokes succeed in assigning great monumentality to the seated figure. Cézanne avoided the chance or the accidental in order to capture the essential elements of the image which he had before him, reduced to a surface which is ordered on the basis of colour harmonies.

"*The strong sensation of nature – and with me certainly it is keen – is the necessary basis of any conception of art, and on it repose the grandeur and beauty of the work to be. The knowledge of the means of expressing our emotion is no less essential, and can only be acquired by very long experience.*"
PAUL CÉZANNE

PAGES 544/545:
Detail of illustration
page 563

PAGES 546/547:
Detail of illustration
page 743

Bottle, Carafe, Jug and Lemons, 1902–1906
Pencil and watercolour
on paper, 44 x 58 cm

The yellow Flowers,
1902
Oil on canvas,
46 x 54.5 cm

Henri Matisse

LE CATEAU-CAMBRÉSIS, 1869 – NICE, 1954

Henri Matisse

Matisse is the most important representative of Fauvism, a movement which traces its origins to the Paris Salon d'Automne of 1905 and the exhibition, in the same room, of works by Matisse, Derain, Vlaminck and a number of others. Their paintings shared an absolute mastery of colour on a flat surface, taking the art of Gauguin and van Gogh as their starting point, but proceeding to more radical conclusions. From Gauguin they took the application of colour in an arbitrary rather than realistic sense, applying it in large flat masses, while from van Gogh they deduced an intuitive and subjective expression of reality. The result was a painting of great brilliance and forcefulness, which led the art critic Louis Vauxcelles to dub them *les fauves* (the wild beasts), the name by which they were known from that point on.

Although the movement was officially identified in 1905, its adherents had been experimenting with a form of painting constructed on the basis of pure colour contrasts for a number of years, as *The yellow Flowers* indicates. Before he arrived at the style which would become his own, Matisse worked in various different idioms following his training in Gustave Moreau's studio. For a while he was close to the Nabis, then he followed an approach closer to Seurat's Divisionism. Dissatisfied with these results, he continued to experiment and by the end of the century his work was focused on colour.

Nonetheless, in the first four years of the 20th century Matisse's work passed through a dark period, of which the present painting is a good example. The highly simplified composition, with its schematic forms, focuses our attention on the patch of yellow. The rest of the painting is organized on the basis of large patches of juxtaposed, flat colours. Starting from the same principals, Matisse's painting would develop over the next few years towards a more cleanly defined style, in which the earthy tones are replaced by pure and luminous colours.

"I never left the object. The object is not interesting in itself. It is the environment that creates the object. Thus I have worked all my life before the same objects, which have constantly given me the force of reality, by guiding my thoughts to everything that these objects had gone through for me and with me."
HENRI MATISSE

Mikhail Larionov

TIRASPOL, BESSARABIA, 1881 – FONTENAY-AUX-ROSES, 1964

Mikhail Larionov was one of the most important painters of the Russian avant-garde before World War I. Together with Natalia Goncharova, with whom he was closely connected throughout his life, he played an active role in the modernization of Russian art and in its international promotion. Together with other artists and intellectuals he created a movement based around the magazine *The Golden Fleece*, which brought the most advanced avant-garde European art to Russia, organizing exhibitions of French artists in the last decades of the century, including the work of the Impressionists, Post-Impressionists and Nabis.

This painting dates from Larionov's earliest period and shows certain characteristics which connect it with Post-Impressionism, and also with the approach which future Fauves such as Matisse and Derain were developing at that time. The artist uses colour in an arbitrary way, dictated by a compositional harmony which prevails over the whole canvas. The colours are arranged across the surface to create strong contrasts of pure colours, emphasizing the two-dimensional character of the picture plane. The composition is realised in a schematic manner, with the forms of the nude described through a firm and simple line which defines the outlines and lends the whole a primitive air that was to remain characteristic of Larionov's work.

Larionov frequently travelled to Paris as the representative of the younger generation of Russian painters. In France he came into direct contact with avant-garde art as it was developing in the early decades of the 20th century. From 1910 this led him towards an abstract mode of painting, Cubist in tendency, which he termed Rayonism and which was to be one of the most important movements in avant-garde Russian art.

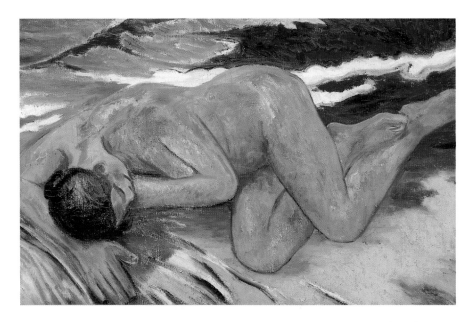

Blue Nude, 1903
Oil on canvas,
73 x 116 cm

Waterloo Bridge,
1905
Oil on canvas,
80.5 x 101 cm

André Derain

CHATOU, 1880 – GARCHES, 1954

Together with Matisse and Vlaminck, Derain was one of the originators
of Fauvism, a movement which crystallized in 1905 and whose signifi-
cance is discussed in the entry on Matisse. Derain dedicated himself
to painting from a very young age, studying with a number of different
artists. In 1898 he met Matisse in an academy of painting in Paris, and
the following year met Vlaminck who became a close friend and col-
league.

Waterloo Bridge is one of a series of canvases which Derain paint-
ed in London between 1905 and 1906. We can see how the artist
schematizes the colour variations in the landscape, reducing them all to
their pure values: the yellow of the sun and its reflection on the water,
the green of the sky and also of the water, the blue with purple hints for
the buildings and the backlit bridge. The result is a chromatic explosion,
using a brilliant and aggressive palette which combines primary and
complementary colours. Derain applies his paint with short, juxtaposed
and vigorous strokes clearly derived from van Gogh and Neo-Impres-
sionists such as Signac. He uses them to organize space and depth,
as well as the fall of light and compositional effects. Brushstroke and
colour are the only resources which Derain deploys in the creation of
his painting, and they become its true subject. In contrast to the realism
and illusionism of the Impressionists, the Fauve artists worked on a
subjective interpretation of nature. This involved an arbitrary use of
colour in order to achieve the greatest visual effect.

*"Do you know a
painter who has
invented a colour
different from those
that compose the
solar spectrum?"*
ANDRÉ DERAIN

While Derain's best-known paintings correspond to his Fauve
period, this was in fact an early stage in his artistic development. His
long career also passed through a Cubist phase (1907–1910), and a
classicist phase in the 1920s – similar to Picasso – and would evolve
towards a detailed realism in the 1930s and 1940s. In the closing years
of his life he returned to a certain monochrome primitivism.

Pablo Picasso

MALAGA, 1881 – MOUGINS, 1973

Pablo Picasso is one of the greatest painters of all time. His art shows an enormous mastery of technique combined with great sensitivity and creative strength. Trained in Barcelona, his early works were in the prevailing fin-de-siècle style. On moving to Paris in 1901 he started to absorb influences from late Impressionist and Post-Impressionist art. In this context he became familiar with Cézanne's work, which would be extremely important for his own search for a unique language based on the relation between form, volume and space. At this period African art (which had started to become known in Europe in the early 20th century) was also a very important influence.

The result of this period was one of the artist's key works, *The Demoiselles d'Avignon*, painted in 1907. His *Head*, reproduced here, was painted during the same period and is closely related to it. Picasso was working on structuring bodies and their surrounding space into geometrical planes in which the traditional relationship of figure to background was being discarded. 1907 also saw the meeting between Picasso and Georges Braque, which would result in a close collaboration between the two men and the birth of Cubism.

During 1908 and 1909 Picasso closely studied Cézanne's work, producing a series of still lifes such as *Still life with Glass and Fruit*. The painting is characterized by order and geometry as well as by a narrow chromatic range. The objects have a solid presence, firmly placed on the table top and giving the impression of compact volumes. Rather than a still life, what Picasso has produced is a play of geometric volumes, reducing the elements to their essential forms.

Around 1910 the collaboration between Picasso and Braque crystallized into a Cubist language of form called Analytical Cubism, which we see here in *Man with a Clarinet*. These works are the result of an intellectual process whose aim was to achieve a representation of reality just as we perceive it. Our perception of that reality, which is dynamic and constantly in flux, is also conditioned by our relation to it in space (viewpoint) and time. Thus our overall vision of reality, or our recollec-

"*There is no abstract art. You must always start with something. Afterwards you can remove all trace of reality. There's no danger then, anyway, because the idea of the object will have left an indelible mark.*"
PABLO PICASSO

Man with a Clarinet,
1911/12
Oil on canvas,
106 x 69 cm

Head, 1906/07
Gouache on brown
paper, 31 x 24.5 cm

tion of it, is formed from a multitude of different views seen from different angles and at different moments in time. The result when transcribed onto canvas is a fragmented or faceted view of reality. The forms break up into multiple planes which mingle together, creating a fusion between figure and background which had already been hinted at in earlier paintings, but which now lead to its ultimate consequences, to the point where it almost meets up with abstraction. The tendency to

▶ *Still Life with Glass
and Fruit*, 1908
Oil on canvas,
27 x 21.6 cm

Bullfight, 1934
Oil on canvas,
54 x 73 cm

monochrome is also characteristic of this period, in which the construc-
tive elements are paramount. Picasso and Braque's collaboration would
result in very similar works, as we can see if we compare this *Man with
a Clarinet* with Braque's *Woman with a Mandolin*, discussed in the next
entry.

Some years later, around 1913–1914, Picasso evolved towards a
different style known as Synthetic Cubism, represented in the Thyssen-
Bornemisza Collection by *Head of a Man*. During this period Picasso
was using collage (involving cut-out paper, cloth and other elements
attached to the canvas), and as a result his works manifested a greater
breadth and clarity in their structures. The planes become larger, the
colours lighter and the composition clearer and more balanced. From
the year 1914, marked by the start of World War I, Picasso and Braque
separated and Picasso began to return towards figuration.

With the outbreak of World War I, the period of avant-garde experi-
mentation came to an end. Without abandoning the Cubist language
which had underpinned his earlier work, Picasso took part in the 1920s

◄ *Head of a Man*,
1913/14
Oil on canvas,
65 x 46 cm

*Harlequin with
a Mirror*, 1923
Oil on canvas,
100 x 81 cm

in what has been called a "return to order". Artists such as Otto Dix and Christian Schad in Germany, and Derain, Braque, Léger and Picasso himself in France, were inspired by classical art from Antiquity to the Renaissance and Baroque. The result was the recovery of an internal rational order and the deployment of figuration within a modernist context.

Harlequin with a Mirror reveals a purist interpretation of reality, in which the barely defined space is identified with its essential elements, obeying a formal harmony which governs the execution of the whole, from the treatment of the volumes to the light and colour. The conception of the figure combines the monumentality and self-absorption of antique art with the iconography of the *commedia dell'arte* (the popular theatre which developed in Italy in the 15th century, with its cast of familiar stereotypes such as the lovers, the scoundrel, the captain etc., whose universal value has lived on in the figures of Harlequin, Columbine, Pierrot and Polichinelle). *Harlequin with a Mirror* is thus a type of synthesized personification of the Mediterranean culture which was so fundamental to Picasso's life and work.

In a very different style but culturally related is the *Bullfight*, a recurring subject in Picasso's work throughout his career, but one to which he particularly turned in the period between the end of the 1920s and the completion of *Guernica* in 1937. The subjects of violence and death are at the centre of these dramatic compositions, which are intimately linked to the theme of love – also violent – which Picasso explored through his series of drawings and prints on the subject of the Minotaur and the Maiden. Picasso's profound interpretation of the world of the bullfight conceived of the subject as a parable of love and death.

"The different styles I have been using in my art must not be seen as an evolution, or as steps towards an unknown ideal of painting. Everything I have ever made was made for the present and with the hope that it will remain in the present ... Whenever I have wanted to say something, I have said it in such a way as I believed I had to."
PABLO PICASSO

Georges Braque

ARGENTEUIL, 1882 – PARIS, 1963

Georges Braque and Pablo Picasso were the inventors of the new pictorial language of Cubism, one of the leading movements of the experimental avant-garde. From 1909 the two artists worked together, even sharing the same studio, in their quest for a new way of representing reality through painting.

With *The Park at Carrières-Saint-Dénis* we see one of the earliest efforts in the Cubist idiom, which takes its starting point from Cézanne's concept of space and volume. Cézanne believed that, in order to represent reality the artist had to grasp its essential elements, namely volume and colour, with volume reduced to three basic geometrical forms: the cylinder, the cone and the circle. In the present work, Braque simplifies reality, reducing it to a series of geometric planes, differentiated by

The Park at Carrières-Saint-Dénis, 1908/09
Oil on canvas,
40.6 x 45.3 cm

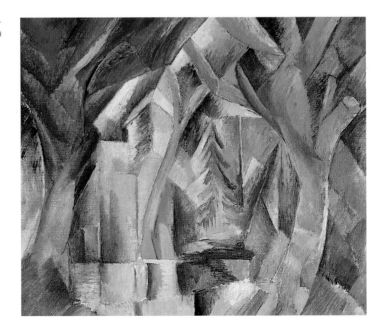

▸ *Woman with a Mandolin,* 1910
Oil on canvas,
80.5 x 54 cm

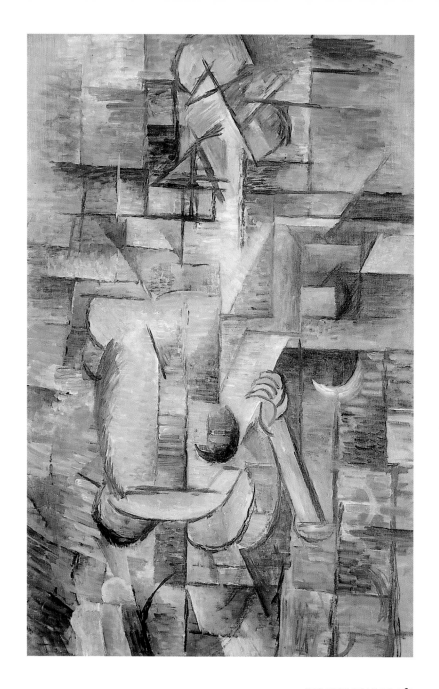

colour, in which the relationships between space and depth are distorted and the figure (or trees) mixed in with the background. He gives equal importance to the elements in the foreground and those in the most distant background, painting both in the same way.

But Braque and Picasso were actually looking for a new way to represent reality, specifically a more exact way of reproducing the way we perceive it. Starting from the premise that our perception of things is not just conditioned by space (or viewpoint) but also by time, they developed a language – the Cubist idiom – in which they reproduced a fragmented vision, simultaneously showing on the canvas our multiple optical experiences in an attempt to reproduce time and space. What resulted was a fragmented reality in which, as in *Woman with a Mandolin*, the forms open up and intermingle, and in a more pronounced way than in *The Park at Carrières-Saint-Dénis*, the figure blends in with the background. Everything is created from multiple facets whose verticals are also open and join up with others.

The outbreak of World War I marked the end of Braque's collaboration with Picasso and an enforced break from painting. He was called up for active service and sent the Front, where he was wounded in the head. When he resumed painting, he tried to take up his Cubist experiments at the point where he had left off. From 1920, however, his painting grew more figurative and classical in style, whereby reality became more obviously apparent in his work and the development of pictorial space less arbitrary and more ordered. In addition, his painting became more decorative, possibly influenced by his early training as a decorative artist in Paris, allowing him to experiment with contrasts between the different textures produced by mixing sand with oil, as in *The pink Tablecloth*.

The pink Tablecloth belongs to a series in which the objects are arranged on a tablecloth of a different colour in each painting. It represents an excellent example of the genre in which Braque would achieve great mastery and international acclaim, namely the still life, which he used to express the aesthetic and pictorial values of immobile natural objects. The multifocal approach to perspective and the treatment of the volumes still conform to the Cubist spatial concept, but without its rigidly geometric character. Here Braque achieves a plasticity in the colours, which combine delicate and harmonious tones, very different from the muted palette of his *Woman with a Mandolin*.

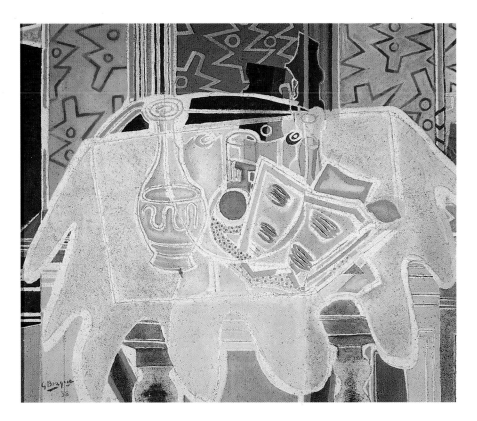

The pink Tablecloth,
1936 (1938?)
Oil and sand on
canvas, 87.5 x 106.5 cm

Juan Gris

MADRID, 1887 – BOULOGNE-SUR-SEINE, 1927

José Victoriano González Pérez, known as Juan Gris, studied painting, illustration and drawing in Madrid, but in 1906 left his native city and moved to Paris, where he made friends with the artists of the Cubist circle, Picasso, Braque and Léger. Gris was an eminently intellectual and logical man, and his works reveal a scientific side not to be found in the work of the other artists. His compositions are the result of an analysis of the geometry of the forms. In his early works Gris broke down his pictorial components into multiple planes, and having rapidly absorbed the lessons of Analytical Cubism, he soon started to work with collage and in the mode of Synthetic Cubism, the style in which his best works were produced. As with the other Cubists, Gris worked on the elaboration of a pictorial language which would allow for the representation of the totality of our visual experience of an ever-changing and dynamic reality, in which both perception and reality are conditioned by their relations with space (the viewpoint) and time. Thus the *Still Life* of 1911 presents us with a geometrical structure which is the result of an analysis of forms and their relations with space, creating a composition of very simplified elements of essentially abstract character.

Although figure paintings are not common in Gris' œuvre – he concentrated chiefly on still lifes – *The Smoker* of 1913 is an important work. It is typical of his style and represents a personal and distinct interpretation of Picasso and Braque's Analytical Cubism. The compartmentalization of the pictor-

Still Life, 1911
Charcoal on paper,
74 x 43 cm

The Smoker, 1913
Oil on canvas,
73 x 54 cm

ial space within a geometrical structure creates independent and juxta-
posed areas in which Gris places the various identifiable features of the
sitter. Like a jigsaw puzzle, the artist composes the image from incom-
plete pieces placed at random, with the intention that the viewer should
reassemble the picture. Another distinctive feature of Gris' work is his
use of a bold, saturated palette of contrasting colours.

Emil Nolde

NOLDE, 1867–SEEBÜLL, 1956

Nolde

Nolde's real name was Emil Hensen, but he took the name Nolde
from the town of his birth. An Expressionist artist, he followed an
independent career path and was not closely associated with the va-
rious avant-garde movements, although in 1906 he joined the group
Die Brücke for one year.

Nolde's work focuses on the three subjects which he painted
throughout his life: flowers, landscapes and religious motifs. He was
an extensive traveller and while still a student travelled around Eur-
ope, living for a while in Paris where he saw Impressonist art and the
work of van Gogh and Cézanne. Between 1911 and 1913 he also trav-
elled in Russia, China and the islands of the Pacific, as part of an
ethnographic expedition, while in the 1920s he visited England, Spain,
France and Italy. His work always maintained a highly individual and
recognizable style, however, which remained largely unchanged

Autumn Evening,
1924
Oil on canvas,
73 x 100.5 cm

Red Clouds, 1930
Watercolour
on paper,
33 x 45 cm

throughout his career. In it, colour has symbolic connotations and is
deployed with great force and brilliance. His art reveals a desire to
depict the strength of colour found in nature.

Nolde painted numerous landscapes. Throughout most of his
life he painted by the sea on the Baltic coast, producing a large number
of works which, both individually and as a series, are among the most
impressive of his œuvre. The compositions are very similar, using a
horizontal format defined by the line of the horizon which expresses
the symmetrical relationship between the sky and the sea.

In the oil painting *Autumn Evening* and in the watercolour *Red
Clouds*, we find the same structure and the same intense lighting,
creating profoundly spiritual and lyrical works. In both cases the com-
position is formed from bands of highly saturated and contrasted
colour with a subjective emphasis on the particular elements in nature
which inspire the painter. Both paintings emphasize the expressive

The Garden Path,
1906
Oil on canvas,
51 x 54 cm

potential of colour, transmitting a sense of the infinity and immensity of nature.

While in *Autumn Evening* we see an interest in the contrasts of light and shade at the moment of sunset, filled with mystery, in *Red Clouds* it is mistiness and atmospheric effects which prevail. In this case Nolde exploits the technique of watercolour to achieve the effect of transparent layers of atmosphere. In both cases we see Nolde leaning towards abstraction.

Flowers were also a recurring motif in his work, and indeed Nolde was one of the outstanding 20th-century exponents of flower painting as we can see in the two paintings reproduced here, dated to the beginning and the end of his career. Once again the artist is fascinated by nature, and he attempts to capture the force of nature's colour and light through painting. *The Garden Path*, executed in 1906, contains reminiscences of Post-Impressionism, yet coupled with a

Sunflowers, 1936
Oil on canvas,
88.5 x 67.3 cm

chromatic brilliance in line with the Expressionism of the artists of Die
Brücke in Dresden. As in *The Garden Path*, Nolde also chooses a very
close-up view in *Sunflowers*, dating from the latter part of his career.
Each flower is individualized, creating a warm chromatic harmony
in which light and colour join together as the principal subject of the
painting.

Ernst Ludwig Kirchner

ASCHAFFENBURG, 1880 – FRAUENKIRCH, 1938

Kirchner is one of the best represented artists in the Thyssen-Borne-misza Collection. The group of works reproduced here offer an overview of his entire career in all its different phases, from his early years in Dresden to his latter period in Davos in Switzerland. Kirchner belonged to the first generation of German Expressionists and was the founder, together with Heckel, Schmidt-Rottluff and Bleyl, of Die Brücke in Dresden in 1905. He is considered to be the leading figure within that group and the artist who made the most significant contribution to it.

E·L·Kirchner.

Kirchner's work, like that of the other early Expressionists, shows similarities with the work of the contemporary Fauve artists in France, such as Matisse and Derain. This can be seen in the simplification of the forms, the outlining of the contours with thick black lines and the use of strong primary and complementary colours. We also find a primitive accent in his work, derived from his knowledge of African and Oceanic sculpture and from the work of Munch and van Gogh. All of these influences found their way into his formal language of expression, whose goal was not simply to manifest its subject in appropriate visual terms, but also to project the artist's inner experiences via painting.

◄ *Fränzi in front of a carved Chair*, 1910
Oil on canvas,
71 x 49.5 cm

Doris in a high Collar,
1906–1909
Oil on cardboard,
70 x 52 cm

In his early works. such as *Doris in a high Collar*, we can see the influence of van Gogh and of Post-Impressionist art in general, resulting in short, thick brushstrokes very heavily loaded with paint, in which the forms and volumes are created by the juxtaposition of primary and complementary colours. Later Kirchner would evolve towards a more schematic style, dominated by the use of black lines, where the short brushstoke is replaced by large masses of colour, while small dabs of colour are used for expressive ends. This is the style of *Fränzi in front of a carved Chair* of 1910, one of Kirchner's most outstanding paintings and one which also includes references

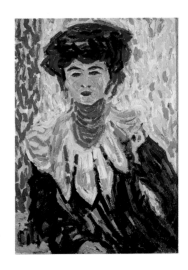

to the primitive art which was so influential upon the avant-garde artists of this period. This primitivism can be seen both in the schematic way of working and, more specifically, in the carved chair which acts as a background to the young girl.

A more explicit reference to African and Oceanic sculpture is to be found in the *Kneeling female Nude*, painted two years later, which clearly reproduces the features and pose found in this type of non-western art, which had only recently been discovered in Europe. The painting reveals certain parallels with Picasso, who during this same period was investigating the new language of Cubism. Kirchner also creates a very

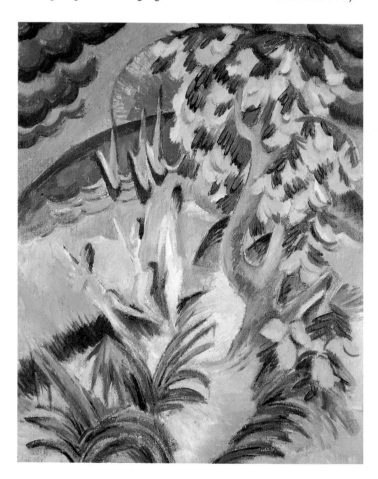

The Bay, 1913
Oil on canvas,
146 x 123 cm

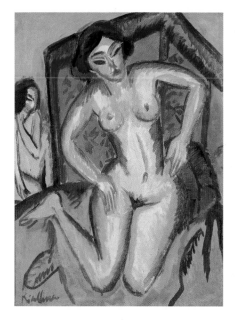

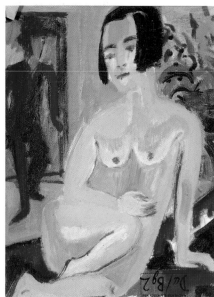

volumetric figure in which each part of the body is resolved almost independently and is treated as a geometrical shape.

Kirchner's work is a constant search for new languages of form which would serve him as a better means of artistic expression, with the aim, as he said, of spanning a bridge between the viewer and the subject the artist wished to convey (hence the name of the group Die Brücke, "The Bridge"). Kirchner was a difficult, hypersensitive and unstable character, and was greatly affected by what he perceived as the rejection of his work both by the general public and the official German art world. For this reason he turned his attention to the marginal figures of modern urban life, not in criticism but because he identified with them. Many of his works depict prostitutes and low-life characters, as in the case of *Berlin Street Scene with red Streetwalker*. The series of Berlin street scenes with prostitutes which he painted between 1913 and 1914 are among his most famous works. The present painting uses a diagonal spatial disposition which creates an acute and unrealistic perspective. At the same time, the lack of proportion between the figures and the street gives a sensation of vertigo. The figures are represented in a schematic and inexpressive way, with no communica-

Kneeling female Nude, 1912
Oil on canvas,
75 x 56 cm

Seated female Nude, 1921–1923
Oil, 75 x 56 cm

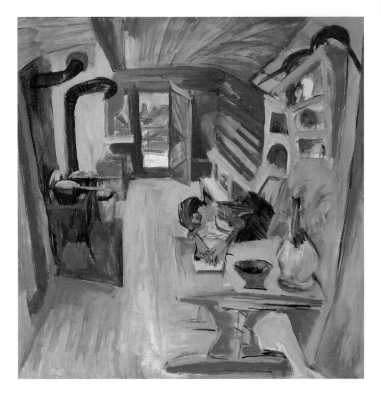

tion between them. The woman in red stands out in the centre, isolated from the rest.

Due to his fragile physical and mental health, in 1917 Kirchner moved to Davos in Switzerland. There he lived in relative isolation, and dedicated himself to painting mountains, villages and shepherds. He painted the world around him as he had done in the city. This is the period of the *Alpine Kitchen*, which retains the brilliant colouring of the earlier works in a composition with a violently tunnelled perspective whose intense contrasts of yellows and greens create a claustrophobic sensation. Kirchner also reworked some of his earlier compositions at this time, or painted on the backs of the canvases. For example, the *Seated female Nude* is painted on the back of the *Kneeling female Nude*. *Berlin Street Scene with red Streetwalker* was also retouched at this time (probably with the addition of the flat red colour of the woman's hat and coat).

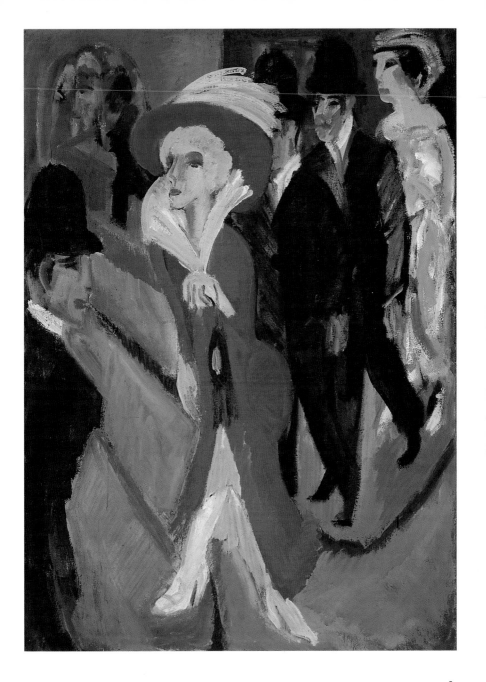

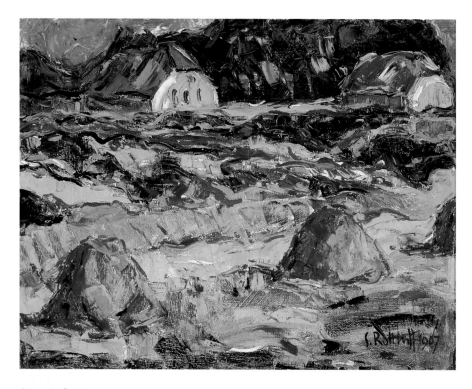

*Autumn Landscape
in Oldenburg*, 1907
Oil on canvas,
76 x 97.5 cm

Karl Schmidt-Rottluff

ROTTLUFF, 1884 – BERLIN, 1967

Schmidt-Rottluff was one of the founders of Die Brücke, the German Expressionist group created in Dresden in 1905 together with Heckel, Kirchner and Bleyl. These artists painted directly onto the canvas using thick strokes of oil paint which they took straight from the tube, without diluting or mixing them, and employing strong colours and a heavily loaded brush. Their interest in colour follows the ideas of the Fauves, and they applied it in a similarly arbitrary way with the object of accentuating the expressiveness of the image. They drew their subject matter from the world around them.

In 1907 Rottluff travelled with Heckel to Dangast and the Oldenburg region, where the two artists spent several months painting out of doors. *Autumn Landscape in Oldenburg,* painted at the end of that summer, shows a number of fields after harvesting, with the hay piled up after it has been cut, and some houses and a wood in the background. The forms are created from thick and heavily loaded brushstrokes in a technique which recalls van Gogh. Like the other early Expressionists, Schmidt-Rottluff uses a very strong and contrasted palette of pure colours and their complementaries. The artist's interpretation of reality is subjective and far removed from the objective and illusionistic vision of the Impressonists.

The scene is constructed from a series of parallel planes placed slightly at a diagonal and created from strips of contrasting colour: yellow, red and green are the dominant colours. The forms take shape from the colour and the result is a powerful and expressive image. It is interesting to compare this painting with *Brick Factory in Dangast* by Heckel, painted that same summer and in the same area, revealing the similarities and differences between the two painters.

"I really feel a pressure to create something that is as strong as possible. The war has swept away everything from the past. Everything seems weak to me and I suddenly see things in their terrible power. I never liked the type of art that was simply appealing to the eye, and I have the fundamental feeling that we need still stronger forms, so strong, that they can withstand the force of the crazed masses."
KARL SCHMIDT-ROTTLUFF

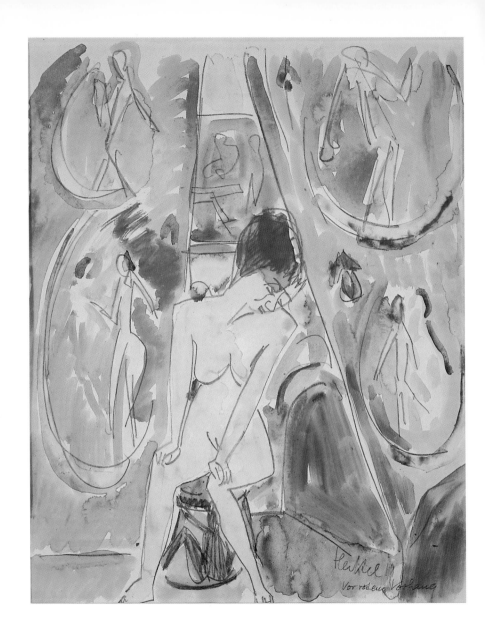

Erich Heckel

DÖBELN, SAXONY, 1883 – RADOLFZELL, 1970

Heckel met Kirchner and Schmidt-Rottluff in Dresden, where he studied architecture, and together they formed the group Die Brücke in 1905. Its spirit was one of confrontation with traditional art and was a defence of the new artistic ideas embodied in the art and figure of van Gogh. The artists of Die Brücke were part of the first generation of German Expressionist painters; along with the Blauer Reiter (Blue Rider) group formed by Kandinsky, Macke and other Munich artists, Die Brücke thereby constituted the leading movement in German art in the opening years of the 20th century.

Brick Factory in Dangast corresponds to these early years, and was painted in the summer of 1907, when Heckel made a trip to the area north of Oldenburg in the company of Schmidt-Rottluff, whose *Autumn Landscape in Oldenburg* from the same trip is also in the possession of the Museum. Both works, which are very similar, show the use of a heavily impastoed technique and the application of the oil paint just as it comes from the tube, resulting in a strongly contrasted picture surface created from bold colours. The thick and uneven brushstroke creates eddying rhythms reminiscent of van Gogh. Through this technique, these painters aimed to convey on the canvas their personal emotions in the face of the landscape which they were painting, projecting their subjective vision onto the work.

This same subjectiveness also dominates *Before the red Curtain*, a watercolour of a female nude. The artist clearly sympathizes with his subject, who is not just presented as a nude study but rather as a tired, broken-down woman who is probably a prostitute – a theme much treated by the artists of Die Brücke as a gesture of defiance against bourgeois conventions. Overall, the painting is imbued with sensitivity, both in the presentation of the subject and in its purely pictorial aspects, such as the chromatic combinations in a palette of reds and earth colours and the strength of the lines which create the forms. The angularity of the forms and the schematic nature of the representation are both typical of the members of Die Brücke.

Before the red Curtain, 1913
Watercolour on paper,
44.5 x 36.5 cm

Brick Factory in Dangast, 1907
Oil on canvas,
68 x 86 cm

The Theatre of Masks,
1908
Oil on canvas
72 x 86 cm

James Ensor

OSTENDE, 1860–1949

James Ensor was a Belgian artist who, although unconnected with any avant-garde group, developed a manner of painting in the late 19th century which was very close to the ideas of German Expressionism. Apart from the years when he studied in Brussels, he spent almost all of his life in Ostend. His subjects are frequently rather macabre in tone and found an important source of inspiration in the great Netherlandish art of the past, namely the fantastical and satirical works of Brueghel and Bosch.

The Theatre of Masks takes up a subject which is typical of Ensor's work. Masks were something with which he was familiar from childhood, as his family had a toy and gift shop which sold carnival masks. He also frequently included skeletons, again reflecting his taste for the macabre. Ensor's paintings are imaginative and satirical. The figures are barely sketched in, located in an unrealistic setting with few spatial references. The traditional relationships between depth and the simulation of a coherent three-dimensional space are dispensed with in this work. The painting combines barely decipherable areas executed in a broken and faint manner with strong areas of colour, such as the green in the upper part and the touches of green and red which draw the viewer's eye to the edges of the canvas, leaving a troubling void in the centre. The mask in the foreground which looks straight out at the viewer seems to have no connection with the setting, nor does it correspond with a specific figure.

The canvas is still in its original gilded frame, which was made to the artist's specifications. It imitates a proscenium; in this way Ensor aimed to create the illusory, trompe l'oeil effect of looking at a scene on stage.

"Oh, one must see them, the masks beneath our great opal sky! Smeared with horrible colours, moving wretchedly, their backs crooked, pathetic figures, horrified figures, outrageous and shy at the same time, scolding and bickering."
JAMES ENSOR

Wassily Kandinsky

MOSCOW, 1866 – NEUILLY-SUR-SEINE, 1944

As a pioneer of pictorial abstraction, Wassily Kandinsky is one of the most important artists of the 20th century. He painted his first abstract canvas in 1910, opening up a new and revolutionary path in art. Born in Russia, where he trained as a lawyer and an economist, he left for Munich at the age of 30 and began his life-long career as an artist. Kandinsky was very active in promoting the avant-garde movements which emerged during the opening decades of the 20th century. He co-founded the Neue Künstlervereinigung (New Artists' Association) in Munich in 1909, and two years later became a founder-member of the Blauer Reiter (Blue Rider) group, the focal point for the first Expressionist artists such as Marc, Macke and Münter. As well as being a painter, Kandinsky was a great theoretician of art, and his reflections on abstract pictorial composition were published in several volumes. He also promoted his ideas through teaching, mainly at the Bauhaus from 1922.

Murnau. Johannistrasse dates from a few years prior to the formation of the Blauer Reiter group. In it the artist looks again at Gauguin and Matisse, whose work he had studied during a recent trip to Paris. His paintings of this period are constructed with thick black outlines which are then filled in with a dense, flat colour in briliant tonal contrasts. The schematic quality and simplicity of the various elements which make up the scene derive from the artist's overriding interest in the visual effects of the colours and the shapes; he is searching more for an aesthetic expression than for a true representation of the scene before his eyes. This is merely the pretext for constructing a composition of chromatic combinations and volumes which together form a work of art.

We referred above to Kandinsky's importance in the evolution of abstract art and the subsequent influence of his discoveries. These were transmitted not just through his paintings but also through his theoretical writings, which are fundamental to our understanding of avant-garde art at the beginning of the 20th century. Kandinsky taught at the Bauhaus, where he worked alongside such major figures as Paul Klee, Feininger, Albers and Gropius.

"The painting is like a thundering collision of different worlds that are destined in and through conflict to create that new world called the work. Technically, every work of art comes into being in the same way as the cosmos – by means of catastrophes, which ultimately create out of the cacophony of the various instruments that symphony we call the music of the spheres."
WASSILY KANDINSKY, 1913

Murnau. Johannis-strasse, 1908
Oil on cardboard,
70 x 48.5 cm

Painting with three Spots, 1914
Oil on canvas,
121 x 111 cm

The interest in colour evident in *Murnau. Johannistrasse* would remain fundamental to his work between 1911 and 1914, years in which he definitively abandoned references to nature in order to create a completely abstract type of work dominated by the musical lyricism of colour. Characteristic of this phase is *Painting with three Spots*; here, colour flows freely over the whole canvas in the same way that musical notes expand in the air and, like them, recreates rhythms, harmonies and tensions which appeal to the viewer's senses. The zone of greatest tension consists of the three irregular spots – red, blue and green – which collide with each other to produce an expansive wave of colour that fades as it comes closer to the edge. The musicality of this period of Kandinsky's work is confirmed in his text *On the Spiritual in Art* of 1912, which argues for a form of painting which has its own values and which responds to the "internal necessity" of the artist to transmit sensations, feelings and emotions.

This "internal necessity" would motivate Kandinsky's artistic quest and his discoveries throughout his life, and would produce stylistic and formal developments. *In the bright Oval* is a mature work painted while Kandinsky was at the Dessau Bauhaus. In it, the key element is no longer colour but the geometric development of the forms and the compositional balance. It presupposes a new order of things which takes as its starting point the artist's fascination with the most essential shape: the point whose versatility made it ideal. From this shape all others were generated as it grew or started to move. Here we find it inside the exterior nucleus of the yellow oval, playing a role in the genesis of that shape, which is still imprecise and whose centre is formed from the brown nucleus with its intercrossing black lines and segments, suggesting the idea that something is taking shape. This work is connected to Kandinsky's evolution of a new theoretical treatise, published as *Point and Line to Plane* in 1926, which analyses the values of the point and its geometrical relations. It may be considered as simply the visual application of his theories or, taking a broader interpretation, as alluding to the cosmic order of nature.

"The content of painting is painting. Nothing has to be deciphered. The content, filled with happiness, speaks to that person to whom each form is alive, i. e., has content."
WASSILY KANDINSKY, 1937

Tender Tension, No. 85, 1923 Watercolour on paper, 35.5 x 25 cm

The markedly geometricized round shape which recalls a draught-man is also to be found in the slightly earlier *Tender Tension, No. 85,* a watercolour closely linked to *In the bright Oval.* This element has been interpreted as a demonstration of the colour palette used in the painting, but also as a counterbalance to the curved forms which gives the composition balance.

With *Around the Line* we find ourselves in the final period of Kandinsky's stylistic evolution, in which the organic forms that are so meticulously realised in pastel tones seem to float in a neutral ground of reddish-ochre colour, far removed from the brilliant and luminous colour of previous periods. This canvas cannot fail to remind us of Miró's universe of microcosms: Kandinsky came to know the Spanish artist after his move to Paris in 1934, fleeing the Nazi regime. At the extreme left of the composition we see an image which is very similar to one which appears in Miró's work *Painting on a white Ground* of 1927, hung in the same room in the Museum: both feature a sort of bird's head with a large beak, placed in the same far corner of the composition and facing the same direction.

Around the Line, 1943
Oil on cardboard,
42 x 58 cm

Max Beckmann

LEIPZIG, 1884 – NEW YORK, 1950

In 1925 the director of the Mannheim Kunsthalle, G. F. Hartlaub, mounted an exhibition of contemporary art which he titled *Neue Sachlichkeit* (New Objectivity), and which introduced a whole new trend in German painting. The exhibition included work by Christian Schad, Otto Dix, George Grosz and Beckmann, although it is still a matter of debate as to whether Beckmann should be included under this label. One could in fact say that Beckmann's art does not fit within any of the prevailing currents of German Expressionism, even though we can appreciate what he himself called "the objectivity with respect to the work represented".

This is evident in the two paintings reproduced here. They deploy a vigorous, nervous and visible brushstroke, heavily impastoed in early works such as this *Self-Portrait*. Beckmann superimposes touches of contrasting colour, particularly on the face, while his sketchy way of representing the hand and upper body are far from the polished, brilliant and finished surfaces typical of New Objectivity. In fact, Beckmann's work is closer to an Impressionist type of handling and he was probably also influenced by the style of Frans Hals.

After World War I Beckmann's forms became expressively distorted and even in his portraits he gives his sitters powerful and expressive features which can at times be exaggerated, as in that of *Quappi*, his second wife, whose calm, clear eyes he magnifies in size and whose elegant and coquettish hands have been greatly lengthened without in the least detracting from her harmonious beauty. In contrast to the *Self-Portrait*, the colour is brighter and more translucent, and the brushstroke broader and more flowing. The upholstery on the chair and the background wall (which may be papered or painted) give the composition a more decorative feel. We should also note that Beckmann has deviated from the classical proportions in the figure, for example in the different lengths of the arms; a common feature in German painting of any period.

Max Beckmann

▲ *Self-Portrait with raised Hand*, 1908
Oil on canvas,
55 x 45 cm

"I paint portraits. still lifes, landscape visions of cities rising from the sea, lovely women and grotesque freaks. People bathing and female nudes. In short, a life. A life simply existing. No thoughts or ideas. Filled with colours and shapes derived from nature and from myself."
MAX BECKMANN, 1924

Quappi in Pink, 1932–1934
Oil on canvas,
105 x 73 cm

Gabriele Münter

BERLIN, 1877 – MURNAU, 1962

Gabriele Münter's career as a painter is closely linked to that of Kandinsky, whom she met in 1902 when she entered the Phalanx academy of painting which Kandinsky had founded in Munich. They began a personal and professional relationship which lasted until 1917, when Kandinsky left for Russia. Münter was a member of the avant-garde groups headed by Kandinsky, particuarly the Blauer Reiter, which he founded with Münter, Marc and Macke in 1911.

This *Self-Portrait* was executed at a high point in her career: although Münter dedicated her whole life to painting, her best works were produced in these early years when she was closely linked to the avant-garde. The present work is a forceful and expressive one, boldly combining the volumetric character of the face, which is created from strongly contrasted areas of light and shade, with the flatness of the rest of the picture surface. The exaggerated chiaroscuro is accentuated by the firm and even brushstrokes, which help to define the forms and emphasize the differences between the two sides of the face. She thereby achieves great expressiveness and a powerful characterization which is not without psychological depth.

The painting reveals numerous stylistic debts to van Gogh, who was a key point of reference for the German Expressionists; it is also related to the work of Alexei Jawlensky, another Expressionist, and a friend of Münter and Kandinsky. She herself acknowledged these influences.

Münter.

"If, stylistically speaking, I was influenced by anybody – which during the years 1903–13 was to some extent the case – it was probably van Gogh, via the intermediary of Jawlensky and his theories (talks of synthesis). However, that is not to compare him with what Kandinsky meant to me. He loved my talent, understood it, defended and furthered it."
GABRIELE MÜNTER

Self-Portrait,
c. 1909–1914
Oil on paper
mounted on
cardboard,
49 x 33.6 cm

Egon Schiele

TULLN, AUSTRIA, 1890 — VIENNA, 1918

Egon Schiele is an isolated figure within the Expressionist sphere. Although he never belonged to any of the groups who defined this movement, his style combines the influence of certain features of the Vienna Secession, particularly the art of Klimt, with an acute and introspective vision and an extraordinary draughtsmanship. Taken together, these elements resulted in a style which mixed a decorative surface with a wrenching vision of reality.

The works in the Thyssen-Bornemisza Collection shown here are highly characteristic of his style, in particular the three watercolours on paper. They all reveal a tendency to the exquisite and decorative, derived from the Secessionist aesthetic, which led Schiele to include in his works ornamental elements of a geometrical character, and to conceive of the outlines of the figure as a rhythm of broken lines which outline the shape against a flat background. Juxtaposed with this tendency, however, is the more Expressionist aspect of his work, which tends to the morbid and to an indisputably erotic tone, characteristics which in many cases have served to obscure Schiele's talents as a draughtsman and portraitist.

Schiele returned throughout his career to the *Self-Portrait*, depicting himself in numerous different ways, at time sophisticated, at others melancholy or anguished, in realistic or imaginary presentations. The present *Self-Portrait* is perhaps one of his most direct. In it the artist finds his means of expression mainly through the hands and the face, which are drawn with thicker lines and attract the viewer's attention. Schiele's exteme thinness, accentuated by the hands with their large and bony fingers, conveys an unsettling feeling which is characteristic of all his work.

The same troubled mood can be sensed in the other works. In *Seated Girl*, the elegant and decorative portrayal of the dress is used to emphasize hands which are also large and sinewy – not like a child's – and a face whose expression is enigmatic and somewhat sensual. This ambiguity also appears in the explicitly sexual *Reclining female Nude*, in

"My existence, my decay, transposed to enduring values, must bring, sooner or later, my strength to other strongly or more strongly developed beings, like a living revelation of religion ... I am so rich that I must give myself away."
EGON SCHIELE

Reclining Nude,
1910/11
Watercolour
on paper,
48 x 32 cm

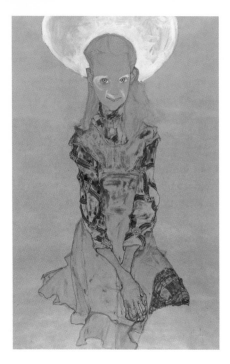

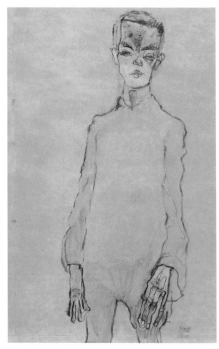

Seated Girl, 1910
Watercolour and
gouache on paper,
45 x 28.5 cm

Self-Portrait, 1910
Watercolour and
charcoal on paper,
45.7 x 31 cm

which the genitals are exaggerated – a characteristic feature of this facet
of his œuvre. Once again Schiele's vision is harsh and troubled. Works
of this type were to bring Schiele the reputation of a pornographer, a
charge against which he defended himself by saying that the problem
was not in his art but in the minds of those who looked at it. In fact, his
models – children in sensual and provocative poses which contradict
their emaciated and sinewy bodies – rather produce a feeling of com-
passion and anxiety in the viewer.

In *Houses on the River Bank. The Old Town*, executed in 1914, we
again find a decorative geometricism as the vehicle for a melancholy
mood. Schiele took great liberties with regard to the panorama which
inspired him, reducing the view to a play of shapes and geometric
volumes depicted in a schematic way. There is no sense of depth. The
scene is dominated by a dark green tone and is organized in horizon-
tal bands. Against this monochrome background, touches of warm
colours in red and orange tones stand out. The composition is con-

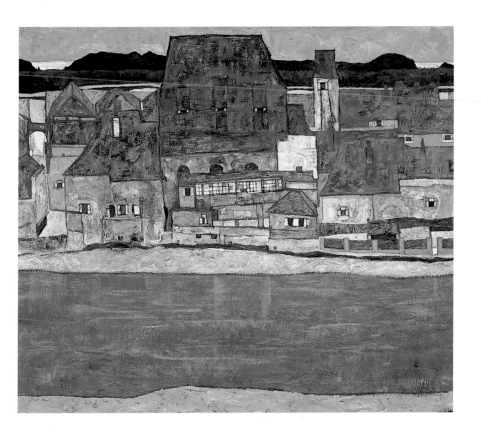

structed in decorative modernist fashion. But in Schiele's vocabulary a forshortened city was a dead city, an empty city without people or life. These urban landscapes – other examples of which were entitled *Dead City* – seem to imply a reflection on the decadence and precariousness of human life.

Houses on the River Bank. The Old Town,
1914
Oil on canvas,
100 x 120.5 cm

The Dream, 1912
Oil on canvas
100.5 x 135.5 cm

Franz Marc

MUNICH, 1880 – VERDUN, 1916

Franz Marc was a member of the New Artists' Association in Munich
and played a central role in the subsequent formation of the Blauer
Reiter group, which included Kandinsky, Macke, Bleyl and Münter.
This group of artists were highly active – not just via exhibitions but
also through their theoretical writings – in the propagation of a new
art, which had broken away from traditional painting. Franz Marc him-
self was constantly striving towards a formal language with which to
express in a symbolic manner life's most profound feelings and values.
For this reason the formal aspects of his art were subordinated to spe-
cific meanings which the artist attributed to them (as Kandinsky would
do in abstract art). Thus the forms, colours and even the animals and
figures which fill his works all carry a particular meaning.

The Dream is a very characteristic work of this period in his œuvre,
and shows his close affinity with first-generation Expressionism. The
painting is organized on the basis of a juxtaposition of colour masses,
which are clearly separated from each other using a faceted structure
influenced by Cubism. Each colour has a specific symbolic meaning:
blue is masculine and spiritual; yellow is feminine, happy and sensual;
red signifies heavy, raw material. Around these three primary colours
Marc elaborated a theory of contrasting complementary colours, from
which he constructed his works.

During this period he dedicated himself above all to depicting
animals, which he saw as representing a purity, truth and beauty not
to be found in human beings. His art therefore represents ideas and
values which are far from simple naturalistic representation. His land-
scapes go beyond the merely descriptive and even the imaginary, pene-
trating the visible universe to convert it into a symbolic one.

*"In this time of the
great struggle for a
new art we fight like
disorganized 'savages'
against an old, estab-
lished power. The
battle seems to be
unequal, but spiritual
matters are never
decided by numbers,
only by the power
of ideas."*
FRANZ MARC

Alexej von Jawlensky

TORSOK, RUSSIA, 1864—WIESBADEN, 1941

A. Jawlensky.

"Apples, trees and human faces merely help me to see something different in them – the life of colour, as comprehended by someone who is passionately in love."

ALEXEJ VON
JAWLENSKY

The red Veil, 1912
Oil on canvas,
64.5 x 54 cm

Born in Russia, Jawlensky spent most of his life in Germany. His father was a military man and Jawlensky studied at the Military Academy in Moscow, but on reaching the rank of lieutenant he began to give classes in painting in Saint Petersburg. In 1896 he left the army and moved to Munich. There he met Kandinsky, with whom he founded the New Artists' Association in 1909, which attracted the membership of other Expressionist artists such as Münter and Marc. Jawlensky was personally and artistically close to the other artists in the circle of Kandinsky, although he developed his own individual style which was strongly influenced by the Fauve work of Matisse, whom he met and worked with in Paris in the years prior to 1909.

This influence is evident in *The red Veil* in the use of colour and the outlining of the forms with thick black lines. We can also see a certain similarity in the creation of undulating and elliptical rhythms. Jawlensky combines an interest in resolving the formal aspects of the work with a desire to transmit not so much the external appearance of the sitter as her inner mood. The image conveys a lyrical and melancholy tone, achieved through the combination of the pose with the expressive gaze. Even though seemingly very schematic, this gaze imbues the sitter with life. The arrangement of the figure and the facial type – oval with almond eyes, a straight nose and small mouth – also revive the style of Russian icons, a genre of painting to which Jawlensky was attracted due to its great spirituality.

The painting is carefully executed, as we can see in the systematically applied round and uniform brushstrokes which establish a constant rhythm across the surface. The arbitrary use of colour, another characteristic of the early Expressionists, is evident in the face and neck, and is highly comparable to Kirchner's use of colour at the same period in Berlin.

Paul Klee

MÜNCHENBUCHSEE, SWITZERLAND, 1879 – MURALTO-LOCARNO, 1940

The main body of Paul Klee's work was executed between the two world wars, by which time the avant-garde activism and artist groupings of the early 1900s had given way to the development of individual styles and a personal pictorial language based on a synthesis of the various avant-garde proposals. The group of works by Klee in the Thyssen-Bornemisza Collection provides an excellent overview of the artistic evolution, of this German-Swiss painter and graphic artist as he moved from a highly schematic figuration to pure abstraction.

Born and educated in an artistic family (his father was a musician and his mother a singer), Klee became a highly accomplished violinist, although he soon opted for painting. In 1906, aged 27, he moved to Munich, where he remained for almost 30 years. From 1911 he became close to the Blauer Reiter group and in particular to Kandinsky. His *View of a Square*, executed in 1912, was shown in the group's second exhibition, which included only watercolours, drawings and prints. Klee's work uses a naive style close to that of children's art (something he was interested in), and transmits a sensation of improvisation and spontaneity in its execution. The composition has two main structuring elements:

View of a Square,
1912 [10]
Gouache on paper,
16.5 x 27 cm

a chromatic melody which unifies the whole scene in golden and green tones, and over it a web of fine lines, which delineate the buildings in a highly schematic manner. The buildings are related to the background in a fragmentary way, at times superimposed on top of it, at others assimilated within it.

In 1914 Klee, in the company of Macke and François Moillet, made a trip to Tunis which was to be crucial to his artistic development. There he discovered light and colour as the basis for constructing a painting, leading him to break definitively with imative representation and steer his painting towards a reflection on the nature of things and ideas. From that moment all his work, both pictorial as well as theoretical, had as its aim the development of a non-figurative language with which to communicate with the viewer.

Revolving House of 1921 shows his evolution towards this type of painting. In that same year Klee became a teacher at the Weimar Bauhaus, a school of art, architecture and design which propounded an avant-garde approach and was to be extremely influential upon the

Revolving House,
1921 [183]
Oil on cotton cloth,
37.5 x 52.2 cm

development of modern art; teachers at the Bauhaus were among the most important artists of their day. There Klee joined with Kandinsky, Jawlensky and Feininger to form the group Die Blauen Vier (The Blue Four) in 1924.

Klee continued to teach at the Bauhaus after it moved to Dessau and later to Berlin, where it was closed down by the Nazis in 1933. *Revolving House* is a programmatic work by Klee, who in that year was pondering issues such as movement and its relation to space, and the process of becoming as an intrinsic element of existence, all subjects which he dealt with in his teachings. For Klee everything is in evolution, and this must be conveyed in art.

The figurative elements in his work were reduced to drastically simplified forms, and he definitively abandoned references to a system of perspectival representation, breaking at the same time with the normal relationships between volume and coherent space. On the other hand, the ordering of the compositional structures leads to a certain delimitation of the different parts of the canvas, a tendency which would become more pronounced in later works.

*Attrappen
(Omega 5)*, 1927 [295]
Oil and watercolour
on cardboard;
original frame,
56.5 x 42.5 cm

Since his basic subject matter was the essence of nature, Klee's painting was never completely divorced from reality. His work nevertheless became ever more poetic and symbolic, and paintings such as *Still Life with Dice* and *Omega 5* are the result of his study of the elements of pure painting as a language. These works thus represent the translation into painting of his theory of colours and forms, the laws which govern them, and their meaning.

The Circus, 1913
Oil on cardboard,
37.5 x 56.1 cm

August Macke

MESCHEDE, WESTPHALIA, 1887–CHAMPAGNE, FRANCE, 1914

Macke's work was produced during a short period, between 1910 and 1914: in August 1914 he was sent to the Front and died there in battle one month later. During those few short years he was an active painter who left behind a series of vigorous works of art, marked by his constant search for new pictorial languages. The three works in the Thyssen-Bornemisza Collection show the different stages of his artistic evolution.

Around 1910 Macke met Franz Marc and slightly after that Kandinsky and Jawlensky. Together, in 1911, they founded the Blauer Reiter (Blue Rider) group. Macke took a very active part in the group's activities, and in the illustration and compilation of the almanac which it published in 1912. He was committed to figurative representation, expressing in his art his own experiences and his desire to resolve formal issues in his quest for a better and more complete mode of expression.

Colour plays an important role in Macke's work, as we can see in these three examples, which are glowing and colourful paintings in which the artist has taken pleasure in the chromatic structure. In this respect, a trip to Paris in 1912 when he met Delaunay marked a milestone in his evolution. Delaunay's influence is reflected in *The Circus*, with its fragmented structure created from geometric forms. Macke took up Delaunay's theories of colour and their combinations, as well as his Cubist-derived approach to composition. He rapidly evolved a type of painting which used a loose and more dynamic stroke, as in *Galloping Hussars*, in which he attempts to represent speed.

The watercolour *Woman on a Couch* is one of the numerous watercolours and drawings which Macke made from life on his trip to Tunisia in the spring of 1914, in the company of Klee and Moillet. Fascinated by the light and colour, he painted the houses, streets, landscapes and people of the country, emphasizing above all the chromatic contrasts and the brilliance of the Mediterranean light.

"It is a tremendous effort for me to paint and I exert so much energy when I am painting that I am always very tired afterwards. I tear the paintings stroke for stroke from my brain. Really. I am actually very lazy. If I have torn out my nerves, however, then these canvas rags should also be worth something, at the very least my energy has been spent on them. They can be appreciated by whoever pleases."
AUGUST MACKE

Galloping Hussars, 1913
Oil on canvas,
37.5 x 56 cm

Woman on a Couch, 1914
Watercolour on paper,
27 x 20 cm

František Kupka

OPOCNO, BOHEMIA, 1871 – PUTEAUX, 1957

While Kandinsky is generally considered the father of abstract art, which he initiated with a watercolour of 1910, this is to forget Kupka who, one year earlier, had painted some non-figurative works and whose investigations in the field of abstraction ran parallel to those of Kandinsky and Robert Delaunay with regard to aims and objectives. Connected with the Cubist and Orphist circles, Kupka's interests centred on the dynamic of colour and the quest for rhythm and harmony, obeying the impulses and visions arising from within the artist, and not from the world around him.

These investigations focused for a while on the motif of the vertical, giving rise to a series of compositions to which the present study belongs. With it Kupka demonstrated that the supposedly static nature of the vertical line can be converted into undulating movement by constructing planes of colour of different intensities (red-orange in this case) from groups of vertical lines. The introduction of oblique planes of contrasting colour in the upper and lower zones of the canvas breaks with the strict verticality of the composition and results, according to the artist, in a descending motion.

"The creative ability of an artist is manifested only if he succeeds in transforming natural phenomena into 'another reality'. This part of the creative process ..., if conscious and developed, hints at the possibility of creating a painting. It can thus charm or move the onlooker without disturbing the organic colour of natural phenomena."
FRANTIŠEK KUPKA

Study for the Language of Verticals, 1911
Oil on canvas,
78 x 63 cm

Kupka was still experimenting with the movement of verticals in 1913, but in the meantime he produced two key works: *Localization of Graphic Mobiles I* and *Localization of Graphic Mobiles II* (National Gallery of Art, Washington), which demonstrate his interest in the abstract representation of movement. The present painting is constructed from a centripetal movement of the structural planes, and features two luminous white nuclei which – because they form the spot upon which the lines of the composition converge – appear to

open onto another dimension, and which accentuate the sensation of vertiginous rhythm and infinite space. Kupka is here striving for a coherent exteriorization of the images or "fragments of images" which well up from within him – like recollections imprinted on the memory – and which give the painting an apparent sensation of immediacy that is contradicted by his systematic and careful way of working: we know that the two versions of this painting were preceded by a large number of drawings, suggesting a deliberate and lengthy preparatory process.

Localisation of
Graphic Mobiles I,
1912/13
Oil on canvas,
200 x 194 cm

Marsden Hartley

LEWISTON, MAINE, 1877 — ELLSWORTH, MAINE, 1943

The art of the European avant-garde reached the United States through the charismatic figure of the photographer and art dealer Alfred Stieglitz. In his famous Gallery 291, Stieglitz organized important exhibitions of the work of European artists, including Matisse, Rousseau, Picabia, Severini and Picasso, whose work had never before been seen in America. Stieglitz also attracted a circle of the most avant-garde American painters, whose work he promoted in his gallery. Hartley was one of these, together with Max Weber, Arthur M. Dove and Georgia O'Keeffe, among others.

In 1912, the date of *Musical Theme No. 2*, Hartley travelled to Paris, Munich and Berlin where, judging from this work, he was influenced by the Cubists and by Kandinsky's theories on art, which are impossible to miss in the present work, given the musical reference which Hartley builds into its title, and which relates to Kandinsky's treatise *On the Spiritual in Art*, published in 1910. Like Kandinsky, Hartley aimed to transmit through painting the same emotions that music evoked, and for this reason he equated each colour with the tones of a musical instrument. But while the importance of colour was fundamental to Kandinsky, in Hartley's work one can barely make out the patches of pastel tones against an earthy and neutral background.

Although Hartley rejected the Parisian Cubism which he encountered that same year, his work shows the clear influence of the early work of Braque and Picasso. Thus he employs a relatively flat composition of square geometrical shapes, arranged in an upward movement in a pyramidal organization, creating a dynamic space emphasized by the strong black lines rather than by the use of colour. After his "musical" phase, Hartley worked in various other styles, all of which were influenced by the European painting which he had seen on his travels and in Stieglitz's gallery. From the 1930s onwards he adopted a naive style which he pursued for the rest of his life.

Musical Theme No. 2 (Bach Preludes and Fugues), 1912
Oil on canvas mounted on masonite,
60.9 x 50.8 cm

Gino Severini

CORTONA, 1883 – PARIS, 1966

Among the succession of "isms" or avant-garde movements of the early
20th century, Futurism is particularly important due to the enormous
influence it had on artists of the time. The first Futurist manifesto, pub-
lished by the poet Filippo Tommaso Marinetti in 1909, was essentially
literary, and had most impact within Italy. It was followed a year later
by the Manifesto of Futuristic Painters, whose signatories included
Severini, who in 1901 had moved to Rome to study with Giacomo Balla,
later moving to Paris and working in the circle of Modigliani, Braque
and Raoul Dufy. The Futurist movement, a true child of its times, ex-
alted the values of modern urban life and the rapid changes that was
spawning: movement, speed, the machine, progress and struggle
became key concepts in the work of these artists, whose painting
assumed a wide-ranging social content.

Although *Expansion of Light* does not carry such social implica-
tions, it shares the Futurist preoccupation with conveying the impres-
sion of movement and the accompanying sensations of light. Starting
from the subject of a ballerina (a figurative allusion which is impossible
to actually make out in the work), Severini presents a light-filled and ab-
stract composition, constructed through a succession of planes which
move around at an angle of 360 degrees, covering the entire surface of
the canvas in a fan-like movement. Severini uses a pointillist brush-
stroke reminiscent of Seurat and characteristic of his early work (and
of Futurism in general), which he learned from his teacher Balla.

The result – in a painting whose rich colouring gives it a decora-
tive feel and in which we can also detect the influence of Cubism and
Orphism – is a sense of the figure moving at speed, through which
Severini aimed to convey the abstract values of light and its movement.
Later the artist turned to war subjects and from the 1920s adopted
a more naturalistic style.

Severini

"We wish to re-enter
into life. Science of
today, disowning its
past, responds to the
natural needs of our
time. In the same
way art, disowning
in turn its past, must
respond to the intel-
lectual needs of our
time."
Technical Manifesto
of Futurist Painting,
1910

Expansion of Light,
1912
Oil on canvas,
68.5 x 43.2 cm

Ludwig Meidner

BERNSTADT, SILESIA, 1884 – DARMSTADT, 1966

The Corner House,
1913
Oil on canvas stuck to wood,
97.2 x 78 cm

Ludwig Meidner represents another strand of Expressionism, one not so heavily focused on the power of colour, but equally striking in the way it conveys a subjective vision of reality and projects the artist's inner feelings. In his own time Meidner was considered "the most Expressionist of the Expressionists", although he trod a rather anomalous path, never associating himself with any of the active groups of the day. After World War I, in which Meidner saw active service, he abandoned painting to become a journalist. During the years of Nazi rule he was professor of drawing in a Jewish school and in 1933 emigrated to England for political reasons.

The Corner House is constructed with enormous precision and with a feel for its overall composition. The elements are built up on the basis of a fragmentation of the surface planes, which, for Meidner, was a way of representing the fall of light; a light whose rays transform the material qualities of things and also alters their direction. Light therefore means that we see objects in movement. This gave rise to a faceted visual idiom which inevitably provokes comparison with the early Cubist experiments of Picasso and Braque.

Aside from these technical aspects, Meidner introduces a series of elements which give his paintings a dramatic mood, such as the deployment of cold, dark tones, the use of black and of a very low viewpoint combined with an exaggeratedly acute perspective looking from below upwards. Together these elements present a distorted and oppressive depiction of the house, evoking an unreal world, more nightmare then dream.

Oskar Kokoschka

PÖCHLARN, AUSTRIA, 1886 – MONTREUX, SWITZERLAND, 1980

Oskar Kokoschka was one of the most individual artists within the Expressionist movement. While still a young man in Vienna, he established a certain reputation among avant-garde artistic circles and as a result moved to Berlin. There he achieved great success as a portraitist between 1910 and 1914.

This portrait of Max Schmidt is highly typical of the artist's work during this period, and is altogether typical of Kokoschka's style. His portraits aimed to convey the sitter's personality: in the artist's own words, he was not interested in defining the social status or profession of his sitter, i. e. his or her external attributes, but rather in conveying -through the means of art – their character, the totality of their lives and experiences. His *Portrait of Max Schmidt* testifies to these same concerns: the intense characterization of the subject centres on the face and the hands, renouncing all spatial references, to the extent that the edges of the canvas remain unpainted. The dark and cold tonality, together with a nervy brushstroke that has been described as Baroque, are also typical of Kokoschka's work of these years.

In 1914 Kokoschka enlisted as a volunteer in World War I. In 1916 he was seriously wounded and invalided out of the army. He subsequently made numerous trips abroad, these becoming compulsory after the advent of Nazi rule when he, along with other avant-garde German artists, was branded as "degenerate" by the regime. Obliged to flee Germany, he eventually settled in Switzerland. His work, however, lost the forcefulness of his pre-war period and his most important paintings date from that early phase.

"How do I define a work of art? It is not an asset in the stock-exchange sense, but a man's timid attempt to repeat the miracle that the simplest peasant girl is capable of at any time, that of magically producing life out of nothing."

OSKAR KOKOSCHKA

Portrait of Max Schmidt, 1914
Oil on canvas,
90 x 57.5 cm

Natalia Goncharova

NECHAEVO, TULA, 1881 – PARIS, 1962

With Goncharova we find ourselves in the world of the Russian avant-garde, which was characterized, among other things, by the notable presence of women among its ranks. Alongside Goncharova, the principal representatives of the Cubo-Futurist tendency were Liubov Popova and Nadezhda Udaltsova, as well as Alexandra Exter and Olga Rozanova, all of whom are represented in the Thyssen-Bornemisza Collection, which brings together work by virtually all the protagonists of the Russian avant-garde.

N. Gontcharova

Rayonnism or Rayism, a term apparently invented by Goncharova herself, refers to a pictorial system whose development has been credited to her husband Mikhail Larionov in 1912–1913. This *Rayonnist Landscape. The Forest* – which became something of a leitmotiv in her painting – is one of the best examples of the new system, which has been seen as a Russian version of Italian Futurism. Rayonnism implies the deconstruction or fracturing of the objects into multiple rays through the fall of a generally artificial light, which sets up a display of refractions and reflections beyond what is seen at first glance. The result is a feeling similar to that which the retina experiences just after having received a strong impact of light. To achieve this effect, the artist arranges numerous white patches of prismatic shape across the centre of the composition just where the strongest light falls. The presence among the dense foliage of a completely white human figure, apparently female, accentuates this effect and presents itself as a sort of luminous spectre.

In the development of Rayonnist painting, it is worth remembering not just the discovery and widespread application of electric light, which was to influence modern painting at this period, but also the discovery of X-rays (invented in 1890 and widely used in Russia), whose images, according to Larionov, could show us the internal structure which lay beneath the external appearance of things.

Rayonnist Landscape. The Forest, 1913
Oil on canvas,
130 x 97 cm

Robert Delaunay

PARIS, 1885 – MONTPELLIER, 1941

Together with his wife Sonia Delaunay-Terk, Robert Delaunay made a decisive contribution to the development of abstract painting, reinterpreting the Cubist principle of the deconstruction of the image in an approach which the critic Apollinaire called Orphism or Orphic Cubism. He differed from the Cubists chiefly in the explosion of colour which characterizes his work: "... contrasts of colour, but developing in time and perceived simultaneously", according to the artist himself. This emphasis on colour was appreciated by the German Expressionists, some of whom were strongly influenced by Delaunay, particularly August Macke.

In *Woman with a Sunshade. The Parisian* everything is calculated through colour contrasts and luminosity, achieved by transluscent nuances of colour. The woman and the parasol to which the title refers are perfectly recognizable, as is the background of the composition which depicts a park. The warm colours (red, yellow and orange) predominating in the main figure cause her to stand out against the cool tones (mainly blues and greens) of the background, organized rhythmically in geometrical, circular areas of colour. Abstract forms and colour relations are the basic tenets of Orphism, which aimed to achieve a musical lyricism in painting, close to Kandinsky's aesthetic aims.

Delaunay's use of colour is based on the physical law of simultaneous contrasts discovered by Michel Eugène Chevreul and published in 1839, which first presented the theory of complementary colours. This law, translated onto canvas, involves the application of primary and complementary colours one next to the other – without mixing them – in order to create white light and its vibration, triggering the viewer's processes of optical perception and causing the light experience to be reconstructed on the retina.

"Simultaneous contrast ensures the dynamism of colours and their construction in the painting; it is the most powerful means to express reality."
ROBERT DELAUNAY

Woman with a Sunshade. The Parisian, 1913
Oil on canvas, 122 x 85.5 cm

Sonia Delaunay-Terk

GRADZIHSK, UKRAINE, 1885 – PARIS, 1979

SONIA DELAUNAY

Like her husband Robert, Sonia Delaunay based her investigations on Chevreul's theories. *Simultaneous Contrasts* is a clear example of this, as its very title is taken from a term invented by Chevreul. In the painting we see all the primary colours (red, yellow, blue) and their complementaries (orange, green, violet), which are produced by variously mixing the primary colours. The result is a rather brighter but similar palette to that of *The Parisian Woman*. Both paintings were produced in the same year but in this case the composition is structured on an irregular grid in which the colours are juxtaposed, leaving room for the inclusion of a natural landscape, in which we can make out the curving lines of mountains, a fir tree in the foreground and the sun.

Alongside luminous colour Sonia Delaunay also employs black

Simultaneous Contrasts, 1913
Oil on canvas,
55 x 46 cm

*Simultaneous
Dresses. The Three
Women,* 1925
Oil on canvas,
146 x 114 cm

and white, through which she accentuates the vibration of light and cre-
ates chiaroscuro effects which we perceive "simultaneously" to the light.
Black and white are also used in *Simultaneous Dresses. The Three
Women*, which is an example of the practical application of colour to
textile design, an activity to which Sonia Delaunay dedicated herself
from 1911 and in which she was enormously successful, leading her to
open a fashion house in Madrid, where the couple lived during World
War I. Sonia Delaunay was the first woman to see her own work hung in
the Louvre in Paris, in 1964.

Piet Mondrian

AMERSFOORT, HOLLAND, 1872 – NEW YORK, 1944

Mondrian can be considered the guiding spirit of Neo-plasticism, both for his fidelity to this new mode of expression – something which led him to break with van Doesburg when the latter introduced diagonal lines into his compositions – and for the influence which his art had on his contemporaries and on later art movements. Leaving aside his classic and most famous period (represented in the Thyssen-Borne-misza Collection by *Composition I* of 1931), the two works reproduced here relate to his early phase, when he had just definitively abandoned figuration, and the final phase in the evolution of his art.

Composition in Grey/Blue was executed during the artist's first Paris period (1911–1914) and was influenced by the Cubism of Picasso and Braque, who were also working in Paris at that period. It is related to a series of compositions from the same period, in which references to nature linger on in the form of trees, albeit painted as a grid of black lines which resemble – as it has sometimes been said – the lead of stained-glass windows in Gothic cathedrals.

The logical culmination of the organization of the picture plane, already investigated in this type of composition, are the paintings of Mondrian's classic period, in which Cubist precepts have been superceded by the new theories of Neo-plasticism. These works are also influenced by the philosophical principles of Theosophy.

In *New York City, New York*, a painting which was unfinished on Mondrian's death in 1944, the artist has substituted his typical black lines on a white background with strips of coloured, pre-fabri-cated adhesive, and thereby remains faithful to the primary colours in constructing the grid of the com-position. This work, and its evocative title, may have been inspired by the huge New York skyscrapers which so impressed Mondrian when he moved there in 1940 to escape the war.

New York City, New
York, c. 1942
Oil, pencil, charcoal
and tape on canvas,
117 x 110 cm

◄ Composition in
Grey/Blue, 1912/13
Oil on canvas,
79.5 x 63.5 cm

The Staircase
(second state), 1914
Oil on canvas,
88 x 124.5 cm

Fernand Léger

ARGENTAN, NORMANDY, 1881 – GIF-SUR-YVETTE, 1955

F.LÉGER

Fernand Léger met Picasso and Braque in 1910 and incorporated the Cubist aesthetic into his work, albeit in a very personal and individual way. It is in the work of artists such as Léger that we can best see the meeting between the postulates of Cubism and those of Futurism, another of the great avant-garde movements and one represented in the Thyssen-Bornemisza Collection by artists such as Balla and Severini. Both movements had an interest in capturing the dynamism of life and the presence of an ever-changing reality. But while Futurism achieved this through a celebration of the modern world, in Cubism the approach was more purely pictorial.

The Staircase reveals stylistic similarities with the work of other Futurists, and in this work Léger is perhaps closer to the latter than to the Cubists. What the artist aims to reproduce is the ascending movement of some figures climbing a staircase. Similar attempts had been made in the past, with photography providing an important source of information as regards the study of movement and its representation in time. Léger here aims to portray a process of movement which simultaneously unites successive moments in time.

The artist works with simple geometrical forms – cubes, cones and cylinders -firmly outlined in black, creating schematic forms which tend towards abstraction. The palette is reduced to the primaries, red, yellow and blue, and there is no causal relation between an object and its colour. On the contrary, both the shapes and the distribution of colour have the function of representing movement. In Léger's works, movement in its literal sense has a greater presence than in the paintings of Braque and Picasso, who focus more on the changing aspects of reality as a function of our own perception of them (conditioned by spatial and temporal factors).

As noted above, Léger started from the basis of Cubist principles, which he combined with Futurist ideas. Gradually his work became more abstract, uniting the Cubist sense of volume with an admiration for the machine and industrial society. Nonetheless, Léger considered

"A work of art must be significant in its own time, like any other intellectual manifestation, whatever it may be. Painting, because it is visual, is necessarily the reflection of external conditions, not psychological ones. Every painting must allow of this momentary and eternal value, which will make it last beyond the period of its creation."
FERNAND LÉGER

Composition.
The Disk, 1918
Oil on canvas,
65 x 54 cm

that painting should be about purely visual values and should not be used to represent a subject but just as an end in itself. For this reason his admiration for the machine functions more as a reference point when working out his pictures, whose contents were to convey the same precision, dynamism and modernity as the modern machine. For Léger, it was the duty of painting to be a symbol of modern society, comparable to machines and industry.

It is in this context that we may view *Composition. The Disk* of 1918, constructed with a compositional and chromatic rhythm which has

The Terrace, 1922
Gouache on paper,
23 x 31 cm

great visual impact, aiming to convey the idea of precision, coldness and automatism, but at the same time filled with great pictorial strength.

 The Terrace of 1922 represents a new stage in Léger's artistic evolution. He had left behind his "mechanical period" in order to return to certain figurative elements, in particular the city and the human figure. There was a general tendency during the 1920s to produce more balanced forms and compositions, accompanied by a return to order (in the some cases more figurative than others). Léger, as we see in this work, softens his palette and creates calmer and more static compositions structured around orthogonal planes. His knowledge of the work of Mondrian and van Doesburg, as well as his meeting with the architect Le Corbusier, were vital influences in this period, in which he focused his interest on the relations between architecture and painting and spatial representation.

The Embarassment, 1914
Watercolour and pencil
on paper and cardboard,
54 x 65 cm

Francis Picabia

PARIS, 1879 – 1953

As a young artist, Picabia was a celebrated Post-Impressionist influenced by Sisley and Pissarro. He held his first one-man show in 1905. Later he became involved successively with Fauvism, Cubism and the Duchamp brothers' Puteaux group, as well as producing a few works in the Orphist manner of Delaunay. After 1913, when he took part in the Armory Show in New York with considerable success, his interest in music led him towards abstraction, and he produced a group of works which he defined as "psychological studies".

This is the period which produced *The Embarassment*, in which Picabia reproduces the appearance of the visible world as processed by his imagination. The composition is an accumulation of impressions and experiences which, in the artist's own words, he allowed to rest in his brain before transplanting them onto the canvas. It alludes to a place, now unrecognizable, where Picabia must have had some meeting or accident which is not revealed by the image, but only suggested in the title printed on the canvas in the upper left corner.

The curving bands and geometrical planes set up a perspectival mesh seen from multiple viewpoints, offering us glimpses of the setting or settings of the incident, albeit in a fragmented fashion which yields up just a few indelible clues. In the lower right corner, for example, there appear to be some steps and a handrail, at the end of which we encounter some ornamental forms similar to mouldings on a wall. In conjunction with the labyrinthine recreation – through different planes of colour – of what could be corridors, corners and doors, these prompt us to think of the inside of a house whose corners have buried themselves in the artist's memory, and which are represented simultaneously on the canvas in a desire to escape them.

Picabia's versatility, and his rejection of the rules of all the artistic movements with which he allied himself through the course of his career, made him one of the most illustrious figures of Dadaism, a movement for which he designed satirical pamphlets and mounted scandalous performances.

"Artists are afraid; they whisper in each other's ears about a bogey man who might well prevent them from playing their dirty little tricks! No age, I believe, has been more imbecilic than ours."
FRANCIS PICABIA

Cubism, 1914
Oil on canvas,
72 x 60 cm

Nadezhda Udaltsova

OREL, 1886 – MOSCOW, 1961

The career of this Russian artist is closely bound up with that of Liubov Popova. In 1912 both women moved to Paris, where they studied with Jean Metzinger and Henry Le Fauconnier, returning to Moscow to work with Vladimir Tatlin. They demonstrate the spread of Cubism to Eastern Europe and reflect the interest which the Cubist system of representation awoke among the artists of the Russian avant-garde, and whose influence would be felt even in contemporary, emphatically Russian art movements such as Tatlin's Constructivism and Malevich's Suprematism. Like Popova, Udaltsova is considered a key representative of Cubo-Futurism, a term coined by Malevich to define certain works which appeared in the exhibitions entitled "The Donkey's Tail" in 1912 and "The Target" in 1913.

The present work has the self-explanatory title of *Cubism* and is typical of Udaltsova's Cubo-Futurist phase, which preceded a brief Suprematist phase in 1916. In contrast with pure Analytical Cubism, which was characterized by its austere palette of greys and ochres, Udaltsova develops a strong chromatic range spotted with lively colours in touches of red, orange, intense blue and white, which accentuate the effect of the vibration of light and help to emphasize the movement within the composition.

This sense of movement is created by the multiplication and juxtaposition of the planes of colour. These are dominated by an ascending diagonal running from left to right, which breaks with the marked verticality of Analytical Cubism (see, for example, *Man with a Clarinet* and *Woman with a Mandolin* by Picasso and Braque respectively), and creates a faster dynamic within the work. The letters painted on this diagonal, combining the Latin alphabet with the Cyrillic, reveal the artist's interest in typography and in the reality of the objective world, connecting with the ideas of Synthetic Cubism.

*Patriotic Demon-
stration*, 1915
Tempera on canvas,
100 x 136.5 cm

Giacomo Balla

TURIN, 1871 – ROME, 1958

Giacomo Balla was the oldest and most famous of the Italian Futurists. Together with Severini, he signed the Futurist manifesto of 1910 and was the teacher not just of Severini, but also of Umberto Boccioni, another active member of the group, better known for his sculpture than his painting. Although he developed a completely abstract style, Balla remained convinced throughout his career of the necessity of remaining close to figuration in order to avoid falling into a completely decorative manner.

Patriotic Demonstration is a good example of this. Executed in 1915, with war raging elsewhere in Europe, it depicts a common event of the time: a public demonstration. The artist conveys the movement of the crowds and the waving of flags through totally abstract superimposed wedges of colour and curved forms. Such demonstrations called for Italy's entry into the war and were strongly supported by the Futurists, who welcomed the advent of the conflict as a break with the status quo and the pathway to a new, purified society. This support was in line with their enthusiasm for social progress, danger and change. What was to come did not fulfil their expectations, however, and many Futurist artists died or were wounded at the Front. Around 1919 the movement fell into disrepute when it openly supported Italian Fascism.

"Futurism, predestined force of progress and not of fashion, creates the style of flowing abstract forms that are synthetic and inspired by the dynamic forces of the universe."
GIACOMO BALLA

In addition to the colours of the Italian flag (white, green and red), a notable element in the present painting is the white band in the middle of the composition which has been interpreted as symbol of infinity, and also as the number 8, alluding to the dynasty of the House of Savoy to which the Italian king, who supported intervention in the war, belonged.

Liubov Popova

KRASNOVIDOVO, 1889 – MOSCOW, 1924

Popova's training was similar to that of Udaltsova, and was influenced by her exposure to Cubism while studying in Paris. On returning to Russia, she worked in a style similar to that of Malevich's Suprematism, in which geometric forms float in space, and through which the Suprematist artists investigated the relations between form and colour in the search for a pure art devoid of any purpose – an "art for art's sake" or, if you prefer, the expression of pure aesthetic sentiment.

In *Still Life with Instruments* Popova employs Suprematist devices but for a different end: she brings movement to the fixed and static character of Malevich's forms. Thus a series of irregular geometric forms in bright, flat colours, seemingly suspended from invisible threads, recreate a moving structure turning around the black oval which is partly hidden by the shapes in front. The strongly delimited outlines of these shapes, their flat colours and the arbitrary arrangement of light and shadow break with spatial depth and invoke a practically two-dimensional space which corresponds with the two-dimensionality of the support. Popova believed that the recreation of a three-dimensional space was an intrinsic quality of sculpture and relief, but not of painting.

◄ *Still Life with Instruments*, 1915
Oil on canvas,
105.5 x 69.2 cm

Architectonic Composition, 1918
Oil on canvas,
45 x 53 cm

For all the richness of the textures produced by a denser and more impastoed layer of oil paint, and the precise tonal gradation which constructs the volumes, the approach in *Architectonic Composition* is essentially the same. The intersection – or "interfoliation", as Popova called it – of the planes, which slice each other in different directions, prevents a clear perception of a sense of depth; rather, it gives rise to a sense of piling up in the foreground, accentuated by the fact that the forms extend right to the edges of the canvas. While in the still life we find references to a musical instrument, specifically a guitar, in *Architectonic Composition* these have been reduced to a structuring of space which is purely geometric and non-objective.

Edward Wadsworth

CLECKHEATON, YORKSHIRE, 1889 – LONDON, 1949

Together with Wyndham Lewis (of whom the Museum also possesses a work on paper entitled *Composition in Red and Mauve* of 1915), Wadsworth is one of the chief representatives of Vorticism, a London-based avant-garde movement created by Lewis. The artists of the group published their manifesto in 1914, in the magazine *Blast* which they founded themselves. Vorticism was based on Futurist and Cubist principles and defined itself as a radically abstract movement which, although it did not last beyond World War I, succeeded in introducing avant-garde trends into the British art scene at the beginning of the 20th century.

Vorticist Abstraction illustrates the principal characteristics of the movement: It is emphatically graphic in style, with straight lines, fractured and dispersed within a composition pursuing an ascending diagonal and occasionally interspersed with curved lines (segments of a circle which almost seem to have been drawn with a compass) which lean out of the vigorously interwoven grid of lines. The colour, in pastel tones, is typical of Wadsworth's habit of contrasting his violent compositions with gentle colours.

Even though the work's abstract character is obvious, it is probably based – like other works by the artist- on a real image, suggested here by the central element which looks like a beach hut and above it the blue and grey bands joined to a line or mast in the same colour, which could suggest a flag. Overall, the source of inspiration for the painting could be a beach scene or port, typical subjects in his work.

The potent sense of movement, the ascending composition and a bird's-eye view all conform to a compositional structure which recurs repeatedly in the few oil paintings surviving from Wadsworth's hand. A large part of his œuvre was destroyed or went missing during World War I, in common with almost all of the Vorticists' work. For this reason the movement still remains little known and little studied, making this oil an exceptionally important one and highly prized by students of Vorticism.

Vorticist Abstraction,
1915
Oil on canvas,
76.3 x 63.5 cm

Max Weber

BIALYSTOCK, RUSSIA, 1881 — GREAT NECK, NEW YORK, 1961

The painter Max Weber was born in Russia but emigrated to the United States while still young. He belonged to the circle around the photographer Alfred Stieglitz and his "291" gallery, whose importance for the introduction of European avant-garde art into America was mentioned earlier in the entry on Marsden Hartley. Weber exhibited at "291" in 1910, although the American public had already seen his work a few years earlier on the occasion of his first one-man show at the Haas Gallery in New York.

A pupil of Matisse while he was in Paris from 1905–1908, Weber developed a style which has been described as "strongly personal". It might also be described as rather eclectic in the way it combines elements of Cubism (with regard to composition and colour) and Futurism (in terms of movement). Whether by coincidence or as a consequence of the common influences behind their work, the result brings him close to the Vorticist style of Wadsworth. This can be seen in *Grand Central Station* in the overall diagonal arrangment of the elements, underlined by the use of transparent bands which reveal a real landscape as the basis of the composition. We can thus make out architectural structures with roofs, windows and tunnels appropriate to the station and its surroundings.

Another feature in common with Wadsworth is the use of quite pronounced broken lines, arranged parallel to each other, which give the image a geometric and dynamic quality and create labyrinthine structures, particularly at the bottom of the canvas and towards the middle, just above the mesh crowned by red semicircles. However, the pronounced faceting of the chromatic structure of the background and the use of multiple viewpoints also brings the work into line with Cubist principles.

"Art is no mere representation; it is and should be interpretation, revelation."
MAX WEBER

Grand Central Station, 1915
Oil on canvas,
152.5 x 101.6 cm

Bart van der Leck

UTRECHT, 1876 – BLARICUM, 1958

B voL

While Bart van de Leck is generally relegated to a secondary position after van Doesburg and Mondrian, his contribution to the development of Neo-plasticism was important and he also had an undoubted influence on Mondrian's work. Like van der Leck, Mondrian used segmented lines to construct some of his best-known oval compositions, which represent the façades of buildings and which he produced in an intermediary phase of his development.

However, while Mondrian and Theo van Doesburg were advancing towards a geometric system of total abstraction, van der Leck resisted abandoning figurative references altogether. Using segments of primary colours (red, yellow and blue) and black, as in the early *Mountains with an Algerian Village*, or small, coloured geometrical shapes against a very light background, as in his *Woodcutter*, the subjects which are indicated by the titles are evident even through the highly schematic representation of the motifs. Thus, in the first painting, we can read the mountains

*Composition.
Mountains with an
Algerian Village,* 1917
Gouache on fibrous
parchment paper,
100 x 154 cm

of the title in the white diagonals, while in *Woodcutter*, a work executed after the artist had left the De Stijl group, we can make out two figures, although it is easy to miss them at first glance.

Mountains with an Algerian Village is a study for a composition painted that same year, and is executed in gouache on fibrous paper. In this case the lightness and transparency of the materials (much less dense than oil and canvas) contribute to a potent luminosity radiating from the white of the background, in keeping with the natural light of North Africa – so important for many 19th-century artists – which van der Leck had encountered during a visit to southern Spain and Algeria in the spring of 1914.

Woodcutter, 1927
Oil on canvas,
59 x 70.5 cm

Johannes Itten

SÜDDERN-LINDEN, SWITZERLAND, 1888 – ZURICH, 1967

*Group of Houses
in Spring*, 1916
Oil on canvas,
90 x 75 cm

A graduate in mathematics and natural sciences, Itten is perhaps better known for his work as a teacher than as an artist. It was Itten who encouraged Gropius to set up the preliminary course at the Bauhaus as an obligatory foundation course for students, and who assumed responsibility for teaching it. Before his time at the Bauhaus he had opened his own art school in Vienna, and would do so again later in Berlin.

This abstract painting (albeit one which retains clear references to the visible world) shows the influences of Delaunay's Orphism in the rhythmical and circular arrangement of the planes, which move out from the houses grouped in the centre. The boldly colourful palette is based on the contrasts of primaries and complementaries, and achieves a very subtle tonal gradation through an almost Impressionist brushstroke, especially in the sky at the top of the canvas. In contrast, the paint is applied more evenly in the red roofs of the houses, giving them a solidity which contrasts with the much more transparent and ethereal atmosphere surrounding them.

Colour was Itten's principal focus of interest, and in this he was mainly motivated by Adolf Hoelzel, who taught him at the Stuttgart Academy. Hoelzel developed the idea of an "absolute art" based on the musical associations of colour, very much in keeping with the ideas of his time, which he passed on to his pupil. The gradation of light is also very rich and expressive in the present work. The white façades of the houses are the principal focus of light, which gradually expands across the whole canvas and accompanies and accentuates the circular rhythms of the composition.

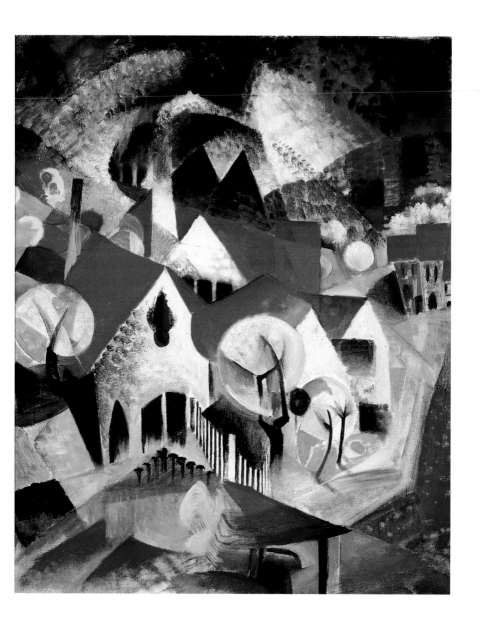

Marc Chagall

VITEBSK, RUSSIA, 1887 — ST. PAUL DE VENCE, 1985

Born into a humble Jewish family, Marc Chagall is a painter whose art is difficult to classify. His style combines references to his own life in Russia, his religious beliefs and traditional Russian art with the new ideas of the avant-garde with regard to colour and composition, learned from the Fauves, Cubists and Surrealists in Paris, a city which Chagall visited in 1910 and where he settled permanently in 1923.

In 1917 he spent two months in his native Vitebsk, where he executed *The grey House*. It is a composition in which – unlike *The Cockerel* – line predominates over colour. The painting is a view of Vitebsk, rendered sombre and unstable by the predominance of ochre and grey colours and the construction of the perspective from different viewpoints. The composition consists of three horizontal strips defining three different spaces: the sky, which could form an abstract composition in itself due to the different pictorial treatment which it receives; the buildings, which are cut off by the fence of the grey house; and the lower part of the canvas, with a road and what could be a pile of logs. All these elements recall Expressionist ideas which can be seen in other paintings in the Museum.

"We all know that a good person can be a bad artist. But no one will ever be a genuine artist unless he is a great human being and thus also a good one."
MARC CHAGALL

In *The Cockerel*, on the other hand, a key work in Chagall's œuvre, the artist plunges us into the world of colour, fable, symbol and dream which we normally associate with his painting. Everything here is unreal and fantastical, from the associations of colour – with the green and blue of the background predominating – to the recreation of the misty, imprecise atmosphere which characterize his dreamlike images. The cockerel, which is larger than life and thus able to support the woman who amorously embraces it, the disconcerting figure of the cow, barely sketched in between the feet of the cockerel and the two pairs of lovers (one in a boat and the other at the woman's feet) form part of Chagall's iconographic universe, whose interpretation, has been widely discussed clearly refers to the theme of love.

The Cockerel, 1929
Oil on canvas,
81 x 65.5 cm

The grey House, 1917
Oil on canvas,
68 x 74 cm

"If a symbol should
be discovered in a
painting of mine, it
was not my intention.
It is a result I did not
seek. It is something
that may be found
afterwards, and which
can be interpreted
according to taste."
MARC CHAGALL

George Grosz

BERLIN, 1893 – 1959

George Grosz

Nude, c. 1919
Watercolour, Indian ink and collage,
49 x 29.2 cm

George Grosz belongs to the third wave of German Expressionists, artists who have been grouped together under the label of *Neue Sachlichkeit* (New Objectivity). Considered the most important satirical artist of the 20th century, much of his work was linked to the dramatic events which took place in Europe in the first half of the century: World War I and its aftermath, the situation in post-war Germany and the rise of Hitler and the Nazi party. Grosz produced various series of watercolours and drawings of a satirical nature, attacking a bourgeoisie and a military who ignored the hardships and sufferings of the rest of the population and brought the country into a state of internal conflict which culminated in World War II. Even before these works, however, Grosz was showing his rebellious attitude to authority and was one of the leading representatives of the Berlin Dada movement.

Metropolis is one of his most famous paintings. It was executed at the height of World War I, and was painted in two stages separated by a period when Grosz was called to the Front. In it, the artist expresses all the anguish and madness of the war for ordinary citizens. He creates an oppressive atmosphere through his use of an almost monochromatic red, the exaggeratedly tunnelled perspective and the masses of amorphous figures who mingle together without any apparent sense of purpose or direction. Grosz here combines the influence of Cubism with Futurist elements. The piling up of elements and figures in the foreground, some of the figures with skull-like faces, gives the image the feeling of a night-

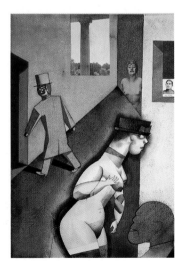

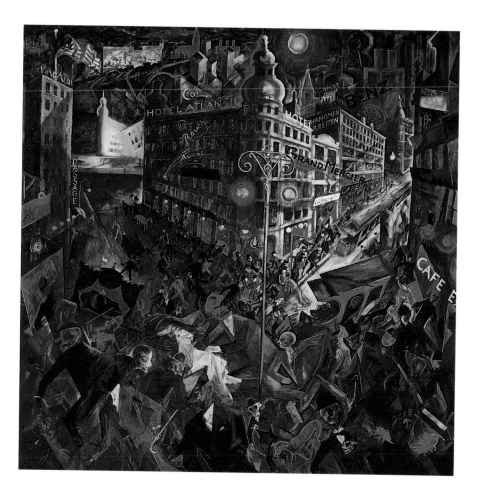

mare, but at the same time, given the context in which Grosz painted the work, points to a profound and lamentable reality.

 Nude and *Twilight* are two good examples of his satirical drawings. These drawings and watercolours always had political connotations and criticized contemporary society, in particular the contrast between the wealthy middle classes who ignored the miserable situation of the beggars around them, many of whom were war-wounded. His caricature-like figures have disagreeable faces and are portrayed as insensitive and soulless. Next to them he juxtaposes the misery of the marginalized, the

Metropolis, 1916/17
Oil on canvas,
100 x 102 cm

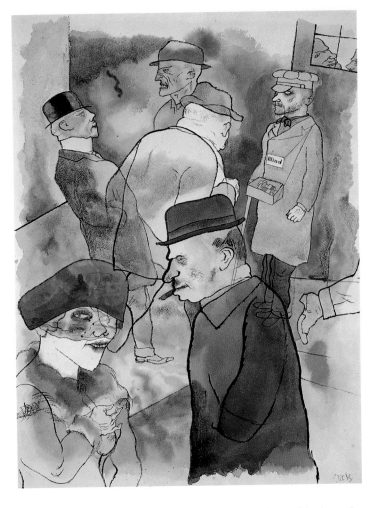

Twilight, 1922
Watercolour
on paper,
52 x 41 cm

old and worn-out prostitutes with their excessive make-up, blind people and other unfortunates begging for alms.

We recognize these same social types in the canvas *Street Scene*, albeit in a more objective vision of the same subject. The composition is balanced, the painting is highly finished and executed with a certain amount of detail and precision. However, it still has a caricaturesque approach in its depiction of the figures and also includes misery and hypocrisy as elements in the narrative.

Street Scene, 1925
Oil on canvas,
81.3 x 61.3 cm

The rise to power of the Nazi party had dangerous consequences
for Grosz, as it did for many other avant-garde German artists. His art
was branded "degenerate" and he was forbidden to paint or exhibit. The
tense political atmosphere led him to emigrate to the United States in
1933. He returned to Germany just one year before his death.

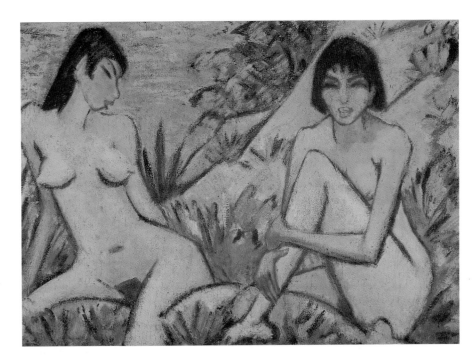

*Two Women seated
in the Dunes*, c. 1922
Oil on canvas,
100 x 138 cm

Otto Mueller

LIEBAU, SILESIA, 1874 – BRESLAU, 1930

Otto Mueller, who was the last artist to join the group Die Brücke in 1910, destroyed many of his early works, which were painted in an Art Nouveau style and influenced by the work of Arnold Böcklin. Later, after a period of working closely with Ernst Ludwig Kirchner, he developed his own style to which he remained faithful throughout his career, and which we can see in the present painting of two women in the sand dunes.

The subject of the painting is in fact man's relationship with nature, a theme which interested all the Expressionists. Mueller gives the female nudes elongated and angular proportions, revealing a knowledge of African and Egyptian art. Both figures, shown in relaxed poses, are identified with the landscape through the texture of their skin, which is literally earth-coloured, blending with the background of the composition. This unification of the colour of the women and the elements around them (the side of the mountain and the sky) is broken only by the green of the vegetation. The lack of spatial depth dictates the arrangement of the elements within just two planes. The clear black outlines which delimit the forms are deliberately used to isolate the human beings from their surroundings – and imprison them within it.

These defining black lines and the softness of the colours and contrasts of light create harmonious rhythms which differ from the nervous and jagged compositions of the other Die Brücke artists, in whose work the natural or urban world which surrounds the figures is seen as hostile. Despite this, the obvious immobility of Mueller's figures, who seem rather like articulated mannequins, gives the work an unsettling character, added to which is a patently erotic charge derived from the poses and the exotic and voluptuous features of the models.

"My art cannot be bought. I will not exchange my feeling for any earthly treasure. Other people might run themselves ragged for money, fame and honour, but I am not taking part in this. I would rather lie on the grass under blooming flowers, let the wind caress me, listen to the hustle and bustle of the people – this gives me strength and amuses me – and dream away the day."
OTTO MUELLER

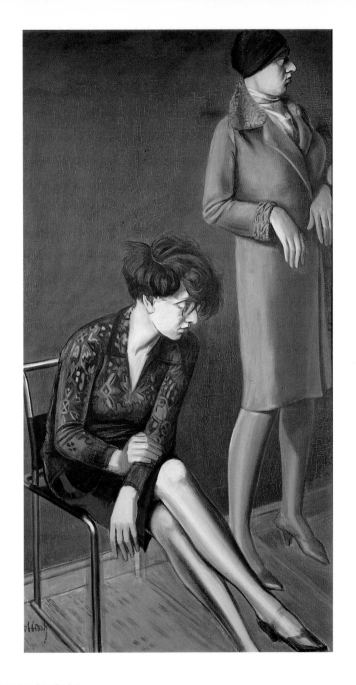

Karl Hubbuch

KARLSRUHE, 1891–1980

Like Otto Dix and Christian Schad, Karl Hubbuch was considered a "degenerate" painter by the Nazi regime, and like the other two artists was banned from exhibiting his work and teaching (he was a professor at the School of Fine Arts in Karlsruhe). These painters pursued an unflattering and direct art which stood up against the injustices of the new regime, and disseminated a negative and decadent vision of the German nation in the war and interwar years, focusing on debt, inflation, the decline in moral standards, social disorders, etc. For the Nazi regime, which claimed to be bringing about the rebirth of a nation from the ashes and one which would be the leader of all of Europe, this was not a desirable form of art.

Hubbuch was one of the most incisive painters of New Objectivity, and he cultivated a genre which was much used by its artists, namely the portrait, of which the Thyssen-Bornemisza Collection has many excellent examples. In this incomplete double portrait (it lacks the other half of the panel with two further representations of Hilde, which is now in Munich), the artist shows his wife in various poses. The first figure is shown as withdrawn, an attitude accentuated by the closed position of her arms which are folded over her knees, and the fact that her legs are crossed, a pose indicating a – generally unconscious – desire to protect or isolate oneself. In the second representation, Hilda is standing up and wearing totally different clothes, looking at an indeterminate spot as if she had just been surprised by the arrival of someone or something.

The bare room is also striking, with its plain ochre-coloured background against which the figures stand out, illuminated by a strong artificial light which makes the woman's skin, probably already pale, seem almost white and corpse-like. The missing half of the panel holds the probable key to the symbology of the work, which has been interpreted as a modern version of the "four humours" on account of the sitter's different moods and clothing.

Double Portrait of Hilde II, c. 1923
Oil on canvas attached to panel,
150 x 77 cm

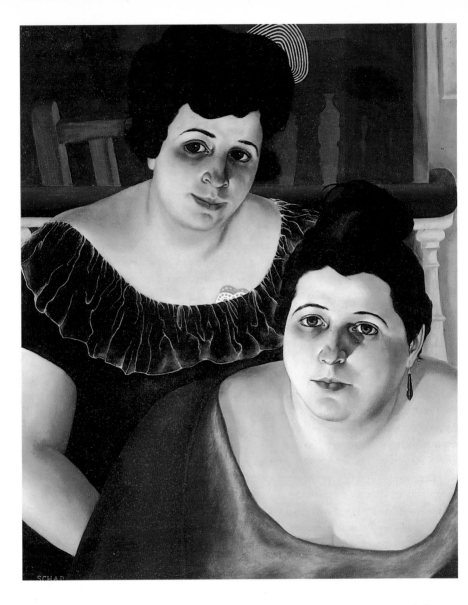

*Maria and Annunziata
del Puerto*, 1923
Oil on canvas,
67.5 x 55.5 cm

► *Portrait of
Dr Haustein*, 1928
Oil on canvas,
73.5 x 50.5 cm

Christian Schad

MIESBACH, BAVARIA, 1894 — KEILBERG, 1982

Christian Schad, a little-known artist despite his long career, is perhaps the most dispassionate, cool and precise of all the representatives of New Objectivity, for which reason his paintings have been described as surgical operations. Using a similar style of portrait to Dix and Hubbuch, Schad places the sitter in front of a plain and undecorated background, concentrating on the physiognomy of the figures whom he represents in a totally unidealized way. This precision, which is accentuated through the use of directed sources of artificial light within closed settings, is present in the two paintings reproduced here. While the light falls on Dr Haustein from the front, so that no shadows are cast directly onto him, in the portrait of Maria and Annunziata it comes from behind, giving the two sisters an unreal and rather fantastical appearance.

"Just being able to paint well will never produce good painting. One is born a good painter."
CHRISTIAN SCHAD, 1927

The two del Puerto sisters were actresses, painted here in a theatre box rather than on stage, a puzzling presentation which may encourage the viewer to wonder about their personalities. This mysterious feeling is particularly evident in the portrait of Dr Haustein, a Jewish doctor specializing in venereal diseases, due to the presence of the threatening shadow on the back wall which is obviously not his own. Haustein's sad expression, his clasped hands which suggest anxiety and his thoughtful although absent gaze, together with the shadow of the smoking woman who is none other than his lover Sonja, all suggest a story of human relations and one in which Schad was involved as a friend of Haustein's. In fact, Haustein's affair with Sonja, a model, drove the doctor's wife to suicide, a tragedy completed by Haustein's own suicide two years later, when he learned that the Gestapo were pursuing him. Another intriguing element is the surgical instrument the doctor holds for no apparent reason under his arm, but which undoubtedly refers to his profession.

Portrait of Hugo Erfurth
with his Dog, 1926
Tempera and oil
on panel, 80 x 100 cm

Otto Dix

GERA, THURINGIA, 1891 — SINGEN, 1969

As one critic said of Otto Dix, he was "the Expressionist among the Verists", as he continuously moved between the two artistic tendencies. He did so naturally, as a man of passionate character, forged by the suffering of the war and the oppression of the Hitler regime (in 1933 Dix was banned from exhibiting or teaching, and in 1937 his work was included, like that of many other German modern artists, in the notorious "Degenerate Art" exhibition). His experiences led him to produce a series of deeply-moving works in which he depicted the horrors of war (crippled war veterans, the indifference of society), in a cool and detached way which left the images to speak for themselves. That same distance, or objectivity, is also evident in his portraiture, which was an important part of his œuvre.

This portrait of Hugo Erfurth, a popular photographer during the Weimar Republic whom Dix had painted on a previous occasion, is a good example of *Neue Sachlichkeit*, or New Objectivity; indeed, Dix's work was central to the Mannheim exhibition which gave the style its name. Using a fine, almost invisible brushstroke, the painting is executed with a draughtsmanlike precision which looks back to the techniques of the German Old Masters of the 16th century, and which complements the aim of the artists of New Objectivity to represent reality in a faithful way.

A striking feature of this portrait is its profound psychological analysis of the sitter, articulated not just through his gaze, which is lost in space as he stares ahead of himself, but also through the expressiveness of his physique, with his rather stooped upper body, his head leaning forward over the torso and a hand not so much resting on as tightly gripping the arm of the chair. No less impressive is the figure of the dog Ajax, outlined in strict profile against the plain blue background which contrasts with his dark fur, in the same way that the paler and more brightly lit figure of his owner stands out against the other half of the background, in which Dix has painted a curtain.

"It is my wish to come very close, strikingly close, to the times in which we live, without submitting to artistic dogma ... I need the connection to the world of the senses, the courage to portray ugliness, life as it comes."
OTTO DIX

El Lissitzky

POCHINOK, 1890 – MOSCOW, 1941

El Lissitzky's *Prouns*, which he defined as an "intermediary state between painting and architecture", are the result of his collaboration with Malevich. Trained as an architect in Germany, where he qualified in 1914, he was from the start associated with western European avantgarde art movements, particularly with the Neo-plasticists and the members of the Bauhaus. El Lissitzky was a multifaceted artist (like the majority of artists in the Russian avant-garde), who produced theatre designs, typography, photography and drawing, but who, despite the importance of his ideas for the architecture of the 20th century, never actually designed a built building.

The *Prouns* were part of the Constructivist tendency in post-Revolutionary Russia. Constructivism, which in line with Bolshevik ideology was oriented more towards production than to the realisation of works of art, unleashed a large number of architectural drawings which, like Lissitzky's *Prouns*, never got further than the drawing-board. The instability of their impossible forms, their often colossal scale, and the influence of the machine led many of these designs to be considered Utopian; even today, with all the technological advances of the past hundred years, it would still be impossible to build them.

Proun 1C, 1919/20
Oil on panel,
68 x 68 cm

Like Suprematist compositions, the *Prouns* involve geometrical forms suspended in space, but constructed in three dimensions. The simultaneous use of different vanishing points gives the viewer the feeling of looking at these structures from different locations in space, thus departing from the traditional laws of Renaissance perspective. While at times it seems that we see El Lissitzky's shapes from the air, as if we were flying over them, a second look returns the viewer to earth and situates the forms above our heads. This type of composition relates to a series of "reversible" axonometric drawings by the artist which can be read the same way in both directions, emphasizing their geometrical aspect.

Proun 4B, 1919
Tempera on canvas,
70 x 55.5 cm

"Constructivism
demonstrates that
the borders between
mathematics and art,
between a work of art
and an invention of
technology, cannot
be ascertained."
EL LISSITZKY &
HANS ARP

Kurt Schwitters

HANOVER, GERMANY, 1887 – KENDAL, ENGLAND, 1948

Schwitters is a difficult artist to classify. He was connected with Dadaism, the avant-garde movement which developed in Europe from the time of the outbreak of World War I in 1914. Its original centre was Zurich, a neutral city which was the refuge for quite a number of artists opposed to the war. It evolved as an artistic movement with a pronouncedly anti-war stance, which rejected all previous art on the grounds that it reflected a society and a set of values which had led the world to the catastrophe of the war. Dada signified the negation of everything, the rejection of accepted values and anything conventional, and a desire to revolt against the status quo. It spread to Paris and Berlin as well as New York. From Berlin, where Dadaism acquired more explicitly political associations, it moved to other German cities such as Hanover, where Schwitters was embarking upon his career as an artist.

Schwitters avoided political connotations in his work and always advocated pure painting, defending art as an independent activity. In the face of the utter nihilism of the early Dadaists, Schwitters evolved towards the construction of a new art, in which he broke with traditional elements. Thus his works have their own generic name: Merz (which came from a fragment of a newspaper cutting which he included in one of his collages and which featured the word *Commerz*). In his Merz works, the artist drew on any objects he found at hand, with a preference for discarded waste material, an approach already seen slightly earlier in the *objets trouvés* of Man Ray and the ready-mades of Marcel Duchamp.

The Alienist (or *The Psychiatrist*) is one of Schwitters' earliest Merz works (numbered as *MZ IA*). Composed from an assemblage

Klrt Schwitters

◄ *Merzbild 1A (The Psychiatrist)*, 1919
Mixed media on canvas, 48.5 x 38.5 cm

Merzbild Kijkduin, 1923. Mixed media on cardboard, 74.3 x 60.3 cm

*Entry Ticket
(MZ 456),* 1922
Collage,
18.2 x 14.5 cm

of scrap materials superimposed on the painted outline of a face, the
paint acts as the unifying element for the diverse objects. The other
Merz works reproduced here, *Merzbild Kijkduin* and *Merz 1925,* trace the
artist's evolution over time. Thus his compositions have grown simpler,
less cluttered with objects and more carefully constructed. Conse-
quently they are more sensory and intellectual.

 In addition to these Merz paintings, Schwitters worked in collage,
as in *Entry Ticket (MZ 456),* which respects the flat surface. The work is
produced from the juxtaposition and superimposition of scraps of cut-

Eight-sided
Composition, 1930
Oil on panel,
91 x 90 cm

out paper of various provenances (newspapers, magazines, visiting cards, postcards, stamps, and in this case an entry ticket to an exhibition at the Lübeck Museum), without the use of any painting or drawing. The composition obeys a rigorous geometry, creating an orthogonal composition which is occasionally broken by diagonal lines and irregular edges.

Eight-sided Composition, the latest work here, is one of Schwitters' occasional incursions into oil painting, in which he comes close to the geometric abstraction being variously upheld in European painting between the wars. The compositional clarity and the equilibrium in the arrangement of the colour masses testify to the evolution in Schwitters' aesthetic thinking over the years.

"I called my new way of creation with any material 'merz'. This is the second syllable of 'Kommerz' (commerce). The name originates from the 'Merzbild', a picture in which the word 'merz' could be read in between abstract forms. It was cut out and glued on from an advertisement for the Kommerz und Privatbank."
KURT SCHWITTERS

Theo van Doesburg

UTRECHT, 1883 – DAVOS, SWITZERLAND, 1931

Theo van Doesburg was the spokesman of the De Stijl group, which crystallized in Holland within the context of World War I. It was founded in 1917 by Mondrian – who would become its most important member –, Vilmos Húszar, Bart van der Leck, the sculptor Georges Vantongerloo and Theo van Doesburg, as well as a number of architects and poets.

The artists of De Stijl published a magazine of the same name, through which they promoted their new theories of art, which were highly complex in their apparent simplicity and were known under the generic name of Neo-plasticism. They aspired to the creation of a universal art which would bring together all the artistic languages in existence and which would also serve a practical and didactic purpose: helping to achieve the harmony and order which was so needed in the world after the upheaval of World War I.

According to Neo-plasticist theories, the purest expression of order and harmony was to be found in the simplicity of the forms which result from the opposition of horizontal and vertical lines, and in the use of pure colour. Neo-plasticist painting thereby renounced for ever all reference to the representational world, as illustrated by

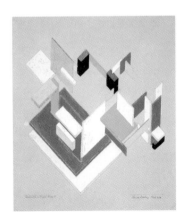

van Doesburg's *Composition* of 1919/20. This development can be traced back to Mondrian, whose work van Doesburg first encountered in 1915 and whose influence he immediately began to absorb, more obviously from 1918, the year in which the two men came very close in their artistic standpoints.

Van Doesburg's interest in architecture, which developed in the 1920s, and the De Stijl emphasis on the integration of the arts, led him to produce architectural drawings based on axonometric projections, which he called "contraconstructions". These constitute van Doesburg's reflections on the spatial

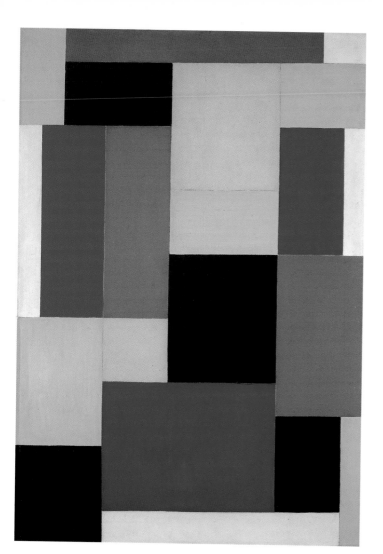

Composition, 1919/20
Oil on canvas,
92 x 71 cm

problems of architecture, and compose a structure by means of planes of primary colours which seems to float in an undefined space, inevitably leading us on to the architectonic compositions (*Prouns*) of the Russian Constructivists, notably El Lissitzky.

◄ *Spatio-temporal Construction II*, 1923
Gouache on paper,
46 x 39.7 cm

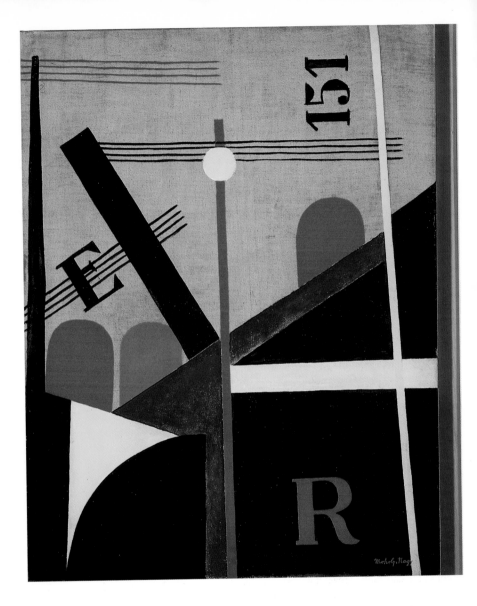

*Large Railway
Painting*, 1920
Oil on canvas,
100 x 77 cm

▶ *Circle Segments*,
1921
Tempera on canvas,
78 x 60 cm

László Moholy-Nagy

BACSBARSOD, HUNGARY, 1895 – CHICAGO, 1946

Moholy-Nagy belongs to the breed of self-taught artist who assimilates the ideas of various different schools in order to develop his or her own powerful and distinctive style. In these two works, executed after his return to Berlin in 1920, we see him orienting himself towards the Suprematism of Malevich. He trained in Law and first took up painting when recovering from a war wound in 1916. Later he also worked as a sculptor, photographer, and interior designer, and taught at the Bauhaus.

Moholy = Nagy

In Hungary and later in Vienna and Berlin, Moholy-Nagy was an active member of the artistic avant-garde. The railway was no uncommon subject for avant-garde artists of the day symbolizing as it did speed and technological progress. Moholy-Nagy's treatment of the subject is abstract, but there are nevertheless clear references to tunnels, rails, pylons and telegraph cables, crossings and barriers. The red vertical line in the centre of the canvas, which we might read as the barrier of a level crossing, divides the composition into two exact halves. This line, repeated on the right and left in yellow and black to accentuate the verticality of the composition, is counterbalanced by the cross of oblique and horizontal lines which give the whole image a dynamic equilibrium.

"My talent lies in the expression of my life and creative power through light, colour and form. As a painter I can convey the essence of life."
LÁSZLÓ MOHOLY-NAGY

A solid equilibrium is also evident in *Circle Segments*, in which the composition is reduced to the barest essentials. The two powerful segments in contrasting black and white against the ochre background create a strong visual impact, both through the contrast of black and white and of straight and curved lines, and through the paradoxical arrangement of the chromatic areas: it would be logical to think that the segment of the black circle, which is visually more dense, solid and heavy, would support the white one, which is much lighter, more luminous, and so on.

Georgia O'Keeffe

SUN PRAIRIE, WISCONSIN, 1887—ABIQUIU, NEW MEXICO, 1986

Georgia O'Keeffe is an exception among American artists active in the first half of the century, in that she never travelled to Europe while she was studying art. She learned to paint in various art schools on the American East Coast and was for a number of years a teacher. The year 1916 saw a radical change in her life and career when the famous art dealer and photographer Alfred Stieglitz showed her work in his "291" gallery in New York.

Stieglitz played an important role in bringing avant-garde European art to America, and also showed the work of the most modern and radical American artists, such as Marsden Hartley, Arthur M. Dove and Max Weber. O'Keeffe moved to New York in 1918, marrying Stieglitz in 1924, who exhibited her work in his gallery almost every year until his death in 1946.

Her painting alternates between abstraction and figuration, although her figurative works always have an abstract quality to them, in that they place more importance on the purely visual aspects of the work than on the subject, which for O'Keeffe was simply the means to a pictorial end. Conversely, her abstract works seem to include references to or to take their starting point from figurative elements. *Abstraction* of 1920 is such a painting. Some have seen in it a vague reference to the night or, in view of its organic forms, vegetal elements. The work exudes great sensuality and mystery, achieved through a monumental conception of the forms and chromatic gradations which accentuate the volume and depth.

Abstraction, 1920
Oil on canvas,
71 x 61 cm

The same characteristics are to be seen in *White Iris, No.7,* a work which forms part of a series of single flowers on a large scale. The scale is a fundamental element in the conception of this painting; it completely changes the significance of the flower, which is rendered as if it were an abstract painting, imbued with an almost musical harmony of undulating tones and lines.

White Iris No. 7, 1957
Oil on canvas,
102 x 76.2 cm

*"Everyone has many
associations with a
flower – the idea of
flowers. ... Still – in
a way – nobody sees
the flower – really –
it is so small ... So,
I said to myself –
I'll paint what I see –
what the flower is
to me ..."*
GEORGIA O'KEEFFE,
1939

Lyonel Feininger

NEW YORK, 1871 – 1965

Born into a family of German origin, Feininger subscribed to no one aesthetic movement in particular, but drew upon many during the various phases of his career. His work reveals the influence above all of Cubism and Futurism, as received via the work of Robert Delaunay. Reworkings of these two sources can be seen in a number of key works in the Thyssen-Bornemisza Collection, including George Grosz's *Metropolis*, and they are also evident in the two paintings by Feininger reproduced here. Executed one year apart, while Feininger was teaching at the Bauhaus, they are considered a pair, due to their similar dimensions and the fact that they look back to the artist's years in Paris between 1906 and 1908, as we know from a letter of 1922 from the artist to his wife.

Both paintings are painted in an angular and highly linear style reminiscent of the comic strips which Feininger produced for various publications, such as *The Kinder-Kid's Relief Expedition*, published by the Chicago Sunday Tribune in 1906. The two paintings also have a very geometrical composition with a balanced although precarious symmetry, which is threatened by the pronounced diagonals (some of them created by bands of colour, such as the strong yellow which slants across the building from top to bottom in *Architecture II*) which Feininger uses to create the sensations of depth and movement, or instability.

One factor which differentiates Feininger from the Cubists is his taste for colour, which he distributes skilfully over juxtaposed surfaces which are sometimes translucent or almost transparent, resulting in a rich range of nuance and variation in the tones which model the forms and lend them three-dimensional volume within a predominantly flat composition. The exquisite tonal gradations in the dress of the woman, and the contrasts of complementary colours in *Architecture II* (which represents a view of the street seen from a window), are a visual delight.

Feininger

◄ *Architecture II
(The Man from
Potin)*, 1921
Oil on canvas,
100 x 78.7 cm

The Lady in Mauve,
1922
Oil on canvas,
100.5 x 80.5 cm

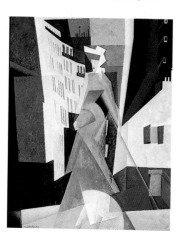

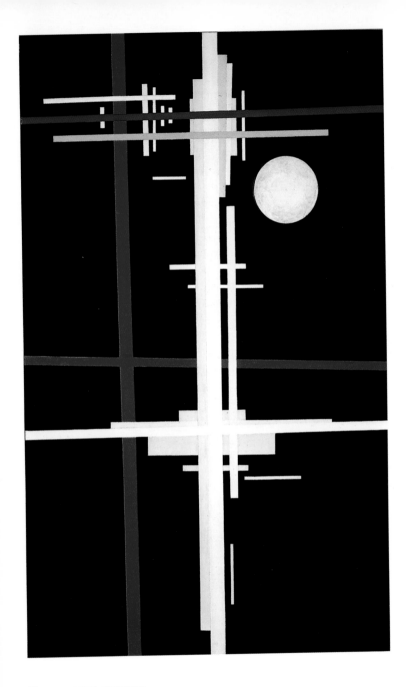

Ilya Chashnik

LIUCHITE, LITHUANIA, 1902 – LENINGRAD, 1929

From the age of 17 until his early death ten years later from appendicitis, Ilya Chashnik was one of Kasimir Malevich's most faithful followers. He took advantage of his multi-disciplinary training, designing textiles and posters and working with another Suprematist artist, Nikolai Suetin, on a project for a residential quarter around the Bolshevik Factory in Leningrad.

The present work is similar to other works by the artist of 1923, and is practically identical to another watercolour with the same title of 1926/27. Against a completely black background (in contrast to the white backgrounds used by his teacher), red and white lines cross over each other, forming a grid which reminds us of Mondrian's late works (cf. New York City, New York). The cruciform shapes are arranged in depth, opening a perspective space towards the upper left corner of the painting. In front of these lines, a horizontal green line in the upper part of the composition defines the plane closest to the viewer. On the right, a powerful focus of light coming from the moon-like circle leads the eye to a much more distant space which continues into infinity.

In contrast with the red cross, the white cross is made up of segments of different lengths which attach themselves to the principal axes. With these, Chashnik has experimented with the alternation of textures and has actually incised the outlines of some of them, so that they seem to be stuck onto the canvas. These characteristics show the artist's interest in bringing out the three-dimensional aspects of space, which would lead him a few years later to produce reliefs from pieces of wood and coloured glass cut in different sizes, which he assembled as if they were three-dimensional jigsaws, creating spatial constructs which are visually very appealing, as is the present composition. Chashnik applied this same type of linear structure to his decoration of porcelain, mainly cups and plates. The result was both extremely decorative and startlingly modern.

"The systematic study of Suprematism, with all its stages and reasonings, is the basis for the invention of the new Suprematist entities from a utilitarian starting point ... The technical-architectonical school developed as a builder of the new form of Utilitarian Suprematism and became an enormous laboratory-workshop, with the co-operation of astronomers, engineers and mechanics, all working towards a single goal: the building of Suprematist entities as a new form of economy, of the utilitarian system of the present."
ILYA CHASHNIK

Suprematist Composition, 1923
Oil on canvas,
183.5 x 112 cm

Stuart Davis

PHILADELPHIA, 1894 – NEW YORK, 1964

Stuart Davis [signature]

The two works by Stuart Davis in the Thyssen-Bornemisza Collection are representative of his early style, when he was influenced by Cubism and collage, and of his late style. Although seemingly very different, particularly in the technique used, both works share Davis' life-long preference for a geometric structuring, the absence of spatial references to indicate depth, and the inclusion of graphic elements such as letters and words.

Sweet Caporal is one of a series of works which recreates in an illusionistic manner a collage of papers, boxes and wrappers supposedly stuck onto the canvas. There is an obvious relation between this work and Braque and Picasso's Synthetic Cubism, which Davis had seen at the 1913 Armory Show. This type of illusionism was already present in American painting, too, in the work of John Frederick Peto at the turn

"*Davis is celebrating the commercial culture of the United States, adding clearly US AMERICA beneath the two signs on which SWEET CAPORAL is read and near the two letters K and B which represent the manufacturer, identified bottom right: KINNEY BROTHERS. Even the box he chose highlights the national colours: red, white and blue.*"
GAIL LEVIN, 1987,
on the painting
Sweet Caporal

Pochade, 1958
Oil on canvas,
132 x 152 cm

Sweet Caporal, 1922
Oil and watercolour
on cardboard,
50 x 47 cm

of the century. While Davis was always most interested in exclusively visual values in his painting, critics have read into his work of this period (including such major paintings as *Lucky Strike* and *Cigarette Papers*) a desire to celebrate modern American culture. Davis has been seen as a forerunner of Pop Art for his subject matter as well as the style and aesthetic of both his early works and his later production.

Pochade falls within what Davis described as his "New Universal Style". Figurative references have almost disappeared, but letters and words are still used, although they are difficult to decipher. In addition, Davis simplifies and depersonalizes the composition through his way of painting, working with a few flat and bold colours. The urban icons of his early style evolved towards more abstract images, used in compositions of more generalized significance and greater graphic impact.

Edward Hopper

NYACK, NEW YORK, 1882 – NEW YORK, 1967

E. HOPPER

"The only real influence I've ever had was myself."
EDWARD HOPPER

The traditional and provincial art scene in North America in the 19th century only began to change when American artists who had travelled to Europe at the beginning of the 20th century returned with a knowledge of the new avant-garde movements. For those who stayed at home, however, the Armory Show held in New York in 1913 brought together more than one thousand works of modern art, of which half were by European artists.

While these events were revolutionary, there was also a strong countercurrent which defended homegrown American values in art and life. This gave rise to a realist tendency which, while it did not succeed in holding back the advance of modern art (which would culminate after World War II with the rise of Abstract Expressionism), produced some important artistic results. One of these was the painting of Edward Hopper who, through an approach which looked back to the classical tradition, produced paintings of intimate scenes profoundly imbued with sentiment and emotion.

The two canvases reproduced here, from 1921 and 1931, reflect Hopper's mature style, and depict one of his preferred subjects: a woman in the intimacy of her room, generally depicted in her underclothes – sometimes naked or seminaked – peacefully at work on some task or absorbed in her own thoughts. Despite this, there are no erotic allusions in these paintings, even though the viewer does to some extent adopt the attitude of voyeur, looking in on a scene in which he or she should not be present. But the "violation" of the protagonists' privacy actually serves to emphasize their solitariness, a theme which Hopper treated in the context of the metropolis, the streets, cafés, petrol stations and hotels normally bustling with city life, but in his canvases desolate and empty.

The solitude and melancholy which envelops these two women is perhaps more evident in *Hotel Room*, considered one of Hopper's most important works. The fact that the scene is set at night contributes to the mood; cold artificial lighting falls on the girl's back and legs, leaving

her face in shade. There is an air of apathy in her pose as she consults a train timetable, and an impersonal feel to the room where, apart from a few essential pieces of furniture, all we see are the suitcases prepared for her departure the following day.

Girl at a Sewing Machine, c. 1921
Oil on canvas,
48.3 x 46 cm

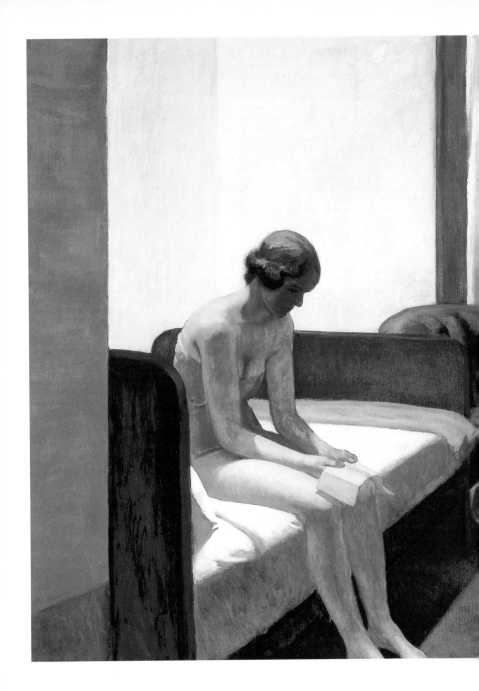

Hotel Room, 1931
Oil on canvas,
152.4 x 165.7 cm

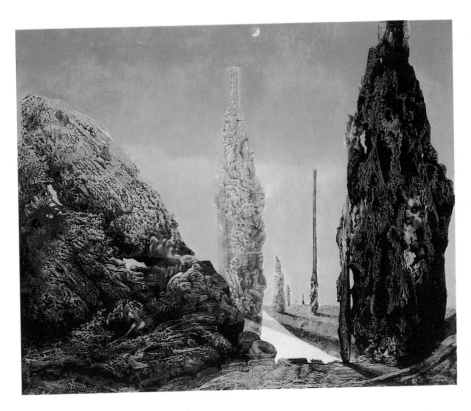

Solitary Tree and
Conjugal Trees, 1940
Oil on canvas,
81.5 x 100.5 cm

Max Ernst

BRÜHL, GERMANY, 1891 — PARIS, 1976

Max Ernst was a graduate of philosophy, psychiatry and history of art. As a child he learned to observe the world around him, accompanying his father (an amateur painter) on painting trips to the woods. Ernst took up painting as an amateur while studying, working in an Expressionist style close to the Blauer Reiter (Blue Rider) group, which he subsequently joined together with Kandinsky, Paul Klee and August Macke.

Ernst's friendship with Hans Arp was fundamental to the development of his Dada period, when he painted *Untitled (Dada)*. This work can be related to *The Alienist* by Kurt Schwitters for the random association between textures and figures whose meaning – if there is one – escapes us. Ernst himself was always against any attempt to explain his works. Another feature reminiscent of Schwitters' collages is the way Ernst has arranged the figures, which are neatly cut out and superimposed one on top of the other, in an adaptation of the collage technique to the medium of oil painting. The strange disks which float in the picture space appear as the main element in a number of his works, and as the only element in *The Sea*, a work in the collection of Baron Thyssen-Bornemisza in Lugano.

Under the influence of Arp, Ernst began to conceive of art as a "medium for the subversion of the spirit". This subversive and restless side of his character led him to experiment with different techniques in search of greater freedom and expressiveness in his artistic language. In 1925 Ernst invented the innovatory technique of frottage, which involved placing the canvas covered in fresh oil on any textured surface which would leave its imprint (such as metal, wood, textiles or stone). Once dry, the surface of the canvas was scraped with a spatula to smooth off any projecting paint. In this way Ernst created by chance the forms which made up the composition. This is the technique used in *Flower-Shell*, which belongs to a series dedicated to flowers produced between 1927 and 1929. This small painting (it measures only 19 x 24 cm) is outstanding for its glowing richness, its textures, freshness and spontaneity.

"Therefore, when one says of the Surrealists that they are painters of an always changing dream reality, this does not mean that they paint what they have dreamed (that would be descriptive, naive naturalism) or that each one constructs his own little world out of dream elements, in order to behave amicably or in an evil way, (that would be a 'flight from time'), but rather that they move freely, bravely and naturally within what is physically and psychologically certainly a real ('surreal') – even if not yet adequately defined – border area between the inner and outer worlds."
MAX ERNST

A similar technique produces the effects seen in *Solitary Tree and Conjugal Trees* of 1940. In this case the still wet oil is covered with a sheet of glass which, once the paint is dry, is prised off with some force, taking part of the paint surface with it. This process is called decalcomania, and was invented by the Spaniard Oscar Domínguez in 1935. Unlike frottage, decalcomania requires the input of the artist's imagination in order to define and elaborate the forms which chance has left lightly imprinted on the canvas. In this way the artist reveals a hidden world filled with human faces, animals (derived from a totemic culture) and vegetal forms, all hidden within trees which have the texture of solidified lava.

An explosion of brilliance and colour accompanies the unfolding of movement in *33 Girls in search of a white Butterfly*. Very different in character to the two previous paintings, there is none of the sense of disquiet which often pervades Ernst's works. The work contains echoes of the avant-garde styles of the early 20th century (Cubism and Futurism) in the deconstruction of the image and its frenetic movement, giving rise to a completely abstract composition which has been related to post-war *art informel* (art "without form").

Untitled (Dada),
c. 1922
Oil on canvas,
43.2 x 31.5 cm

Joan Miró

BARCELONA, 1893 – PALMA DE MALLORCA, 1983

Joan Miró's work is difficult to classify. In his youth he was closely linked to the development of the Surrealist movement, started by André Breton in 1922 and evolving out of Dadaism. Miró was one of the signatories to the First Surrealist Manifesto, which defined the movement as a "purely psychic automatism" aiming to reveal "the true process of thought without the intermediary of reason or aesthetic or moral rules". In reality, Miró's ideological links with Surrealism are less specific than generic, in that his art unfolds within an iconographic universe derived from the imagination of the painter and creates an imaginary world.

His style quickly developed towards this type of painting, represented by two works in the Thyssen-Bornemisza Collection. After an early period in which he worked in a more explicitly figurative manner, from 1923 Miró began to evolve a schematized representation of figures and objects, with the aim of eventually just representing the idea or the symbol. His goal was to liberate form from everything which was not essential, leaving just the bare symbol with nothing to distort it. *Catalan Peasant with a Guitar* of c. 1924 is one of his first paintings to use this new language, and is thus considered fundamental within his œuvre. In it the key elements of his mature work are already defined. A flat and monochrome surface is used as an intermediary space in which are suspended a few disconnected elements. Only the fine black line which depicts the schematic figure unifies them. We find a similar composition in *Painting with a white Background*, in which the palette is reduced to pure colours and their complementaries. In both paintings the artist has achieved a feeling of spontaneity and freshness. Nonetheless, Miró's system of working was totally unspontaneous, given that all his paintings were worked out using a large number of preparatory sketches and drawings.

◄ *Catalan Peasant with a Guitar*, c. 1924
Oil on canvas,
148 x 114 cm

Painting with a white Background, 1927
Oil on canvas,
55 x 46 cm

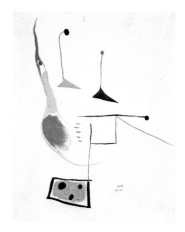

Yves Tanguy

PARIS, 1900–WOODBURY, CONNECTICUT, 1955

Yves Tanguy

Yves Tanguy produced his first drawing as a self-taught artist in 1922. Seeing a work by De Chirico subsequently aroused his interest in Surrealism, and in 1925 he became a member of the group, introduced by Breton. His pictorial style, which involved a precise and ever more complex draughtsmanship, was comparable to that of Miró in that it recreated biomorphic forms which merely suggested real objects. Dalí and Magritte, on the other hand, followed an approach in which the objects maintained their identity and were easily recognizable, albeit strangely interrelated.

Dead Man watching his Family corresponds with Tanguy's early style. It is still possible to recognize some plant forms and other organic forms which suggest sea creatures such as fish, tadpoles and jellyfish, in a desert-like landscape half-way between the seabed and the land, although undoubtedly derived from the world of dreams. Notable is the vertical element suggestive of a tower on the horizon. A similar shape is found in Magritte's *Exhibition of Painting* of 1965. These monolithic forms reveal a search (common to all the Surrealist artists) for the primitive and the atavistic in the collective subconscious, lost in some corner of our memory and only capable of coming to the surface through dreams, when the subconscious is liberated from the impediments of the real world. The light tonality of this early work would gradually give way to a darker palette which became increasingly pronounced.

The dreamlike quality of Tanguy's painting was a constant in his work, as we can see in *Imaginary Numbers*, the artist's last work before he died. Again, it involves the delimitation of open and unlimited spaces, characteristic of his intermediary period – as can be seen in *Now and Always*, also in the possession of the Museum – through lines of what look like very polished stones, which extend into a sort of infi-

nite labyrinth. The soft, malleable aspect of the rocks and the black and threatening sky of limitless depth convey a nightmarish anxiety. In comparison with *Dead Man watching his Family*, we can see how the simple and naive drawing and the rapid and unsubtle brushstroke have become much more precise and detailed. Some of the elements in *Imaginary Numbers* are highly finished and almost sculptural, while the composition is very studied and modulated by the rhythm of light and shade.

*Woman before a
Mirror*, 1936
Oil on canvas,
71 x 91.5 cm

Paul Delvaux

ANTHEIT-LEZ-HUY, BELGIUM, 1897 – BRUSSELS, 1994

Paul Delvaux's career spanned his exceptionally long life of nearly 100 years. From 1919, when he produced his first works, he would never abandon painting. As he himself acknowledged, it was his discovery of the work of De Chirico which set him on his chosen path, as was the case with other Surrealist artists such as Tanguy and Magritte, although Delvaux's art differs substantially from theirs.

Woman was one of Delvaux's lifelong artistic interests, as can be seen from a simple glance at a catalogue raisonné of his work. She is always painted nude, and if any drapery or item of clothing appears, it is usually in the form of a cloak covering her back, or some form of transparent veil which shows her body. These women are usually enveloped in darkness in some way, although, paradoxically, their white and luminous skin glows with its own light. If the figures are set in an interior, the room is lit with an artificial light coming from a lamp or torch, emphasizing the darkness visible through the windows. If it is an outside scene it will be set in cloudy darkness or in a dim twilight after the sun has already set. *Woman before a Mirror* is an exception, in that the light which penetrates into the cave is a natural daylight even though the woman is placed far from it, inside the cave and enveloped in darkness.

The woman here corresponds to Delvaux's standard model: silent, immobile, and lacking any expression in her face or her eyes, which have no pupils. These are women who "look without seeing and without being seen" in the words of Gisèle Ollinger-Zinque, the author of the catalogue of the exhibition devoted to Delvaux at the Fundación Juan March in Madrid (March–June 1998), in which this painting was included. The definition could not be more accurate, as the mirror which hangs apparently without support (richly ornamented with a carved frame and an elaborate if incongruous lace band), is placed to the right of the woman and is therefore outside her line of sight. Its only function is to show the other side of her face. "I do not feel the need to give a specific explanation of what I do, nor do I need to biographically reinforce figures whose only raison d'être is obviously the painting".

"Actually, the human form is as much a part of the painting as any other element (a door, a window or a tree), put in to evoke a certain impression. Of course, their meanings are not perceived in the same way, the significance differing from object to object, and even if I exaggerate in my insistence that the character, woman, plays a peripheral role, I willingly concede that this same element is the essential link to the poetry of the work."
PAUL DELVAUX

René Magritte

LESSINNES, BELGIUM, 1898–BRUSSELS, 1967

Magritte

"The images must be
seen such as they are.
Moreover, my paint-
ing implies no su-
premacy of the invis-
ible over the visible."
RENÉ MAGRITTE

The influence of Giorgio de Chirico's Pittura Metafisica (Metaphysical
Painting) was extremely important for many of the Surrealist painters.
His analysis of the reality underlying things and his transposition of
their meaning, which altered the logical order of appearances, were
ideas which would be taken up by Surrealism. This painting by Magritte
is a good illustration.

The Key to the Fields poses a mystery which the viewer must solve
through an intellectual effort, but whose solution depends on the view-
point of each person: what is the true reality of what we see? In the
painting, Magritte uses realistic and totally conventional images which
he paints without distortion and with few elements. His composition is
not subjected to Freud's principles of psychic automatism, as frequently
deployed by the Surrealists to liberate images from the subconscious.
On the contrary, it is structured rationally with an intentional geometri-
cization and balance, together with a clean draughtsmanship which
delineates the outlines of each form with great precision.

The surprise appears when the viewer notices the same landscape
which he or she has seen through the window on the broken shards of
glass. Was the landscape painted on the glass, thus imitating the real
landscape which it concealed? Are the shards of glass which have fallen
into the room pieces of painted glass or, more likely, pieces of a mirror
which reflected the landscape? How is it possible for the landscape to
be reflected in them if it is facing them and very far away? Perhaps what
is represented is the reflection in a mirror of a broken window in the
room, situated hypothetically opposite and thus outside the picture
plane? Whatever the possibility, the painting is a trick which calls into
question the apparent meaning of the world which surrounds us and
invites us to reflect on it. Deceiving the viewer through the use of win-
dows and mirrors is a device which has been employed many times in
painting over the centuries, as it permits the artist to show an inverted
image of reality and of ourselves, with inifinite possibilities for revealing
new viewpoints or showing what is outside the picture space.

The Key to the Fields,
1936
Oil on canvas,
80 x 60 cm

Salvador Dalí

FIGUERAS, 1904 – 1989

*"To translate into im-
ages for the first time
Freud's discovery of
the typical long, well-
plotted dream, the
consequence of the in-
stantaneousness of an
accident caused by
awakening. Just as a
curtain rail falling on
a sleeper simultane-
ously causes him to
wake and gives rise to
a long dream that
takes him to the guil-
lotine, the noise of the
bee here causes the
sting of the dart that
will wake Gala."*
SALVADOR DALÍ, 1944

*Dream caused
by the Flight of
a Pomegranate one
Second before
Awakening*, 1944
Oil on wood,
51 x 41 cm

The brilliant, eccentric and ever attractive Salvador Dalí became – for better or for worse – the leading and most popular representative of Surrealism, also for the general public. This was due in part to his talent for self-promotion, to which he devoted his whole life, but also to the hypnotic character of his images which capture the viewer's at-tention through their fine draughtsmanship, minute detail and striking colours. Moreover, it was perhaps Dalí who best knew how to depict a world of oneiric images which most people associated with their own dreams.

The present painting is one of the best-known in Dalí's entire œuvre. The omnipresent figure of Gala provides the model and, although asleep, the way her naked body is painted accentuates the marked ero-ticism of the image. Dalí had met Freud in 1938, and Freud's theories about dreams channel the subject of the painting towards Dalí's princi-pal obsession – sex. Even if it is not as explicit here as in others of his works, such as his famous painting *The great Masturbator*, sexual allu-sions underly the various symbols distributed across the canvas. The bee symbolizes virginity, as does the pomegranate, which is also a sym-bol of fertility. From an open pomegranate a fish emerges, from whose enormous mouth emerges a tiger, and from its mouth another tiger. These creatures, who are poised savagely over the woman's body, repre-sent sexual desire, and the bayonet pointed towards her arm is clearly here a phallic symbol.

In the background Bernini's elephant with the obelisk on its back reinforces the symbolism of the bayonet. In addition, the painting's title suggests a fact which recent dream research has proved: at various points during dreaming we will hear a sound as greatly magnified, much louder than it would be were we awake. The reception of this noise, however light, may us wake up, or lead us to incorporate it into our dream in an irrational manner, with new images suggested by the noise.

Composition, 1939
Oil on canvas,
30.5 x 40.5 cm

Roberto Matta

SANTIAGO DE CHILE, 1911

A qualified architect, Roberto Matta first took up painting after being introduced to the Surrealist circle in Paris by Salvador Dalí in 1937. Nonetheless, just one year later he showed his work in the Surrealists' first group exhibition in Paris. In 1939 Matta and Tanguy moved to America, where little by little most of the Surrealists joined them, in order to escape wartime Europe. Their presence in America would give vital stimulus to the subsequent development of Abstract Expressionism. Matta's art in particular was extremely influential and important for Rothko, Pollock and Motherwell in their early stages.

Composition of 1933 is one of the artist's early works. It is notable for its use of a very dark chromatic range of blacks and ochres, which result in a space which is totally undefined: we cannot see what lies behind nor how deep it is. Only the foreground is strongly lit, revealing geomorphic forms painted with light and rapid brushstrokes appropriate to the technique of automatic composition. The spatial ambiguity is further complicated by the geometric and irregular tracings of fine white lines, which in some cases create floating square forms arranged perpendicular to the picture plane and elsewhere take on spiral forms projected towards the background. The simplified graphic character and the irregular lines of this linear grid create the impression of an unfinished image.

We can also make out some tiny, bright white spots which mark out the vertices of the square forms and which are joined up by the white lines. These small dots are the only areas in which Matta has loaded the brush with paint, as the colour is elsewhere applied in fine layers which allow the weave of the canvas to show through. Matta called his paintings of this period "psychological morphologies" or "interior landscapes", revealing the internal provenance – from the subconscious – of these strange landscapes. It is in this light only that we may interpret Matta's paintings.

MAYYA

"I tried to pass from intimate imagery, forms of vertebrae, unknown animals, and little known flowers to cultural expressions, totemic things, civilizations."
ROBERTO MATTA

Arshile Gorky

KHORKOM VARI, ARMENIA, 1905–SHERMAN, CONNECTICUT, 1948

A. Gorky

Arshile Gorky was born in Armenia and arrived in the United States in
1920. There he pursued his artistic career in a process which would take
him from an early style influenced by Cézanne through to Surrealism
and on to Abstract Expressionism. His Surrealist work of the 1930s fol-
lowed in the footsteps of artists such as Tanguy, André Masson, Matta
and Miró, whose paintings had an abstract appearance but incorpor-
ated vaguely figurative references.

The two works reproduced here date from the last years of Gorky's
life, when he finally arrived at a personal artistic language. *Hugging* still
retains formal reminiscences of abstract Surrealism, but incorporates a
degree of spontaneity which gives the impression of an unfinished work
and one executed at speed. While in fact Gorky always made preparatory
sketches, he placed great emphasis on the spontaneous stroke, using
thick brushes, and on the expressive value of the unfinished canvas in

*Hugging / Good
Hope Road II
(Pastoral),* 1945
Oil on canvas,
64.7 x 83.7 cm

Last Painting, 1948
Oil on canvas,
78 x 101 cm

which the priming showed through. *Last Painting* is in fact the last work the artist made before his death, and the one left on his easel when he committed suicide in his studio. Some critics have considered the painting to represent an evolution towards a truly Expressionist language, although others see it as simply unfinished. Whatever the case, it illustrates the artist's working process, which would be fundamental to American Abstract Expressionism.

Gorky, De Kooning and Hofmann (all three of European extraction and American immigrants) were the first generation of American artists to take – under the common denominator of Abstract Expressionism – the leading role in avant-garde developments and to transplant it from Europe to the United States. The collection of works by these artists and others from the same movement such as Rothko and Pollock in the Thyssen-Bornemsiza Museum is sufficiently extensive to be able to offer a panoramic and detailed overview of the movement.

Ben Shahn

KAUNAS, LITHUANIA, 1898 – NEW YORK, 1969

Ben Shahn

Among the realist movements which developed in America in the early decades of the 20th century, and whose genesis we have discussed in the entry on Edward Hopper, the Social Realism of Ben Shahn stands out in particular. Of Jewish origins and born in Lithuania, Shahn emigrated with his family to America when he was still a child. His painting was profoundly influenced by the catastrophic Wall Street Crash of 1929 and its dire political and social consquences. From this point on, his works served as a vehicle of social criticism in which the unemployed, the downtrodden and the marginalized became the point of reference.

With the outbreak of World War II, these themes began to acquire a strong symbolic content which sometimes had personal implications. In *Four-piece Orchestra*, the artist presents two glaring inconsistencies which are as obvious as they are difficult to explain: firstly, the discrepancy between the figure in the suit and tie playing the 'cello (which

Four-piece Orchestra,
1944
Tempera on
masonite,
45.7 x 60.1 cm

Carnival, 1946
Tempera on
masonite,
55.9 x 75.5 cm

Shahn paints in a strong red colour) and the other two figures, who are clearly labourers in their working gear; and secondly the contrast between the bare trees of the wood in the background and the tall green grass on which the musicians are seated. Even more troubling is the expression of the sleeping man in *Carnival*. The meaning of the painting, reinforced by the unreal character of the scene in the background, probably alludes to the man's dreams of a happy life with a loving partner, even while his expression is almost a grimace of desperation, something reinforced by the tense and unnatural position of his arms, contrasting with the slackness of his legs.

Formally, Shahn's painting is characterized by a very sketchy handling in which the characters are physically barely defined. Rather, they become almost archetypes, repeated in numerous different paintings with the same features (thin nose, small almond-shaped eyes). Significantly, they are always shown with their mouths closed. Shahn's use of colour involves slight dissonances which accentuate the already highly expressive character of his paintings.

Casablanca B.,
c. 1947–1954
Oil on cardboard,
41.3 x 60.7 cm

Josef Albers

BOTTROP, GERMANY, 1888 – NEW HAVEN, CONNECTICUT, 1976

Josef Albers was fundamental to the development of geometric abstraction in America, an approach which followed Abstract Expressionism at the end of the 1950s. Albers, a German by birth, arrived in America in 1933 following the closure of the Bauhaus by the Nazi regime. There he had studied and taught since 1920 and was thus able to bring to his teaching in America the rationalist and experimental principles of European geometric abstraction.

Casablanca B looks forward to the work of artists such as Frank Stella in the 1960s. It reveals one of Albers' key interests, namely the implications of colour in painting – a subject discussed in a number of his theoretical writings. For Albers, colour is the essence of every painting; it is autonomous and the whole work is generated by it. The relationships between juxtaposed colours give rise to the aesthetic experience which the picture constitutes. The work is composed around the interaction of the colours, based on the concepts of harmony and proportion and on optical effects. In addition, the painting is self-sufficient and does not have to be a reflection of the artist or his personal experiences. For Albers, art should be something objective, and nothing personal should appear in it (not even the brushstroke).

All these ideas would subsequently be followed up by the artists of post-painterly abstraction. Albers' work synthesized many concepts which would later be taken up and radicalized in the work of artists such as Morris Louis, Barnett Newman and Stella.

"As 'gentlemen prefer blondes', so everyone has a preference for certain colours and prejudices against others. This applies to colour combinations as well. It seems good that we are of different tastes. As it is with people in our daily life, so it is with colour. We change, correct, or reverse our opinions about colours, and this change of opinion may shift forth and back."
JOSEF ALBERS

Nicolas de Staël

ST PETERSBURG, 1914 – ANTIBES, 1955

"The motto for every great painter must be: to go to the very ends of oneself."
NICOLAS DE STAËL

Grey Composition,
1948
Oil on canvas,
148.5 x 68.5 cm

Of Franco-Russian origin, Nicolas de Staël received a solid artistic education starting at the Academy of Fine Arts in Brussels and later reinforced by his numerous visits to Holland, Spain, Italy and North Africa. In 1943 he settled in Paris, where he studied with Fernand Léger and met Georges Braque. From that year his art became completely abstract and can be associated with the currents of *art informel* (art "without form") prevailing in post-war Europe, bringing him great international acclaim.

His *Grey Composition* is a good example of the style known in Europe as *tachisme*, a movement which developed parallel to Abstract Expressionism in North America and which is practically identical to it. It is characterized by the application of broad, expressive and abitrarily arranged patches of colour using a heavily loaded brush, conveying the irrepressible creative force of the artist on the canvas.

After a purely abstract phase, in 1953 – the year he produced *Mediterranean Landscape* – recognizable subjects began to reappear in de Staël's art. This painting is notable for the subtlety of its colour, based on a soft palette of blues, mauves and greys combined in a masterly way with touches of white and orange-yellow on the houses at the foot

of the rocks, on the right of the canvas, thereby accentuating their luminosity. The colour, which is very dense and applied with a palette knife that leaves its mark in the interruptions between the colour masses, creates a play of soft chiaroscuros and a relief effect on the rocks and the sea, giving the whole composition a look of solidity which distinguishes it from a work with purely realistic intentions. As happens in Lucio Fontana's work, the thickness of the oil emphasizes the material characteristics of the paint, which speaks to us of a freedom of expression liberated from any rules, in which the only criterion is the individual sensibility of each artist.

Mediterranean Landscape, 1953
Oil on canvas,
33 x 46 cm

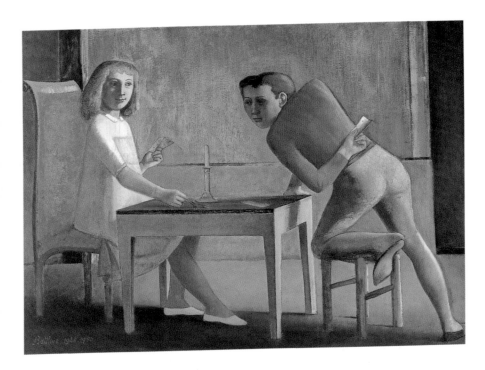

The Card Game,
1948–1950
Oil on canvas,
140 x 194 cm

Balthus
(Balthazar Klossowski de Rola)

PARIS, 1908

Balthus is another artist whose work is difficult to place within the international artistic panorama of the post-war period. His unusual artistic training consisted of copying Old Master paintings in the Louvre, and later, during a trip to Italy, the works of Masaccio and Piero della Francesca. This latter was an important influence on his work, above all in the powerful presence of the large and monumental figures, painted in contrasting but not clashing colours (Piero systematically used red for the clothing of many of his figures, whereby the stronger the red, the more important the figure within the composition), and in the use of a directed light, whose contrasts model the objects and figures making up the scene.

In *The Card Game*, Balthus adds to the above features the Renaissance austerity of an enclosed and centralized composition, governed by a geometric order which Piero had achieved in his art by employing classical architectural settings as the background to the principal scene. Balthus plays with all these elements and adapts them to the modern age in his choice of a contemporary domestic setting – in this painting, for example, the girl is sitting on an Art Deco chair. With its curving back and straight, plain legs it is almost identical to an ebony chair designed by Clément Rousseau in 1921, now in the Musée des Arts Décoratifs in Paris. These settings have only the most essential furniture in them and are devoid of unnecessary decorative elements. As well as focusing attention on the principal action, this reduction of the space to its essentials also heightens the already rarified atmosphere of the scene.

The protagonists of the composition are two young people, whose poses and expressions reveal that something more than a mere game of cards is taking place. Critics have pointed to the lack of innocence in these children – the dominant pose of the girl who knows that she is winning, the boy who holds his cards behind his back, not trusting the girl, and finally an air of subtle youthful perversion. This latter quality has led to the comment that "no other painter has so incisively reflected the tensions of adolescence" than Balthus.

"Every time that I have placed the last brushstroke on a painting, I am overcome by the idea that I have forgotten everything that I knew about my art and will have to discover everything anew. It is as if you wake up, have to write a speech, and then realize that you cannot recall the simplest rules of grammar."
BALTHUS

Blue Soap Bubble,
1949/50
Construction,
24.1 x 30.5 x 10.2 cm

"I do not share the
Surrealists' theories
of dreams and sub-
conscious. Though
I fervently admire
much of their work,
I have never officially
been a Surrealist and
I believe that Surreal-
ism had more healthy
possibilities than the
ones which have
been developed."
J. CORNELL to
ALFRED H. BARR,
1936

Joseph Cornell

NEW YORK, 1903–1972

Surrealism played an important role in the evolution of art after World War II. Elements of Surrealism such as automatism and chance – themselves derived from Dada – are to be found at the root of the movements which emerged in North American art during these years, even in those which would seem to be totally at odds with each other, such as Gorky and Pollock's Abstract Expressionism and early Pop Art.

Half-way between Surrealism and Neo-dada is the work of Joseph Cornell, who, despite the strong ties of friendship and shared artistic aims which connected with him with the Surrealists who had moved to America, always denied any relationship with Surrealism. Nonetheless, his boxes are essentially Surrealist objects, given that the found object was one of the principal media used by artists such as André Breton, Man Ray and Meret Oppenheim. This aspect of Surrealism has its direct origins in the Dadaist ready-made of Marcel Duchamp.

Juan Gris Cockatoo No. 4, c. 1953/54
Box with mobile collage,
50 x 30 x 11.5 cm

America at the end of the 1940s saw the emergence of assemblage art, which had its formal roots in Surrealism, Dadaism, and Cubist collage. This was the context in which Cornell developed his boxes, a type of work which would henceforward be identified with him and which he continued to produce throughout his life. For Cornell, the boxes were the condensation of his memories; each element within them held a symbolism or meaning associated with his personal experiences, preoccupations and anxieties. The different objects inside the boxes formed part of his environment and his personal imaginative world. Despite the fact that it has generally been seen as primarily decorative, Cornell's work constitutes an important link between European Dada and Surrealism and North American Neo-dada, one of whose most important representatives would be Rauschenberg.

Willem de Kooning

ROTTERDAM, HOLLAND, 1904 – NEW YORK, 1997

The work of Willem de Kooning exhibits the freedom of action which is associated with one of the strands of Abstract Expressionism in North America. De Kooning thereby never entirely abandoned figurative references in his work, as we can see in these two paintings. Within Abstract Expressionism two tendencies existed side by side: on the one hand were artists such as Arshile Gorky, Jackson Pollock and De Kooning himself, whose painting was energetic and gestural and has come to be identified with the term Action Painting; on the other was the style represented by Mark Rothko, who formulated a purely abstract and contemplative type of painting.

"The attitude that nature is chaotic and that the artist puts order into it is a very absurd point of view, I think. All that we can hope for is to put some order into ourselves. When a man ploughs his field at the right time, it means just that."
WILLEM DE
KOONING

De Kooning's production can be understood within the parameters of Action Painting. It was gestural, using violent strokes and lines and often including dramatic references to death, hard sex and violence. Born in Holland, De Kooning emigrated to America in 1924 but only became a professional painter in the 1940s. In the twenty years which separate the two paintings in the Museum, his style changed from an abstract Surrealist approach (which vaguely resembles Gorky) to a type of painting in which the oil paint itself becomes a key element.

The approach to line which we see in *Abstraction* develops towards the gestural approach found in *Red Man with Moustache*. The colours also become more brilliant

Red Man with Moustache, 1971
Oil on paper stuck to canvas,
186 x 91.5 cm

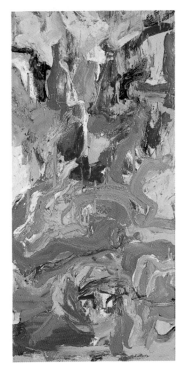

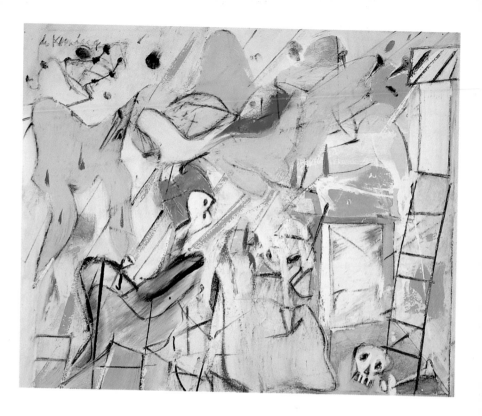

and garish. Curiously, *Abstraction* contains a wealth of figurative ele-
ments, including references to an interior space on the right-hand side,
with a door in the background, a line between the floor and the wall, a
window on the right and a ladder. The left half of the painting is less
defined. The word *Abstraction* may therefore be used here in its more
literal sense, that of abstracting from an existing reality.

Abstraction, 1949/50
Mixed media
on plywood,
37 x 46.5 cm

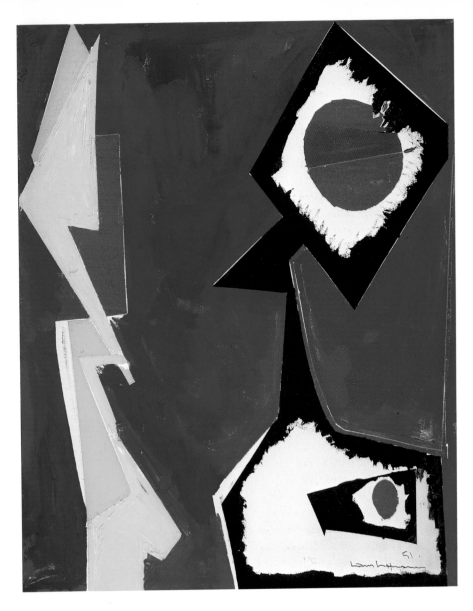

Blue Enchantment, 1951
Oil on canvas,
152.4 x 121.9 cm

▶ *Untitled*, 1965
Oil on canvas,
122 x 91.4 cm

Hans Hofmann

WEISSENBURG, GERMANY, 1880 – NEW YORK, 1966

Hans Hofmann is considered to some extent to be the father or mentor of Abstract Expressionism as, through his teaching, he exerted an important influence on the generation of Pollock and Rothko, thirty years younger than he.

In 1932, as the Nazi regime increased its stranglehold, he emigrated to the United States. There he was highly active as a teacher (as he had been in Germany), first at the Art Students League in New York and later at the Thurn School of Art in Connecticut. In 1934 he opened the Hofmann School of Fine Arts in New York. Part of his prestige was due to the fact that he had personally known some of the great European painters, such as Matisse, Picasso, Braque and Gris, while he was living in Paris between 1904 and 1914.

Hofmann taught a type of painting based on the tension of the forces which emanate from the pictorial elements themselves: the contrasts of colour and of the forms. For Hofmann, colour masses had to be in a state of constant interaction, a tension which would generate effects of expansion/contraction from the meeting of opposing forces.

Paradoxically, he developed all these ideas at the end of his career, when the results of his teaching were already evident in the work of his youngest pupils. His most developed style, which he achieved in his 60s, progressed parallel to that of his students, as if he himself were discovering these concepts at the same time that he was teaching them. This is the case with the two paintings in the Museum, of which *Blue Enchantment* was painted when Hofmann was almost 70, while *Untitled*, perhaps the most important example of his late style, was painted when he was eighty-five, one year before his death.

"Art is not only the eye; it is not the result of intellectual considerations. Art is strictly bound to inherent laws dictated by the medium in which it comes to expression."
HANS HOFMANN

Jackson Pollock

CODY, WYOMING, 1912 — THE SPRINGS, EAST HAMPTON, 1956

Jackson Pollock was the greatest exponent of Action Painting, dedicating himself totally to abstraction and gestural action in his painting. *Brown and Silver I* belongs to the central phase of his career, during which he defined the pictorial language which is most closely associated with him, and also the means of realizing it – a crucial factor in his work.

Pollock's work is witness to a process, and is therefore a reflection of pure action. Around 1947 he radically changed his method of working. Pollock abandoned the easel and the paintbrush and even the stretcher of the canvas. Instead he placed the canvas directly on the ground, or nailed it to the wall, and worked on the canvas without stretching it. He applied paint directly in drips or by pouring it from the tin, using synthetic and metallic paints, as we see in the present work.

Brown and Silver I was executed on the ground and, as is common with Pollock, is part of a larger work which he later cut into two halves. In fact, it was normal for Pollock to paint large surfaces which he would subsequently divide up to create different paintings. Nonetheless, this process was to some extent premeditated, as his compositions – this one amongst them – were self-contained, forming a unitary block. Pollock worked around the canvas, entering into it, creating abstract compositions from dense areas on which he superimposed lighter ones.

Pollock's works have a sense of spatial depth achieved through the superimposition of different weaves of paint and colour contrasts. The composition is organized through interlaced rhythms which at times move out towards the edge of the painting and at others towards the centre, where the principal weight of the painting is located. In this example the silver forms seem to float over the surface of the canvas as if they had no contact with it, creating an atmospheric effect.

"The modern artist, it seems to me, is expressing an inner world – in other words – expressing the energy, the motion, and other inner forces."
JACKSON POLLOCK

Brown and Silver I, c. 1951
Enamel and silver paint on canvas, 145 x 101 cm

Karel Appel

AMSTERDAM, 1921

K·4ppeL

Karel Appel is considered the most important painter among the post-war generation of Dutch artists. His work achieved great fame in America, where he had a studio in New York, working there for part of the year. In 1948 he was one of the founding members of the Cobra Group. The present work belongs to the late phase of Cobra, which held its last exhibition in 1951.

The group's aims were to let the subconscious operate freely in order to liberate its full expressive potential. The results were some violent images produced through a method close to the automatism of the Abstract Expressionists such as Pollock and de Kooning. As we can see in the present work, however, their work nevertheless retained the Expressionist character intrinsic to northern painters and the ever-present references to the visible world. In Appel, these features all came together in a series of figures half-way between human and animal, a species of horrible masks which at times recall the masks characteristic of Ensor, but which in this case recreate fantastical figures only to be found in the artist's mind. In spite of their horrific quality, the naivety of these creations suggests the irrational world of monsters often found in childrens' drawings.

In keeping with the horror of the image, Appel uses a broad, aggressive, thickly-loaded and nervous brushstroke, which becomes a pure gesture of unconscious expression and which can be considered a forerunner of European *art informel*. The palette is reduced to red, yellow, white and black, with the occasional green and grey touch, all characteristic of his painting in general.

Wild Horses, 1954
Oil on canvas,
190 x 112 cm

*Concetto spaziale – Venice
was all Gold*, 1961
Oil on canvas,
150 x 150 cm

Lucio Fontana

ROSARIO DE SANTA FE, ARGENTINA, 1899 — COMABBIO, ITALY, 1968

Lucio Fontana, who in 1966 was awarded the International Grand Prize at the Venice Biennale, is here represented by a work from a series representing various aspects of that city. The composition is a thought-provoking one, in which the thickness of the oil, rhythmically arranged in concentric circles, ignores the two-dimensionality of the canvas, creating a huge three-dimensional space in relief whose tactile qualities invite the viewer to touch as well as to look. In this respect it is important to remember Fontana's training as a sculptor in his father's studio in Milan (Fontana was the son of the Milanese sculptor Luigi Fontana), as well as his later activity as a ceramicist, which he continued throughout his life.

The movement of the circles creates the effect of a whirlpool spiralling towards the centre of the canvas and thus leading us to the central vertical opening, an enigmatic point which invites us to lean into an undefined and profound space suggested by the colour black. In relation to the work's title, this crack may allude to the fissuring of the splendour of past eras, and thus lead on to the creation of new sculptural effects on the canvas, juxtaposing the profound darkness which we can make out inside with the luminosity exuded by the golden colour of the oil, producing a pronounced effect of chiaroscuro. The construction of space thus achieves a new dimension in Fontana's work, resulting in new and different visual sensations.

Fontana's *attese*, or slashed canvases, such as this one, appeared in his work from 1958 and have been considered the culmination of action or gestural art. In them, the expressiveness of the artist's pictorial language and his subjective vision prevail, recreating for the viewer a world of emotions born from his own experience.

"The subconscious moulds the individual; it completes and transforms him, giving him the guidance which it receives from the world and which he from time to time adopts."
LUCIO FONTANA

Mark Rothko

DVINSK, RUSSIA, 1903 – NEW YORK, 1970

MARK ROTHKO

Although he was born in Russia, Rothko lived almost all his life in America, to where his family emigrated when he was ten. His work represents the least gestural side of Abstract Expressionism and is different to Action Painting as represented by Pollock, although the two artists have some elements in common.

Rothko's painting is based on the superimposition of large and uniform masses of colour, always using an orthogonal structure either through juxtaposed bands of colour, or, as in the present case, the superimposition of squares and rectangles. The almost square format of the canvas is also habitual in his work.

From the late 1940s his works repeated this basic format, varying the colour combinations and the proportions between the volumes, but always maintaining frontality and symmetry. However, as in Pollock's work, these are not flat pictures, but imply a slight sense of depth, as if the centre square were suspended in the air, floating on the canvas, coming nearer to the viewer then moving away. To obtain this effect Rothko worked with subtle textures, creating chromatic fields of delicate tonal gradations using an irregular application of the paint, giving rise to some more impastoed areas and others with fine glazes. In addition, the contours are always diffuse and undefined. The feeling which these paintings convey is one of calmness, but also of introspection and a certain air of mystery.

"I think of my pictures as dramas; the shapes in the pictures are the performers. They have been created from the need for a group of actors who are able to move dramatically without embarrassment and execute gestures without shame. Neither the action nor the actors can be anticipated, or described in advance."
MARK ROTHKO

Although he never wished to admit any connection between his paintings and his personal experiences, with *Green on Maroon* Rothko moves away from a brilliant palette in which reds, oranges and yellows were predominant, to a more subdued and fainter colour range, coinciding with one of his periods of depression, which would eventually result in his suicide nine years later.

Green on Maroon,
1961
Mixed media on
canvas,
258 x 229 cm

Mark Tobey

CENTERVILLE, WISCONSIN, 1890–BASLE, SWITZERLAND, 1976

Mark Tobey developed an abstract painting inspired by calligraphy which he himself called "white writing". He used a technique in which he applied a continous white line on a textured surface to form strokes which had the appearance of linguistic symbols. At times critics have linked him with Abstract Expressionism, and in fact his work is very similar in appearance to Jackson Pollock's. However, there is nothing gestural or suggestive of automatism in Tobey's work, which is rather the result of a long process of elaboration and conforms to a pantheistic philosophy. In comparison with the improvised and unfinished look of Pollock's paintings, works such as *Earth Rhythms*, very typical of Tobey's œuvre, have a highly finished appearance in which a harmonious rule and uniform rhythm prevail.

Initially trained in Seattle, Tobey soon found himself drawn to Oriental cultures, to which he was introduced via his local museum. His interest led him to study not just Oriental art but also Oriental philosophies and religions, and at the age of 28 he converted to the Bahai faith, which preaches the unity of humankind as a totality in which the individual is an integral part. Tobey travelled to China and Japan, where he furthered his knowledge of Oriental art and calligraphy.

In this context, his paintings can be understood as a representation of the philosophy and religious beliefs which governed his life. His works are all-embracing: in them, the parts are subordinated to the whole and lose their individuality. In addition, the rhythmical aspects (central to the present work as the title indicates) and the flow of the continuous line are elements which come very close to Oriental culture.

"I have sought a unified world in my work and use a movable vortex to achieve it."
MARK TOBEY

Earth Rhythms, 1961
Gouache on
cardboard,
63.5 x 47.5 cm

David Hockney

BRADFORD, ENGLAND, 1937

David Hockney is a multifaceted artist who has worked in various techniques throughout his career, from the most traditional such as oil and engraving to the most innovative, such as the photographic collages made with a Polaroid camera. His work of the 1950s and early 1960s was linked to the rise and evolution of Pop Art in England. At this period he was a student at the Royal College of Art in London, where his contemporaries included Kitaj and other founders of Pop Art such as Patrick Caulfield and Allen Jones.

However, Hockney's subject matter is not that of the normal Pop Art subjects which were inspired by issues relating to modern society. In general, he looked at a more personal world peopled by family members and friends; domestic environments, in which swimming pools became the symbol of the relaxed environment which Hockney enjoyed as a consequence of his hedonistic concept of life. The present work was the result of a trip to Italy and of the artist's intellectual preoccupations and sense of humour. It is also contains a deliberate allusion to Michelangelo's supposed homosexuality with which Hockney openly identifed after having publicly acknowledged his own homosexuality at around that time.

The painting is dedicated to Cecchino Bracci, a young man who was Michelangelo's favourite for some years, who died aged only fifteen and to whom the great Florentine painter dedicated forty-eight epitaphs. Cecchino appears in his shroud, wrapped in a white cloth from which only his hands are visible and crowned with a sort of bowler hat which acts as a deflating element in the drama of the whole. His distorted face is that of an anonymous figure whom we only know through Michelangelo's verses. One of these verses is reproduced at the lower right of the canvas against the red background in very small scale, thus forcing the spectator to come closer and read it. The Expressionist character of the painting, which is simple as well as very theatrical, indicates Hockney's admiration for childrens' art and Dubuffet's Art Brut. The limited palette of flat colours applied in large areas contributes to the painting's effect of simplicity.

"Best of all I like handmade pictures; consequently, I paint them myself. They always have a subject and a little bit of form. Balancing the two makes me, I suppose, a traditional painter."
DAVID HOCKNEY

In Memoriam: Cecchino Bracci, 1962
Oil on canvas,
213.3 x 91.4 cm

James Rosenquist

GRAND FORKS, NORTH DAKOTA, 1933

James Rosenquist coincided with other Pop artists, including Rauschen-
berg and Johns, at the Art Students League in New York, to which he
won a scholarship in 1955. He also worked at this period as a billboard
painter, something which would be a crucial influence in his later work.
In 1962 he held his first one-man show and sold every work.

Like Lichtenstein, Rosenquist developed a painting which was
based on images from advertising, but unlike his colleague, used the
techniques of commercial billboard illustration. He thus produced enor-
mous canvases resembling great advertising hoardings which, in ex-
treme cases like *The Flamingo Capsule*, reached almost ten metres long
by three metres wide. Although the dimensions of *Smoked Glass* are
more modest – it measures a mere 51 x 81.5 cm – the images within it
are nevertheless conceived on a monumental scale. There are only three
principal objects in the painting: a cigarette end against a red back-
ground, part of a woman's face with the mouth tremendously empha-
sized, and a car headlight. From their colour these would seem to be
fragments of greatly enlarged photographs of the type used in billboards
at this period, although the painting ultimately has an abstract effect as
a result of the superimposition of the fragments and their precise and
silhouetted outlines.

The images also rely on a widespread ploy still used today: that of
the association between the sensual woman and the image of a car as a
symbol of masculine status. As Edward Lucie-Smith has noted, "One of
the most characteristic and disturbing aspects of Pop Art is that, though
figurative, it often seems unable to make use of the image observed at
first hand. To be viable, its images must have been processed in some
way." In fact, Rosenquist, like Lichtenstein and Rauschenberg, trans-
lated onto his canvases real images which had previously been repro-
duced in other printed media.

Smoked Glass, 1962
Oil on canvas,
61 x 81.5 cm

Express, 1963
Oil on canvas
with silkscreen,
183 x 305 cm

Robert Rauschenberg

PORT ARTHUR, TEXAS, 1925

Robert Rauschenberg is considered by many to be one of the most important artists of the second half of the 20th century. His extensive œuvre is the result of a constant process of experimentation in different pictorial languages, techniques, media and subject matter. Nonetheless, his work has one characteristic which is constant to it: the depiction of a fragmented reality, created through a bringing together of different elements, whether in three dimensions, as with his "combines" and his sculptures, or in two dimensions, such as the present painting.

RAUSCHENBERG

A highly educated man, Rauschenberg was attracted to the arts when young and studied cinema and music as well as history of art. Later, when he was a student at Joseph Albers' Black Mountain College, he met the dancer and choreographer Merce Cunningham and the experimental composer John Cage, with whom he collaborated from that time onwards. Their mutual influence and Rauschenberg's interest in their performances is evident in his numerous works, involving musical motifs. *Express,* for example, includes the image of a group of ballerinas and, above them, a single dancer who is probably Cunningham. Alongside these influences from his immediate circle, Rauschenberg's work always contains a latent reference to Dada, in particular to Duchamp's ready-mades (works of art made from found objects) and to collage. By producing his own art from its discarded materials, he thereby makes critical reference to North American industrial society.

His relationship with Cage and Cunningham was not just an outward or anecdotal one. He also shared their ideas, and was particularly influenced by the aesthetic philosophy of Cage. One of its central ideas was that art should serve to "unfocus" the viewer's mind, inducing him to become more conscious of himself and his surroundings. This idea is perfectly in harmony with the fragmented approach of *Express,* which is an accumulation of different images, all of them sharing the common element of movement. Before them, the viewer is compelled to stop and think.

"Painting relates to both art and life. Neither can be made. (I try to act in that gap between the two.) A pair of socks is no less suitable to make a painting with than wood, nails, turpentine, oil, and fabric. A canvas is never empty."
R. RAUSCHENBERG

Woman in the Bath, 1963
Oil on canvas,
171 x 171 cm

Roy Lichtenstein

NEW YORK, 1923–1997

If a preconceived image of American Pop Art exists in the mind of the art lover, it will undoubtedly take the form of Roy Lichtenstein's comic-strip compositions, as famous and widely reproduced as Warhol's Campbell's soup cans. Pop Art was born simultaneously in North America and Britain, with the same aim of highlighting new aspects of the consumer society which had taken hold in both countries in the 1950s. The familiarity resulting from these images is due both to their closeness in time to the present, and also to the fact that they represent everyday objects or scenarios familiar from the world of advertising. Furthermore, Pop Art in America was a reaction to the staleness of Abstract Expressionism, which had dominated since the end of World War II. Both artists and the public now felt the need for change, motivating artists to turn away from abstraction towards an emphatically naturalistic approach.

Woman in the Bath is a fine example of Lichtenstein's most typical work. The painting is probably inspired by a newspaper or magazine advertisement, which in this case has not survived. With its charming and impersonal feel, the whole painting exudes the playful and carefree mood typical of billboards of the period. The disconcerting – and appealing – element in Lichtenstein's images lies precisely in their decontextualization, which elevates what was no more than a cheap reproduction in a newspaper to the status of art.

The artist maintained that "there are certain things in commercial art which are enjoyable, vigorous and vital". Faithful to these ideas, he reproduced in his images the "Benday dots" (named after their inventor Benjamin Day) which are used to convey colour and shade in poor-quality printing processes. Lichtenstein enlarged the original image onto the canvas with the aid of a projector, sketched the outlines in pencil, then coloured it in with a brush. His use of just two colours, blue and red, on the white background is similarly a reflection of the economy of cheap printing processes.

"All my art is in some way about other art, even if the other art is cartoons."
ROY LICHTENSTEIN

Richard Lindner

HAMBURG, 1901 – NEW YORK, 1978

R. LINDNER

Lindner trained in his native Germany, but in 1933 was forced to flee the country when the Nazis came to power. He spent the following years in Paris, before finally emigrating to America in 1941. This background, in conjunction with the fact that his mother was American, means that Lindner's art marries his European heritage with the new lifestyle which he discovered in his adopted country. He settled in New York and was fascinated by the city from the outset. From it he derived his urban subject matter, which he always portrayed, however, from the point of view of the lowest strata of society.

Moon over Alabama is the poetic title of a prosaic image which deploys the artist's typical male and female types. Both figures are abnormally corpulent, with anonymous faces hidden by masks which give them a coldness devoid of all expression or emotion. The woman may be a prostitute and the man a real gangster, although there is no sense of provocation in their gestures or poses. Their mechanical movements, like those of automata, reflect the mutual indifference bred by life in the big city, which moves at a pace as frenetic as their steps.

The entire composition is structured in a balanced way around the axis formed by the bodies. The hard line and violent colour relate to some extent to the work of the Pop artists, with whom Lindner often exhibited, but the geometric forms which create the human figures (particularly that of the woman), and the background with its coloured planes arranged in large shapes, contain echoes of European Cubism and Futurism.

The subject of the couple, a recurrent one in Lindner's work, is usually accompanied by sexual connotations. Here, however, these seem diluted by the nature of the composition: the single axis formed by the two figures joined at their backs seems to refer above all to the contrast of opposites and to the opposition of male and female, an idea which is emphasized by the contrast between their skin colours (white and black) and between the woman's multicoloured dress and the man's single-colour suit, exemplifying the opposite interests of the two sexes.

Moon over Alabama,
1963
Oil on canvas,
200 x 102 cm

Clyfford Still

FRANDIN, NORTH DAKOTA, 1904 – BALTIMORE, 1980

Clyfford Still began to paint abstract works in the 1930s, but did not arrive at his definitive style until he moved to New York in the mid-1940s. From that point on he produced a type of painting which was well defined and always remained within the same parameters. Like other Abstract Expressionists such as Mark Rothko and Jackson Pollock, he consciously restricted himself to working within one style and one technique.

The painting in the Thyssen-Bornemisza Collection conforms to this type. On a single colour surface, often directly on top of the plain canvas, Still arranged large areas of colour with jagged outlines. Sometimes, as here, these occupy large areas of the canvas and are of equal size, creating a tension among themselves and interacting in a space which is seemingly without depth. On other occasions, Still played with the contrast of a large monochromatic canvas in which a patch of colour was placed like a torn strip.

"Paintings should speak for themselves!"
CLYFFORD STILL

The value which Still gives to these irregularly-shaped and sponta-neous-looking patches of colour, seemingly placed at random, implies the expression of pure painting. Here the painting is not a medium to express or reveal personal sentiments, but is rather simply a celebration of itself. It is about the properties of colour, the expressive value of the shapes and the edges and the aesthetic of the empty spaces. There is absolutely no reference to a world outside of the painting. In this re-spect it is significant that at this period Still did not even give his works titles, as he considered that "paintings should speak for themselves".

Untitled, 1965
Oil on canvas,
254 x 176.5 cm

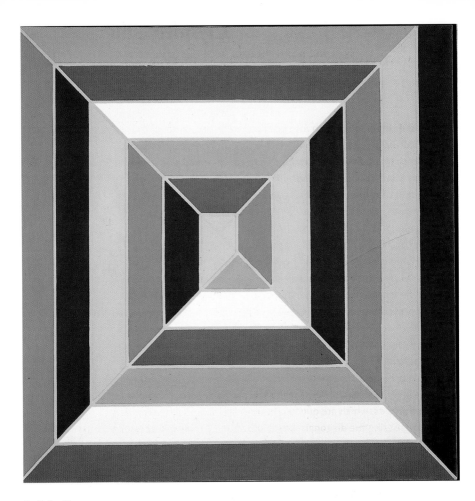

Untitled, 1966
Alkyd on canvas,
91.4 x 91.4 cm

Frank Stella

MALDEN, MASSACHUSETTS, 1936

F. S.

At the end of the 1950s, North American culture was dominated by the rise of Abstract Expressionism, whose followers were of less interest artistically than the original founders of the movement, such as Gorky, Rothko and Pollock. As a reaction to the abuse of gestural art, reduced in many cases to a mere formality, a new type of abstraction developed which looked to the strengths and possibilities inherent in painting but within the framework of harmony, balance and experimental analysis. The father of this tendency in America was Joseph Albers, who had started to paint in this way in the 1930s.

Following Albers were a number of younger artists who, like Stella, developed a type of geometric and impersonal painting with strictly pictorial preoccupations. Stella's normal practice was to develop a type of composition which he investigated through a series of paintings until he had exhausted its possibilities. The present work is one such painting. It forms part of a series in which Stella worked with a helical structure. Moving out from the centre, he places bands of colour arranged orthogonally which multiply in space in a rhythm which could be infinite. These bands, which are outlined by a continuous golden line which breaks on crossing the diagonals, are coloured in different tones from black to white in a single order which is repeated rhythmically. All Stella's works employ similar compositions, sometimes using circular forms, but always with this ordered and rhythmical approach. He emphasized that his work was a beginning and end in itself, and that he conceived of it as an object: "My painting is based on the fact that one can only see in it what is there. It is truly an object".

"My painting is based on the fact that only what can be seen there is there. It really is an object. Any painting is an object and anyone who gets involved enough in this finally has to face up to the 'objectness' of whatever it is that he's doing."
FRANK STELLA

Alberto Giacometti

BORGONOVO, SWITZERLAND, 1901 – CHUR, SWITZERLAND, 1966

Alberto Giacometti (signature)

"Whatever I look at, everything goes beyond me and astonishes me and I myself do not know exactly what I see. It is too complex. One simply has to try to copy the visible in order to take stock of what one sees ..."
ALBERTO
GIACOMETTI

Portrait of a Woman, 1965
Oil on canvas,
86 x 65 cm

While Giacometti's sculpture has received the highest public and critical acclaim, his painting is largely overlooked in the specialist literature and is thus practically unknown. In the course of his career Giacometti executed more than 350 oils and many more drawings. These deserve to be set in the context of his famous sculptures, to which they are in some ways related, in order to better understand his life and work.

The present oil portrait of a woman is a late work. Like others from this period, it more resembles a drawing than a painting, as the entangled and scattered strokes which define the contours and the face of the model, together with a minimum presence of colour – applied in the same way around the outer edge of the figure – conform more to the approach of a drawing than a painting. The image has the immediacy of a sketch, executed in a rapid and nervous style, and gives the impression of being unfinished. The title gives no indication of who the sitter might be, but from the date of the work we know that she must be one of the artist's friends or relations, given that during this period he used the same models over and over again.

The presentation of the figure is severe and hieratic and we are unable to tell if she is seated or standing within the undefined setting, which suggests no more than an interior. In concentrating the colour underneath the lines which define the head and the area around it, Giacometti deliberately accentuates the face – in itself rather ambiguous and imprecise – and focuses the viewer's gaze on this part of the body. The evident isolation and the air of severity, as well as the figure's immobility, could suggest Existentialist influences absorbed by Giacometti from his great friend Jean-Paul Sartre.

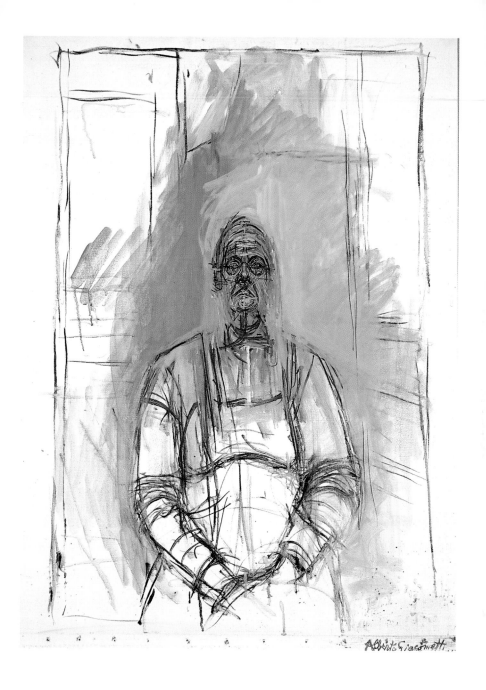

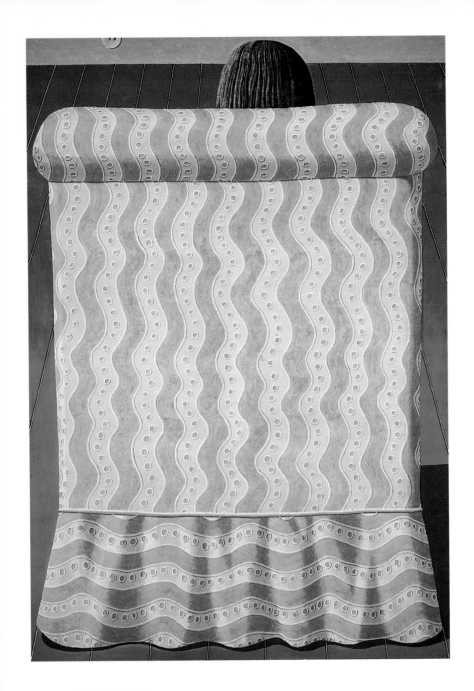

Domenico Gnoli

ROME, 1933 – NEW YORK, 1970

Domenico Gnoli is an isolated and little-known artist who worked in a highly original figurative style which produced surprising results. He is better known for his graphic work in America, where he moved in 1954: his contributions to magazines such as *Sport Illustrated* and *Show Magazine* won him the Gold Medal as Illustrator of the Year in America in 1966.

In his paintings, everyday objects such as clothes, or details of clothes, and domestic furniture take on a monumental scale which frequently extends beyond the edges of the canvas. This outsize scale, together with a precise and meticulous brushstroke which perfectly recreates the textures and surfaces of the objects, results in hallucinatory "landscapes" of buttons, stitches, overstitches, and embroideries (sometimes on the neckline or back or a woman's dress), which can at times be taken for abstract compositions. In the artist's own words, these compositions are worked out through "given and simple elements" which he merely isolated and depicted.

This feeling is also present in the Thyssen-Bornemisza *Armchair*, although a reproduction does not fully convey the sensation of the original, as it lacks the dimensions of the canvas, which is more than 2 metres high by 1.5 metres wide. The outsize scale of the chair, and its decontextualization in the way it is shown with its back to the viewer, preventing us from seeing the figure seated in it, create an enigmatic image which attracts our attention through the bright and contrasting colours of the upholstery. In addition, the transparency of the setting and the absence of atmosphere recall Metaphysical Painting.

"I always use elements which are given and simple; I never want to add anything or to eliminate. I have never any desire to deform; I isolate and I represent. My themes come from the present, from familiar situations, from daily life; because I never intervene actively against the object, I feel the magic of its presence."
DOMENICO GNOLI

Armchair, 1967
Oil and salts
on canvas,
203 x 143 cm

Telephone Booths,
1967
Acrylic on masonite,
122 x 175.3 cm

Richard Estes

KEWANEE, ILLINOIS, 1936

Richard Estes is considered one of the best exponents of Super Realism – also known as Hyper Realism and Photorealism – in painting. Through its scrupulous fidelity to an object from real life, Super Realism invariably delivers a surprise, all the more so when applied to sculpture, in which life-size figures are dressed in real clothes and accessories, and are even given body hair.

In painting, Super Realism sought to emulate images taken with a camera, generally by projecting the photographs – in paint – onto the canvas. This desire to recreate the photographic image clashed with the move away from the formal imitation of reality which had begun in the late 19th century, when the invention of mechanical means of capturing the real world freed artists to deconstruct their whole notion of the purpose of painting. It was the advent of photography which in part caused painting to break with its traditional aim of imitating nature, and from this point of view encouraged the investigations into the object of painting which we see developing after Post-Impressionism. This has been crucial for determining the evolution of pictorial language down to the present day.

Richard Estes, however, goes beyond the mere demonstration of virtuosity which this type of painting can represent. His works combine different views of the same spot, subordinating them to a fixed geometric structure which determines the final composition of the desired image. In this case, *Telephone Booths* establishes a very strict vertical rhythm, which contradicts the horizontal direction of the support, using a completely frontal viewpoint. It seems that these booths were on the crossing of Broadway and Sixth Avenue with 34th Street in New York. The reflections on the glass and the metal surfaces, and the technical mastery in the rendering of the highly finished surfaces, are common to Estes's urban views which, like those of his fellow American Hopper, are sometimes devoid of human presence. Where figures do appear (as in this painting), they are painted with the same coolness and distance as the other elements in the composition.

"I think the popular concept of the artist is a person who has this great passion and enthusiasm and super emotion. He just throws himself into this great masterpiece and collapses from exhaustion when it's finished. It's really not that way at all."
RICHARD ESTES

Lucian Freud

BERLIN, 1922

Lucian Freud was encouraged to take up painting as a career by his grandfather Sigmund Freud. His family, of Jewish origin, were obliged to flee the Nazi regime and moved to London in 1931. Lucian Freud thus followed in the footsteps of other famous German artists, such as Grosz and Christian Schad, who had similarly emigrated to various countries in Europe and to North America to escape persecution.

Freud belongs to the so-called School of London, a name given to a group of artists who have little in common other than that they marked a return to figurative painting in Europe in the second half of the 20th century, in opposition to the non-objective tendencies absorbed from American art. Alongside Freud, other members of the group included Francis Bacon, Michael Andrews, Leon Kossof, Frank Auerbach and Ronald B. Kitaj, all of whom are represented in the Thyssen-Bornemisza Collection.

"I know my idea of portraiture came from dissatisfaction with portraits that resembled people. I would wish my portraits to be 'of' the people, not 'like' them."
LUCIAN FREUD

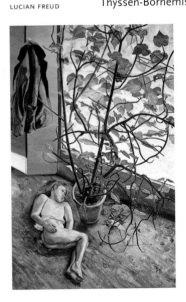

Freud painted portraits from the beginning of his career, characterized by a precise draughtsmanship and a surprising rawness, even crudeness, in their rendering of nude or near-nude bodies – as evident, for example, in *Large Interior*. For this reason he has been called the "painter of flesh". Freud's models are almost always members of his own family or close friends, although at times they are not identified – a prudent move by a living artist, who wishes to protect his own privacy and that of his family. In common with almost all of Freud's paintings, both works here are set inside his studio. They date from a period when his work showed the pronounced influence of his friend Francis Bacon in their acute distortion of space, further emphasized in the case of the *Self-Portrait* by the device of representing the reflection of his own image in the mirror.

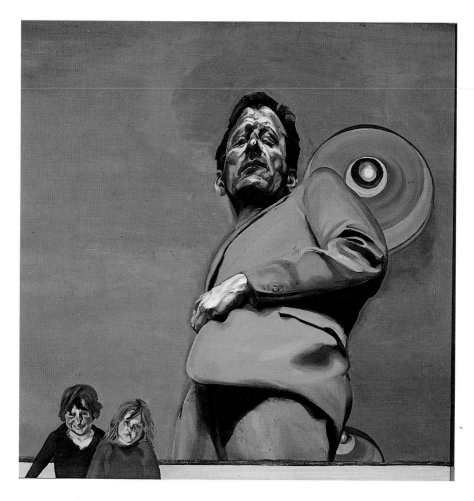

From the 1960s Freud's brushstroke changed, becoming looser and more expressive, almost gestural. This becomes increasingly pronounced in his subsequent work, and culminates in the third and most recent painting by the artist in the Museum, the *Portrait of Baron Thyssen-Bornemisza* (1981/82), illustrated at the front of this book.

Reflection with two Children (Self-Portrait), 1965
Oil on canvas, 91.5 x 91.5 cm

◄ *Large Interior, Paddington*, 1968/69
Oil on canvas, 183 x 122 cm

Francis Bacon

DUBLIN, 1909 – MADRID, 1992

Francis Bacon [signature]

Portrait of George Dyer in a Mirror, 1968
Oil on canvas, 198 x 147 cm

Without doubt, Francis Bacon achieved the greatest international acclaim of all the painters of the School of London. He was also the oldest and the first to become well known, thus making him the leading figure in the movement. Bacon left home at the age of 16 to start work, and was a self-taught artist. His painting is highly individual and thought-provoking, arousing curiosity and admiration in the viewer.

Bacon, who never denied his homosexuality, here depicts his lover George Dyer, a regular figure in many of his works, in line with the practice of the School of London artists, who used their family and close friends as models. Dyer is placed in a claustrophobic, closed and oppressive space typical of Bacon's compositions, with neither doors nor windows to allow the possibility of escape. In this case the room is also circular, as if it had no beginning or end, emphasizing the isolation of the figure within it, who is surrounded by nothing but a profound sense of solitude. The chair and the mirror are the only elements which Bacon has allowed into this empty space, as they have a functional role within the composition.

Dyer's face can only be seen through the distorted and split image reflected in the mirror, as although he is seated facing the viewer, his head is turned in the opposite direction. The human figure becomes a sort of incoherent mass which gives a visionary or dreamlike character to these images. These two characteristics have been interpreted as a premonition of Dyer's suicide, which took place only three years after this painting was completed. Alongside the violent and almost invariably tragic mood of his canvases, Bacon used a counterbalancing harmony of colour, deploying different tones of the same colour range (either warm or cool) throughout the canvas.

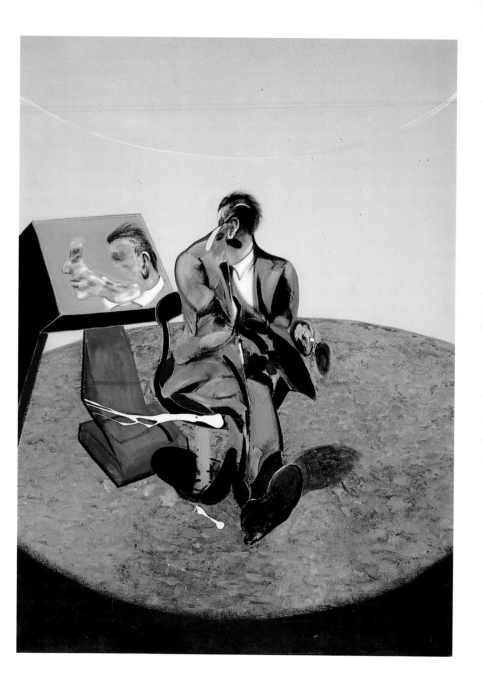

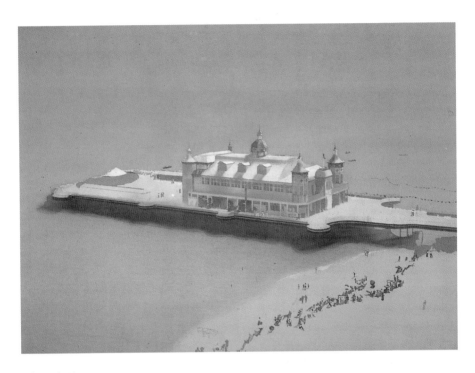

Lights V. The Pier
Pavilion, 1973
Acrylic on canvas,
152 x 213.3 cm

Michael Andrews

NORWICH, 1928–LONDON, 1995

Michael Andrews is the least known of the School of London artists, as he was an unambitious man and little interested in self promotion. He achieved international recognition late in his career in the 1980s, partly due to his small œuvre and the fact that many of his works are in private collections. His rigorous, slow and conscientious working methods meant that the general public was generally unaware of his art.

The differences between his style and that of the other members of the group, who are listed in the entry on Freud, are obvious both in his choice and his treatment of his motifs. Andrews was the most objective of the group, chosing rural or urban landscapes as his subject. His compositions are thus totally different to the closed spaces preferred by Bacon and Kossof, nor do they show the interest in the representation of the human figure common to the other artists, although Andrews occasionally painted a portrait, for example the *Portrait of Timothy Behrens* of 1962, also in the Thyssen-Bornemisza Collection.

Lights V is one of a series of seven canvases of varying formats which were inspired by a photograph, published in the press, of a balloon flying over Gloucestershire. Andrews conceived of the idea of representing a series of landscapes as if seen from a balloon, of which only *Lights V* clearly shows a group of people, albeit painted on a tiny scale and very schematically. The technique of fine layers of acrylic applied with a spray gun gives an unusual, almost crystalline transparency to the composition, which combines with the photographic precision of the drawing to create an unreal, almost dreamlike landscape, which seems to be about to dissolve in the vastness of the ocean surrounding it.

Behind their apparent objectivity, Andrews' landscapes contain a series of philosophical reflections on the insignificance of the human being in the face of the vastness of the world around him. This idea, which has its roots in the Existentialist pessimism generated by World War II and expressed by writers such as Sartre, is fundamental to an understanding of the feelings of isolation and unhappiness contained within the paintings of the School of London.

"What one sees, with the correct interpretation of it, is the way in which Andrews has defined reality."
R. CALVOCORESSI, 1996

Ronald B. Kitaj

CLEVELAND, OHIO, 1932

Kitaj's work falls within both the School of London and British Pop Art. Born in America, he moved to London in 1960 to study at the Royal College of Art. From that time onwards he lived in London, where he formed links with artists from various groups. In fact, the independence and variety of styles among the members of the School of London have given rise to a debate which continues today as to whether they can actually be considered a coherent movement – an argument which the artists themselves have never settled.

The portrayal of friends and family members – as we see here – in an intimate domestic setting was one of the common interests of the School of London, but here the similarities end. Giving absolute predominance to line, Kitaj's works are filled with literary, political and sociological allusions which are difficult to interpret, and require the viewer to have prior knowledge of the subject in order to understand it.

Both these works are painted in a similar format and one which is highly characteristic of Kitaj, but differ in their treatment of colour. *A Visit to London* is closer to drawing than painting, even though it is painted in oil. The colours are limited to white, black and a range of greys, with some elements merely sketched in, such as the protagonists' shirts and the cushion behind one of them. The painting depicts two American poets and friends of Kitaj: Robert Creeley (above) and Robert Duncan, who were also friends themselves, although totally different in their personalities and approaches to poetry. Significantly, Kitaj has underlined these differences through the colour of their clothes. In contrast, in *The Greek from Smyrna* colour is applied in broad areas with a very flat treatment, giving rise to the sensation that the figures are not of flesh and bone but are simply silhouettes cut out and stuck onto the canvas. Although the model for the man walking indifferently past a prostitute, who is trying to solicit his custom at the door of a brothel, is the Greek writer Nikos Stangos, the figure actually represents the Greek poet – and similarly homosexual – Constantine Cavafy. The figure descending the staircase of the brothel is none other than the artist himself.

"There will always be skylarks; even a few nightingales. But arts are not only the human equivalent of the song of the singing birds."
RONALD B. KITAJ

◄◄ *The Greek from Smyrna (Nikos),* 1976/77 Oil on canvas, 244 × 76.2 cm

A Visit to London (Robert Creeley and Robert Duncan), 1977 Oil on canvas, 182.9 × 61 cm

Index of Artists

Copyrights

The copyright of the works illustrated, if not otherwise indicated, is held by the artists, their heirs or estates, or their assignees. Despite intensive research it has not always been possible to establish copyright ownership. Where this is the case we would appreciate notification.